CASPAR DAVID FRIEDRICH
and the subject of landscape

CASPAR DAVID FRIEDRICH
and the subject of landscape

JOSEPH LEO KOERNER

REAKTION BOOKS

Published by Reaktion Books Ltd
11 Rathbone Place
London WIP IDE, UK

First published 1990,
reprinted with corrections 1995
Copyright © 1990 Joseph Leo Koerner.

Designed by Ron Costley
Photoset by Rowland Phototypesetting Ltd
Bury St Edmunds, Suffolk
Printed and bound in Singapore by
Toppan Printers

British Library Cataloguing in Publication Data

Koerner, Joseph Leo, *1958*–
Caspar David Friedrich and the subject of landscape.
1. German paintings. Friedrich, Caspar David
I. Title
759.3
ISBN 0-948462-42-6

Contents

━━━

PART I

Romanticizing the World

———

'Die Welt muß romantisiert werden. So findet man
den ursprünglichen Sinn wieder.'

*The world must become romanticized. That way one finds
again the original meaning.*

Novalis

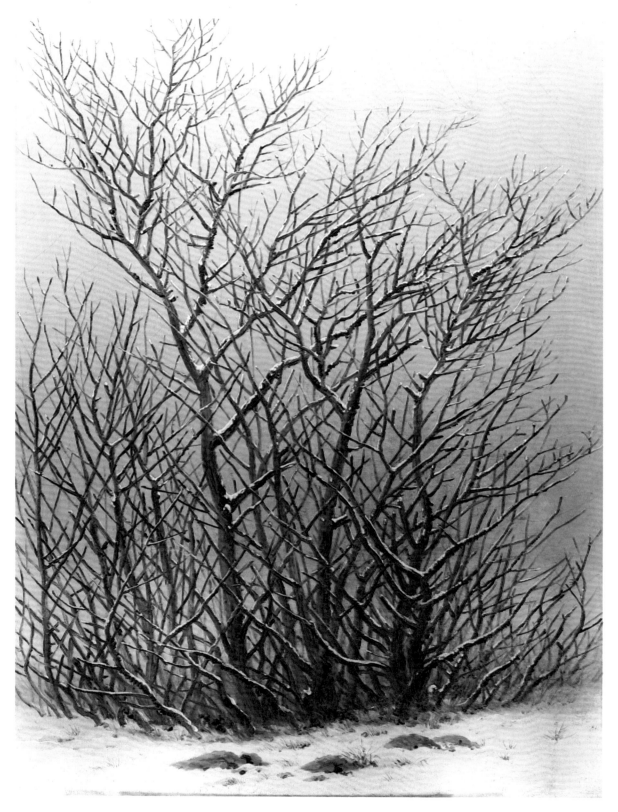

1 *Trees and Bushes in the Snow*, 1828
Staatliche Kunstsammlungen, Gemäldegalerie, Dresden

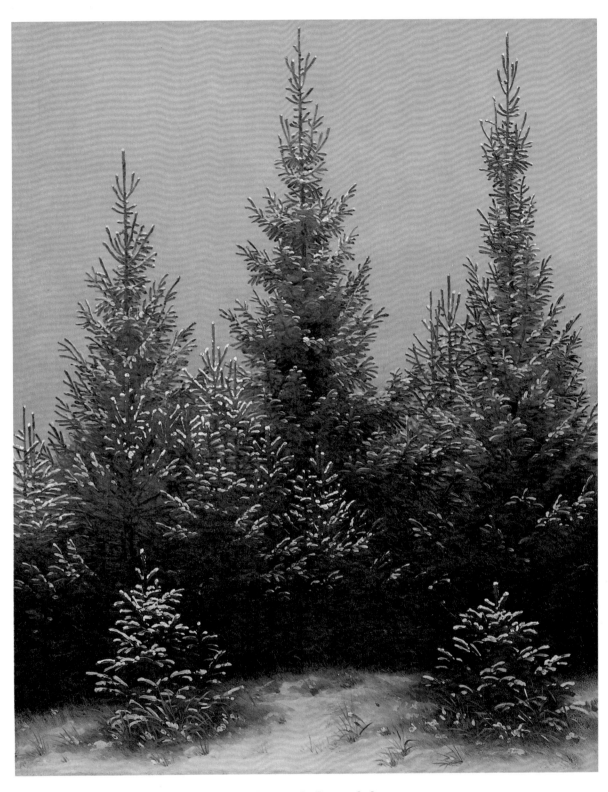

2 *Fir Trees in the Snow*, 1828
Ernst von Siemens-Kunstfonds, Bayerische Staatsgemäldesammlung, Munich

I

From the Dresden Heath

———

You are placed before a thicket in winter (illus. 1). The thicket, a cluster of bare alders, rises from the snow to fill your gaze: a mesh of grey-brown lines traced sometimes with white. The alders' forked twigs and branches, tapering to sharp points, compose loose patterns against the dull sky. Here and there appear regular networks, the products of branches evenly spaced, overlapped and viewed from one spot before the thicket. Just above the ground, where the thicket is densest, you see branches dissolving into an abstract play of criss-crossed lines. Only rarely, however, has the artist simply x-ed his canvas with thin brown lines, heedless of the logic of each individual plant. In the variously pointing twigs near the canvas's edge, in the curved and unpredictable growth of larger, moss-covered stems which pass over and within the network, the artist recuperates – becomes a scholar of – the singularity of *this* thicket. The random signature of each specific twig as it forks out at its own angle, and in its own shape and thickness (despite whatever law commands its ordered growth), underwrites the particularity of the whole. It testifies that the network was and is this way, and no other way, and that you, therefore, are placed here, rather than elsewhere, before this thicket in winter.

Somehow the painting places *you*. Somehow it singles you out to stand before a thicket, just as it singles out each individual branch of that thicket and displays its particularity against the dull sky, as if the singular itself were contingent upon the placement of your eye. Once installed, you seek confirmation of your arrival, some motivative sign or plot that will explain why you are here. The thicket, though, is unremarkable. Neither is it itself a superior specimen of a thicket, nor does it shape a space before itself which could be a setting for other, more remarkable, presences. The alders stand lifeless, their dull brown branches composed in random, broken configurations. The snow that highlights and surrounds the thicket is itself sullied variously by withered crab grass, clods of grey soil and dry leaves trapped since autumn among the alder stems. You do not stand before a 'landscape', since the thicket blocks any wider prospect of its setting; nor do the snow and alders, pushed up against the picture plane, quite constitute the monumentality of a 'scene', for they provide no habitat for an event.

What alone welcomes you, what corresponds to your attention, is the thicket's very placement in a picture. The visual field centres itself around the alders, framing them off as systematically as any random mesh of branches can be framed. The few twigs

that pass out of the picture (at the left and beside the patch of blue sky) seem controlled by fine-tuned coincidences of picture edge and outer twig elsewhere. And, above and below, the open sky and snow-covered earth preserve a certain margin around the thicket. That is, although you are placed before nothing that should command your attention, this void, pictured, seems already to imply your gaze. The framed and centred thicket appears to you, if nothing else, as something *viewed*. You might believe that it is yours whose sight you see of a thicket in the snow. You might even suppose, in a space as lifeless and alone as this, that all the order is the order of your gaze, the patterns of the branches ones that you have arranged.

This painting, however, will not be familiarized. Towards you the thicket borders on the solid, mundane ground of clods, dead grass and snow. Further into space, however, in the thick of the alders, the ground drops off indeterminately. You could presume that the foreground snow simply gives way to a gentle sloping of the land, or that the thicket is rooted in a sunken patch of earth. Yet your placement forbids certainty on this matter of ground. At their bases, the alders stand silhouetted against a narrow, horizontal stripe of purplish-grey, delimited below by the snowy foreground's curved edge, and above by a band of lighter grey. This stripe may invoke the thicket's spatial extent, yet it neither measures, nor limits itself to, that space. Indeed its blurred boundaries, neutral colour and nebulous shape render space radically indefinite, causing the alders to appear as presences conjured up from a bottomless deep. The thicket's placement at the very centre of the canvas, moreover, its seeming coincidence with the order of your gaze, only intensifies the caesura between the mundane and particularized foreground in which you exist and an entirely indeterminate and potentially infinite background. For by insisting that the edges of the canvas appear as the limits of the thicket, the painting confounds any ordered progression of vision into depth, any contextualization of the thicket within a stable and continuous 'terrain'. The thicket thus rises up before you abruptly, as pure foreground, like a net woven over an abyss.

You survey the painting for the trace of a horizon. You search for something more than just a shallow foreground spread out immediately against the sky. Less than a third of the way up the canvas, you are given a sign: a subtle shift in areas of grey, in painted planes of grey, that meet along a blurred horizontal line about where the horizon might be. Below, the lighter plane is a band mirroring the foreground strip of snow in size and shape. It can read either as a hazy winter landscape stretching indefinitely into the distance, or as merely a division within blankets of fog or clouds. This line, hardly a line, is too insubstantial to confirm for you the meeting of earth and sky, yet you balance your vision against this even change of hue from pale to darker grey. Call this the world in which the thicket stands. You bear down further on the painting. You examine its surface, where those planes of grey meet along a horizontal. No change of substance is registered here, only the universal blank of pigments evenly applied. You bear down, too, upon the thicket, upon that overpainted

network of lines that control the scene's particularity. This is a thicket fashioned of thinnest paint, a mere glaze of greyish brown laid down translucent, like the fog that is its ground, over grey. Here you discover the thicket's only stable scale (for who is to say whether the alders are trees or shrubs?): a thing no larger than the painted likeness it is, a miniature on a canvas 31 × 25 cm in size. An unremarkable object decorating the unremarkable. You have surveyed the thicket and found it groundless – alders on a void, themselves a void. You turn at last to interpret what you see.

The scene of a thicket in the snow may stand devoid of life, emptied of all human reference, all continuities of scale and space which would connect the viewer to the landscape. Yet in the intensity with which it fixes on its motif, and in the way it arrests the viewer by its very focus on the unremarkable, the canvas fashions about itself a humanizing plot. This story might read: someone, perhaps a traveller through the countryside, has paused to behold a certain group of alders. What has captured his gaze remains uncertain. Perhaps he admires the sublime contrast of slender branches set against an inscrutable ground of snow, fog and clouds; perhaps he believes that the alders, in their lifeless, inhospitable form, harbour some secret message for him about himself or about the world, 'thoughts that do often lie too deep for tears'. The canvas simply depicts what the traveller saw. To the viewer, meaning is merely indicated, never confirmed. Each clod of earth in the foreground, for example, is punctuated by a dark spot, like the entrance to a burrow. Against the wanderer's exile and estrangement might thus be set a condition of refuge and dwelling. The four clods, moreover, correspond in number and position to the main alder stems that grow above, suggesting a graveyard allegory of death and life. The tiny patch of pale blue sky at the upper right, which eases the dull monochromy of the winter scene, embellishes this reading: against the death-in-life of earthly existence, the canvas offers a vision of transcendence, hence the formal caesura between the detailed and mundane foreground (the finite) and the boundless, horizonless distance (the infinite). The particular content of such plots or allegories are less important than their felt presence within your experience of the canvas. If nothing else, they shape the thicket into a meaningful object, excavating it from a larger passage through inanimate nature (the traveller's journey, say) and inhabiting it with an uncertain, but totalizing subjectivity, as the picture of an *experience* of a thicket.

You are placed before a thicket. You seek entrance to that which commands your attention. The scene becomes an extension of yourself, a buried meaning, an experience half-remembered, or what you will. You believe that, because this is a painted scene, it is somehow *for you*, and that insignificant nature, represented, will have a bearing on your life. Frozen in your passage before the canvas, however, like a moth drawn towards a flame, you discover your kinship with the canvas: object among objects.

You are placed before a grove of fir trees in the snow (illus. 2). The trees and pale blue sky create an architecture ordered around your gaze and coincident with the canvas's geometry. The tallest fir, stationed at the middle of the painting, establishes the central axis of a rigorous symmetry that commands the whole. This symmetry is tempered throughout by a natural randomness of detail. Thus, for example, the two large trees that flank the central fir, as well as the pair of saplings planted in the foreground, are not matched exactly in size, shape or placement within the visual field. And the diagonal rising right to left, carried by the snowy upper branches of smaller trees before the central fir, finds nowhere a corresponding diagonal rising left to right. Such apparent inconsistencies, however, are always gauged against that prevailing rage for order that points the centre tree's snow-capped tip at the precise midpoint of the picture's upper framing edge, and that divides the canvas horizontally into perfect halves where the sky reaches down between the right and central firs. The grove's episodes of asymmetry and randomness, its excursions into the accidental and particular, function merely to place the picture's order within the natural world. They assure you that the geometry you see does not belong to the canvas alone, but is coextensive with the grove itself, which seems somehow to have grown precisely to accommodate and frame your gaze. The uncanny coincidence between natural object and pictorial order emerges partly from the shape of the represented objects. Fir trees generally take the form of upright isosceles triangles, and their boughs, twigs, and needles establish diagonals which rise upward from their stem, contrapuntal to the trees' shoulders. The bilateral symmetry of the fir grove before you, and its construction out of diagonals, out of fir trees rising from the ground and triangular slices of blue sky descending from above, becomes generalized, ubiquitous. Within this grove of firs, anywhere you look you will be placed before the same basic order, the same reciprocity between your gaze and its object, your body (itself symmetrical and tapering towards the top) and the world.

The picture does not so much place you as embrace you. It fashions before you a small space flanked by saplings and celebrated by symmetry: a clearing sized to a body such as yours. The grove becomes a frame for your gaze, a natural altarpiece with you as its single, consecrated object. Its inclusive form, which asserts that order resides in the things themselves rather than in the specific constellation of the visible viewed from one point in space, assures you that such altars, once recognized, are everywhere discoverable.

This scene of a grove of fir trees immediately invites comparison with the image of the alder thicket in the snow. Painted thinly in oil on identically sized canvases, both pictures station you before a single, unremarkable fragment of a winter landscape. Both are devoid of all human reference, all traces of culture, history or plot, save whatever subjectivity is implied in the image's intense and centralizing focus. And both depict their objects – bare and evergreen trees – from close up, creating a scene that is pure foreground, and that therefore resists spatialization into a larger landscape,

8

or into a continuity of scale with your world (although the fir grove and alder thicket appear roughly similar in size both to each other and to their implied viewers). Such obvious correspondences between the two pictures, the sense you have of their belonging together as a pair, only heightens differences within your experience of each image. Against the concave strip of snow and clods before the alders, which serves to exclude you from the space of the thicket, the fir trees gather about a concave foreground that surrounds you, establishing you as the grove's potential centre. Against the random and singular pattern of bare branches silhouetted against the sky and viewed from one particular point, the fir grove posits a ubiquity of order independent of your gaze and spread throughout the landscape. Against the barrenness of the alder branches, which allow or even compel your gaze to pass through them to an indeterminate distance of uncertain substance and structure, the fir trees, ever green, form an impenetrable barrier to your vision, inviting you to remain where you are, at the centre of this natural architecture. And against a thin and empty world of absences, of branches overlapped on branches overlapped upon a void, the fir grove founds presences even in winter: the opaque boughs against a clear blue sky, the undisturbed silhouetting of the snow-tipped foreground saplings against the dark, snowless bases of the larger trees, the self-presence of the viewer in a quasi-sacral space. Such contrasts transcend the simple distinctions of a bare and leafy tree, frozen and partly thawing ground, dull and cheerful sky, which might inscribe the companion pieces into some traditional allegory, say, of death and life. These pictures compare not so much the objects in a world, as your experience of the world. They display you to yourself in your various orientations toward the things you see, the spaces you inhabit and the infinities you desire. Thicket and grove are thus not paired primarily through analogies of composition, scale, canvas size or motif, but rather through their shared address of an experiencing subject. They are linked together, that is, as episodes in a single passage, 'experiences' metaphorized as moments within a journey when the wanderer pauses and beholds.

In exactly *whose* experience, though, are these two moments finally linked? The alders and the firs betray no evidence of earlier travellers to their site, no sign that you, the viewer, are not the first and only person to pause before these winter scenes. And yet something in these canvases eludes the immediacy of your experience, insisting that the firs and alders are not, and never were, moments within *your* life. Each picture depicts a radically unremarkable nature, purged of human meaning and therefore of any clear relation to yourself, within a composition so centralized and intensely focused that it appears endowed with a quite particular and momentous significance. This significance eludes you, and you stand before the pictures as before answers for which the questions have been lost. They are fragments of an experience of nature elevated to the level of a revelation, a revelation, however, whose agent and whose content have long since disappeared.

You are placed before the grove of fir trees in the snow, just as you were placed

before the thicket of alders, and the solitude that confronts you begins to swell. It has inhabited the empty reaches of the winter landscape, and it unfolds past the place where the original wanderer, hesitating in his path, took note of what nature revealed to him. This solitude expands beyond the picture frame, now beyond this voice that speaks here. And it confronts you with the image of your true arrival to the landscape, your embarkation on a *Winterreise*: while you are placed before these winter scenes, the foreground snow before the alders and the firs lies empty still.

In a very simple sense, Caspar David Friedrich's paintings of the thicket and the grove, now kept in Dresden and Munich respectively, *are* linked together by a subject anterior to the viewer. At around 1900, the two canvases hung in a private collection in Stuttgart, where they bore the title *Aus der Dresdner Heide I/II (From the Dresden Heath I and II)*. Their owner was a descendant of one of Friedrich's first and most ardent supporters, the Berlin publisher and nationalist Georg A. Reimer, who was born in the artist's own hometown of Greifswald in Swedish Pomerania just two years after Friedrich's birth in 1774. Reimer must have purchased the works sometime around 1828, when they seem to have been first exhibited in the Leipzig Easter Fair. *From the Dresden Heath* probably represents Friedrich's original title for his paintings, or at the least it can instruct us on the nature of their pairing as it was understood by nineteenth-century viewers.

The title, which distinguishes between the two canvases merely by the numerals I and II (corresponding, respectively, to the fir grove and alder thicket), neither names the specific objects represented, nor does it specify their precise semantic content or their placement within a traditional image cycle (for example the Seasons, Times of the Day and Five Senses). Rather, it names their common *origin*, as things derived 'from' the flat wastelands outside Dresden. Such a localization might seem strange at first. The grove and thicket themselves betray nothing of their specific geographical site. Indeed Friedrich's radical reduction of the visual image to an isolated fragment of insignificant nature functions precisely to obscure the landscape's legibility as topography or 'view'. The painting's early title, however, is not meant to identify the images as recognizable depictions of characteristic Dresden sights. Instead, it fashions for Friedrich's canvases a specificity of a very different kind. On the one hand, by asserting that these firs, these barren alders covered with snow, were objects seen on the Dresden heath, the title intensifies a quality of singularity *per se*. In the painting of the alder thicket, Friedrich conjoins an extreme randomness of detail with a centralized and symmetrical overall design in order to assert that the pattern of branches silhouetted against the sky captures this *particular* thicket as seen by a unique observer from a single spot in space. At this level, the title merely adds to the work's demonstrative or deictic character by referring to the represented terrain by its proper name. On the other hand, while the title indicates the common derivation of both canvases 'from' the Dresden heath, it leaves open the precise relation between painted

image and natural source. The preposition 'aus' signals a movement away from origins. It extracts the paintings from the specific places they represent, confronting their viewer not with the immediate prospect of a scene upon the heath (for then the canvases would have been better called *On the Dresden Heath*) but rather a memory or after-image of that scene. *From the Dresden Heath* indicates not so much the space of Friedrich's canvas as their time, their unique source within a singular temporal experience of nature.

The title imagines for Friedrich's panels an originary experience, unifying the separate scenes through a plot that runs something like this. The artist, who is the implied subject of the landscape, i.e. its initial viewer *and* its ultimate theme, wanders upon the Dresden heath, halting occasionally before views of unremarkable nature. The canvases represent the content of these pauses, although not in the manner of images produced immediately in the landscape. *From the Dresden Heath* does not, in other words, denote paintings done 'after' reality, as in the seventeenth-century Dutch theorist Karel van Mander's lapidary term for descriptive art, *naer het leven* ('after life'). Rather, it signifies something wrested from nature: not pictures brought back to the city from the artist's travels in the countryside, but memories of that travel somehow refashioned into pictures.

We know something of the artistic process whereby Friedrich derives his paintings from an experience of nature. In the upper right of a sheet dated 'den 28t Aprill 1807', the artist has sketched in pencil the precise form of a fir tree as it rises above the undergrowth (illus. 3). Towards the base of the page we can discern a further reduction of motif, in which parts of three different boughs are studied simply for the particular arrangement of their twigs. The sheet belongs to a small sketchbook, kept now in the National Gallery in Oslo, consisting mostly of such drawings of individual trees, shrubs and branches executed from life. These are the images produced directly in the landscape, *naer het leven*, as it were, yet the results are curiously lifeless and distanced. Friedrich abstracts his motifs from their surroundings, setting down their outline somewhere on the blank sheet of paper. Radically unframed and deliberately purged of any perspectivizing construction of continuous space, these sketches are far removed from that heightened subjectivity discerned in the paintings of the alder thicket and fir grove – far removed, that is, from the sense that what we see is an object already viewed by, and therefore always organized around, a prior observer. Although produced in the midst of the artist's wanderings, the Oslo sketches seem to fragment lived experience, to sequester the visible world from the contingencies of a human observer. At one level, Friedrich's interest here is simply to register the shape of a natural object in its particularity by tracing its singular pattern on a sheet of paper. Once committed to paper, these transpositions serve as the raw material for finished paintings which are executed outside nature, in the closed and urban space of the artist's atelier. Indeed Friedrich seems to have used the sketch of the fir at the top of the Oslo sheet for the central tree of his 1828 painting *From the Dresden Heath I*.

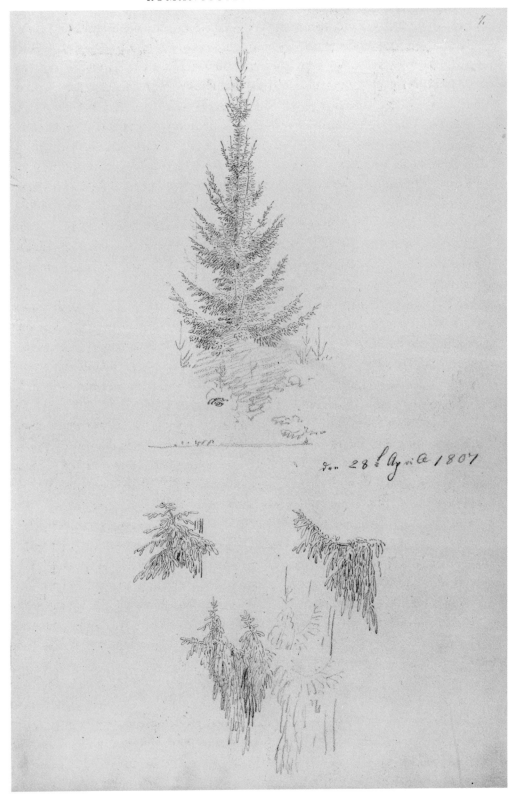

3 *Study of Fir Trees*, 28 April 1807
From the *Sketchbook of 1807*, sheet 7, National Gallery, Oslo

The attention focused on random detail in that canvas, and the attendant sense we have that the painting captures the absolute singularity of its object, thus emerges out of an interplay between nature study and finished work. Extracted from the totality of the landscape and deposited on the study sheet as unique fragments, the Oslo sketches are blueprints of the particular itself. This particularity is embodied not only in the drawing's attention to the sheer irregularity and therefore uniqueness of each object in nature, but also in its explicit connection to a unique moment in time, through the artist's prominent inscription of the precise date of execution. The date testifies, among other things, to the embeddedness of representation in the artist's lived experience, even if the drawing itself, in its abstract and fragmenting quality, fails to fully express that experience at the moment of its occurrence. Once integrated into a fully represented 'scene', in this case, the rigorously framed and ordered oil painting executed some 21 years later, the nature study refers the work of art back into its original temporal moment. The belatedness of this reference, the fact that the tree only appears as something seen, something experienced, long after it is seen no more, is perhaps registered in the painting's season. Among the many reasons for Friedrich's preference for winter landscapes is their appropriateness for staging such references backward in time, such plays between the originary, but unrepresentable, fullness of experience and the retrospective construction of art *as* experience. Experience, as far as we can see it, unfolds long after its time.

The pendant canvases *From the Dresden Heath* represent early, though troubled, examples of what later German thought would call *Erlebniskunst*: that is, art (*Kunst*) that comes from, and is an expression of, experience (*Erlebnis*). It is hard today to imagine a painting that would *not* be thus. That a great work of art is the transposition of experiences, that this transposition is founded upon an artist's unique inspiring genius, and that we, the audience, ourselves regard the encounter with the work as *our* experience – these are assumptions that have become self-evident since the nineteenth century, indeed since the advent of a Romantic aesthetics, whose most programmatic practitioner in the visual arts is Friedrich. *Erlebniskunst*, however, is only an episode in the total history of art. Before Friedrich, pendant canvases like *From the Dresden Heath I and II* would have been linked together as episodes in legend or history, as distinct stages within a natural cycle (Seasons or Times of the Day), as examples of discrete types of landscape (heroic, pastoral, elegiac, etc), or as natural analogues to differing human characters or qualities (the Four Humours, the Five Senses). Each image would correspond to a separate category within a system whose perimeters coincide with the whole of nature or humanity. Such images will undoubtedly become experiences for us, yet in the universality of the systems they articulate, which will always include more than the particular case of the individual viewer or artist, they intend a mode of reception different from that of *Erlebnis*. Friedrich's two canvases, on the other hand, are paired as exemplary moments within a single continuity of experience: the artist's personal *Erlebnis* of landscape. It may be

that the very exemplarity of the thicket and grove relates to their resonances within more objective and universal categories, for example, that the barren alders might represent the pastness of the pagan past (perhaps also invoked in the double meaning of *Heide* as 'heath' and 'heathen'), while the evergreens could refer to the continuing promise of the Christian faith. This is the opposition that informs, for example, Friedrich's earliest surviving pendant oils, *Cromlech in the Snow* and *View of the Elbe Valley* from 1807 (illus. 11, p. 33 and 12, p. 34). Against the boulders of a pagan grave and its surrounding oaks, the artist sets a mountain summit with fir trees, anticipating his most controversial Christian interpretation of landscape, *Cross in the Mountains*. In *From the Dresden Heath*, however, such religious categories must ultimately be subsumed under the concept of experience. For in the obscurity and eccentricity of their reference, they will always seem to us as at most possible motivations for Friedrich's initial pause before these objects on the heath.

Experience, which alone fashions the grove into a pendant to the thicket, is imagined as pauses within a journey through inhospitable nature. The framed and centralized structure of Friedrich's images may suggest that there is a reason for these pauses, indeed that the winter landscape, while resolutely not a home for the human subject, nonetheless has some place, or at least some message for him. Such signs of belonging are, though, unstable, being ordered around and contingent upon the particular placement of the eye before the scene. Belonging would disappear at the moment when the subject of the landscape would step forward to enter the scene, or when he would embark again on his winter journey. What renders the symmetry of the fir grove uneasy, for example, is our dizzying sense that, were we able to glimpse beyond the edges of the picture, we would discover a forest of fir trees stretching endlessly and without order into space. The grove's structure, its apparent accommodation of the viewer, is not something discovered within the landscape. It is a peculiarity of the viewer's placement, which is to say it is an order located in experience, or better: experience ordered as if it were moments of belonging.

2

The Subject of Landscape

Ordered as if experience were belonging, for Friedrich always demonstrates the fragility of such illusions. In a small canvas, *Hut in the Snow*, produced a year before the pendants *From the Dresden Heath* and kept now in Berlin, what is experienced is the passage between belonging and estrangement (illus. 14, p. 36). Again we are placed before something unremarkable in the dead of winter: a ruined hovel on the heath. Built perhaps as a hay shed, the hovel, hardly a hovel, decays into wilderness, appearing scarcely built at all, rotting wood enclosing an overgrown and hollow mound. Yet stationed at the centre of the canvas, and affording a dark place of entrance for our gaze, this hint of an interior, however uncertain, evokes the promise of refuge from cold, inanimate nature. The hovel, that is, offers a vision of dwelling that halts the subject in his passage through the landscape, contrasting with his wandering the condition of arriving at and remaining in a place. This clarifies the radically reduced plots of *From the Dresden Heath*. The objects of Friedrich's attention – the ruined hut, the embracing architecture of the fir grove, the thicket with its foreground burrows – express a thwarted reciprocity with the world. They recollect an at-homeness which only intensifies our estrangement from their wintry surrounds.

In the ruined hovel and its landscape, Friedrich represents a passage from refuge to exposure, culture to nature, life to death. The hovel stands abandoned and overgrown, the remnant of its door already engulfed by vegetation. The hay it shelters emblematizes, through the biblical metaphor 'all flesh is grass' (Isaiah 40:6), the evanescence of human life itself. And the surrounding trees, scarred by years of cropping, are ruins now, their recent branches left unharvested. Significantly, Friedrich's art labours against such dissolution. Placing the hovel's apex precisely on the central axis of the canvas, and reciprocating its sloping sides with the fanning branches of the trees above, the artist restores and monumentalizes the hovel's architecture, as if painting itself were the construction of a refuge. Friedrich's hovel, grove and thicket, however, aspire to ever greater states of emptiness, their fearful symmetries enshrining so little in which to dwell that we as viewers feel ourselves witness to a dissolution of the subject of landscape itself.

This dissolution is momentous for the history of art. Before Caspar David Friedrich, no major Western artist had fashioned canvases as empty as these. Contemporary viewers wondered at the disorienting barrenness of Friedrich's landscapes. The artist's friend and follower Carl Gustav Carus (1789–1869), for example, recounts how

cultured visitors to Friedrich's studio sometimes mistook his mountain scenes for seascapes, or praised pictures which they viewed 'upside down on the easel, mistaking the dark clouds for waves and the sky for the sea'. These early anecdotes of Friedrich's reception, anticipating the legends of abstract painters in our century, recuperate for us the historical strangeness of works like *From the Dresden Heath*. They indicate that the barren scenes of thicket, grove and hovel were achieved only through a deliberate and epochal purgation of landscape painting's subject. What is the intended goal of this askesis? What are Friedrich's canvases the experience of?

One answer provided by the artist's own writings and subsequent literature about his art, is that his landscapes mediate a religious experience. Friedrich empties his canvas in order to imagine, through an invocation of the void, an infinite, unrepresentable God. The precise nature of this divinity, as well as the rites and culture that might serve it, remain open questions, yet the religious intention in Friedrich's art is unmistakable. The artist once remarked about his painting *Swans in the Rushes*, 'The divine is everywhere, even in a grain of sand; there I represented it in the reeds'. The small canvas thus interpreted, kept now in Frankfurt, depicts its subject from within, from a perspective level with the swans (illus. 4). The dense reeds that fill the scene appear to tower over us, while we, as if imploded into the tiny foreground space, are offered neither ground on which to stand, nor a horizon to steady our gaze. Friedrich illuminates this diminished prospect with the mere glow of the moon and evening star, so that the eye, even once accustomed to the dark, struggles to recognize silhouettes, sheer blanks and tiny specks of light. Friedrich's own remark about *Swans in the Rushes* interprets these reductions pantheistically, as demonstrations of God's presence in everything, however small. Yet the presence of God seems finally at odds with the painting's absences, its lack of colour, light, space and ground. *Swans in the Rushes* evokes rather the longing for the infinite. Our gaze that, thwarted by the reed-bank, passes from earth to moon; the dark surface of the canvas which, refusing entrance, keeps us outside looking in; and the swans who sing sweetest when they yearn for death – these indicate a negative path, in which God cannot be found *in* a grain of sand, but at best in the unfulfilled desire that He be there.

A cycle of landscapes, produced by Friedrich around 1811 chronicles this desire (illus. 5, 6 and 7). Like the thicket and grove of firs, which were recognized as pendant scenes only through their shared title *From the Dresden Heath*, these canvases neither illustrate a single legend or history, nor do they conform to any traditional image sequence. Their linkage, documented only in a letter of 1811 by an admirer of Friedrich, is suggested visually in similarities of scale and general arrangement, as well as in the presence of a human figure who inhabits each scene variously. In one of the canvases, recently acquired by the National Gallery in London (an almost identical canvas, believed now to be a contemporary copy after Friedrich, hangs in Dortmund), Friedrich introduces explicitly Christian elements. These furnish the landscape with a plot, which can then be read back into the other pictures, fashioning

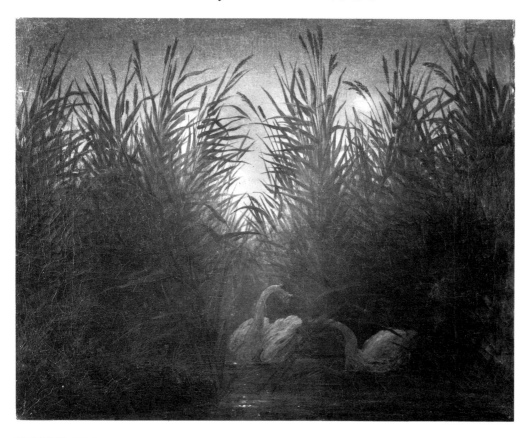

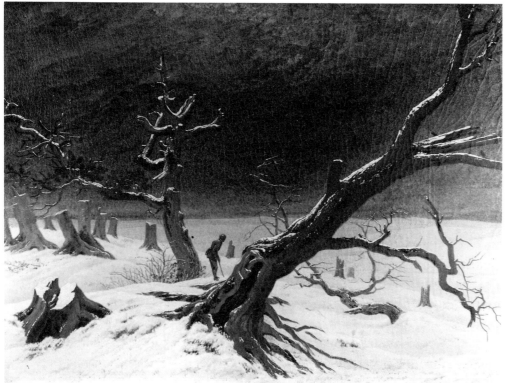

4 *Swans in the Rushes, c.* 1819–20
Freies Deutsches Hochstift, Frankfurt

5 *Winter Landscape,* 1811
Staatliche Museen, Schwerin

them into stages in a single process culminating in the scene shown in *Winter Landscape with Church*.

A wanderer sits propped against a boulder before a large crucifix rising from a grove of snow-capped firs (illus. 7). At the foreground to the right, two crutches mark the path he has taken, at intervals, suggesting that they were cast off. While all stands now at rest, these crutches suggest a theatrical prehistory for the scene, in which the traveller, in ecstasy or exhaustion, discards his supports one by one as he approaches the Cross. The various stories conjured up – the cripple healed by his faith, Everyman throwing off the crutches of an earthly existence to die in Christ – are so familiar, so sentimental that we might be content to leave the traveller where he is, in a shelterless winter landscape empty now of a homeward path. We do not, that is, envisage a future moment when the traveller, rested and comforted, turns and gathers up his strewn props to leave the scene. This is the endpoint of his journey. And as if to answer his prayers, or to settle the scene's account for us, Friedrich raises a spired building, a church, baseless and in pure silhouette, above the lost horizon. Rhyming visually with the grove that encloses the crucifix, and rising to precisely the height of the tallest fir, the structure of the church clarifies the symmetry and order of the natural world, both in this canvas and in all of Friedrich's works where the holy is indicated as potentiality. The vision of the Church, we shall learn to say, discovers the fir grove as a *symbol* of the divine, even as the carved crucifix already uses nature for its ministry.

Significantly, the church does not command the composition of Friedrich's scene as a whole. Placed off to the left, its own symmetry ordered around its tallest spire, it forms a single flank of a bilateral symmetry centred on a small fir tree rising at the centre of the canvas, between the church and the taller fir to the right. Friedrich's canvas thus fashions its own altar, in which the church and grove with crucifix are wings perfectly balanced around an unremarkable tree. It is not coincidental that this central fir would have covered the wanderer's view of the cathedral as he approached the fir grove from the right. From this inner perspective of the scene, the church is not fulfilment, but hidden promise, which explains why the traveller should be resting here in the landscape, rather than seeking hospice further on. For us as viewers of Friedrich's landscape, the Church has other valencies. Fashioning a relation to the other objects in the scene, it explicates their meaning and their *kinds* of meaning. The fir trees, carved crucifix, and visionary church form a spectrum of divine presences in the landscape, from the merest suggestion of the sacral in the gothic geometry of the fir grove and in its potential symbolisms (e.g. the evergreen as eternal faith), to the traditional human icons of God made man (the wooden cross as work of art), to a full eruption of the sacred (the visionary church that transcends the landscape's very 'naturalism'). Like traditional representations of heavenly Jerusalem, Friedrich's church aspires to be the end through which all means – natural, historical, pictorial, and experiential – discover their true sense.

But then the London canvas's aspect as teleology is already given in its placement

in Friedrich's cycle of landscapes. Partly through their season, partly through their placement within a plot revealed by the London scene, the other two pictures line up as prior stages in the life of nature and of man. In what probably is the first picture, the human figure appears as hunter in a wooded scene (illus. 6). Flanked by two living oaks equidistant from the scene's borders, he aims his gun from the very centre of the scene's foreground. Earliness here is registered not only through the scene's abundant foliage, but also through the way the human figure inhabits the landscape. Almost hidden from our view by the dense undergrowth, the hunter expresses a remaining oneness with the world, while his destructive occupation suggests, perhaps, the recklessness of youth. In *Winter Landscape*, now in Schwerin in East Germany, Friedrich evokes a mood of greatest desolation: a wanderer on crutches halts between two oaks, now ruined, and gazes into the winter landscape (illus. 5). What has captured the traveller's attention remains uncertain, for here trees, ravaged and mowed, give no sign of life or consolation. And unlike the ordered, symmetrical firs of the London panel, with their echo of the visionary cathedral, the oaks flanking the traveller veer off wildly out of the picture, while the surrounding stumps jut from the earth in random configurations, like grave-stones in a churchyard without a church. Such disordered and macabre nature is, however, appropriate to the wanderer's attitude for, exposed and in transit, gazing into a viewless prospect, he is now a seeker.

The plot and structure of *Winter Landscape with Church* (illus. 7) discovers what he is seeking: not only belonging in Christ, which means a passage out of wandering, temporality and death, but also a gathering of symmetries. In the way crippled Everyman is answered by Christ of the Passion, and in the way believer and carved crucifix, viewer and work of art, fir grove and church, nature and art, faith and salvation are perfectly paired, Friedrich dramatizes in the landscape the reciprocity that should occur before it: between landscape painting and its sacral meaning, between you and the painted object of your gaze.

Is this, then, the subject of Friedrich's landscapes? In *From the Dresden Heath*, did we simply not see that the ruined alders were just a station along the way, and that the fir grove, shaped *as if* to house a crucifix, appears empty while its essence or Idea lies a little further onward, as a visionary church? Clearly the figure on crutches who gazes into the waste in the Schwerin *Winter Landscape* enacts the very situation implied by Friedrich's much later pictures of thicket and grove: the artist-traveller upon the heath, halted in the landscape, registering through his presence that what we see is not nature, but the experience of nature belatedly re-imagined. Clearly, too, the resolution achieved in *Winter Landscape with Church* maps one trajectory of that experience in which the human subject, once hunter, then spiritual seeker, ends his search in God. And since the church remains hidden from the wanderer's view by the small but centralized tree at his side, the grove of firs in *From the Dresden Heath*, too, might configure a similar arrangement. The wanderer's perspective, internalized into the structure of the painting-as-experience, has now become our own.

Yet what is momentous about Friedrich's art within the history of painting, and what marks his artistic progress from 1811 to 1828 and beyond, is that he prefers to leave us here, on this side of the fir grove in winter, denied the view of the church, the divine, the Idea, determinate meaning, belonging. The subject of landscape, what Friedrich's canvases are finally about, remains always only *almost* visible. The fog that wraps the Church's base, the mute firs that conceal their symbolic significance: these often function to turn the landscape back on the viewer, to locate *us* in our subjectivity as landscape painting's true point of reference. While the plot of this cycle leads to the Gothic cathedral, a sign both of divine presence and of an earlier kind of art that could embody divine presence, Friedrich fashions in his landscapes a different itinerary, one in which we dwell in all the intermediate spaces, where religion would be merely a remembered promise. 'I lost the love of heaven above, I spurned the lust of earth below,' wrote the poet John Clare. To navigate this purgatory, where the artist fashions his works again as altars but must leave out the gods, is part of the historical project called Romanticism.

6 *Landscape with Oaks and Hunter,* 1811
Stiftung Oskar Reinhart, Winterthur

7 *Winter Landscape with Church*, 1811
National Gallery, London

3

Romanticism

What does it mean to say that Caspar David Friedrich is a quintessentially Romantic painter? Certainly his paintings embody a range of tastes, beliefs and attitudes commonly associated with the historical movement termed German Romanticism: a heightened sensitivity to the natural world, combined with a belief in nature's correspondence to the mind; a passion for the equivocal, the indeterminate, the obscure and the faraway (objects shrouded in fog, a distant fire in the darkness, mountains merging with clouds, etc); a celebration of subjectivity bordering on solipsism, often coupled with a morbid desire that that self be lost in nature's various infinities; an infatuation with death; a valorization of night over day, emblematizing a reaction against Enlightenment and rationalism; a nebulous but all-pervading mysticism; and a melancholy, sentimental longing or nostalgia which can border on kitsch. Certainly too, the German Romantics, that loose group of writers and intellectuals who, around 1800, began using the term 'romantic' to denote what they invent, considered Friedrich as one of their own. Ludwig Tieck, the group's most urbane, productive and versatile talent, once recalled a conversation he had with Novalis about painting. Tieck noted that while at the time (c. 1800), Novalis's views seemed quite unintelligible, the artist Friedrich 'later, out of his own rich poetical character' was able to make these ideas 'largely a reality'. For a while, at least, the Romantics could praise Friedrich's landscapes as the visual embodiments of their ideas; which would also mean that his was an art of the idea, and therefore of its cult, the philosophy of German idealism.

What exactly were those ideas that Tieck felt had been fulfilled by Friedrich? Clearly Novalis could not make them intelligible in conversation, nor did Friedrich *know* them before he *made* them real. Tieck insists that the artist realized them autonomously, through his unique genius. Friedrich's Romanticism, therefore, is not a conscious adherence to a distinct project already understood by the Romantic ideology, but is the partial realization of ideas that previously had been by their very nature obscure and unintelligible. But then does this not describe the very function of the term 'Romantic' for the movement that bears this name? As evocation of the faraway and indistinct, as the evocation *of* an evocation, Romantic names that which is properly unnameable about the project of Romanticism.

Friedrich Schlegel, the movement's central and most radical polemicist, wrote to his brother August Wilhelm: 'I can hardly send you my explanation of the word

Romantic, because it would take – 125 pages'. The estimated length of this explanation only ironizes, through its mock precision, the absence of definition in Schlegel's master term. In his most famous text, the Fragment 116 from the first issue in 1798 of the *Athenaeum*, the founding journal of early Romanticism, Schlegel describes Romantic poetry as something which, by definition, cannot yet (or ever) be described:

The Romantic kind of poetry is still in a state of becoming; in fact that is its real essence: that it should eternally be becoming and never be completed. No theory can exhaust it, and only a divinatory criticism would dare attempt to characterize its ideal. It alone is infinite, just as it alone is free . . .

Novalis's conversation with Tieck would have been, from this perspective, a 'divinatory criticism' of Friedrich, yet Schlegel's account asserts that truly Romantic art is resistant to theory and criticism. Moreover, since it is never completed as object or event, and since indeed its completion would render it no longer Romantic, the art of Romanticism sets out partly to defy historical analysis. To reiterate, what is achieved by calling Friedrich's landscapes romantic? Into what history can we inscribe his vision?

In one of his *Logological Fragments*, Novalis formulates Romanticism actively, not as finished product but as future process, not as historical achievement but as imperative:

The world must become romanticized. That way one finds again the original meaning. Romanticizing is nothing but a qualitative potentializing. . . . This operation is still wholly unknown. When I confer upon the commonplace a higher meaning, upon the ordinary an enigmatic appearance, I romanticize it. The operation is reversed for the higher, unknown, mystical, infinite. This becomes logarithmized through such a couple, receiving an ordinary expression. Romantic philosophy. *Lingua romana*. Alternating elevation and debasement.

To romanticize is to discover the world's original meaning. While the process is radically new, the sense it reveals must once have been apparent in the world, hence Novalis's nostalgic words, 'one finds *again*'. The philosopher Hans Blumenberg has demonstrated how, as hermeneutic of lost or forgotten meaning, Novalis's romanticizing implies the projection of a literary genre on to the whole of reality: the *Roman* or novel, with its perceived origins in the past languages and literatures of medieval Christian romance. Romanticizing means simultaneously reading the world as if it were a book, and imagining, or writing, a book that would be consubstantial with the world. 'This operation is still wholly unknown' even to Novalis and his circle, for in order to render the world readable in its infinity, romanticizing must itself be unknown, indeterminate, open-ended. Yet is it not precisely its closure, its sense of an ending, that makes a *Roman* more legible than the world? Novalis acknowledges the incommensurability of book and world within his notion of 'qualitative potentializing' as bestowing 'upon the commonplace a higher meaning'. For within Novalis's logological fragment itself, the romanticizing book, and by extension Romanticism, gets measured against the extravagance of its aim, and receives thereby an enigmatic grandeur. 'Alternating elevation and abasement', that is, occurs in the very distance between the fragment and its project: the world-book.

It is in such a context that we can understand Friedrich Schlegel's famous and audacious statement, made to Novalis in a letter of 1798: 'For my own part, the goal of my literary projects is to write a new Bible, and to wander in the footprints of Mohammed and Luther'. The early Romantics founded their metaphor of a world-book upon the traditional Christian conception of God as author of two books: the Book of Scripture and the Book of Nature. Schlegel imagines writing a book that can vie with Scripture, and another that will explicate that other text, nature, whose legibility has been lost to man since the Fall. Like Novalis's recuperative operation called 'romanticizing,' Schlegel's new Bible remains pure project, which is to say radically incomplete and therefore incommensurate to the totalities of Scripture and world.

Romanticism inhabits this space between immense ambition and slight achievement, between hyperbolic aims and ever-reduced means. In answer to Schlegel's letter, Novalis writes that the Bible should be 'the idea of every book.' Yet what the founders of Romanticism, such as Novalis and Schlegel, wrote in order to describe their project were usually only fragments. In the *Athenaeum* Fragments, the 'Logologische Fragmente', and even the letters exchanged between friends, the partializing form of the texts deliberately shapes the fragmentary nature of their theoretical content. Like the antique torso or ruined cathedral, the fragment can refer back to a whole that has passed away, and more specifically, to pasts presumed to have been more in possession of a now lost whole (e.g. Antiquity and the Christian Middle Ages). At the same time, detached from its original context, the fragment now stands also isolated from its present, thus constituting in some sense a self-enclosed and complete whole. The signs of its rupture, the accidents and particularities of its broken profile, become the marks of its individuality and therefore autonomy. This interplay between part and whole makes the fragment ideal for articulating Romanticism's project, or better: for formulating Romanticism properly *as* project rather than realization. It might also alert us to the difficulties of using the term Romantic as historical explanation for an artist like Friedrich. More radically than any modern critical 'discrimination' of Romanticisms, the early German Romantics themselves claim to author only fragments of Romanticism.

In the 22nd Fragment from the *Athenaeum*, Friedrich Schlegel writes:

The project is the subjective kernel of an object in becoming. A complete project must be at once totally subjective and totally objective, an indivisible and living individual. . . . The sense for projects, which one could call fragments from the future [*Fragmente aus der Zukunft*], is distinguishable from the sense for fragments from the past only by its direction. In the former the direction is progressive; in the latter, however, regressive. What is essential is the capacity to at once idealize and realize objects, to supplement and, in part, to complete. . . . [O]ne could say that the sense for fragments and projects is the transcendental component of the historical spirit.

Reading the fragment is an historical enterprise, indeed is exemplary for historical consciousness *per se*, even when it is a fragment from the future. What, then, of the

fragments from the past which are Caspar David Friedrich's canvases?

As we have seen, the alder thicket and fir grove assume, through their very title, the character of something wrested from a greater whole (illus. 1 and 2). The phrase 'from the Dresden Heath' recalls specifically a kind of title, or more often subtitle, cultivated by the German Romantics in which they claim for their short-story, *Märchen* or novel, that it was taken 'from an ancient tale', 'old chronicle', etc. This conceit, derived perhaps from a preoccupation with collecting lost or vanishing texts (such as myths, fairy tales and folk songs, etymologies), dignifies the present work by asserting that what we read is only part of a greater whole. It will be the reader's duty to 'supplement and, in part, to complete' the verisimilitude of a fragment that he reads. In the pictures of thicket and grove, the whole from which Friedrich excerpts his motif is part subject, part object: a physical place (the heath) and a personal experience of that place (the artist's travel in the landscape). These canvases are partly derived from the drawings in his sketchbook, which is now in Oslo, in which the various objects of the artist's original attention, the rocks, trees, and thickets, stand isolated from the heath on which they appear (illus. 3). The canvas, then, already represents that activity of supplementing a 'fragment from the past' which Schlegel terms 'historical'. Yet while perhaps *less* fragmentary than their sketched sources, the paintings *From the Dresden Heath* retain their epochal emptiness, their reduction of landscape to the narrowest slice of seemingly insignificant nature. What we described as the intense particularity of the two scenes, its celebration of the accidental and specific within the shape of each represented object, however small, is like the profile of a broken torso or ruined temple: a singularity born from loss and fragmentation. On the other hand, Friedrich exhibits thicket and grove as if they were wholes, constructing the canvas's visual field around whatever order and symmetry these objects can offer. This operation of making the insignificant appear monumental, the empty full, the shallow deep, is akin to what Novalis terms 'qualitative potentializing'. Fashioning each object as if it were the bearer of some higher significance, as if the thicket were the culmination of a quest and the grove an altar to the hidden God, Friedrich romanticizes the world.

'To the religious mind', wrote Novalis, 'every object can be a temple, as the ancient Augurs intended.' The architecture of Friedrich's fir grove, indeed, implies such an augury. The three firs and the enclosure before them potentially recall the spaces of Christian worship, for example, the Gothic triptych, the church apse with three windows or Friedrich's own altar design of 1817–18 for the Marienkirche in Stalsund (illus. 8). In *Winter Landscape with Church*, the landscape realizes this potential. The wanderer discovers the icon of God in nature; and we, the painting's interpreters, are shown analogies between fir tree and cathedral in confirmation of our exegetical surmise. If Schlegel desired that his writings be Bibles, Friedrich fashions the Romantic painter's corollary aspiration: that his canvases be altars.

Yet Romanticism also insists that such aspirations are finally only projects, only

8 *Altar* (Design for the Marienkirche in Stralsund), 1817–18
Germanisches Nationalmuseum, Nuremberg

fragmentary indications of an aspiration. It may be clear from the writings of Friedrich and his admirers, as well as from such early, overtly allegorical works as *Winter Landscape with Church*, that represented nature can *appear* to harbour religious significance. But this appearance in Friedrich's landscapes generally is highly ambivalent. Even in *Winter Landscape with Church* the Gothic spires rise above the horizon without a base, as things somehow contradictory to the logic of their setting; and the wanderer, having passed through landscapes empty of divine signs, discovers the icon only as he passes, in death, out of this world. More strikingly, the alder thicket and fir grove of the later *From the Dresden Heath* position us in an intermediary space, where the artist-wanderer still travels in an empty landscape, and where belonging, arrival and meaning are at most memories or projects, accessible only if we ourselves romanticize the painted image before us. Our own interpretative path thus far represents such an

operation. Informed partly by the logic of Friedrich's canvases, partly by the evidence that unfolds around them, we have deduced a course that leads from ourselves, singled out by the landscape's arresting structure, through the artist Caspar David Friedrich, implied by the image's character as *Erlebnis*, to his temporal moment, the culture of German Romanticism. As we explore Friedrich's art within its historical context, we must keep in mind how his canvases, and Romanticism generally, characterize the way meaning *per se* is or is not present in objects. That is, whether we choose to read them as religious allegories, expressions of a Romantic theory of the subject, belated experiments in rendering the cosmos legible or commentaries on contemporary German history and politics, Friedrich's landscapes will remain properly open-ended, if only because they presuppose, from the start and for the epoch which we too inhabit, that the operation which shall interpret them 'is still unknown'.

My analysis divides into two parts. In Part II, Art as Religion, I examine the nature of meaning in Friedrich's landscapes in a discussion of a single painting and the controversy it provoked. The critical reception of the so-called *Cross in the Mountains* or *Tetschen Altarpiece* will help to place Friedrich within the formal, iconographic, religious and aesthetic concerns of his day. Moreover, the controversy over Friedrich's canvas, occurring at a turning point in the history of art criticism, demonstrates how his art emerges concomitantly and in dialogue with the nascent discipline of art history in Germany. If, at the start of my study, I stationed myself and the reader as the picture's representative viewers, an analysis of the *Cross in the Mountains* rediscovers Friedrich's original audience. In Part III, The Halted Traveller, I shift focus again, from the historical viewer to the viewer *in* Friedrich's pictures. The turned figure or *Rückenfigur* who inhabits the foreground of so many of the artist's landscapes, functions to infuse Friedrich's art with a heightened subjectivity, and to characterize what we see as already the consequence of a prior experience. This visual conceit endows the picture with a complex temporal fabric. In our encounter with the *Rückenfigur* and his vision, we feel ourselves late, and therefore estranged, *vis-à-vis* the fullness of nature. The final chapter of the book, *Déjà vu*, questions the precise time, as it were, of Friedrich's pictures. This means, on the one hand, observing how the artist represents landscape as a product and expression of history, both natural and human, and, on the other hand, examining how (or whether) Friedrich's art can be read as the product of a specific moment in German political and cultural life.

'Distant mountains, distant people, distant events . . . all become Romantic, indeed that is what Romantic means.' Novalis, again defining Romanticism as the indefinite, reminds us that, to Friedrich and his culture, all evocations of the faraway, whether as infinite landscape, unfathomable divinity or impenetrable past, belong to the same project. Art 'historical' analysis, the discernment of the artist within his specific time, is itself a Romantic legacy and cannot be for us purely explanation. For it is in the nature of Friedrich's art that all yearnings, historical, existential or religious, are thematized and fused into one constellation, which is the subject of his landscapes.

28

PART II

Art as Religion

———

'Aber Freund! wir kommen zu spät. Zwar leben die Götter,
Aber über dem Haupt droben in anderer Welt.'

*But, my friend, we have come too late! The gods are still alive,
But up there, above our heads, in a different world.*

<div align="right">Hölderlin</div>

9 *Landscape with Pavilion*, 1797
Kunsthalle, Hamburg

10 *Mountain Landscape*, 1803
Goethe Nationalmuseum, Weimar

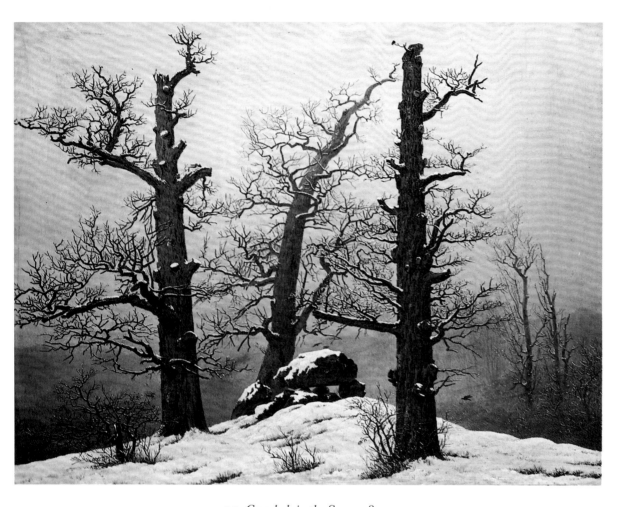

11 *Cromlech in the Snow*, 1807
Staatliche Kunstsammlungen, Gemäldegalerie, Dresden

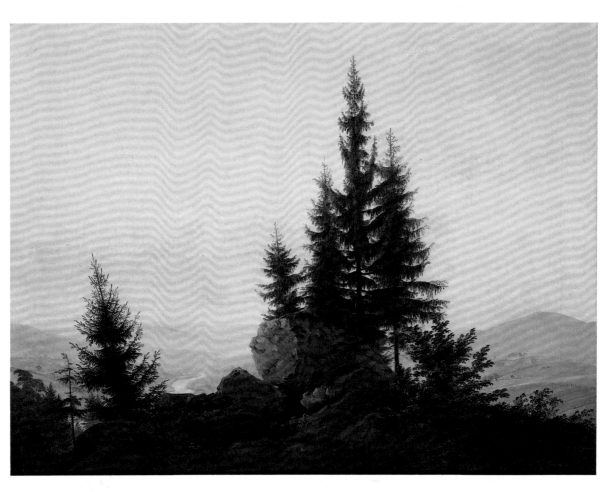

12 *View of the Elbe Valley*, 1807
Staatliche Kunstsammlungen, Gemäldegalerie, Dresden

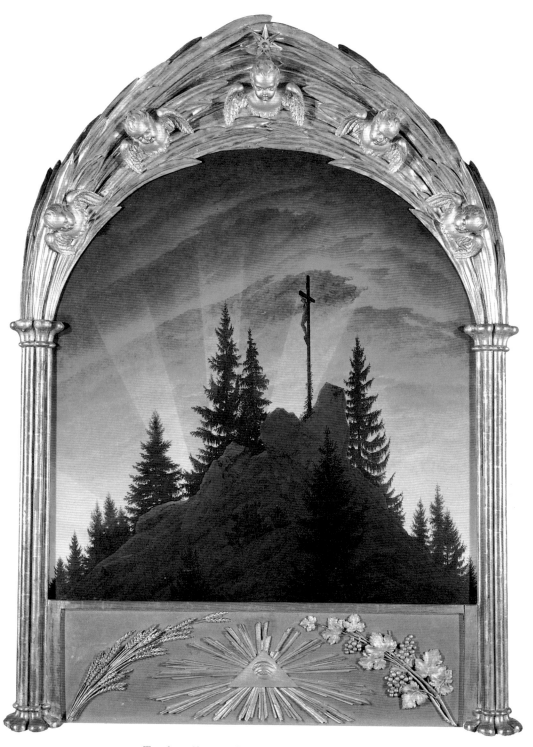

13 *Tetschen Altar* or *Cross in the Mountains*, 1807–8
Staatliche Kunstsammlungen, Gemäldegalerie, Dresden

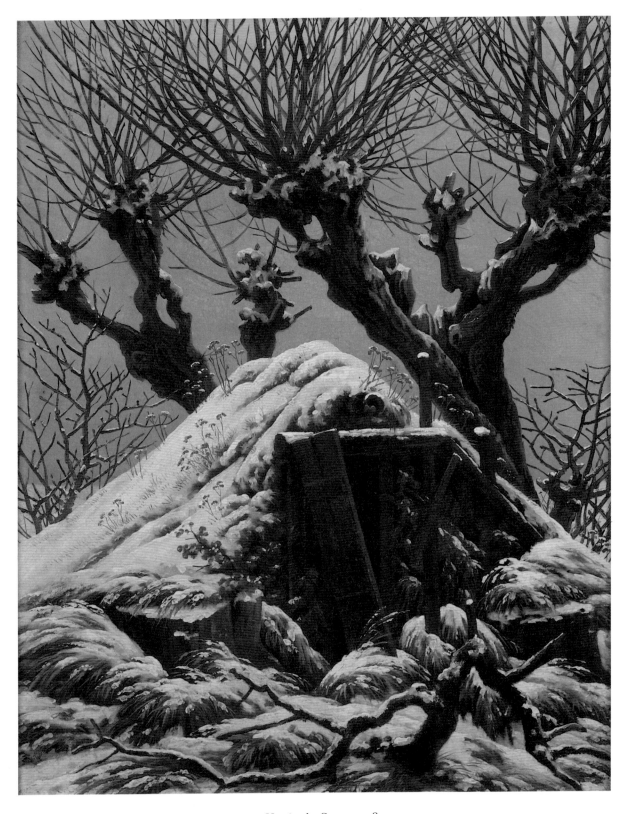

14 *Hut in the Snow, c.* 1827
National Gallery, West Berlin

15 *Epitaph for Johann Emanuel Bremer, c.* 1817
Schloss Charlottenburg, West Berlin

16 *Two Men Contemplating the Moon, c.* 1817
National Gallery, West Berlin

17 *Large Enclosure, c.* 1832
Staatliche Kunstsammlungen, Gemäldegalerie, Dresden

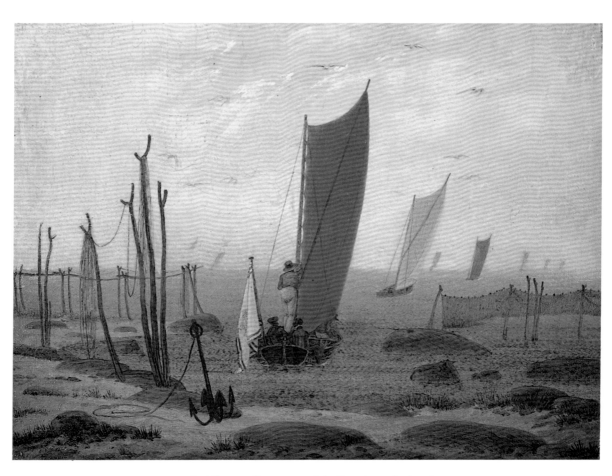

18 *Morning (Departure of the Boats), c.* 1816–18
Niedersächsisches Landesmuseum, Hanover

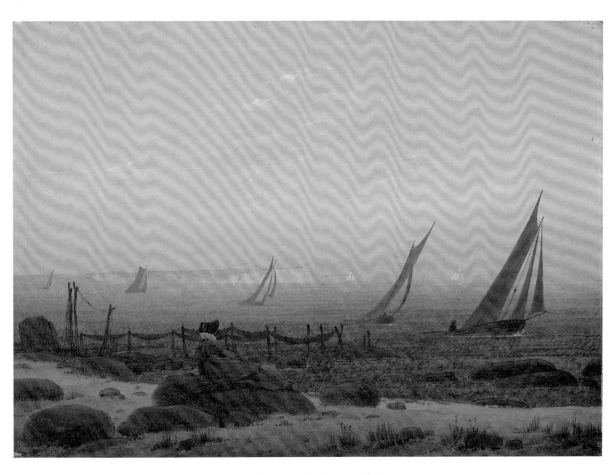

19 *Woman at the Sea, c.* 1818
Stiftung Oskar Reinhart, Winterthur

20 *Fog*, *c.* 1807
Kunsthistorisches Museum, Vienna

21 *Morning in the Riesengebirge*, 1810
Schloss Charlottenburg, West Berlin

22 *The Churchyard*, 1825–30
Kunsthalle, Bremen

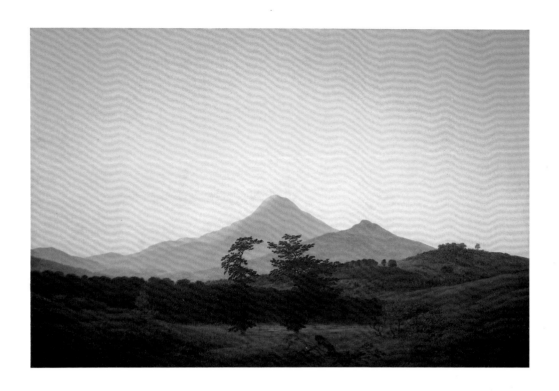

23 *Bohemian Landscape with Two Trees, c.* 1810
Wurttembergische Staatgalerie, Stuttgart

24 *Hill and Ploughed Field near Dresden, c.* 1824
Kunsthalle, Hamburg

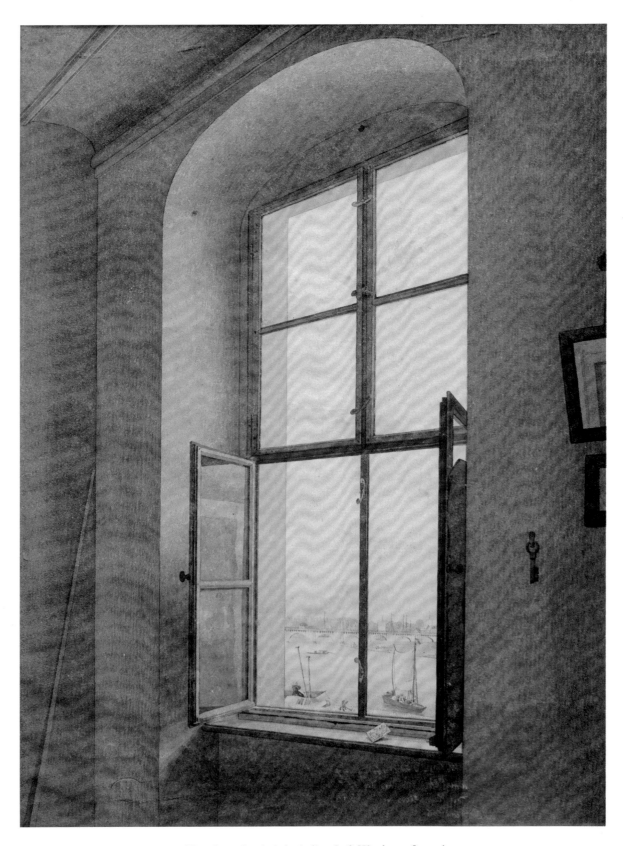

25 *View from the Artist's Atelier, Left Window*, 1805–6
Kunsthistorisches Museum, Vienna

4

The Non-Contemporaneity of the Contemporary

Few paintings are as complexly located in the history of art as Friedrich's large oil *Cross in the Mountains* (illus. 13). Painted over a period from about January to December 1808, the picture was the artist's largest and most ambitious to date. Partly because of its unusual subject matter, pictorial treatment and intended function, and partly because of the public debate it sparked, it established Friedrich instantly as one of Germany's most influential and controversial young painters. The problem which it posed to its contemporary public is encapsulated in its alternative titles. As *Cross in the Mountains*, it is a landscape painting depicting a carved and gilded crucifix or *Gipfelkreuz*, such as still mark the summit of peaks throughout Germany and Austria. The exaggerated definition of the sun's rays, which illuminate the sky like searchlights, may heighten the spiritual aura of the scene and the ivy which clings to the base of the cross, improbably in such an exposed and elevated environment, may suggest an allegorical dimension to the scene. Yet Friedrich never extends these eccentricities beyond what could, under certain circumstances, be observed in a real mountain land-scape. As the *Tetschen Altarpiece*, taking its name from the Tetschen Castle of Count Franz Anton von Thun–Hohenstein in northern Bohemia, where the work was held in 1809–1921, it suggests a function as a working instrument of the Christian ritual. Even without its title and independent of any evidence as to its intended use, the canvas's basket-arch format and heavy gilded frame invokes a tradition of sacred art reaching back to the fourteenth century: namely, the carved and painted retable altarpiece, with its multiple functions of glorifying the altar and the Eucharist renewed upon it, countering through its representations the obstacles of faith (i.e., lay ignorance of Scripture, sluggishness of emotion, and weakness of memory) and, at least in its Catholic contexts, labelling the altar's primary dedication.

Early viewers of the *Cross in the Mountains*, and even Friedrich himself, were unsure what to make of this hybrid creation. They observed that its frame, designed by the artist himself and executed by the sculptor Gottlieb Christian Kühn, distanced the work from the concerns and ambitions of contemporary landscape painting. In the symbolism of the 'predella' (wheat, grapevine, eye of God) and crowning arch (palm leaves, putti, star), they understood an allegorical directive for reading the painted scene thus enclosed, even if they disagreed on what exactly that framing allegory was. The ensemble's character as altarpiece must have been indeed more apparent to these original viewers than it is to us today, for they were able to experience its intended

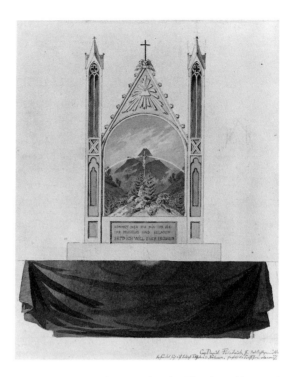

26 *Cross in the Mountains* (design for the *Tetschen Altarpiece*), *c.* 1807
Kupferstichkabinett, Dresden

orientation in space. Flanked by fluted columns, topped by overhanging full-relief sculpture, and outfitted with a heavy, stepped base, the *Cross in the Mountains* was designed not to be hung flat on the wall, as it is today in the Kupferstichkabinett in Dresden, but to be stood on a table as a three-dimensional object. A project drawing for the work shows this original orientation (illus. 26).

When Friedrich first displayed his finished work in his atelier in Christmas 1808, it apparently followed the arrangement shown in the sketch. One of Friedrich's closest friends and supporters in Dresden, the Prussian General and military educator Johann Jacob O. A. Rühle von Lilienstern, wrote an account of this exhibition and its circumstances in his epistolary *Travels with the Army in the Year 1809*. According to him, Friedrich hesitated to show the work to his friends, who wanted to see the canvas in its specially designed frame before the ensemble left Dresden. Friedrich had designed it in sympathy with the architecture and atmosphere of its place of destination, which was to be a small private chapel in the Tetschen Castle. 'Torn from this context and placed in a room not adapted for such a display', Lilienstern wrote, 'the picture would lose a large part of its intended effect.' Friedrich finally exhibited the work at home, in his atelier, to a flood of curious spectators. 'In order to counteract the bad effect of the totally white walls of his small room, and to imitate as well as possible the twilight of the lamplit chapel, a window was veiled and the painting, which was too heavy for an ordinary easel, was erected on a table over which was spread a black

cloth.' This was the situation greeting the *Cross in the Mountain*'s first public: a landscape painting enframed like an icon, an easel replaced by a makeshift altar table, an artist's atelier reconsecrated as a church.

Not surprisingly, this simulacrum of the sacred elicited a mixed response. Some joined as in a congregation not merely of the religion of art, but of art *as* religion. Thus Marie Helene von Kügelgen, wife of a Dresden painter Gerhard von Kügelgen, wrote of her pilgrimage to Friedrich's atelier:

Yesterday I crossed the Elbe and went to Friedrich to see his altar painting. There I met many acquaintances, among them Chamberlain Riehl and his wife, Prince Bernhard, Beschoren, Seidelmann, Volkmann, the Barduas, etc. Everyone who entered the room was deeply moved, as if they had set foot in a temple. The loudest bawlers, even Beschoren, spoke quietly and solemnly, as if in a church.

The 'bawlers' (*Schreihälse*) did not, however, keep their silence once they left the church. While admirers like Marie Helene von Kügelgen preserved a sense of the work's still only metaphorical sacrality within the artist's atelier (hence her repeated 'as if'), opponents found the whole affair blasphemous. As Friedrich's most vociferous critic, Friedrich W. Basil von Ramdohr, wrote in the work's first published review, 'It is true presumption when landscape painting wants to slink into the church and creep on to the altars'. The artist's friends and supporters rallied to his defence, filling the aesthetic journals of Germany with polemics and counterpolemics.

Rühle von Lilienstern's apology for the altarpiece narrates a story of its commission. Friedrich had already displayed a small sepia rendition of a cross in the mountains in the 1807 exhibition of the Dresden Academy. Although this sepia is lost, we can get an idea of its manner from a sheet datable to around 1803 (illus. 10). Rather than constructing his scene as a smooth progression into space, Friedrich fashions the landscape in a series of abrupt, disconnected symmetries arranged around a centralized crucifix, which stands overarched by a mountain soaring above the cloudy horizon, its base concealed. Because of its 'deviation from the conventional form of landscape composition', Lilienstern wrote, this sepia met with a mixed critical response. One viewer, however, was enchanted. Countess Maria Theresa von Thun-Hohenstein, née Countess Bühl, begged her husband, Franz Anton, to buy it. The Count, who was building his wife a private chapel in his Bohemian castle, asked the artist instead if he could refashion the sepia sketch into an altarpiece. Friedrich, however, who 'could only paint and create to his satisfaction when he took up the brush out of his own inner impulse, free from any purpose determined from outside', at first resisted the commission. He accepted only when his designs proved promising and when he devised a way of 'bringing the painting into harmony with the small chapel, and tying them together organically' through a specially carved frame. Lilienstern, in effect, shifted responsibility for the altarpiece from painter to patron, at the same time preserving Friedrich's artistic integrity through the Romantic myth of autoproduction: that is, the creative genius producing his work out of, as well as for, himself alone.

Until recently, historians accepted Lilienstern's account of the *Cross in the Mountain*'s commission, sometimes even asserting that the work was destined not simply for a private chapel, but for a high altar of the Tetschen Castle. In 1977, however, a researcher discovered in the Děčín branch of the Litoměřice State Archives in Czechoslovakia a series of letters which write a very different history for the work. On 6 August 1808, Maria Theresa wrote to her husband the Count Thun-Hohenstein, 'The beautiful Cross is, alas, not to be had! The worthy Northerner dedicated it to his King'. This was the reactionary Gustav IV Adolf of Sweden, for Friedrich, the *brave Norde*, was born in Greifswald, in a part of Pomerania intermittently under Swedish rule from the Peace of Westphalia (1648) to the Napoleonic invasion (1807). In contrast to Lilienstern's tale of the altar being conceived by an enthusiastic patron, the letter of the Countess reveals the *Cross in the Mountains* to have been a work conceived by Friedrich himself to honour his king.

The artist's loyalty to the Swedish crown was probably inspired by Gustav's specific politics and piety. Fiercely anti-Jacobin and a foe of Napoleon, the king brought Sweden into the European coalition against France, remaining on the field even after Russia joined with Napoleon in 1807. Dresden, where Friedrich had lived since 1798, was the place where Gustav negotiated his alliance with England intermittently between 1803 and 1805. Friedrich fervently opposed Napoleon and was so anti-French that in 1808 he refused to receive letters from his own brother Christian, who was travelling in Paris and Lyons. Friedrich would have thus celebrated his king's diplomatic efforts in Dresden. Gustav was also a religious man deeply influenced by the evangelical theology of the Moravian Church. This Protestant denomination, consolidated in the eighteenth century by Count Nicholas Ludwig von Zinzendorf but tracing its origins back to the Hussite movement of the fifteenth century, is characterized by a christocentric and radically inward devotion, in which, as Zinzendorf wrote, faith was 'not in thoughts nor in the head, but in the heart, a light illuminated in the heart'. In Dresden, and earlier in Greifswald, Friedrich stood close to the religious figures who introduced the Swedish king to this faith sometime during his travels in Germany. As a new kind of altarpiece, the *Cross in the Mountains* may have been designed to reflect and encourage Gustav's renewed piety. Focusing on the figure of Christ, yet mediating His reality not as objective history or theological doctrine but as a feeling elicited in the viewer by an emotionally charged landscape, Friedrich's canvas fits well into the 'theology of the heart' of the Moravian brotherhood. Art historians have also suggested that the sun, whose rays illuminate the sky and emanate from around the eye of God on the predella of the frame, might refer to one of Gustav's personal symbols, the midnight sun. The *Cross in the Mountains* becomes at once the working instrument of a faith shared by the king and his loyal subject Friedrich, as well as a celebration of northern piety in its political struggle against Napoleon, embodiment of the destructive, secularizing Enlightenment.

Political events and the swift demise of Gustav's rule made Friedrich's intentions

obsolete. Late in 1806 Swedish forces in north-west Germany were defeated by the French in Lübeck; in 1807, Russia conquered Finland, previously under Swedish rule, and the kingdom of Denmark and Norway declared war on Sweden; and in 1809 Sweden's western army organized a coup d'état, overthrew Gustav, and declared his heirs ineligible. Late in 1808 Friedrich, left with his canvas and its costly frame, must have accepted Thun-Hohenstein's offer, and by January 1809 Maria Theresa's mother, Countess Brühl-Schaffgotsche, was corresponding with her daughter about the difficulty of transporting the work to the Tetschen Castle. Simultaneously, Friedrich and his circle retooled the legend of the genesis and meaning of the work, by inventing a fiction about the altar's 'organic' integration into Thun-Hohenstein's private chapel.

The context of *Cross in the Mountains* does not stop shifting here, however. In the recently discovered letters of Countess Brühl-Schaffgotsche to her daughter we learn of the mother's astonishment over the price and impracticality of her daughter's purchase, for, she wrote, the work will not hang in the Tetschen chapel, nor can it serve as altar anywhere else in the castle. Brühl-Schaffgotsche knew that the chapel already had an altarpiece, a panel executed around 1790 by the Director of the Prague Art Academy, Joseph Bergler. The story of the *Cross in the Mountains*'s original sacral function began as a buyer's ruse to encourage Friedrich to part with his masterpiece. The artist was indeed fooled, for he planned a trip to Tetschen to oversee the painting being installed and consecrated as a working altar. At this embarrassing prospect, the patrons wove lies. They informed him that the altar would be set up in Prague, not Tetschen. When Friedrich then decided to travel to Prague, they gave him the slip again, and in the end he seems never to have seen his work *in situ*. What he would have seen was the *Cross in the Mountains* hung in Countess Maria Theresa's bedroom, surrounded by smaller paintings and all the furnishings of domestic life. Today the work hangs in the Gemäldegalerie in Dresden, representing the continuing secularization of a religious image, which began when the work left the artist's atelier. It remains a landscape painting enframed as if it were a religious image.

An old photograph of the Countess's bedroom reveals that together with Friedrich's *Cross in the Mountains* hung a large, framed engraving of a painting which had been exhibited in the Gemäldegalerie in Dresden since 1754, Raphael's great *Sistine Madonna* of 1512–13 (illus. 27). Enormously influential for the Romantics, this Italian canvas was often taken to represent a turning point in the history of art, in which painting extricated itself from the concerns of religion. Philipp Otto Runge, Friedrich's only equal in Romantic landscape painting in Germany, wrote of Raphael's work in 1802:

Is it not strange that we can feel our whole life clearly and distinctly when we see dense, heavy clouds running past the moon, now their edges gilded by the moon, now the moon swallowed entirely by their forms? It seems then to us as if we could write the story of our life in images

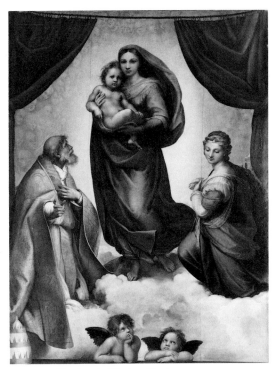

27 Raphael, *Sistine Madonna*, 1512–13
Staatliche Kunstsammlungen, Gemäldegalerie, Dresden

such as these. And is it not true that since Buonarotti and Raphael there have been no genuine history painters? Even Raphael's picture in the gallery tends toward landscape – of course we must understand something totally different by the term landscape.

And again:

In the art of all periods we see clearly how humanity changes, and how no age has ever returned which already once existed. Whatever gave us the unfortunate idea of trying to call back the art of the past? In Egyptian art we see the hard, iron roughness of the human race. The Greeks felt their religion, and it dissolved into art. Michelangelo marked the pinnacle of achievement in composition; the *Last Judgement* is the endpoint of historical composition; Raphael already produced much that was not composed historically; his Madonna in Dresden is obviously only a state of feeling, but expressed through a well-known figure; since his time there has been no true history painting; all beautiful compositions tend toward landscape – Guido [Reni]'s *Aurora*. There has not yet been a landscape artist who gives his landscapes true meaning, who introduces into them allegories and intelligible, beautiful ideas. Who does not see the spirits in the clouds at sunset?

For Runge, the *Sistine Madonna* stands at the end of the tradition of Christian history painting and at the start of a new saeculum of art called landscape. Like Romanticism, landscape can be posited only as project, having not yet found its true practitioner. In Raphael's canvas, Runge discerns a fragment from this future landscape art. While devoid of anything we might now call landscape, it mediates between the 'well-known figure' (the Virgin and Child with saints) and something more abstract and sublime,

a 'state of feeling'. Runge can observe this historical shift by reading Raphael's canvas from foreground to background as if it were a landscape: from the two winged putti at the base, elements from the traditional repertoire of religious art, through the clouds that function as the scene's miraculous ground, to the distance, where the clouds, transformed into an aureole of angels' heads, harbour rarified 'spirits'. Runge himself repeated this arrangement in the complex structure of his masterpiece, the small *Morning* from 1808 (illus. 28). Here Raphael's foreground angels have become the attendant putti tossing flowers at a newborn child; the Madonna has been partly abstracted into her art historical successor, a baroque Aurora: and the aureole of angels' heads is displaced to the upper field of the picture's decorated frame, where it appears like puffs of clouds in a blue sky. Interpreted through such Romantic revisions, Raphael's canvas, present in reproduction in the Countess Thun–Hohenstein's bedchamber, makes some sense of the fate of Caspar David Friedrich's epochal landscape. If the *Sistine Madonna* shifted painting from religion and the altar to a purer form of art, the *Cross in the Mountains* attempts that project augured by Runge: to fashion a new landscape for a new epoch, in which history, meaning, allegory and the idea are legible not only in the figure of Christ on the Cross but also in the spirits of the clouds at sunset.

Certainly Runge's account does not *explain* the coincidence of an engraved Raphael and a Caspar David Friedrich in the bedroom of a Bohemian castle. The Countess's interest in these particular images might reflect a 'Romantic' taste, yet she obviously would not have decorated her chamber intentionally as the epochal conjunction of, as it were, the first landscape and last altarpiece. Runge's remarks do, however, outline an historical framework through which a contemporary might have understood this final context and function of the *Cross in the Mountains*. The real and fictive vicissitudes of Friedrich's canvas demonstrated just how elusive such categories of landscape and altarpiece, secular dwelling and sacred chapel, art and religion were at 1800, and how they could elude even the canvas's very creator. Runge asserts that painting, like humanity itself, exists in a state of constant flux. Every epoch, unrepeatable and unique, produces out of itself an art that is forever new. The great figures of the past – Michelangelo, Raphael, the Greeks – cannot be models for the present, but can at best prophesy for this age its future tasks. This curious vision, which regards the *Sistine Madonna* as already almost modern landscape, but which cannot yet say what landscape is, endows the present moment with an intense and volatile historicity. Modernity, again like Romanticism, consists of fragments from the past and the future. In the case of *Cross in the Mountains*, Friedrich literally enframes his determinedly progressive landscape composition in a pictorial form, and therefore function, of a much earlier age: the retable altar of the Christian Middle Ages. That the work never finally adorns a chapel is absolutely fitting for the age, however, for as Runge observes, we cannot 'call back the art of the past'. The *Cross in the Mountains* resists contextualization. Any 'historical' approach to its function or significance must take

28 Philipp Otto Runge, *Morning* (small version), 1808
Kunsthalle, Hamburg

this into account. Even Friedrich himself must have had to unlearn the habit of
thought which defines the canvas strictly, say, as a celebration of Gustav IV Adolf's
policies and devotion. Confronted by a multivalency that far exceeds the semantic
richness traditionally attributed to great works of art generally, we shall now approach
Friedrich's canvas as the sum of its various receptions in the art criticism of its time.

This criticism erupted almost instantly after the work was exhibited in the artist's
atelier in Christmas 1808. By 21 January 1809, Ramdohr's censorious account filled
22 pages of four numbers of the society periodical *Zeitung für die elegante Welt* (Journal
for the Elegant World). And within a month or two, the artist's supporters published

their defence: Gerhard von Kügelgen, also in *Zeitung für die elegante Welt*, Christian August Semler in *Journal des Luxus und der Moden* (Journal of Luxury and Fashion) and Ferdinand Hartmann in the literary periodical *Phoebus*. Such journals were the nerve centre of educated German society. Emerging from Enlightened culture of the late eighteenth century, they were read by a growing public hungry for novelties and eager to fight remaining prejudices of the day. Although their print runs were relatively small (the most important journal of the period, Johann Cotta's *Allgemeine Zeitung*, published in Tübingen, printed 2000 copies), their readership was far larger. As Henri Brunswig has shown, one copy of a journal, placed in a café or in a reading club, serviced an entire community, and a private subscriber was expected to pass his copy to friends and perhaps the educated and educators of the small neighbouring towns. Within this network of journals and readers' clubs, every artist and intellectual was 'aware that what he does and what he writes will be judged and that the verdict will be widely reported' throughout all the Germanies. In the case of the *Cross in the Mountains*, the debate soon expanded beyond a judgement of a particular Dresden artist and his novel creation. On trial was a whole new culture or sensibility spreading through the German-speaking world, a sensibility that called itself 'Romantic' and posed a threat to the values of *Aufklärung* on which the debate's forum, the literary journal and its educated readership, had originally been founded.

The debate was as much about the nature and role of art criticism as about the *Cross in the Mountains*. Friedrich's chief antagonist, the Freiherr von Ramdohr, was a Dresden critic of rather conservative tastes who, since the 1780s, had championed academic classicism in art. This meant not only that he favoured order, balance and clarity of composition and that he advised artists to copy and imitate the style and subjects of antique art, but also that he believed that art could be reduced to a set of rational and restrictive rules, and that these rules, once codified, could be learnt. In this he simply belonged to mainstream European rationalism which asserts that reason can perceive things aright, and through that perception improve whatever needs improving. 'The critic', writes Ramdohr at the outset of his critique of Friedrich, 'becomes useful as warning: warning to the genius, if he wants to travel upon new paths; warning to the age, when it has either dozed off through its blind belief in the prevailing artistic manner, or fallen under the spell of a fantastic deception or surprise.' Ramdohr's caveat against *Cross in the Mountains* and the epoch that might be duped by its enchantments has a clear prehistory. The judgements he had already made in his first book on aesthetics, *Charis* (1793), had earned the wrath of a younger generation of intellectuals who were precisely set on 'travel[ling] upon new paths'. In the preface to his *Herzensergiessungen eines kunstliebenden Klosterbruders* (Heart-effusions of an Art-loving Monk), Wilhelm Heinrich Wackenroder names 'H. von Ramdohr' as the embodiment of the shallow, soulless, 'oversmart' critic who 'single[s] out the good from the bad, placing them finally all in *one* row in order to view them with a cold, critical gaze'. *Herzensergiessungen*, published anonymously in 1796 and in collaboration

with Ludwig Tieck, was the book that launched the Romantic movement in Germany. Against an art adherent to the rules of a fixed ideal, and therefore against a normative criticism that would legislate that ideal and evaluate works according to it, Wackenroder set the figure of the artistic genius who, by definition, transcends all rules and who demands a criticism based on feeling and interpretative empathy. Against the Neo-classical taste for clarity in outline, composition and signification, he set an aesthetic of the infinite, the obscure, the ambivalent and the multivalent. And against the academic emphasis on the study of Antique art, he set a plethora of historical models or inspirations, which included not only the High Renaissance in Italy but also Gothic art of the German Middle Ages as embodied, for the Romantics, by Albrecht Dürer. When Ramdohr beheld *Cross in the Mountains* in the artist's darkened studio in Dresden, he discerned at once its kinship with the movement that had repudiated him. At the heart of his rejection of this particular work's composition, colour, subject matter and religious ambition lay a recognition of Friedrich's culture:

That mysticism which currently slinks in everywhere and wafts towards us from art as from scholarship, from philosophy as from religion, like a narcotic vapour. That mysticism which substitutes symbols and fantasies for painterly and poetic images, and which wishes to confuse classical Antiquity with Gothic carvings, stiff *Kleinmeisterei* [by which he means the German engravers and woodcut artists working in the shadow of Dürer], and mere legends. That mysticism that sells word games instead of concepts, builds principles upon far-fetched analogies, and everywhere seeks to merely *sense* what it should either know and recognize or else modestly be silent about.

Every reader of the *Zeitung für die elegante Welt* would have understood that 'that mysticism' to which Ramdohr refers is Romanticism.

Ramdohr sensed that the darkness engulfing the landscape in Friedrich's canvas augured the end of the Enlightenment and the dawn of a new era of the irrational that Novalis had already celebrated in his *Hymns of the Night* (1800). He appreciated, too, that the *Cross in the Mountains* represented an approach to painting radically new in the history of art, and that this novelty had an enormous effect 'on the great mass' of the public. Yet, convinced that the work 'robs the essence of painting, and particularly landscape painting, of its most characteristic advantages', Ramdohr proposed to combat the painting's subjective appeal by assessing its achievement according to objective rules of art which he, Ramdohr, himself laid down. These rules were developed around three questions posed to the work: first, how successful was Friedrich's canvas as a landscape painting; second, what is the content of its allegory, and was allegory itself appropriate to the genre landscape; and third, was the ensemble's ambition to serve as an altarpiece for Christian worship compatible with the true nature of art and religion. Generalized, these points query the form, content and function of *Cross in the Mountains* and provide a framework with which to structure our analysis of Friedrich. Friedrich's art will be considered through Ramdohr's categories: Chapter 6, Friedrich's System, deals with composition and pictorial form;

Chapter 7, Allegory and Symbol, analysing not only *what* certain works of Friedrich mean, but *how* they mean, reads his art against a background of the Romantic theory of the sign; and Chapter 8, The End of Iconography, focuses on the question of the religious function of Friedrich's images. In brief, Ramdohr, by measuring what Friedrich does against what the rules of academic classicism dictate should be done in landscape, decides against the *Cross in the Mountains* as landscape, allegory and altarpiece. After the advent of Romanticism we may have little taste for Ramdohr's view of what painting ought to do, yet, as we shall see, his account of what Friedrich does is as acute and compelling as anything written on the artist to this day.

Herein lies one of the most curious aspects of the whole affair. While Ramdohr succeeds in describing what is really new about *Cross in the Mountains*, and competently explains the ideas that might inform the work, Friedrich's apologists fail miserably on both accounts. While they agree that Friedrich's canvas introduces something radically new into painting, they never quite explain what this novelty is, nor do they properly address Ramdohr's very specific criticisms as to the work's composition, signification and intended use. But then the artist's supporters are not really interested in such local arguments. They set out to defend genius *per se* against the burden of tradition and the constraints of the academy, and this defence does not require a favourable judgment of Friedrich's canvas. Their argument with Ramdohr amounts to a reorientation of the way works of art are to be judged and understood. Just as *Cross in the Mountains* constitutes a revolution in landscape painting, its Romantic defence signals a revolution in the language and practice of art criticism.

The controversy over *Cross in the Mountains* represents an epochal confrontation between a normative or universalist aesthetics, grounded in classical rhetoric and confident in the faculties of judgement and taste, and a subjectivistic aesthetics, whose master term is the symbol and whose only universal is Genius. Ramdohr mounts his argument by measuring Friedrich's canvas against an ideal of landscape painting which he posits at the outset. This ideal is forged from 'principles' discerned within the work of past masters, chiefly Claude and Poussin, who are believed to reflect an eternally valid canon for art. Gerhard von Kügelgen, rebutting Ramdohr's argument, calls this method 'dictatorial', not only because it wrongly supposes that one man can legislate what is good for another, but also because it judges present and future art against standards established in the past. As Runge's account of Raphael and the rise of landscape painting shows, the Romantics were keenly aware of the historicity of art, its embeddedness in the particular time in which it was produced. Similarly Kügelgen, defending Friedrich's freedom to deviate from tradition, remarks:

Throughout art history *[Kunstgeschichte]* we observe art consent to varied forms, and who among us wants and is able to determine that it might not agree to forms not yet known. Friedrich's originality should be all the more welcome to us, since it presents us with a form of landscape painting previously less noticed, in which, within its very peculiarity *[Eigentümlichkeit]*, is revealed a spirited striving after truth.

29 *Cross on the Baltic*, 1815
Schloss Charlottenburg, West Berlin

Much could be said about the multifarious use of the word *Eigentümlichkeit* by the German Romantics. Translatable variously as 'peculiarity', 'characteristic quality', or 'strangeness', *Eigentümlichkeit* relates to a complex cluster of words such as *eigen* (the adjective 'own', as in 'one's own'), *Eigentum* ('property'), *eigentlich* ('actually', 'literally', or 'truly'), and *eigentümlich* ('strange' or 'eccentric'). Used by Kügelgen, Lilienstern, Tieck, Novalis and Schlegel to denote a principle of individuation, whereby everyone and everything has its own unique existence and character, *Eigentümlichkeit* functions as a key word within the Romantic theorization of identity. It locates truth within – or better as property *(Eigentum)* of – the unique, particular, experiencing, and radically autonomous Self.

The notion of *Eigentümlichkeit* is foundational, for example, to Friedrich Schleiermacher's philosophy of religion. In his *Monologues* (1800), he writes: 'It became clear to me that every man must represent humanity in his own way, in a particular *[eigen]* mix of its elements'. And just as each individual creates his own picture of the world, so too he fashions, from his inner 'perceptions and feelings', a unique image of God. Rather than studying a monolithic thing called 'religion', Schleiermacher is concerned with a plurality of religions, each with an individual form that is historically and culturally determined. Friedrich, who knew Schleiermacher personally, formulated his subjectivistic aesthetics in similar terms. In his fragment 'On Art and the Spirit of Art', written towards the end of his life and published posthumously, he speaks of the 'Temple of *Eigentümlichkeit*' without whose power a person can do nothing great: 'The spirit of nature reveals itself differently to each individual, and for that reason nobody can burden anyone else with his own teachings and rules as if they constituted an infallible law'. Friedrich dedicates his art to this temple, attending always to the *Eigentümlichkeit* of vision and the visible. *From the Dresden Heath* confronts us with an individuality felt both in the enframed accidents and anomalies of insignificant nature, and in the particularizing illusion that what we see is the personal experience of one subject in one life. We shall see that this life – Friedrich's biography – evinces too a radical individuation. As the quintessential Romantic character in his personal habits, his artistic path and his treatment by the public, Friedrich recalls those darker senses of *Eigentümlichkeit,* meaning strangeness and eccentricity. His is the predicament of Novalis's hero Heinrich von Ofterdingen who, at the opening of the novel of the same name, describes his 'singular condition' as something which 'can and will be understood by no one'. The controversy elicited by the eccentric landscape *Cross in the Mountains* is but the first important critical instance of this predicament.

In his defence of Friedrich, Kügelgen associates *Eigentümlichkeit* with the artist's quest for truth. Informing this view is a new conception of the historicality of art: where Ramdohr and Neo-classicism judge a work against a timeless ideal, Friedrich's supporters interpret the *Cross in the Mountains* by positioning it within what Kügelgen calls 'Kunstgeschichte'. Evaluated according to this method, a painting should be as unique and original, indeed as *eigentümlich*, as its age. Historicism, the endeavour to

read any event or object as having a specific character engendered by the process of historical development, emerges as a major current in German thought during the Romantic period. It is in the critical debate over Friedrich's landscape that the spirit of historicism first enters into the reading of a contemporary work of the visual arts.

Two aspects of historicism in the debate are of interest. First, there is the issue of Friedrich's ensemble of landscape painting and gothicizing frame. Even Ramdohr suspects that the *Cross in the Mountains* is not wholly independent of past art, but links up to traditions other than classical Antiquity or French academic landscape painting. In what he regards as Friedrich's slavish attention to the minutest details of the natural scene, an attention that makes the artist incapable of ordering his scene as a harmonious whole, Ramdohr discerns the influence of 'Albrecht Dürer and other earlier masters'. Ramdohr admits that the 'idea of stamping the German school with a particular *[eigentümlich]* national character of unpretentious truth and simple faithfulness' is 'attractive in itself'; yet the manner of Dürer, while appropriate to its era, has since been superseded by the achievements of Italy and France. Some art is relative, while other art, Antiquity and its academic heirs, remains eternal. Ramdohr observes a self-consciously German quality in *Cross in the Mountains*, and surmises that behind it lies a message of nationalism, locating the issue of historicism within the politics of the period. To the Romantics, it was precisely because the art of Dürer and the German Dark Ages appeared so historically remote, so embedded in an obsolete and vanquished epoch and culture that it offered an alternative to a Neo-classical tradition which, claiming to be somehow above history, offered no place for artistic originality and individuation. In 1808, when Friedrich, the *brave Norde*, designed his canvas with its Neo-Gothic frame for the anti-Napoleonic Gustav IV, the identification with a vanished national past must also have carried a political meaning. Against the French Enlightenment's brutal progeny, against Napoleon's destruction of tradition and history, the German Romantics could invoke a medieval past which, although dubbed as 'dark' by *Aufklärung*, was believed to be unique to Germany. Moreover, through its very demise in the Renaissance and the Enlightenment, the era of Gothic art seemed to demonstrate that the rules of art and politics were not universal but invented by man. This historicist vision of contingency might have encouraged Germans to believe that, out of their *Eigentümlichkeit* as a people, they could create their 'own' state. Here we begin to discern the ideological underpinnings of Romantic *Eigentümlichkeit*. In Justus Möser's multi-volume *History of Osnabrück* (1768–80), a work which had a great impact on German Romanticism, the state is not legitimated by religion, reason or the rights of man, but by the particular history of places and peoples. Such histories are chronicles of ownership, 'Eigentum', by which the individual becomes what he owns and owns what is given to him by the community into which he was born. As we shall see, the pictorial argument of works like *Cross in the Mountains*, which so disturbed the French tastes of a writer like Ramdohr, partakes of this complex. It is not accidental that Ramdohr's crassest invectives against *Cross in the*

Mountains are phrased literally as quotations in French: ' "Ôtez-moi ce bon Dieu ... Il est hors d'ensemble!" ' and ' "Votre mauvais style m'en dégoûte!" '

Secondly, the historicism of Friedrich's supporters and their insistence that his canvas cannot be evaluated according to *a priori* rules and ideals, raises the question of how this work, or any work, can be judged at all. To Kügelgen the answer is clear: 'If only critics [like Ramdohr] would come upon the simple idea of appreciating each art work according to the true-to-life impression it makes upon the sense and the heart, and of reproaching it where it is cold, sluggish, and untrue'. The value of a picture lies in its power to move its individual viewer. Ramdohr acknowledged the great emotional effect the *Cross in the Mountains* had on its audience, yet his critical evaluation, entrusted to the 'higher' faculties of taste and judgement, discounted such effects. Steeled against the vagaries of subjective response and changing fashion, and trained in antiquity's timeless ideals, the Enlightened professional critic works precisely to form and perfect the aesthetic response of his readers, fostering in them the essentially moral faculty of judgement.

Seen from this perspective, Romanticism democratizes aesthetics. By allowing emotion to dominate reason and education, it undermines the authority of all evaluative institutions that are founded on absolute values, and on the possession and transmission of acquired culture or *Bildung*. Friedrich Schlegel suggests as much when he writes: 'Poetry is republican speech: a speech which is its own law and end unto itself, and in which all the parts are free citizens and have the right to vote'. Yet within this republic, Romanticism posits a new and in its own way more rigid hierarchy, based on the possession and recognition of genius. In his defence of Friedrich, Rühle von Lilienstern places the creative artist above the reproach of any critic:

All genius is of an infinite nature, and is, to itself and for all others, the measure and plumbline and substitute for all finite experience. It is safest to let it flourish freely, where and when it is encompassed within the process of creation.... It behoves genius to break new ground everywhere, and to ripen according to its own experience, just as it allows no rules from without to intrude upon it, preferring rather to err in the heights and depths than to remain content in the false ground of impoverished certainty. 'Can genius really err?' *Genius*, never! – insofar as it is understood as the divine, creative principle.

Criticism does not instruct or measure genius, but is itself measured by it. And what is called taste becomes simply an individual's capacity to recognize genius when it is present in art. Lilienstern affirms this principle when he asserts that it takes a genius to know one:

Should not genius speak as much from a critic as from an artist? And how else could the existence of genius manifest itself in the critic than indeed through the open and natural act of his criticism.

The idea that genius makes both art and its interpretation possible, that genius in understanding corresponds to genius in creation, has its origins in the aesthetics of

Immanuel Kant. In the *Critique of Judgement* (1790), he claims that 'genius' engenders a 'freedom without which there can be no fine art, indeed not even a correct taste of one's own by which to judge art'. As Hans-Georg Gadamer has shown, the Romantics drew the consequences of this new valorization of genius as universal aesthetic principle. Historicism revealed to them that taste and judgement vary over time. From the standpoint of art, however, all great works are linked together as unconscious productions of eternal and infinite genius.

If Ramdohr's normative criticism is deemed incapable of judging works of genius, and if the index of aesthetic value resides now in the individual's subjective response a work elicits in an individual beholder, what tasks remain for the institutions of criticism? At one level, Friedrich's defenders claim for themselves simply the role of publicists for genius's creations. Thus in Kügelgen, academic 'connoisseurs' like Ramdohr, who see themselves as 'instructors of artists and the public', are replaced by a new kind of critic called a 'friend of the beautiful', who, 'through spirited reflection and descriptions of art works exhibited singly here and there, widens appreciation for them and makes known those talents who remain still hidden'. When such a critic judges what he sees, he does so as an 'organ of the public, before whose eyes the work is set only so that the various comments and judgements of the public can be brought together under one point of view'. But the 'friends of the beautiful' are more than mere publicists for hidden talent, for their inexhaustible criticism reflects something hidden within any great work of art: an infinity of possible readings.

Friedrich's contemporaries discerned at once that the artist constructed his land-scapes precisely to elicit a multiplicity of interpretations. In responding to Ramdohr's criticism of allegory in *Cross in the Mountains*, Christian August Semler describes the unique capacity Friedrich's canvases have to *mean* in many ways:

Among the numerous types of allegorical images there exists one kind of image . . . in which an artist does not attempt to express a specific sequence of thoughts, but rather puts together a few symbols of some quite comprehensive ideas which, in their relation to one another, indicate only something very general. Beyond this every viewer is left to think through these relations according to his own individual direction and feeling. In such ambiguous [*vieldeutigen*] allegories, it is very possible that the artist himself interprets his work differently than many beholders; but this does not at all detract from the value of the image. . . .

This semantic ambivalence not only does not devalue a work, but is in fact the symptom of a work's greatness. Semler's reading, in which the artist represents but one among many interpreters of *Cross in the Mountains*, places the whole debate between Ramdohr and the Romantics in a new light. The critical dispute will not, in the end, settle the matter of Friedrich's genius, but has already proved this genius through the multiplicity of judgements, interpretations and views expressed about his work. It is in this context that we can understand Novalis's famous statement: 'The true reader must be an extension of the author'. For the process performed on the work by the critic is the same as that performed upon the world by the artist. Both

are fundamentally acts of reflection: the art work as reflection of the experiencing subject in the landscape he experiences; criticism as reflection of the viewer within the work of art. Within this hall of mirrors, a viewer can no longer judge works of art from a distanced or objective position, for he himself will be fashioning art. Or as Friedrich Schlegel wrote: 'Poetry can only be criticized by means of poetry. An evaluation of art which is itself not a work of art . . . has no rights of citizenship within the realm of art'. Friedrich's contemporaries appreciated that the artist's landscapes not only allowed for, but in fact demanded, poetic criticism, for as one reviewer wrote in an 1827 issue of *Blätter für literarische Unterhaltung*, 'That before the works of this artist the viewer is himself forced to invent, in order to complete them, gives them precisely their particular magic'.

Friedrich produced his landscape-altarpiece *Cross in the Mountains* at a moment of radical change in the way art was thought to function and to signify. In the critical debate it sparked, the conflict between a normative and a subjectivistic aesthetic paradigm was staged for the first time within the reception of a contemporary painting. What emerges as new here is, on the one hand, a faith that great works of art should be infinitely and eternally interpretable, and, on the other hand, the idea that such interpretations should involve the placement of the work within the history of art. These assumptions about meaning and history form the foundations of the discipline of art history as it was born in Germany in the course of the nineteenth century, and as it survives in the academy to this day. Perhaps this is why, within their various criticisms and anticriticisms, Friedrich's contemporary foes and supporters articulated most of what can and would be written about the painting until our time. For in a very specific sense, our critical discourse finds its own prehistory in the controversy over the *Cross in the Mountains*. In the course of our study we shall see that this discovery of our method in its object, which is to say the reflection of ourselves in Friedrich's landscape, was anticipated from the start. Friedrich paints at the origins of, and in uncanny harmony with, modern art history. The night that darkens the landscape of *Cross in the Mountains* represents the end of art as religious object stylized as the birth of art as historical object.

A year after Friedrich's death in 1840, the Dresden scientist, gynaecologist and painter Carl Gustav Carus commemorated his friend and mentor in an essay entitled 'Caspar David Friedrich, the Landscape Painter'. Carus opens his eulogy by describing German landscape painting at the end of the eighteenth century. Artists of meagre talent, pandering to a fossilized classicist critical establishment, produced

a pair of dark, mannered trees on either side of a foreground, some ruined temple, or a rock nearby; then, in the midground, some staffage figures mounted or on foot, where possible a stream or bridge and a few cattle; and behind a passage of blue mountains, with some competent clouds above: this was about what qualified as landscape back then.

After this era of degradation and stagnation in the art of painting,

it was Friedrich who, with a wholly profound and energetic spirit, intervened in an absolutely original manner in the desert of the everyday, the prosaic, the vapid, defeating it with his trenchant melancholy, out of which arose a uniquely *[eigentümlich]* new, resplendent-poetical direction.

Carus links this reorientation to the 'volcanic convulsion which, from the year 1789 on, transformed Europe, resounding in a special way through both learning and art'. The French Revolution stands here both as the enabling circumstance for, and as an analogue of, Friedrich's art. It enabled, because, through political rupture, it effected fundamental changes in the taste and sensibility of artists and their public; and it was analogous to Friedrich himself, insofar as his landscapes too represent a revolution of attitudes towards art and artist. Friedrich's disruptive potential was recognized from the start; for the one opinion shared between Ramdohr and his opponents was that *Cross in the Mountains* introduced something totally new into the history of art.

By the time of Carus's eulogy, however, Friedrich's position within the art of his time had curiously reversed itself. His last works shown at the Dresden Academy in 1841 demonstrated, according to Carus, 'with what singular and ironclad peculiarity *[Eigentümlichkeit]* Friedrich infused the self-same, melancholic, ever-alive spiritual Romanticism of poetry into his works, even through his last years'. That is, while in 1809, Friedrich's *Eigentümlichkeit*, his difference from all other painters and his autonomy from tradition, made him original, by the time of his death it was what kept him in the grip of a Romantic individualism that was now *passé*. Only a decade after the *Cross in the Mountains*, Friedrich's art was beginning to appear old-fashioned beside an ascendent variety of new styles and pictorial approaches, e.g., the Neo-Gothic religious art of the Nazarenes, the 'heroic' landscape of Joseph Anton Koch and other German painters in Rome, and the naturalistic landscape and history paintings of the Düsseldorf school. Thus a contemporary reviewer of the 1820 Dresden Academy exhibition writes: 'Year after year Friedrich stumbles ever deeper into the thick fog of mysticism. Nothing is foggy or weird enough for him, as he ponders and strives to excite the mind. His pictures have already in part stopped being works of art'. And in a notice from 1839, published in *Zeitung für die elegante Welt* (the same journal that had, 30 years earlier, carried Ramdohr's reactionary review), Dresden is portrayed as a cultural backwater where a dictatorial critical opinion obstructed any 'truly free artistic life', and where the painter Caspar David Friedrich still painted his 'darkened, foggy' landscapes, 'sidestep[ping] nature's core.'

After Friedrich's death, these landscapes fell into oblivion. His name excluded from most nineteenth-century accounts of the history of German art, and his canvases buried in the storage bins of various local collections, Friedrich was virtually unknown by 1900. It was only through the efforts of the Norwegian art historian Andreas Aubert, who discovered some of the artist's canvases in the warehouse of the Dresden Gemäldegalerie in 1890, and through the huge 1906 retrospective of 100 years of

German painting exhibited in the National Gallery in Berlin, that Friedrich began to emerge as the key German painter of the early nineteenth century. Rediscovered, he was at once hailed as uncannily modern for his time. Reviewers of the 1906 exhibition, in which Friedrich was represented by 36 oils and over 20 drawings and watercolors, saw in his treatment of light and colour an anticipation of Impressionism, while Friedrich's distinctly German sensibility and subject matter were celebrated as prophetic of an authentic national tradition whose triumph, these reviewers predicted, was still to come. A century after the controversy over *Cross in the Mountains*, Friedrich had once again become 'ahead of his time', now to function, however, as an artistic ideal for a revolution from the right. By 1940, a German critic claimed Fredrich for that present age by positing a link between the resurgence of Friedrich's popularity and the expansion of the German state through Nazism:

It is no accident that his rediscovery coincides with the beginning of this martial saeculum, and that the pinnacle of his influence coincides with the outbreak of the World War. No accident, too, that since 1933 Caspar David Friedrich's effect has begun to grow.

At this nadir of Western civilization Friedrich's art is represented as having achieved its moment of greatest renown.

Of course, the phenomenon of an artist's changing critical fortunes is hardly unique to Friedrich. Yet the speed with which he passed, within his life, from the *avant-garde* to the antiquated indicates something about his 'historical' position. Friedrich, for whom no time is quite right, emblematizes that condition of non-contemporaneity which Nietzsche celebrated in his early essays collected under the hermetic title *Unzeitgemäße Betrachtungen* (Untimely Meditations). According to the Romantic myth of the artist, non-contemporaneity describes the place of the creative genius in history. While every epoch and culture will produce its own geniuses, each at once unique unto and expressive of their particular age, what all have in common, indeed what elevates them above all vagaries of history to the level of an aesthetic universal, is their estrangement from the time and world which gave them birth. When, for example, the Norwegian landscape painter Johann Christian Clausen Dahl remarks about his friend and artistic mentor that 'Friedrich was not truly understood by his time', he implicitly reads the neglect of the artist by patrons and critics not as consequence of changing fashions, of a culture's short attention span for already known styles or visions, but rather as the result of a public which, from the very first, never really knew the artist.

The Romantic aesthetic burdens the artist with an impossible task. On the one hand, it demands that genius should be wholly individual and unique, capable of producing works autonomously, which is to say, outside tradition, independent of the limiting charges of patron and public, and always in advance of any known interpretative and evaluative paradigms. On the other hand, it also calls on the artist to transcend this individuality and to found within his art a new mythology, one which would be relevant and binding for the culture as a whole. The ideal of the infinitely interpretable

work of art, even while it valorizes subjectivity in art's production and reception, still imagines that there be an interpreting community, however diverse its voices. Quite a different matter, however, is critical neglect, which is what replaces controversy in Friedrich's reception after around 1820. Neglect and misunderstanding by the public, and consequently the artist's isolation, solipsism and retreat into an over-filled self: these are the grimmer fates that await the artist who would embrace Romanticism's task. In Friedrich's case, the painter responds with a reciprocal mistrust of human fellowship. 'You call me a misanthrope because I avoid society,' wrote Friedrich in an aphorism addressed to his public, 'You err; I love society. Yet in order not to hate people, I must avoid their company.' Friedrich's reclusiveness, almost legendary in his own time, was for him an attitude necessary for his art. In a text composed around 1830 but published only posthumously, Friedrich writes:

I have no intention of working against the dictates of the day, of swimming against the current, when such dictates are purely a matter of fashion. Rather, I dwell in the hope that time shall annihilate its own offspring, and that it shall do so quickly. But much less am I so weak as to do obeisance to the demands of the age when they go against my convictions. I spin about me my chrysalis, and let others do the same; and I leave it to time to decide what shall come of it, whether a brilliant butterfly or a maggot.

The cocoon, hyperbolizing the artist's self-enclosure in the *Eigentümlichkeit* of his art, evokes an organic analogue of the whole process of genius's unfolding in history: withdrawal from, or death to, this world of passing tastes and fashions; metamorphosis in the medium of time as arbiter of greatness; and rebirth in some future when the artist, fully understandable, will be either forgotten (the maggot as Death's attribute) or remembered eternally (the butterfly as Christian symbol of the resurrection).

In Friedrich, death can represent the extent of self-sacrifice demanded of an artist who would be true to himself. Writing of a certain painter, 'XX . . . known because of his tendency to paint only somber subjects' even against the advice of his friends, Friedrich laments how little understanding such friends have for the 'inner impulses and drives of the soul'. XX, who of course stands for Friedrich himself, can paint only what God 'created, coined, and stamped' him to do, which is to depict 'with a serene heart, sad airs and solemn, dusky landscapes'. In the face of misprision by even well-meaning contemporaries, Friedrich exclaims: 'Oh Father, forgive them; for they know not what they do, for they cause the opposite of what they intend'. Society, instead of accepting the genius for who he is, seeks instead to remake him in its own image, driving him further into melancholy, a predicament compared here to the Passion. Friedrich absolves his own epoch of the errors of its critical judgement by quoting verbatim from the words of Christ on the cross in Luke 23:34. At a time when myths are founded subjectively, and when religion is framed as a 'theology of the heart', the redeemer will be one who sacrifices himself not for the sake of our souls, but for the sake of our selves, our interiority. Seen from the perspective of the artist as martyr, a scene like the grove of firs in *From the Dresden Heath* is not devoid

of its Passion or crucifix. In the solitude that has infused all represented things, and in that original fragmenting, isolating, solipsistic gaze implied by the objects we see and by how they are seen, we can discern Caspar David Friedrich as Man of Sorrows internalized in a 'Temple of *Eigentümlichkeit*.'

Quite early in his career, Friedrich explicitly constructed one landscape around his own grave. In a sepia from 1804 entitled *My Burial*, now lost but known to us from contemporary descriptions, an open grave, freshly dug and marked by a cross with the inscription 'Here rests C. D. Friedrich in God', appeared at the centre of a churchyard. Surrounding this were other mounds, some displaying the names of Friedrich's already deceased mother and siblings. A priest, sermonizing to a group of mourners, gestured towards a butterfly, symbol of the artist's resurrected soul, in the air above the open grave. Behind rose ruins of a certain Gothic church said to be from 'Friedrich's birthplace' (presumably the ruined cloister Eldena, near Greifswald). And above appeared a rainbow surmounted by five butterflies (the souls of Friedrich's departed relatives) fluttering before a ray of light. It is not difficult to picture the composition, for the basic motif appears often in Friedrich's *oeuvre*, although never with such an overtly self-referential tenor. In the scene of *Winter* from the late sepia series *Stages of Life*, for example, a cadaverous man and woman sit at the edge of their open grave (illus. 132, p. 224); and in the 1809 *Abbey in the Oak Forest*, now in Berlin, a cortege of monks files past an open grave stationed at the centre of the picture's lower framing edge (illus. 88, p. 169; see also the destroyed canvas of *Cloister Cemetery in the Snow* from 1817–19, illus. 66, p. 133). This grave is meant as the artist's. In the canvas's pendant, the famous *Monk by the Sea* (illus. 87, p. 168), the lone figure on the shore represents Friedrich himself seen from behind but recognizable through his lost profile. In *Abbey in the Oak Forest* the artist as monk, having longed for death at the edge of the sea, is now brought by his brothers to rest.

Contemporary viewers of *My Burial* could gloss such macabre 'self' portraiture with an anecdote from the artist's life. An anonymous critic of the 1804 Dresden Academy exhibition, where the sepia was first shown, composed his review as a dialogue between two visitors to the gallery. One of the speakers, a woman, remarking that the picture came from deep within the artist's heart, recounts a story of the circumstances behind the scene's melancholy subject. One winter day in his youth, Friedrich and his younger brother went skating on a frozen lake. The brother had been reluctant about the outing, but Caspar David convinced him to join. When the two were on the lake, the younger boy broke through the ice and Caspar David, unable to help him, watched his brother drown. 'A quiet melancholy fell over his entire life,' concludes the woman, 'his art directs itself only to objects of mourning, and he paints burial scenes in all forms, so that he himself, with his brother, can return to the dwelling place of peace.' In other accounts of the incident, the brother drowned attempting to save Caspar David, who had himself come into danger on the ice.

The death of Friedrich's younger brother Johann Christoffer on 8 December 1787

becomes a recurrent topos in the literature on the artist. Sometimes it functions to explain landscapes in which nature appears as universe of death, as in the great catastrophe scene of *Sea of Ice* from 1823–5 (illus. 113, p. 201). Sometimes it interprets the whole character of Friedrich's art by attributing the prevailing mood of melancholy to an unresolved but very specific work of mourning. All the artist's 'losses' – of critical acclaim, of an ideal of German national unity, of confidence in the traditional forms of religious faith, etc – that might contribute to his melancholic personality and be registered in his art would then be subsumed under this formative trauma of death. Of course, Friedrich's personal disposition requires no historical cause, being, as the artist himself says, 'created, coined, and stamped' in him congenitally, as it were, as the *Eigentümlichkeit* of his genius. Nor do his burial scenes demand a biographical gloss; for the fascination with death, the depiction of the churchyard as feeling's *locus amoenus*, and indeed the whole *larmoyant* vein of so many of Friedrich's works can be understood as part of the general repertoire of sentimentality shared in Germany by both the Storm and Stress artists of the late eighteenth century and the Romantics of the early nineteenth. By linking the painted landscape to the artist's biography through the story of the ice lake, however, the 1804 reviewer of *My Burial* transposes a general allegory of life and death into the specificity of an individual *experience*. Friedrich occasions this shift to *Erlebniskunst* by appropriating the eighteenth-century churchyard scene literally for his *own* grave, and by transforming the artist's signature ('I made this') into an epitaph ('I was this').

The anecdote of death by drowning is not without its own allegorical dimensions, however. For one thing, that Caspar David is made out to have in some sense caused his younger brother's death, having convinced him to venture out on to the ice, recalls the biblical story of Cain and Abel. Cain's punishment was to wander as 'a fugitive and vagabond in the earth' (Genesis 4:14), hiding from God, but unslayable because marked by God. As Geoffrey Hartman has shown, Romantic artists recognized in Cain an emblem of themselves. Isolated from life but unable to die, Cain exists in a purgatory between life and death, in that state of between-ness pictured by Friedrich in, for example, his *Winter Landscape* (illus. 5, p. 17). Like those other mythic solitaries of the literature of the period, the Wandering Jew, Faust and the Ancient Mariner, the Romantic Cain bears less the mark of guilt than of a crippling self-consciousness which increases with solitude. To Friedrich, who in his later years felt himself scorned by his culture simply for expressing who he was, this mark was indeed that of self-hood, of *Eigentümlichkeit*, of being, as one acquaintance put it, 'the oddest of all oddities'. In the proleptic fantasy of *My Burial*, Friedrich might receive what was withheld from him on the frozen lake in 1787 and what might be recalled in all of the artist's pictures that stage a subjective yearning for death: union with his brother in the beyond. Far more importantly, however, what is pictured here, as well as in works like *Winter Landscape with Church*, is a release from an entrapping interiority which is ceaselessly repeated in the mourning and autobiography of his art.

5

Sentimentalism

—

Before turning to Caspar David Friedrich's biography and artistic development up to the *Cross in the Mountains*, let us set before us the artist's face. At around 1800, Friedrich executed a *Self-Portrait* in soft black chalk for his friend, the Danish painter Johan Ludwig Gebhard Lund (illus. 30). Observing himself in a mirror, the artist has built up the subtle contours, folds and veins of his face through a delicate and carefully crafted web of hatching. This modelling technique, in which parallel strokes curve to adhere to the surfaces they describe, is common in German drawings of the period and derives from the graphic manner of French eighteenth-century engravers. Friedrich, whose academic training would have emphasized sketching from prints of works of art, thus transposes this method of obedient copying to the depiction of his own face. At the same time, however, the artist also animates his likeness through the curious pose he strikes. His shoulders aligned parallel to the picture plane, his face turned sharply to three-quarters and his eyes fixed directly outwards towards the beholder, Friedrich depicts his body at work, engaged in the act of simultaneously sketching, posing and seeing. The awkward divergence of face and gaze affects the way we read the labour expended in the finished drawing. Holding his body in place in front of the mirror, Friedrich must provide his gaze with a stable object to be replicated in all its minutest details. Yet this gaze, represented at odds with the body's immobile posture, betrays the difficulty of its task. The act of sketching, the meticulous, disciplined, rigid and at bottom self-effacing operation of modelling the visible according to an academic formula, engenders a split within the represented body. Observing himself as he observes himself in the mirror, Friedrich discovers and represents the struggle between his public, visible, portrayable face, and a hidden inner energy legible only in the gesture of the gaze.

In another *Self-Portrait* sketch, dated 8 May 1802 and kept now in Hamburg, the artist stands before us equipped for a rather different struggle (illus. 31). Dressed in travelling clothes, with a makeshift visor over one eye and a round ink flask dangling from his coat, this is Friedrich not as academic portraitist, but as landscape painter in harness for sketching outdoors. The visor, which together with his shapeless cap gives him the appearance of a wounded soldier, probably functioned as a means to steady his gaze. For by viewing his object only with his active right eye (note that self-portraiture, through the agency of the mirror, reverses the orientation of the sitter), and therefore by sacrificing the apprehension of volume through stereoscopy,

30 *Self-portrait*, *c.* 1800
Statens Museum for Konst, Copenhagen

31 *Self-portrait with Cap and Visor*, 8 May 1802
Kunsthalle, Hamburg

32 *Self-portrait*, *c.* 1810
National Gallery, East Berlin

he achieves a more precise perception of outline, which accords well with the abstract and quasi-diagrammatic quality of Friedrich's sketches produced directly 'from nature'. In the Oslo study sheet of fir trees, we recall, the aim was precisely to wrest the object from the contingencies of viewpoint and setting, even if later on, when the drawing would be reworked in the studio into the canvas *From the Dresden Heath*, the artist would intensify the fir tree's subjective aspect as something seen (illus. 3, p. 12). Interestingly, the 1802 *Self-Portrait* not only *depicts* the artist-traveller outfitted for sketching 'on the heath', as it were. In its technique (sepia wash over graphite outline), its sober style and its inscribed date of execution, the *Self-Portrait* as image also itself *resembles* Friedrich's early nature studies. Accordingly, the artist does not struggle here to chronicle the difficult labour of representation, much less to capture an inner self, but rather depicts himself as mere instrument and object of vision. Assembled together with those other apparatuses of nature study, the paper visor and oval flask of sepia, Friedrich's Cyclops gaze, strangely impersonal, stares out at us from within a picture whose oval format seems to echo the shape of an eye.

Friedrich's self-portraits are staged as dramas of the gaze. In the 1800 likeness fashioned for Lund, the act of looking is incarnated within the complex posture of a body simultaneously representing and being represented. And in his Hamburg likeness of 1802, Friedrich dresses up his gaze for the act of objective nature study, producing a self-protrait which is appropriately purged of subjectivity. Friedrich's most histrionic depiction of his gaze, however, occurs in a remarkable *Self-Portrait*, now in East Berlin (illus. 32). Executed in black chalk and datable to around 1810, this sketch shows the artist at the height of his career, at the moment when the controversy over *Cross in the Mountains* was replaced by a general celebration of his art by the most influential critics of his age. In the Berlin *Self-Portrait*, the calm, youthful face of Friedrich's 1802 likeness has given way to a veritable caricature of Romantic selfhood. If, as Johann Wolfgang von Goethe wrote, 'the Classic is the healthy, the Romantic the sick', then Romanticism's disease is that of the spiritual invalid who, possessed of an immense and impassioned interiority, dwells in a state of psychic disequilibrium that can at any moment pass from inspired creativity to madness, love or suicide. Friedrich expresses precisely this 'self'-willed infirmity of self through certain exaggerations of physiognomy and posture. His sunken cheeks, intense gaze, wild eyebrows, hunched shoulders and clouded brow indicate a mind alternately ferocious and vulnerable. Friedrich, of whom the French sculptor David d'Angers wrote, 'Voilà un homme qui a découvert la tragédie du paysage', depicts himself here as tragic hero, aspiring to evoke in us tragedy's dual emotions, pity and terror. Even more theatrical is the play of light and shadow across the artist's features. Friedrich's right eye seems to peer out at us from an unnatural darkness which destabilizes his whole face, endowing it with an uncertain depth, as if something (perhaps what the Romantics termed the *Nachtseite* or 'night-side' of genius's nature) were lurking behind what we see.

The demonic quality of Friedrich's gaze here owes much to the drawing's overall

composition. The artist stations his left eye at the approximate centre point of the sheet, reserving above his likeness a rather wide margin of space. This at once intensifies the sitter's gaze by organizing the pictorial field around it and heightens the contrast between the artist's lit and centralized left eye, and the eccentric, shadowed and active right eye (active because, as the *Self-Portrait* of 1802 documents, it was with this eye that Friedrich scrutinized his objects). This plot of concealment and revelation accords well with the public face Friedrich cultivated. Contemporaries discerned in the artist's unkempt beard, for example, an emblem of his melancholia and withdrawal from society. Friedrich Hartman, the Dresden painter and early defender of the *Cross in the Mountains*, once joked of this beard: 'Whosoever wishes to see Friedrich once more should hurry, for he soon will be totally overgrown'. In the Berlin *Self-Portrait*, this veiling of the artist is augmented by that curiously shapeless drapery which enwraps his body. As if to prophesy his future rejection by and withdrawal from his public, Friedrich portrays himself as already 'cocooned' against the vagaries of time. The clothes enshrouding him are purged of any reference to social position or contemporary fashion, and thus prepare his effigy for posterity in a manner curiously reminiscent of the Neo-classical portrait bust.

Commentators have discerned in this drapery other valencies as well. On the one hand, some argue that this *Self-Portrait* simply depicts the artist as he really appeared when working in his atelier. Wilhelm von Kügelgen, son of the Dresden painter Gerhard von Kügelgen, describes how the 'blond and Cossack-bearded Friedrich contented himself with wearing a long gray travelling cloak when he worked, which raised doubts as to whether he had anything on underneath; and Friedrich's acquaintances knew that he did not'. Thus in comparison to, say, Georg Friedrich Kersting's portrait of *Caspar David Friedrich in his Studio* from 1812 (illus. 33), in which the artist stands before his easel dressed conventionally in trousers and a stylish jacket, the 1810 *Self-Portrait* confesses to the sitter's private appearance, and perhaps to that nakedness known only to his intimates. On the other hand, other commentators have noted that the particular shape of the artist's garments here recalls a monk's habit, such as Friedrich wears in his self-portrait *in figura*, the *Monk by the Sea* from 1809. The two readings are, of course, compatible. Already Wackenroder had transposed the values and Gothic ambience of monastic life into the domain of art in his *Heart-effusions of an Art-loving Monk*, the book in which the confrontation of Romanticism with Friedrich's future critic Ramdohr was initially staged. By fashioning a *Self-portrait as Monk*, the artist could thus both ally himself with the Romantic sensibility which supported his art and legitimate his own attitude of withdrawal from the world through the model of Christian *askesis*. His practice of working in his atelier with nothing on but a cloak simply accords with this general self-stylization. For along with the cell-like bareness of his atelier, Friedrich's travelling cloak evokes both a sense of penitent self-denial for the sake of art and a notion of the artist as purgatorial wanderer, never at home and always in transit, even when he stands in his own studio.

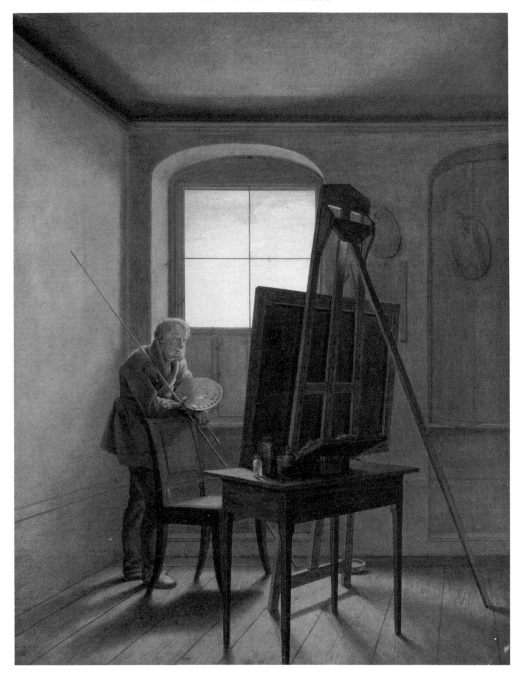

33 Georg Friedrich Kersting, *Caspar David Friedrich in his Studio*, *c.* 1812
National Gallery, West Berlin

However much it represents the artist as self-concealed, withdrawn and tragically eccentric, though, and however much it heroizes the artist's subjective gaze over the objective *visibilia* of his physical person, the Berlin likeness remains a theatrical and, in the end, rather conventional mode of artistic self-representation. The melancholy painter, betraying his inner struggle through the divine *furor* of his gaze, has been a trope of self-portraiture since the Renaissance. Given the radicality of Friedrich's conception of the relation between art and self, it is not surprising that, after this, the artist never again represents himself full face, as it were. For in place of self-portraiture as the representation of the artist's physical person, Friedrich proposes a more totalizing and reflexive project: the whole of represented nature will appear as the picture of the artist's inner experience of self and world. At first, Friedrich registers the self-referential status of his landscapes by inhabiting them with a human figure bearing his own personal features. The blond man with bushy whiskers seen in lost profile in *Monk by the Sea* (illus. 87), *Morning in the Riesengebirge* (illus. 21, p. 43) and *Mountain Landscape with Rainbow* (illus. 89, p. 170) serves this function. While marked by features unique to Friedrich, this figure's gaze remains hidden, and the sublime substance of his vision has expanded to engulf him. More typically, however, Friedrich abstracts the identity of this internalized viewer by peopling the foreground of his landscape with figures turned fully away from the viewer. We shall later have occasion to analyse in depth the so-called *Rückenfigur* as visual master-trope of Friedrich's art. At this point I would simply note that these anonymous subjects mark the landscape before them as 'something viewed'. In the famous 1818 *Wanderer above the Sea of Fog* (illus. 77, p. 155), for example, the figure seen from behind may conceal from us his identity, yet in the way the landscape appears to emanate from his heart, he stands as source for everything we see. Eventually, Friedrich was able to do away with even the *Rückenfigur* and still preserve, if not indeed enhance, our sense that the landscape is an interiorized self-portrait of the artist. Interiorized, for in works like *From the Dresden Heath* (illus. 1 and 2) and *Hut in the Snow* (illus. 14, p. 36), we enter into the very fabric of the artist's gaze, ourselves experiencing through particularized nature the radical *Eigentümlichkeit* of the creative subject.

In the early self-portraits of 1800, 1802 and especially 1810, Friedrich struggled to depict what is most elusive in the human face: the active eye as mediator of the inner self. It was in landscape painting, however, that the artist discovered a *via negativa* to this end. Turning first away from the viewer, then replacing his person with a surrogate, and finally absorbing himself into the substance of his paintings, Friedrich depicts his gaze for what it is *to him:* not something seen, but that which sees. It is in this context that we can begin to understand the Romantic philosopher F. W. J. Schelling's statement that 'in landscape painting only subjective representation is possible, since landscape has only a reality in the eyes of the beholder', and Friedrich's lapidary assertion: 'The painter should not paint merely what he sees in front of him, but also what he sees within himself. If he sees nothing within, he should

34 *Mother Heide, c.* 1795
Stiftung Pommern, Kiel

35 *Adolf Gottlieb Friedrich, c.* 1795
Stiftung Oskar Reinhart, Winterthur

36 *Market-place at Greifswald, c.* 1818
City Museum, Greifswald

not paint what he sees before him . . . '. Friedrich's landscapes are perhaps the most consciously subjective works of art before our century. Which is to say: as speculative Idealism's proper pictorial incarnation they represent the 'subject' not as mere *substance* presentable to itself, as in the Cartesian *cogito* or, for that matter, the self-portraits of a Rembrandt or a Dürer, but as *function* of the cognition of appearances.

All of Friedrich's paintings, whether of self or nature or history or the politics of the emergent German state, aim at 'self' portraiture. It is necessary, however, to reverse this infinite expansion and to ask what is indeed unique about the *productions* of this particular self.

On 5 September 1774 Caspar David Friedrich was born, the sixth child of ten, into a family of moderate means and Protestant piety. The father, Adolf Gottlieb Friedrich (1730–1809), was a soap-boiler and chandler from Neubrandenburg in the north German region of Mecklenburg, who set up business in Greifswald around 1763. Caspar David's mother, Sophie Dorothea *née* Breckly, died in 1781, and thereafter her children were looked after by a housekeeper named 'Mutter Heide' and educated by private tutors. This suggests that the father had achieved a certain *petit bourgeois* affluence. But the small town of Greifswald (illus. 36 and 138, p. 231), with its 5,000 inhabitants, was poor. As the only town in Pomerania that had remained under Swedish rule almost continually since the Thirty Years War, it had been the site of frequent and violent conflicts between Sweden and, in succession, Brandenburg, Russia and Prussia. When Caspar David's father arrived in Greifswald, the city was enjoying a rare period of moderate prosperity and peace, supported by its active port on the Baltic, by various trade subsidies from the Swedish crown, and by its university, reputed to be one of Europe's worst. It was by means of this last institution that Friedrich began his early training as an artist in 1790 through the University Drawing Instructor Johann Gottfried Quistorp (1755–1835).

Quistorp's pedagogical method was typical of the period. In theory, as he wrote in 1803 in a letter to Runge, he opposed artists who 'slavishly imitated' the art of their predecessors, or adhered blindly to the 'prattle about rules', a stance which allied him to the Storm and Stress movement, with its valorization of originality over imitation. In practice, however, he demanded that his students begin their training by copying from model-books and from prints of old masters, for only thereby could a young artist acquire what Quistorp called 'the mechanical aspect of art which is so difficult to bring forth from oneself'. Quistorp was equipped to offer this kind of training, since he possessed an extensive art collection which encompassed some 50 paintings and 1400 drawings and engravings, including works by Hans Holbein the Elder, Palma Vecchio, Jan Gossaert, Adam Elsheimer, Anthony van Dyck, Adriaen van Ostade, David Teniers, Charles Lebrun and Jakob Philipp Hackert. Thus however provincial Greifswald may have been, Friedrich had access to a very wide range of pictorial traditions. Interestingly, the few surviving works by Friedrich from this period

37 *Male Nude seen from Behind*, 1790–94
City Museum, Greifswald

– a group of formulaic outline drawings in a late Baroque manner copied from Johann Daniel Preissler's model-book *Praxis Invented through Theory* (1728–31) – document how far back in the European tradition Friedrich's early training under Quistorp reached. Friedrich seems not to have distinguished himself in this context. His *Male Nude seen from Behind*, for example, with its awkward treatment of the figure's feet in relation to the ground-plane, its misjudgment of the structure of the staff-bearing arm and its rather illegible depiction of the back of the figure's head demonstrate the aspiring artist's struggle with the tasks assigned to him (illus. 37). It is perhaps in reference to such an 'invented' praxis as Preissler's that Friedrich was to write, some 30 years later, 'a picture must not be invented, but rather felt'.

Quistorp's influence on Friedrich was not limited to exercising the young artist's draughtsmanship, however, but also involved exposing him to that culture of 'feeling' which would inform Friedrich's mature aesthetic. Quistorp's circle included the pantheistic philosopher and historian Thomas Thorild (1759–1808) and the poet, theologian and pastor of Wolgast, Gotthard Ludwig Kosegarten (1758–1818). Kosegarten, who was highly celebrated in his day and whose first volume of poems was illustrated by Quistorp, preached a particular theology of the heart, in which the subjective experience of nature's primal, and therefore divinely created, beauty leads to a direct experience of God. Kosegarten's faith found its most important expression in his so-called *Uferpredigten* ('Shore-sermons'). Staged outside in nature, Christian

worship utilizes only the landscape for its services, treating the various elements of nature loosely as symbols for the personages, instruments and doctrines of faith. Typically, Kosegarten set his shore-sermon in Rügen, a large island in the Baltic off the coast of Pomerania, for in this bleak and ascetic landscape the poet found a natural reflection for his own self-consciously Northern piety. In the third eclogue of Kosegarten's verse epic *Jucunde* (1803), for example, the heroine's father, a village pastor, preaches to his flock 'in the greening valley by the coast', accompanied only by the 'trumpets of the sea and the many-voiced pipe organ of the storm'. The pastor's shore-sermon opens with a creation story, in which God infuses himself into his created symbol, the sun, which is described as 'the visualized image of the hidden Father/ Who dwells in the light that blinds all those who approach'. The prayer avoids a fully fledged pantheism, however, by closing with a nay-saying of the visible world:

> Look to on high, you loved ones! Not on the colourful
> Blossoming clod of earth that feeds you, limiting your gaze. In the vapours
> Of clammy sludge let not the wings of spirit dwell.

Kosegarten's shore-sermons stand close to Friedrich's art, both in their specific settings and in their characteristic turn of thought, which at once affirms and negates God's immanence in nature. Heinrich von Kleist observed an analogy between Friedrich's landscapes and the Wolgast preacher's poetic theology when he wrote of the 'Kosegartenian effect' of the 1809 *Monk by the Sea* (illus. 87, p. 168).

Kosegarten seems himself to have recognized his affinity with Friedrich, for he was one of the earliest collectors of the artist's works, and in 1806 he even invited the painter to execute an altarpiece for the 'shore-chapel' in Vitte. Friedrich, in turn, found in Kosegarten's Rügen the *locus* of artistic election. For, as Helmut Börsch–Supan demonstrated in his 1960 analysis of Friedrich's pictorial structure, it is in the sketches fashioned during his first trip to the island that Friedrich makes his most important compositional breakthrough. In a sketch of the *Rügen Landscape: The Jasmund Meadow*, dated 16 June 1801, for example, Friedrich does away with both conventional framing devices (flanking trees, a foreground ruin, etc) and with markers measuring the scene's smooth recession into depth, producing a nascent version of that disorienting, boundless space characteristic of his major works from 1806 on (illus. 38). And in the sepia *View of Arkona* of 1805–6, the artist constructs the coast of Rügen so that we as viewers, bounded by the bank and cliff to our left, and set off balance by the shoreline falling off to our right, feel ourselves swept into the infinities of sea, horizon and sky. Arkona, the northernmost point on Rügen, is seen here from the very shore by which Kosegarten built his chapel (illus. 39). We know too that in 1824 Friedrich produced a series of views of Rügen, one of which was meant to 'illustrate' Kosegarten's shore-sermon from the third eclogue of *Jucunde*. Although empty of pastor and congregation, the transcendent structure of the *Arkona* sepia accords with the tenor of Kosegarten's sermon.

38 *Rügen Landscape: The Jasmund Meadow, near Monchgut by Vilmnitz,* 16 June 1801
Städelsches Kunstinstitut, Frankfurt

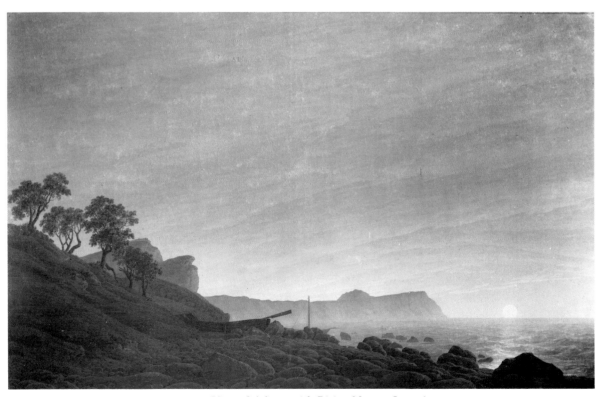

39 *View of Arkona with Rising Moon,* 1805–6
Albertina, Vienna

Although Friedrich would already have known Kosegarten's poetry during his early training in Greifswald, his attempt to create, as it were, a visual analogy to the shore-sermon emerged only later, after the artist had settled in Dresden in 1798. Friedrich first had to discover what it could possibly mean *pictorially* to render landscape at once wholly natural and wholly infused by divinity, at once devoid of the instruments and legends of faith and yet functional as devotional image. On its own Kosegarten's sacramental reading of nature offers no brief for landscape painting, nor can it explain Friedrich's project. The rhetoric of the shore-sermon, like much eighteenth-century nature poetry, and indeed like the *paysage moralisé* of the Renaissance, constructs a system of analogies between the mind and nature, God and His creation, and the Book of Scripture and the Book of the World, analogies which are then explicated theologically in the course of the poem-sermon. Subsumed under this rhetoric, Friedrich's landscapes might appear as themselves *analogous* to, and therefore readable as, a shore-sermon. However, as Ramdohr observed already when rejecting the religious pretentions of *Cross in the Mountains*, painting is not nature, nor can it mediate, as written texts can, a framing 'allegory'. Friedrich's later interpreters may, and usually do, introduce an allegory into Friedrich's landscapes by setting them against contemporary texts – Kosegarten, the poets and philosophers of Romanticism, even the written comments of the artist himself. Yet this impulse contradicts our immediate experience of Friedrich's landscapes, which always station us on the way to, but never having yet arrived at, the altar, the divine, or meaning; neither does it accord with the Romantics' expressed belief in the tautegorical character of their productions – that is, the idea that art, like myth, is the best possible formulation for an unknown thing which cannot be more clearly or characteristically represented. Kosegarten can be of help in our understanding of Friedrich, however. When the aspiring artist encountered the young Romantics in Dresden, he was prepared for their ideas through his contact in Greifswald both with a religious Pietism, and with the aesthetic sensibilities of Storm and Stress. Moreover, in understanding his impulse to 'illustrate' the shore-sermon of Kosegarten (as he seems to have done explicitly in 1824), we will observe the evolution of a new mode of pictorial analogism, in which the poem's system of symbolic association finds echo in a comparable system specific to painting and to the experience of painting.

After studying under Quistorp in Greifswald for four years, Friedrich enrolled at the age of 20 in the Copenhagen Academy of Art in 1794. This decision to do his formal training in Denmark rather than in one of the two great academies of central Europe at the time, Dresden and Vienna, was probably taken on the recommendation of Quistorp. But it may also reflect the young artist's own ambitions and sensibilities. Copenhagen was the centre of the so-called 'Renaissance of the North', that late eighteenth-century revival of the ancient Germanic and Nordic past. Strongly influenced by England's Gothic Revival, and anticipating Romanticism's rediscovery of

the Middle Ages, the Scandinavian renaissance encompassed diverse phenomena: the philological recovery of ancient Norse myths, languages and literatures; the shift in archaeological interest from the monuments of Classical antiquity to the remnants of native past cultures, such as rune-stones, pagan graves and cultic sites; a taste for the unclassical drama of Shakespeare, and the cloudy, pseudo-Gaelic poetry of Ossian; a fashioning of a new mythology, combining the reconstructed national legends with the Protestant faith supposedly best preserved in Scandinavia; and the new aesthetic appreciation for northern landscape and nature. Kosegarten was this renaissance's most popular German poet, and Nicolai Abraham Abildgaard (1743–1809), painter and instructor at the Copenhagen academy, was its most important artist and aesthetic theorist, which suggests that Friedrich's move from Greifswald to Copenhagen may have been partly informed by this shared sensibility.

40 *Nude Youth*, 1798
Library of the Art Academy, Copenhagen

In Copenhagen, Friedrich embarked on a course of instruction modelled on the traditional curriculum of the Académie Royale de Peinture in Paris. Students worked their way through a fixed sequence of classes beginning with copying from prints, progressing to sketching from plaster casts and finally, and only by the end of the programme, to drawing from live models. Informing this regimen was the doctrine, implied by the Renaissance humanistic theory of painting and elaborated in the writings and institutions of the French Academy, of the supremacy of history painting over the genres of, in descending order, portraiture, animal painting, landscape and still life. Philipp Otto Runge, who attended the Copenhagen Academy between 1799 and 1801, and who was to reject history painting's traditional primacy, wrote of his

41 *Scene from Schiller's 'Die Rauber'* (Act V, scene 1),
18 June 1799
National Gallery, East Berlin

42 *Scene from Schiller's 'Die Rauber'* (Act V, scene 3),
22 June 1799
National Gallery, East Berlin

'eternal attack of yawning' elicited by the Academy's rigid course of study, and compared his training to the new, innovative Paris curriculum under Jacques–Louis David, where students mostly studied live models. We possess no writings by Friedrich documenting his Copenhagen experience. His surviving work from the period, however, does not suggest that he was an inspired or inspiring pupil (illus. 40). From a series of watercolours from 1794 illustrating Friedrich Schiller's history play *Die Räuber*, however, we can at least discern that the artist's early ambitions included *grand peinture* (illus. 41 and 42).

Although in theory a mere 'recreational accessory' to history painting, landscape painting was in practice an important part of the art of a number of instructors at the Copenhagen Academy. For example, Nicolai Abildgaard, although known primarily for his figural compositions in the manner of Michelangelo, produced numerous view-paintings or 'veduta'. And students at the Academy could be trained in landscape by Erik Pauelsen, Christian August Lorentzen and Jens Juel. Juel (1745–1802), who was the premier portraitist in Denmark at the time, was also the Academy's most talented and original landscape painter, and he seems to have exerted the greatest influence on Friedrich. Juel's landscape art derives partly from the work of seventeenth-century Dutch painters like Aert van der Neer, and partly from vedutas by Swiss masters like Johann Ludwig Aberli. It is distinguished by its dramatic representation of light, its interest in recognizably 'Northern' scenes, and its relative

43 Jens Juel, *Northern Lights*
Ny Carlsberg Glyptotek, Copenhagen

naturalism which, unlike the more mannered and pathos-charged Sentimentalism of Copenhagen's other landscapists, discovers its vehicles of 'feeling' in the real landscapes of Denmark.

In his canvas *Northern Lights*, for example, Juel bestows a gentle sublimity upon the rather mundane scene of a gate, some bushes and small trees, and a wanderer resting at a thatched shelter by the road (illus. 43). Reducing 'setting' to a narrow strip of dark foreground, and halting our visual progress into depth through the wall and closed gate that run parallel to the picture plane, the painter allows his landscape to function as mere parapet for the canvas's true subject, the *aurora borealis* of the northern sky. Juel introduces here a number of devices that Friedrich later exploits in his mature art, for example: the use of visual barriers (bushes, wooden gate and stone wall) which, closing off our access to the distance, makes the viewer feel at once captive in the foreground and dwarfed by the infinity beyond; the radical reduction of midground and the attendant obfuscation of foreground through darkness, which causes the landscape to plunge suddenly from the near world of murky boundaries and mundane particulars to a clarified, boundless and insubstantial distance; and the juxtaposition of different kinds of night lights (here the glow of the unrisen sun and the wanderer's warming fire) which fragment visible reality into so many disjunctive epiphanies. Most importantly, a work like Juel's *Northern Lights* would have demonstrated to Friedrich that the sublime can be present in landscapes neither exotic nor

Antique, that pathos and sentiment can be expressed without histrionic plots of storms, shipwrecks, avalanches and erupting volcanoes, and that infinities, everywhere present, must be invoked subjectively, not as attributes of setting or event, but as simply the transformation, through painting, of *how* we see.

In most of his Copenhagen works, Friedrich seems not yet to have learned these lessons. His struggle remains still a simple one of training his pen to the outline of things observed, and in this task he was a slow learner. The example of Juel's *Northern Lights* can be felt, however, in the composition of a watercolour like *Landscape with Pavilion*, produced in 1797 and now in Hamburg (illus. 9, p. 31). Friedrich establishes the foreground as a series of barriers arranged parallel to the picture plane: again the closed wooden gate, again the thatched shelter open to the left, and, in between, a pile of boulders outlined in jagged pen strokes. Yet where Juel reveals an expanse of light and space behind such enclosures, centring his composition on the gate and on the avenue of sight beyond, Friedrich offers nothing but a foreground set off horizonless against a blank sky. Our gaze encounters here no central view, but is instead dissipated among the objects near at hand. The gate, displaced to the picture's edge, closes off a bridge and blind road into trees, while to the right the interim between the shelter and the boulders, suggesting perhaps a grassy lane, offers no place of penetration for our gaze.

Once stationed resolutely here, we can discern a principle of order in the scene. At the centre of the landscape, rising above the boulders and shrub beyond, a tall fence post topped with a round finial and wooden spikes divides the foreground into equal halves. Flanking this subtle vertical are objects paired in exactly measured symmetry: at the far right, the three planks leaning on the shelter, and at the far left, the three first vertical stakes of the fence; a little inward at the right, the dark entrance to the shelter, and at the left, the slanted post and finial of the foreground gate; and, near the middle, the left edge of the pavilion and a tree just to the left of the central post. Such subtle symmetries accord with the general principle of bifurcation in the landscape, not only in the play between grassy lane and closed bridge, but also in the opposition of bare to leafy trees, and of the thatched hovel to stately pavilion. It is easy to read these pairings symbolically, as constitutive of a *paysage moralisé*, in which the viewer stands halted at the crossroads between, say, death and life, poverty and riches, evil and good. One recent commentator has suggested that the pavilion, the place of stability in the composition and the object of our yearning, represents Paradise closed off from us by gate and bridge (ie death and passage to the beyond), while the thatched hut represents the impoverishment of our earthly existence. At one level, Friedrich's watercolour is simply topographical, depicting an actual belvedere near Klampenberg, north of Copenhagen. Such descriptive specificity, combined with the artist's careful integration of pictorial structure (like the central pole and flanking symmetries) into what seems at first sight to be a disturbingly random natural scene, suggests that Friedrich aspires to make meaning appear not as the artist's constructed

invention, but as the outcome of the individual viewer's own ordering and interpretative labour.

This subtle subjectification of landscape painting's semantic value, this sense that significance resides in the way we see things, rather than what things in themselves might possibly be or mean, is demonstrated powerfully in one aspect of Friedrich's *Landscape with Pavilion* overlooked in the literature. The belvedere, with its windowed upper storey and balustraded rooftop, suggests the possibility of overview (hence *bel vedere*), and stands opposed to the watercolour's low and limited perspective on its scene. Instead of offering our gaze a sublime vista of the horizon, Friedrich gives us rather the glimpse of an elevated place where such a gaze might unfold. In *Landscape with Pavilion*, the sublimity that would be visible from there is only evoked obliquely, through the way the landscape drops off just beyond the pavilion (which is why the treetops there are level with our gaze), and the light which illuminates the pavilion's far side. This gesture of stationing the viewer outside, or just behind, a more privileged place of viewing is characteristic of Friedrich's mature art, and it is embodied in such ubiquitous devices as the *Rückenfigur*, the closed gate and the partialized view through a window. In the early *Landscape with Pavilion*, which stands close to Juel and to the moralizing landscape of the eighteenth century, we can already observe the effect that surrogates for an open panorama have on the way we read the picture's very 'subject'. The juxtaposition of the pavilion's lit right exterior to the thatched hut's darkened interior might be allegorized as, say, the Pearly Gates and Hellmouth, or even the infinite and finite. Yet from our place of exile outside the panoptic belvedere, we are made to feel ourselves as precisely *not* as the centralized focus of an allegory, not as a *homo viator in bivio* commanding the choice between the way of life and the way of death. Already here, at 1797 and in however timid a graphic style, Friedrich has begun to redefine the subject of landscape. Neither representing this or that locale, nor this or that moralizing allegory, his landscapes aspire to reflect in their pictorial and semantic structures the contradictions and constitutions of subjectivity *per se*.

To clarify the nature of this redefinition, I shall consider three pictures produced by Friedrich in the decade leading up to the *Cross in the Mountains*. In each, nature is treated elegiacally, as expression of evidences of past life, yet each represents differently the character of nature's expressivity. Together they outline a path, characteristic of the trajectory of Friedrich's historical achievement, from the loco-descriptive and moralizing veduta of late eighteenth-century Sentimentalism, through a peculiar form of history painting, to a kind of art which will come to be called Romantic landscape.

The watercolour of *Emilias Kilde*, dated 15 May 1797, represents a famous well in Sølyst, near Copenhagen, built to commemorate the death of Count Ernst Schimmel-mann's first wife Emilia, née Countess von Rantzau (illus. 44). The well itself was designed in 1780 by Abildgaard, and had already been portrayed by Juel in an oil of 1784. Friedrich's 1797 watercolour, which is one of a number of early landscapes

44 *Emilias Kilde: Monument in Park near Copenhagen,* 15 May 1797
Kunsthalle, Hamburg

depicting fountains and springs from parks around Copenhagen, thus takes up a motif already saturated with significance for the artist's academic milieu. It is hard to say what 'meanings' Friedrich himself has bestowed upon his veduta that are not already present in the real fountain in Sølyst. For in the elegiac act of dedicating a well to the deceased Emilia, landscape itself, here the natural spring, has been endowed with human significance and harnessed into an allegory of life and death. The terms of this allegory are given in the text inscribed on the well, which Friedrich transcribes in the original Danish on the verso of his sheet, and indicates graphically within the watercolour through some scribbles on the well's bright front face. Addressed to the deceased, the inscription designates the landscape as a place frequented by Emilia, consecrates this spot as 'holy' ('Helligt er det sted'), and stages there a scene of mourning, in which the name Emilia fills the beholder's heart with 'innocence, Heaven's innocence' and 'tears'. The image of saturation and overflow is appropriate to the place. For the spring water that pours forth from the well evokes, on the one hand, the state of innocence, in the metaphor of origin or source, and, on the other hand, the work of mourning, the waters metaphorized as tears, which transform the well into an eternal *larmoyant* within the landscape. This kind of text has ancient roots in the wayside inscription used to guide strangers to a watering place. As Geoffrey Hartman has shown, already in the votive epigrams of Theocritus and the Greek Anthology such nature inscriptions engendered a poetry combining elegy and description, in which the reader, addressed as a traveller, is exhorted to rest and perhaps to hear the voice of the living commemorating the dead. When Friedrich comes to represent Emilia's well 'from nature', as he writes on the verso, he does so not as original mourner, but as one who has obeyed the *siste viator* of a poetic inscription in nature. Or more precisely: his own commemoration, which depicts the monument from the side, at an oblique angle, gives the viewer the impression of having been halted in passage neither by the memory of Emilia, nor even by the inscription's exhortation, but by the beauty and feeling expressed in the veduta itself. Yet in the way the cubic monument determines the scene's organization of space, and in his summary treatment of the surrounding trees and foliage, Friedrich still depends on the fountain, its inscription and its sad history to fill the landscape with feeling.

In a watercolour dated 26 May 1799, *Scene of Mourning*, Friedrich attempts to construct on his own a story of loss and mourning (illus. 47). A woman sits with two boys in a bleak landscape by the sea. The woman's pose, the way she props her head in her hand, suggests the traditional attitude of melancholy or inner distress, a motif which Friedrich developed in a woodcut of *c.* 1803 (illus. 46), as do the sprawled or slumping bodies of her two companions. Beyond and to the right of these figures, a gravestone marked with a cross explains the cause of their sorrow and establishes for the scene its elegiac character. The woman, presumably a mother surrounded by her sons, grieves for a loved one lost at sea; the duration of her sorrow is measured by the ivy that covers the tomb. Another sheet produced by Friedrich ten days earlier

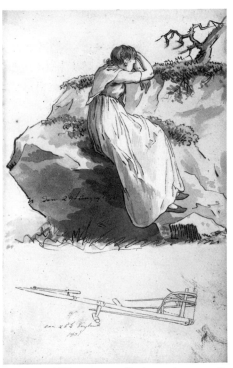

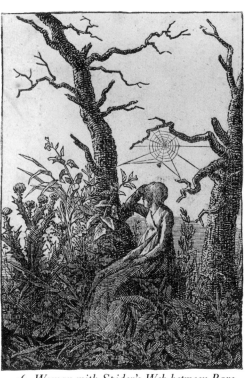

45 *Seated Woman on a Rock*, 29 August 1801
Kunsthalle, Mannheim

46 *Woman with Spider's Web between Bare Trees*, c. 1803 (woodcut by Christian Friedrich).
Kunsthalle, Hamburg

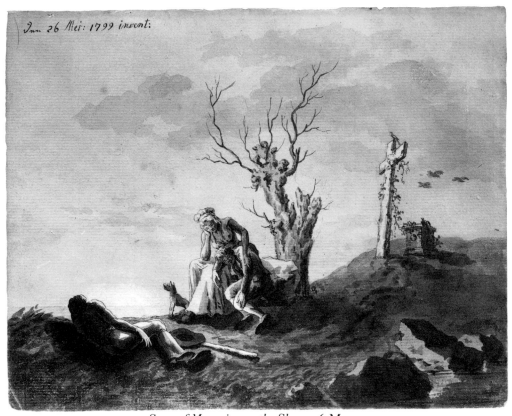

47 *Scene of Mourning on the Shore*, 26 May 1799
Kunsthalle, Mannheim

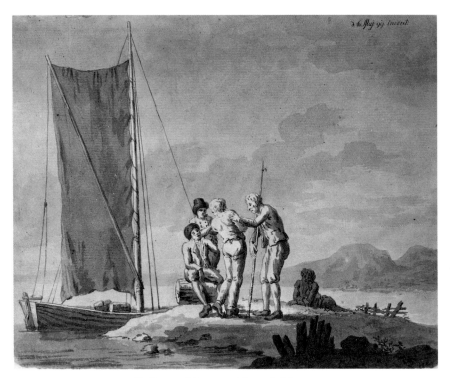

48 *Scene of Leave-taking*, 16 May 1799
Kunsthalle, Mannheim

(16 May 1799) reads as a pendant to this scene of mourning (illus. 48). A youth, turned from us to lost profile, bids farewell to his companions, while to the left his sailing boat stands rigged for departure. Against this scene, the sheet of 26 May represents either the tragic aftermath of the youth's adventure, or else simply an alternative or universalizing version of leave-taking as death. In any case, the relation between the two watercolours elicits from us connective narratives, as does, on its own, the relation between the figures and the grave in *Scene of Mourning*. In *Emilias Kilde*, it was the monument and its real site in Sølyst that elegized the dead, investing Friedrich's landscape with feeling, and writing for it a plot of life and death, as well as rebirth through nature and memory. In *Scene of Mourning*, Friedrich extricates his landscape from this dependency on site and prior inscription. In place of Abildgaard's fountain for tears, Friedrich fashions along with the monument a group of tearful mourners, who in their posture and legible surrounds constitute the text of elegy.

This emphasis on narrative, as opposed to topography, is implied in the sheet's own inscription at the upper left, which reads: 'den 26 Mei: invent:.' Abbreviating the Latin *inventio* or *invenit*, the term 'invent:' occurs in only three other inscriptions in the artist's *oeuvre*: at the upper left of the 16 May pendant sheet (illus. 48), and above Friedrich's two early compositions after Schiller's *Räuber* (illus. 41 and 42). Replacing phrases like 'sketched after nature', such as appeared on the verso of *Emilias Kilde*, the term denotes a kind of pictorial making traditionally associated with history

painting. For in academic discourse since the Renaissance, invention, signifying both the general planning of composition and the choice and interpretation of subject matter, was regarded as the specific strength and province of the history painter. The particular history represented need not be, and indeed, from the standpoint of academic classicism, should not be, itself newly invented by the painter, but can be any fable, sacred or profane, ancient or modern, that Scripture, history or poetry might provide. It is unclear, and perhaps finally unimportant, whether the pendant scenes of *Leave-Taking* and *Mourning* illustrate a story already known to their audience, as is the case in the slightly later Schiller drawings. What Friedrich's inscription does proclaim, however, is that these sheets express death and mourning narratively, as a story legible within a histrionic figural group.

Within this narrative, landscape functions simply as the domain of analogy, in which the inner sentiments of the human subjects are pictured through appropriately evocative elements in nature. This is the function, for example, of the decidedly anthropomorphic tree in *Scene of Mourning*. Its left contour responding to the profile of the figural group at its base, its two main branches stretching into the sky like arms raised in a gesture of wild lament, the ruined tree articulates a pathos that the scene's human figures, in their passive, introverted poses, cannot themselves express. Landscape and its inhabitants, which is to say nature and consciousness, are presented in a state of reciprocity or sympathy: the three birds in flight at the left, corresponding to the three mourners, visualize in their seaward journey the desire of the living to join with the dead; the dog howling as it gazes off towards the setting sun voices a natural dirge for the deceased; and the rocks to the lower left, rhyming visually with the body of the youth lying at the right, not only become themselves potentially animate through this correspondence, but also integrate the human figure into the landscape, perhaps in a manner anticipating death.

What, though, does this affinity between desolate nature and a fable of human tragedy achieve for our own sympathy, our own emotional reciprocity with either the desolate landscape or the ruined family? In *Scene of Leave-Taking*, Friedrich's 'invention', which in essence *is* that system of formal and symbolic correspondences between human figure and natural setting, compromises the work's effect both as landscape and as history painting. For on the one hand, the mother and her two sons are so incorporated into the natural world that they appear less as actors in a solemn human event than as mere spirits of the place, staffage figures whose fable serves only to explicate a moral sentiment analogizable to any dreary seascape. On the other hand, the landscape they people is so blatantly anthropomorphic, so overdetermined by human meaning and plot, that it scarcely qualifies as nature at all. While its withered tree and visibly trodden soil are more random and therefore specific in their contours than are, say, the rather formulaic foliage and terrain of *Emilias Kilde*, the landscape of *Scene of Mourning* appears far more staged and artificial than any of Friedrich's Copenhagen vedutas. This is partly because a work like *Emilias Kilde*, through its

compositional device of depicting the fountain from the side rather than head on, implies the presence and particularity of the viewer. Even though the evocation of feeling depends here largely on the existence of a prior history and elegiac inscription not legible within the landscape as such, the *siste viator* of inscription is already implied by the structure of the image, which insists that the veduta we see is something already subjectively viewed: a landscape beheld by a halted traveller. In *Scene of Mourning*, Friedrich peoples his landscape with subjects that enact the feelings the artist would evoke in us, yet for all their gestures of interiority, and for all their correspondences to the elements of landscape, they neither elicit our inwardness, nor do they mediate for us our affinity with the natural world. What Friedrich learnt in the next few years was how to free his art both from its dependence on the conventional sites of feeling (the graveyards, elegiac fountains and ruined abbeys of Sentimentalism), and from artificial, externalizing and 'invented' histories. When in the 1830s the artist proclaims that 'a picture must not be invented, but rather felt', he registers the achievement of his art as a movement from history painting to *Erlebniskunst*, or more precisely, as the internalization of history and inscription into the experience of the viewing subject.

Friedrich's *Fog*, executed in oil on canvas in 1807 and kept now in Vienna, is representative of this achievement (illus. 20, p. 42). It stands at the very beginning of the artist's work in oil, for, with the exception of a few minor canvases dating from 1798 to 1799, Friedrich's 'finished' paintings before 1807 are all executed in watercolour, gouache and sepia. Ostensibly, *Fog* represents a vision of departure, of boats embarking from a shore, and it therefore belongs within the general thematic orbit of the pendant watercolours of *Leave-Taking* and *Mourning*. Friedrich, however, has radically altered what it is that can be said to depart in his landscape, as well as how, in the first place, the picture constitutes for us its vision.

Friedrich stations us at the ocean's edge, before a scene of departing boats which have all but disappeared into fog. There are remnants enough, though, to write plots for the picture. The nearer boat, a tender, is rowed from the shore carrying passengers to the square-rigged ship anchored out at sea. In the foreground, in that narrow strip of rocks and dead grass which is the site of embarkation and which constitutes the only area of the scene not veiled by fog, we are left with an anchor and its severed towline, and, to the right, two Y-shaped sticks – presumably poles for hanging fishing nets to dry, such as we see on the shore in Friedrich's *Morning* of 1816–18 (illus. 18, p. 40). At one level, commentators are right in discerning in these two sticks the suggestion of crutches, and in the beached anchor the traditional emblem of Hope. Given so little within this canvas, we viewers tend to make the most of what we have, and so we postulate that someone has embarked from this shore and left behind his props, in a manner analogous to the wanderer in *Winter Landscape with Church* (illus. 7, p. 22). Such a reading engenders further speculation: the shore might represent the place of death, and the departing tender, like Charon's bark, might ferry the soul beyond this world to a transcendent realm whose promise of eternal life is signalled

in the foreground anchor. The spiritual tenor of Kosegarten's shore-sermons unfolds throughout the represented scene.

At another level, however, the sticks in Friedrich are in fact not discarded props, but the instruments of everyday labour isolated so as to *seem* as though they were crutches; and the anchor, sometimes just an anchor, rises before a wholly natural scene such as could be observed from any shore along the Baltic at dawn. This uncertain coexistence between nature and emblem, between ordinary landscape meticulously portrayed and whatever figurative meaning might be felt to lie 'behind' it, is Friedrich's most important and difficult semantic achievement as a painter. In terms of Friedrich's crucial phase of development between 1797 and 1807, it enables narrative, like the plots illustrated in the pendant watercolours of 1799, as well as elegiac inscription, like the poem recorded on the verso of *Emilias Kilde*, to appear as the personal and always only speculative invention of the individual viewing subject. If in *Fog* we seem to visit landscape as mourners, our intimation of death has been elicited neither by sentimental monument and epitaph, nor by tragic history, but by something inherent in the structure of the pictorial image itself which causes us to *read* the seascape as if it were a grave.

In *Fog*, Friedrich constructs the scene of departure on a radical caesura within pictorial space, between a barren foreground and an unfathomable distance beyond. The strip of beach, rendered in focused detail and contrasting therefore with the blurring of sea and sky beyond, serves to situate us within the represented space. Yet in the way it passes out of the picture at both sides, refusing to frame or to stabilize our view out to sea, and in the way it establishes neither material nor structural continuities with what lies beyond, this beach also leaves us, as it were, stranded in the foreground. Nor do the boats at sea offer orientation. Ostensibly floating on the water's waveless, textureless surface, they are so obscured by fog that they appear not as objects occupying the scene's midground, but as monochrome silhouettes placed flat on a uniform ground that would be coextensive with the picture plane. Or rather, they hover in a limitless void of mingled sea and sky whose boundary lies at our very feet, in that edge, that narrow parapet, which is itself dissolving eerily into boulders half submerged by sea.

Reproductions of Friedrich's *Fog* lessen the canvas's obscurity. They tend to magnify the tonal contrasts between the ships and their greyish-blue ground, and between the still sea and the dull sky. Before the painting itself, the viewer must work hard to discern the square-rigged ship and its tender in the fog. And, once spotted, they can again be lost, so that they retain always their potential status as mirages. This is partly due to the glassy surface that Friedrich generally achieves in his oils. Building up his image with multiple layers of glazes thinly applied, the artist not only erases all evidence of brushwork and outline, but also produces an intensely reflective surface which, from certain angles and under particular lighting conditions, conceals the painted image altogether. Making out the boats in *Fog* involves, quite literally,

discovering a point of view within our world where the picture's surface is free of shine. In this tiny canvas (34.5 × 52 cm), with its deliberately hazy subject, we *find* the silhouettes of the ships best when we view the work from close up, so that the shadow of our bodies, cast over the picture's surface, picks out the represented world. Friedrich was a master of all transitions between the visible and the invisible, whether they occur within a represented landscape (e.g. fog in the mountains, fire in the night, the rising and setting sun and moon, visions through half-opened doors, distanced windows and obscuring gates and fences), or are the consequence of an image's actual viewing situation. In *Fog*, he effects *before* his canvas, and through strictly pictorial means, a drama of appearance and disappearance appropriate to the motif of departure represented *within* his canvas. The reflective surface before us itself acting as a barrier to our gaze, we mimic in our bodily movements the gestures, of one who, left behind on a foggy shore, struggles to glimpse perhaps the embarkation of a loved one.

Friedrich allows loss, absence, the departure of things close to us, all to occur within our immediate experience of the image: as the fog that renders nature fugitive, and as the oil painting itself that flickers between a detailed description of a coastal scene in fog and a blank surface reflecting light. More powerfully than *Emilias Kilde*, which suggested in its oblique prospect the presence of the halted traveller as surrogate viewer, or even than *Landscape with Pavilion*, which thematized vision itself through its panoptic belvedere, *Fog* implies within the represented scene the subjective process of perception and interpretation. And therefore, rather than regarding the landscape's haze or the picture's compositional disjunctions as, respectively, natural or artificial analogies to the human history of departure or death, it may be more appropriate to regard the painting's ostensible subject-matter – ships departing from the shore, the soul's journey to eternal life, etc – as so many narratives explicating the picture's more basic plot, which is the difficult relation between subject and object, ourselves and the Vienna canvas. This reorientation helps clarify the question of whether the foreground poles signify crutches or the anchor hope, or indeed whether nature really means more than meets the eye. In an art that seeks to erase the difference between experience and the representation of experience, our own allegorization of landscape will not recuperate a hidden core of meaning constructed by the artist, as when we discern in the ivy-covered tomb in *Scene of Mourning* an emblem of the promise of a resurrection. It will simply return us to the scene's imagined originary moment. For within the fiction of *Erlebniskunst*, what halted the artist traveller on the foggy shore in the first place, and what still commands our attention in the afterimage of that experience, is both an uncertain intimation of death through the absence or loss of vision, and a desire to find in nature the vehicles, signs and images of transcendence, and penetrate thereby into the fog, into another life, into the reflective surface of the canvas.

It is extremely difficult to account historically for this transformation in *how* landscape

means. The increased specificity of a picture like *Fog* over against such works as *Emilias Kilde* and the watercolours of 1799; its closer, more particularizing description of the natural world, combined with what might be called its heightened inwardness, its sense that the feelings elicited by the landscape, as well as the way these feelings are elicited, emerge from regions of subjectivity deeper than the melancholy moods of Friedrich's earliest works – these all are aesthetic developments common to much of the art and literature of the period. It is possible, for example, to describe these developments according to the traditional historiographical scheme, whereby the eighteenth-century Age of Sensibility or Storm and Stress movement gives way around 1800 to the culture of High Romanticism. Friedrich's early development would thus trace a path similar to that which leads, say, from Kosegarten to Novalis, or from a descriptive poet like William Lisle Bowles to Coleridge or Wordsworth. While sharing with their sentimental predecessors an emphasis on landscape and feeling, the Romantics distinguish themselves by their unique fusion of nature and consciousness, a fusion which occurs not only within the landscapes they represent (as when the poet's perceiving mind seems to merge with the scene perceived), but as well, and more radically, in the way these landscapes address their readers or viewers. The affinity between Friedrich and Romanticism was registered even by the earliest critics of *Cross in the Mountains*, and it will continue to inform historical accounts of his development. But the question remains: where does this affinity get us in our understanding of his landscapes?

When Friedrich finished his studies at the Copenhagen Academy in 1798, he travelled via Berlin to Dresden, capital of Saxony, where he remained until his death on 7 May 1840. According to his *curriculum vitae*, he chose to settle here 'in order to continue his artistic efforts in close proximity to exquisite art treasures, and surrounded by a beautiful landscape', in a city in which 'learning and the arts are blossoming, and which is rightly called the German Florence'. Dresden and its environs, lying in the basin of the Elbe River, were renowned for their natural beauty, and the Dresden Academy of Art, founded in 1769, was particularly strong in the area of landscape painting. Students at the Academy were granted daily access to the great Gemäldegalerie in the city and were permitted to study the print and drawing collection up to twice a week. Immediately on arriving in Dresden, Friedrich enrolled in the Academy, partly as a means of connecting himself to a local network of artists, critics, patrons and employers, and partly in order to enjoy the registered student's visiting privileges to the Gemäldegalerie and its 'treasures'. He thus became part of the city's veritable army of students who, as one contemporary observer put it, 'hasten[ed] from house to house all day ... ek[ing] out a miserable existence'. In 1800, one-fifth of Dresden's population were theological candidates, usually employed as private tutors. In his early years in Dresden Friedrich seems to have made his living variously by instructing privately the children of wealthy families in drawing, guiding tours of the region and hand-colouring landscape prints for sale by local art dealers.

As Henri Brunswig has argued in his account of the social circumstances of Romanticism, it was from precisely the surplus of over-educated, highly ambitious, under-employed, and deeply frustrated middle-class young men that the Romantic movement drew its members:

The students thronging the universities are well aware of the difficulties ahead of them. This makes them more eager to attract attention to themselves. To become famous is a short cut to the heights of a career in politics or the civil service.

Of all the Germanies, Saxony had the greatest number of authors. The little city of Göttingen alone, with its 8000 souls, boasted 79 officially recognized writers. Together with its university and the local artistic patronage of the Duke of Saxony–Gotha–Altenburg, a rich literary milieu helped make Dresden one of the centres of the Romantic movement. The Schlegels (August Wilhelm and Friedrich, as well as Wilhelm, Karoline and Charlotte Ernst), Novalis, Tieck, Heinrich Steffens, the philosopher Gotthilf Heinrich von Schubert, Schleiermacher, Schelling, Adam Müller, and later Kleist all frequented or lived in Dresden during the first years of the century.

It is unnecessary to detail here the various personal connections and allegiances between Friedrich and the writers of Romanticism. Nor is it possible, or even appropriate to map how specific literary or philosophical texts become, so to speak, visualized in his art. Romanticism's projective character, as always only a 'fragment of the future', resists functioning as historical explanation for any given work of art. Herein lies the challenge of Friedrich's landscapes to art history today. Friedrich worked within a culture whose explicit theoretization of art far exceeded in subtlety and wilful complexity virtually all current art historical discourses, indeed whose penchant for theory *per se* both engenders and surpasses our own present 'age of criticism'. Given an epoch when philosophy was believed to fulfil itself in the work of art, when art was deemed, as Philippe Lacoue–Labarthe and Jean–Luc Nancy have put it, 'the speculative *organon par excellence*', there can be no clear separation between theory and history in our own analysis of that epoch's cultural productions. It is, for example, a historical fact that Friedrich, lauded in 1817 as the '*Metaphysikus* with the brush', paraphrases in his writings the aesthetics of Schelling and refers to 'Hegel's philosophy'. Yet to recuperate the *meaning* of such relations between the artist and his intellectual context, or more difficult, between painting and theory, one will oneself have to be a *Metaphysikus* of historical discourse, prepared to excavate the originary historical ground of one's own interpretive edifice. At the very least, to interpret Friedrich thus would mean reaching towards a level of theoretization about art and history commensurate to that of *his* age.

It is hard to say whether the specific achievement of Friedrich's 1807 *Fog* is predicated upon his encounter with Romanticism. The fugitive landscape does effect within us a certain mode of self-reflection, a certain apprehension of the contingency of object and meaning upon the viewing subject, which accords well with the general

project of speculative Idealism. In addition to his encounter with Romanticism through the literary circles of Dresden, Friedrich would have already encountered a pictorial application of a Romantic aesthetic to landscape painting in the precocious art of Philipp Otto Runge, whom Friedrich first met in Greifswald in 1801. Yet if Friedrich's art is genuinely philosophical, as clearly the Romantics themselves believed, then it is so precisely through the irreducible specificity of the art object itself, which is to say: through its *visual*, rather than verbal or discursive, construction. It is this which we shall have to clarify before turning to the way pictorial form determines the 'meaning' of Friedrich's landscapes.

The contemporary discourses of history and criticism are becoming as ill-disposed to the distinguishing between form and content in the analysis of a work of art as they are, say, to disputing whether our soul survives the death of our body. Founded on the notion of the image as always the irreducible *relation* between signifier and signified, and more generally on the total embeddedness of thought in language and representation, most modern semiotics, whether implicit or explicit, can imagine neither pure content, unsupported by the materiality of a signifer, nor pure form, ie the non-reference of a sign totally cleansed of its commerce with the symbolic order. When the latter is claimed, as in certain unreflective formalisms, or in the once *avant-garde* notion of 'pure painting', one tends today to discern an ideology motivating such attempts, and the very practice of sanitizing the sign becomes once again invested with political or social 'content'. In the framed nothingness of *From the Dresden Heath*, or in the passage into loss plotted by *Fog*, Romantic landscape seems to prefigure the blinding and blinded project of twentieth-century abstraction, which is why Friedrich can figure as the origin of such histories as, for example, Robert Rosenblum's controversial *Modern Painting and the Northern Romantic Tradition*. If we submit Friedrich's art to the semiotics of Romanticism, however, we discern a far more complex state of affairs. Abstraction will always be only a passing moment in our experience of the image, just as Friedrich himself is often compelled to raise a cathedral above the last horizon of his spiritual 'histories', as modernity's return of the repressed. Yet neither does this return fully eradicate the moment of blankness. The inextricability of content from form, assumed as axiomatic to criticism today, is itself but one moment within a larger allegory. Unravelling this allegory, which will involve reading Friedrich's landscapes against Romanticism's semiotic master-term, the symbol, will reveal the historical emergence, and therefore contingency, of what we today call the sign.

6

Friedrich's System

——

Is it even provisionally possible to generalize about Friedrich's formal innovation in landscape? Can we speak of some structuring principle, some compositional logic, that informs all his landscapes, regardless of subject, such that they each bear the mark of his authorship? The Freiherr von Ramdohr seems to think so in his review of *Cross in the Mountains*. 'My criticism,' Ramdohr assures us at the outset of his argument, 'is not directed against Mr Friedrich's painting, but against the system that is conspicuous in it.' By 'system' Ramdohr means something like a fully developed method of landscape composition, exemplified in *Cross in the Mountains*, but also repeatable in the execution of other future pictures. At one level, by imputing a system to Friedrich's art, Ramdohr simply reflects his own Neo-classical aesthetic, which, as we have seen, evaluates and dictates artistic productions according to a set of fixed rules whose efficacy and closure are ultimately guaranteed by that cultural totality *par excellence*, the example of Antiquity. Thus before analysing Friedrich's system, Ramdohr sets forth what is proper to landscape painting, circumscribing its specific domain and ideal by placing it within academic criticism's own controlling system: the hierarchy of the genres.

Figure painting, Ramdohr tells us, takes as its subject the human body, and must fashion its images according to principles commensurate with that task. Its essential dimension should be, like the body itself, the vertical. All painterly means (composition, light, colour, etc) must function to valorize, which is to say, to isolate and distinguish, the upright figure over against its ground, hence, in history painting, the subordination of all parts to the singular action of the great individual, and hence too the preference for local colour and for the clarifying effect of light as a medium for modelling the figure in space. Landscape painting, on the other hand, does not depict the singular man, but rather the manifold of nature. Its essential dimension is the horizontal, the ground plane as it recedes evenly and coherently into depth. Rather than establishing boundaries around a principal body, landscape's task is to establish continuities between bodies, to harness the manifold into a unified whole. In place of figure painting's unity of the body, landscape substitutes the constructed coherence of the viewer's visual field through the devices of linear perspective and of the layering of space into foreground, midground and background. And in place of local colour and light as mere isolating media, landscape represents colour always modified by atmosphere and distance, while light is celebrated as a substance in itself, indeed as

97

one of landscape painting's proper subjects.

In demonstrating how *Cross in the Mountains* systematically, as it were, disobeys these canons, Ramdohr characterizes quite accurately some of Friedrich's formal innovations in the field of landscape painting. Instead of constructing his picture as the ordered progression of a ground plane into depth, the artist isolates a single vertical mass, detaching it from any visible connection to a 'ground', and positioning it before us so that it at once obscures our prospect of the horizon, and allows us no point of access to its space. And because the mountain also covers the sun, the landscape, such as it exists, is thrown into darkness and is therefore stripped of those traditional strengths of the genre: aerial perspective and the representation of light.

Ramdohr discerns that these innovations constitute an assault on the hierarchy of the genres. The pictorial devices traditionally appropriate to history painting and portraiture (verticality, isolation of objects, contrasts of light and shadow, etc) are transposed in *Cross in the Mountains* to the representation of landscape. This would indeed accord with one of the work's basic intentions, which is to refigure *the* quintessential history within Western art, Christ's Passion, as a mundane albeit emotionally charged scene of a carved cross in the midst of ordinary nature. For Ramdohr, of course, who still believed that each pictorial genre possesses its own separate essence, such an amalgam was inadmissible. Yet to the Romantics it had already become an aesthetic ideal. Had not Runge in 1802 prophesied the sublimation of the fossilized tradition of history painting into a new form of landscape? Against the academic doctrine of the hierarchy of the genres, Romanticism proposed two radical alternatives: either the work of art should synthesize all possible poetic types, which is the ideal behind Romanticism's exemplary genre, the novel or *Roman*, or else each work, as the unique or *eigentümlich* expression of genius, should inhabit its own category, which is exactly how Friedrich's supporters defended *Cross in the Mountains* against Ramdohr's prescriptive criticism. For as Friedrich Schlegel wrote around 1800, 'The modern poetic types are either only one or infinite in number. Each poem a genre in itself'.

We shall leave aside, for the moment, the presence of an ideological subtext in such a position, how, for example, the erasure of hierarchy and of absolute values in art, combined with the utopia of a union of equal creations, might reflect the political ideal of the modern bourgeois republic, that is, the hope, nascent among advanced thinkers in Germany at 1800, of a new, unified German nation constituted by equal citizens. What concerns us here is neither the demise of the Neo-classical aesthetic, nor the blurring of art and politics in Romanticism, but rather the simple validity of Ramdohr's description of *Cross in the Mountains*, and in particular his assertion that, for all its apparent disregard for rule and tradition, Friedrich's canvas itself proposes a *system* of representation. Romanticism, even with its celebration of the radical *Eigentümlichkeit* of all individuals and their productions, was not opposed to totalizing systems, although the actual systems which the Romantics did draft (as, for example,

the anonymous text of *c.* 1796 transcribed by Hegel and entitled the 'Earliest System-Programme of German Idealism') took the representative form of the fragment. This paradox of the co-presence of the fragmentary and the systematic is articulated by Schlegel in his *Athenaeum* Fragment 53: 'It is equally deadly for the spirit to have a system and to have none. Therefore, it will have to decide to combine both'. It is within this paradox that Friedrich's system will come into focus.

Ramdohr does not reject *Cross in the Mountains* only by measuring it against the standard of tradition. He also detects something wrong with the scene itself: a fabric of errors which compromises the image's aesthetic value and undermines the systematic character of Friedrich's system. In Ramdohr's account, the picture's flaws arise from the ambiguity of the landscape's implied viewpoint. From our position vis-à-vis the foreground, we as viewers feel ourselves stationed *below* the mountain's summit, somewhere down its slope, so that we look upward at the cross. Yet Friedrich renders the crucifix itself as if it were observed from *across*, from some point in space high above the level of the foreground as it disappears under the lower framing edge. At such an altitude, Ramdohr correctly argues, the earth's horizon would become visible beyond the summit, indeed would be approximately level with the crucifix's base. To this ambiguity of viewpont are added discrepancies in Friedrich's treatment of light. Judging from the convergence of the sun's rays at an imagined point just above the canvas's lower edge, we would indeed seem placed below the Crucifix, so that the mountain rises between us and the sun. Yet in that case, as Ramdohr notes, primly quoting a French authority on the rules of optics and perspective, we would neither see the sun's rays, nor could the gilt Christ appear as it does, reflecting light on its surface, for 'the sun, no matter how low it stands [on the horizon], can illuminate no object from below'.

Of course, what Ramdohr here describes as error contributes to the picture's astonishing effect. Judged simply by our view of the foreground trees, and by the mountain's steep slope visible at either side of the canvas, we indeed hover above the ground as it would pass below the canvas's lower limit. And when we gaze upwards at the summit, we are lifted even higher, so that our contemplation of the crucifix becomes a sublime elevation, or upward fall, appropriate to an encounter with the sacred. Friedrich achieves this effect by overturning the conventions of landscape painting. The mountain's shoulders, running diagonally along the picture plane, suggest also the orthogonals of linear perspective which lead the eye horizontally into depth. Yet instead of converging at a vanishing point on the horizon, these lines construct the apex of a pyramid concealing any horizon. Having reached their intersection with our gaze, we experience the dizzying discovery that we have travelled up rather than out, and that what we thought would be the meeting of sky and earth is a radical disappearance of ground: the horizon transformed into a nearby abyss. And where conventional, Claudian landscape space is basically structured as a concavity flanked at its sides by framing coulisses and receding from us towards a

centralized view of the distance, *Cross in the Mountains* presents us with a convexity that resists our gaze and is bordered on both sides by a groundless view to the sky. With neither a firm ground on which to stand, nor a stable horizon on which to fix our gaze, we thus encounter Friedrich's crucifix within an anxious state of visual disequilibrium. Finally, the crucifix's visible reflection of the sun from below may indeed contradict the logic of earthly space and light, yet it also imagines a mountain as high as the heavens, something which is suggested too by the way the clouds seem to respond to the vertical of the cross. The carved Christ establishes also through its shine a relation to the sun that, if not natural, may therefore be symbolic in nature: an illumination whose very illogic signals the presence of the divine, like the sun's eclipse in the Passion story.

That the viewer 'cannot embrace a standpoint' before the landscape proves, for Ramdohr, that Friedrich's system is rotten. Yet from another perspective, that of an aesthetics of the sublime, this indeterminacy can constitute the experience of transcendence. For Immanuel Kant as for his Romantic heirs, sublimity in art occurs at the moment of representation's collapse, when the mind, seeking to comprehend its object, fails and attains thereby an intuition of a transcendent order. According to this model, our incapacity to find our place within Friedrich's scene, which is to say, our loss of a determinate relation between ourselves and represented nature through the artist's deliberate disruption of the conventional 'system' of landscape, becomes a symbol of our relation to a transcendent order. In *Cross in the Mountains*, the religious origins of this aesthetic project are self-consciously preserved. The relation between man and God, expressed traditionally by crucifix and the Passion history, is transposed here to a relation between self and world, expressed now within the very structure of represented nature. When lived experience as it occurs before the painted canvas aspires to convey what had been mediated iconographically (i.e. literally through the depiction of the icon), then all clear distinctions between form and content, structure and meaning, become unsustainable, and we enter into a mode of referentiality whose domain is *Erlebniskunst* and whose Romantic terminus is the symbol.

Significantly, neither Ramdohr nor his Romantic opponents ever themselves articulate how the structure of *Cross in the Mountains* might relate to its specific subject. In order to attend to the historicity of landscape's meaning, then, let us for the moment stay within the interpretative bounds of the 1809 controversy and consider some further aspects of Friedrich's system as form.

According to Ramdohr, the illogical viewpoint of *Cross in the Mountains* has bad consequences for its treatment of visual detail. By hiding the sun behind the mountain, Friedrich casts his scene in shadow, so that instead of the atmospheric unity of traditional landscape, in which the manifold of earth and sky are unified by an all-embracing envelope of light, we see only a sharp contrast between a dark and therefore barely legible foreground, and a glowing and rather unnaturally coloured sky. Now *Cross in the Mountains*, like *Fog* of 1807, loses much of its complexity in

reproduction. A colour plate of the work tends either to accentuate the visibility of objects represented in the foreground, by amplifying the work's tonal contrasts, or else it conceals the whole terrain in an impenetrable darkness. Before the original canvas, the viewer has access to both possibilities. At first the mountain indeed might appear as a dark silhouette or undifferentiated blankness, additionally obscured by the usual reflected glare on the canvas's varnished surface. As our eyes grow accustomed to shadow, however, and as we bear down on the work to dispel its surface sheen, we discover within this seemingly massless area an astonishing variety of objects – grasses, different types of fir, variegated rocks and soil, etc – equal to the diversity of nature. Our impression becomes less one of a landscape observed and depicted already in shadow than of a scene first depicted fully in light and then belatedly covered over by a layer of dark glaze. We shall encounter this effect again in Friedrich's scenes of fog-covered mountains, where the extraordinary transitions achieved between the solid forms of earth and the concealing mists and clouds appear as if Friedrich has actually overpainted with grey a totally finished landscape free of fog (e.g. illus. 77–80, pp. 155–8).

Ramdohr's deepest objection to the pictorial manner of *Cross in the Mountains* stems from such ambiguities, such shifts between the visible and the invisible, and between the part and the whole. On the one hand, Ramdohr argues, Friedrich fails to endow his scene with a coherent structure, allowing us no single site of entrance into the landscape, and depicting the summit as a flat silhouette observed from a great distance. On the other hand, within the massless surface of the mountain, the artist also lavishes attention on the minutest details of the scene, depicting 'every twig, every needle on the fir trees, every spot on the boulders' as if it were observed from close up. This finer optic, which Ramdohr attributes partly to Friedrich's fatal infatuation with the art of Dürer and his contemporaries, further undermines the unity of the scene. Again, Ramdohr's criticism has great descriptive power. Beheld from a distance, *Cross in the Mountains* seems indeed to position us outside the spaceless landscape, in a place always both too high and too low. But observed from nearby, the canvas's surface appears decorated with an assemblage of objects, each so detailed that it draws preternaturally close to us. Trapped within a play between proximity and distance, familiarity and estrangement, presence and absence, the microscopic and the colossal, we *ourselves* become discontinuous, able neither to enter into the represented world, nor to observe it as a whole, from some standpoint *sub specie aeternitatis*.

'We are potential, *chaotic* organic beings', wrote Schlegel in one of his posthumous fragments. The human condition, here imagined as a purgatorial state between a lost unity, mythicized as Eden and theorized by Schiller and others as the 'naive', and an always future restoration of unity, informs the Romantic conception of order and formal coherence in art. Produced within this purgatory, the work of art must express both the chaos of its origins and the order which is its prophetic 'potential'. Elsewhere Schlegel notes that there are certain ancient discourses 'from which one could learn

49 *Dolmen by the Sea*, 1806–7
Staatliche Kunstsammlungen, Weimar

disorganization, or where confusion is properly constructed and symmetrical'. Such 'artful chaos' *(Kunstchaos)* possesses 'enough stability to outlast a Gothic cathedral' (*Athenaeum* Fragment 389). Friedrich's landscapes aspire to this condition, and it is appropriate that one of his most frequent motifs is that of the ruined Gothic church as structure which at once orders and fragments pictorial space. As we shall see, the carved crucifix within *Cross in the Mountains*, along with the work's gothicizing gilt frame, recollects this order, yet between these two remnants of the cathedral lies the whole *Kunstchaos* of modern landscape. Schlegel's oxymoronic terms are useful in describing the painting's curious conjunction of incoherence and system which even the Neo-classical Ramdohr could discern. For while Friedrich may disorganize conventional landscape composition, he also constructs a new and in many ways stricter system, one founded on the ancient order of symmetry.

It is a striking feature of *Cross in the Mountains* that tends to be overlooked if we behold the canvas for too long: the summit rises symmetrical at the very centre of the visual field. The diagonals of the mountain's slopes, angled at about 45°, pass out of the scene at corner points of the canvas, so that the picture plane is dissected into roughly equal triangles. That this rigid coincidence between the landscape's structure and the geometry of the canvas gets overlooked, indeed that it appears somehow natural to the order of things, is partly due to its *resemblance* to yet another system informing our reading of any image, namely the conventions of linear perspective. As

50 *High Mountains, c.* 1823–4
Destroyed 1945, formerly in National Gallery, Berlin

we observed, Friedrich constructs the principal diagonals of the painting so that they appear like orthogonals, even if they actually describe the sloping profile of the summit. The expectation, persistent since the Renaissance, that parallel lines converge at a centralized vanishing point, and that the picture itself is a plane intersecting the visual pyramid at a right-angle, helps mask the aggressive symmetries of *Cross in the Mountains*. That is, by superimposing his own system on to an older, and by this time wholly naturalized system, Friedrich conceals the overtly 'artful' and constructed quality of his picture, reconciling the landscape's quasi-diagrammatic quality to its concomitant naturalism (i.e. its epochal claim that what is represented as 'altarpiece' is not the Passion, but rather a natural scene with carved cross experienced as Passion).

The symmetry of this landscape does not stop with the manner of its enframement. In the foreground, two firs, although of differing heights, rise above the lower framing edge at points precisely equidistant to the canvas' sides. Deeper into space and slightly off to the right, the two trees immediately flanking the crucifix, along with the V-shaped summit rock, together form another symmetrical grouping centered on the cross and organizing too the reciprocity between the pyramid of the mountain and the similarly shaped bands of clouds above. And in the background, the sun's rays establish further symmetries and describe triangles running inversely to the pyramid of the mountain and to the bands of clouds. Noting this succession of variously centred symmetries, Börsch–Supan likens the resultant to and fro movement of the eye into depth to the

'swing of a pendulum'. The simile of the pendulum implies the existence of a fixed pivot point determining all movements and positions within the landscape. Each of the various symmetries of *Cross in the Mountains*, however, order only a small segment of the image. The perfectly enframed mountain, paired foreground firs, symmetrical summit group and geometricized sun's rays (themselves like positions of an inverted pendulum) are discontinuous, parallactic systems, each with its own centre, scale, implied viewpoint and logic. Against the achieved homogeneity of space through linear perspective, against even the coherency of system implied by the mechanism of a pendulum, Friedrich proposes fragmentary constructions of chaos, and therefore always only partialized constitutions of the viewing subject *as* subject.

To understand such *Kunstchaos*, it is useful to consider its dominant devices: symmetry and the succession of discontinuous systems. The rigid symmetry of Friedrich's pictures is without precedents in the history of landscape. Philipp Otto Runge, it is true, had already fashioned radically symmetrical images a few years before *Cross in the Mountains*, images which he termed 'landscapes'. In small *Morning* of 1808, for example, certain minute natural details, notably the shiny bulbs and roots of the two *Amaryllis formossissimae* at the lower corners of the picture's figural frame, are rendered with striking specificity, even if their overall shape, size and orientation

51 Philipp Otto Runge, *Amaryllis formossissimae*, 1807
Kunsthalle, Hamburg

are determined by the paired relation of the picture's two symmetrical sides (illus. 28). Each bulb has uniquely coloured and configured stem plates and outer skins, and each is displayed to us with differently positioned highlights; we are thus given the impression not of Runge's faithful replication, in reverse, of a single plant or floral arabesque, but rather of his depiction of two real and unique plants posed side by side before a single light source and arranged so as to cohere to a symmetrical pattern (illus. 51). And in this seemingly perfect fit between nature's particularity and artist's system, or between the mimetic and the arabesque, landscape offers no real resistance to the rage for order. The coastal view that spreads to the horizon in the work's central panel, while prefiguring of certain aspects of *Cross in the Mountains* (e.g. the centralized and symmetrical overall composition, the paired plants at the lower framing edge, the reciprocity of the landscape's forms with the shape of the purple clouds beyond, and the arch-shaped visual field), excludes any randomness, any discontinuity of system which, while compromising symmetry, would also endow the scene with a heightened sense of the real.

In Friedrich, landscape rarely exists in such magical conformity to the order of representation. His symmetries, always fragmentary, are staged as a complex agon between, on the one hand, objects in the world which are themselves partly symmetrical and which, represented, appear to determine the order apparent in the image; and, on the other hand, a symmetry always already inherent in the visual field, whether as the rectangle of the canvas, or as the bilateral symmetry of the artist's or the viewer's bodily gaze. These symmetries and asymmetries dramatize not so much the intrinsic order and disorder of nature, nor even the partiality of the artist/viewer's own subjective rage for order, but rather precisely the match and mismatch between the two: that is, the dyadic relation, never quite symmetrical, between painting and viewer. It would be easy to go one step further and interpret this potential analogy between pictorial form and cognitive structure in the light of one of the central motifs of German Romantic philosophy: the resolution of the subject–object dualism within the work of art. In the Schelling of the 1800 *System of Transcendental Idealism*, for example, the artwork, at once an autonomous production of the creative subject and a wholly objective thing in the world, is entrusted with the renovative task of constituting, for the individual, 'the original ground of all harmony between the subjective and the objective . . . in its original identity'. Friedrich, to be sure, makes us uncertain whether the symmetries we see are inherent in things themselves, or in our experience of things, and this aporia in itself fosters an exemplary identity between viewer and viewed. And yet, is the specificity of Friedrich's system, its uniqueness vis-à-vis, say, that of an artist like Runge, really addressed if we read it against, or rather allegorize it as, the *System* of Schelling? Our own desire for an *interpretative* symmetry between the immediate experience of the work of art and, in this case, the machinery of Idealist metaphysics must itself be measured against Friedrich's landscapes, which always also celebrate the radical alterity of nature, landscape and

image through their attention to the non-systematic: the unpredictable profile of a ruin (illus. 66); the random plurality of viewpoints; the unreduplicatable chaos of shattered ice (illus. 113, p. 201) or of barren branches stretched across the sky; the lone tree, solitary traveller or single ship on the horizon which *must* rise stubbornly at the centre of the picture, neither because it is 'like ourselves', nor because the world is organized around it, but precisely because its *Eigentümlichkeit*, its demonstrative *this*-ness, forbids any answer or symmetry or repetition or reciprocity.

Friedrich founds his symmetries contingently, on broken analogies between the cultural and the natural, and between a perceiving mind and an often cold, inanimate landscape. Occasionally the artist will position some man-made structure at the picture's centre, allowing it to subsume all natural surroundings under its symmetrical architecture. In *Abbey in the Oak Forest* of 1809–10 (illus. 88, p. 169), for example, the Gothic monument, while now a jagged ruin, is perfectly centred and displayed *en face*, as if to recollect for us its original symmetry. Around it the bleak landscape seems to respond to its form. The flanking oaks, though radically individualized in their wild profiles, are evenly paired off against each other around the central axis; and the visible extent of the ground-plane, rendered as a murky curve originating behind the two alders at the lower corners of the canvas, and reaching up to the level of the ruined abbey's furthest wall, is reciprocated by the nebulous shape of the glowing heavens above. At one level, these symmetries simply express the analogy, current in Friedrich's culture since Goethe's 1773 essay on the Strasbourg cathedral, between Gothic architecture and the German forest. Landscape can be continuous with the abbey's structure because 'the Gothic' is itself already a natural or naive architecture, reflective of a religion and a culture that was linked organically to its time and place, which is the Christian Middle Ages in Germany. As Romantic ruin or fragment, Friedrich's cathedral does not really lose its symmetry. On the contrary, its collapse accommodates it to nature's chaos, enabling it to enter in a deeper order, one that allows, as Goethe wrote for all Gothic forms, 'the parts to grow together into *one* eternal whole'.

At another level, however, Friedrich insists that these symmetries are contingent on our placement before the scene, that were we somehow to step to the side of our centralized position, the oaks, ruined choir, paired alders and the whole reciprocity between earth and sky would dissolve into a jumble of things, like those crooked grave markers rising helter-skelter from the snow. It is the *canvas*'s symmetry, its straight edges, rectangular format and measurable midline that recovers the cathedral's order within dissolution and transforms a picturesque scene of ruins and churchyard in the wilderness, common in landscape painting since at least the Dutch painter Jacob Ruisdael's *Jewish Cemetery* (illus. 52), into something far more personal and disturbing. The landscape's symmetry, as well as the attendant analogism between the order of the cathedral and the order of the canvas, become the consequences of an attitude or activity on the part of the viewing subject.

52 Jacob Ruisdael, *Jewish Cemetery*, 1653–5
Detroit Institute of Arts

This incorporation of the beholder into the whole structure of the visible is powerfully demonstrated in the pendant canvases *Bohemian Landscape with Milleschauer* (illus. 53) and *Bohemian Landscape with Two Trees* (illus. 23, p. 45), both from 1810 and now in Dresden and Stuttgart respectively. Friedrich pairs his pictures not only as terms of a temporal opposition between morning and evening, but also as alternative relations between subject and landscape. A spring morning in the Bohemian landscape (illus. 53) is experienced through the smooth movement of our eye into depth, carried by a road that winds from the foreground into the distance, as well as by the broad and various panorama that spreads our visual attention equally across the visual field. At sunset (illus. 23), the path before us has vanished. Our visual passage into depth has been thwarted by various barriers running across the whole composition, and our eye is arrested at two moments in the scene: the poignant gap between the tops of the two trees in the midground that bend towards each other almost to form a natural arch and the glow of light spilling from behind the mountain's summit to mark the instant of the sun's departure. Pictorial symmetry, here trees paired as if in a sacred architecture before a centralized sunset, occurs contingent both on the particular placement of the viewer in space, and on the recorded instant in time. Such contingencies heighten our sense of our own visual attention, offering within the landscape an

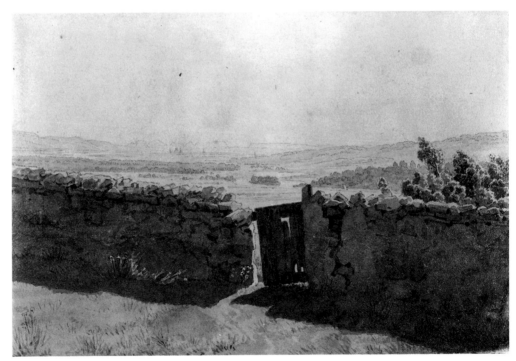

53 *Bohemian Landscape with Milleschauer, c.* 1810
Staatliche Kunstsammlungen, Gemäldegalerie, Dresden
54 *Landscape with Ruined Wall, c.* 1837–40
Kunsthalle, Hamburg

analogy to the singularity and evanescence of our own experience. Movement between Friedrich's pendant scenes of a Bohemian landscape becomes a shift *in us* between a diffuse and innocent gaze (the Dresden canvas), and an intensified and, as it were, more self-conscious mode of seeing (the Stuttgart canvas).

In *Abbey in the Oak Forest*, Friedrich dramatizes the activity of the viewing subject within his picture's human plot: the solemn cortège of monks marching in pairs and bearing a coffin to an altar lit by candles. The picture's structure, continuous with this distant altarpiece, becomes a version of devotion. We oversee the gaze of one who positions himself in line with the ritual, and we regard the painted canvas as if it were *itself* an altarpiece. And when we recall that *Abbey in the Oak Forest* was fashioned as the pendant to *Monk by the Sea* (illus. 87, p. 168), indeed that its symmetries are, so to speak, symmetrical to those of its companion piece, the absolutely subjective nature of Friedrich's system *as* system becomes apparent. For the funeral is the artist's own. At our feet lies his open grave, like some tabernacle for a consecrated host, or like the 'sarcophagus' which would traditionally be a German Gothic altarpiece's predella. Here we can observe the culmination of that trajectory toward the subjective that we traced from *Emilias Kilde* and *Scene of Mourning* to *Fog* of 1807. Not only is landscape itself elegized as monument or tomb, but the original elegist, Friedrich, has himself become the corpse at the system's absolute centre. Beyond any conventional religious allegory of transcendence, beyond any encoding of the Gothic abbey as 'Christendom' and the surrounding oaks as the 'pagan' past (Börsch–Supan), *Abbey* effects and interprets the passage between order and disorder in art, and therefore between identity and alterity in our cognitive experience. Observing his own funeral with a particularizing gaze that constitutes the landscape's fragile symmetry, Friedrich takes *us* to the point of our true return to nature – death – and imagines our re-emergence into '*one* eternal whole'. Yet without *lived* experience *(Erlebnis)* to hold chaos at bay, and without the constructive work of altar, cathedral, canvas and culture, it remains profoundly uncertain whether this order will be that of a heavenly Jerusalem, such as Friedrich occasionally constructed as visionary architecture (e.g. illus. 7, p. 22 and 66, p. 133), or that of the macabre corpse (illus. 128), of the body rendered as random as the skeletal branches of the oak trees.

The Dresden poet, playwright and patriot Theodor Körner wrote two ecphrastic sonnets on Friedrich's *Abbey in the Oak Forest* which were published posthumously in 1815. Körner, who died in 1813 as a 21-year-old volunteer soldier in the war against Napoleon, reads into the canvas's funeral procession a consoling message of redemption:

> The fountain of grace flows in death,
> And those there are the comrades in bliss,
> Who pass through the grave into eternal life.

Religious allegory, however, is only one step along the poem's way. For Körner quickly transposes this plot of transcendence discernable within the landscape into an account

of the painting's effect on the viewer. By elevating us to the eternal, Körner argues, Friedrich's canvas justifies our faith in the redemptive powers of art *per se*, and in our own subjective capacity to feel those powers. Thus the poem concludes:

> Here I can boldly trust my heart;
> Cold admiration I shall not have – no, I feel,
> And in feeling art completes itself.

Art achieves its end here neither in a Christian faith, nor even in the promise of an afterlife, but rather simply in the evocation of *any* authentic emotion, an evocation founded upon a certain reciprocity between painting and viewer, the demonstration of which *is* Körner's empathetic ecphrasis itself.

Friedrich often stages such covenants within his pictures, although generally with more ambiguity than Körner's poem-painting would suggest. In a lost canvas dating from 1810, formerly in Weimar, the artist 'illustrates' a poem by Goethe entitled *Schäfers Klagelied* (1803), in which a shepherd, mourning the loss of his beloved as he wanders about the landscape with his flock, discerns in a receding rainbow an emblem of his desire. Friedrich makes this part of the poem's plot concrete by stationing one end of the rainbow above the figure of the shepherd-poet, and the other end at the vanishing point of his gaze. The rainbow, the traditional symbol of the covenant between man and God, and therefore of the promise of passage from this world to eternal life, becomes here a quasi-diagrammatic link between the shepherd and the landscape. Quasi-diagrammatic, because even in Goethe's poem the 'I' is never able to stand within the rainbow's path, but yearns both for its origin, which rises 'above that house' where the beloved used to dwell, and its end, which points 'over the sea'. Quasi-diagrammatic, too, because from *our* viewpoint the rainbow constructs a perfect symmetry for the scene, one which, by implication, idealizes the work of art's union of poem and painting, of proximity and distance, of viewer and viewed. That is, by virtue of its formal symmetry the biblical emblem of covenant is analogized to Romanticism's dream of an identity between subject and object.

A similar notion informs Friedrich's roughly contemporary *Mountain Landscape with Rainbow*, now in Essen (illus, 89, p. 170). Here the ends of the rainbow are coterminous with the limits of the canvas, and the figure in the landscape, this time a self-portrait of the artist, is placed just off-centre in the foreground. The painting's symmetries (the gentle pairing of foreground trees and the placement of the distant mountain's summit exactly along the central axis of the canvas) articulate in the horizontal dimension a reciprocity expressed as well in the vertical: between the oval glow in the sky just above the rainbow and the oval shape of the lit foreground where the artist-wanderer stands. In deliberate contradiction to ordinary nature – for rainbows only appear when their light source lies behind the viewer – the rainbow expresses the relation between the viewer *in* the picture and the apparent goal of his yearning, which is that mysterious oval of light that illuminates him.

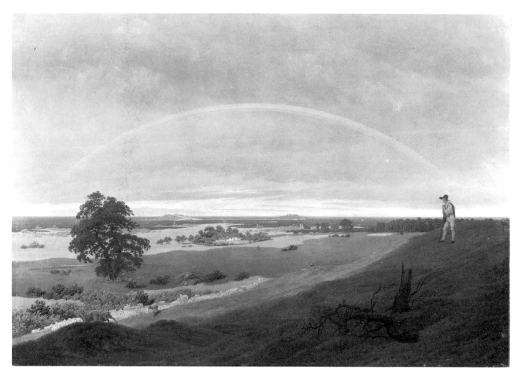

55 *Landscape with Rainbow, c.* 1810
Lost, formerly Staatliche Kunstsammlung, Weimar

In both *Mountain Landscape with Rainbow* and the lost Weimar picture, the rainbow's structural symmetry functions to idealize the subject–object dualism of human experience, as it is theorized by Romantic aesthetics. That the covenant between man and God, which is the rainbow's conventional *symbolic* tenor, can now articulate the covenant between the mind and nature, is predicated on the rainbow's status as *natural* occurrence. Like the Gothic spires in *Winter Landscape with Church* (illus. 7, p. 22), which rise symmetrical to the fir grove, but which remain still within the decorum of ordinary, observable nature, Friedrich's rainbows are at once an emblem in an allegory and an object in nature, at once the idealizing diagram for and an ordinary object of perception. This distinguishes them from the symmetrical and ultimately still rococo figurations patterning the 'sky' of Runge's small *Morning*: however perfect their shape, and however magical their fit within the boundaries of the canvas, Friedrich's rainbows belong still to the realm of a landscape that can be experienced empirically, and therefore of *Erlebniskunst*. This is perhaps one reason why Friedrich inhabits both these canvases of 1810 with a human figure against whom the landscape is paired off as 'something seen'.

In a number of the artist's works, such figures, usually depicted with their backs turned to the viewer, function as a primary device for establishing the landscape's formal symmetry. Sometimes they appear in pairs flanking the canvas's central vertical axis, so that our eye is held captive in the narrow interim between their bodies (illus.

16, p. 38); sometimes one stands alone at the centre of the visual field, so that the landscape appears as a symmetrical emanation from his or her heart (illus. 77, p. 155 and 97, p. 178). In making the landscape's order appear as contingent on the order of their bodies, these figures would offer yet another idealizing account of the relation between self and object. The randomness and alterity of nature, radicalized in *Abbey in the Oak Forest* as physical death, would then be controlled through the fiction of a world rendered homologous to our own bilaterally symmetrical physical being.

Is this really the case in Friedrich's landscapes, though? In the great *Woman at the Window* from 1821, now in Berlin, pictorial symmetry expresses not an identification with, or emersion in, the landscape, but rather a separation from it (illus. 76, p. 154). It is true that the thin mullions of the upper window form a cross centred along the canvas's midline, and that this cross, together with the woman's devotional posture, the triptych structure of the lower window, and the general austerity of the interior space endows the whole ensemble with the 'potential' character of an altar, so that random nature *should* obey the picture's system, as it did in the sacralized landscape of *Abbey in the Oak Forest*. It is also true that Friedrich has lined up the woman along the central axis of his picture, focusing her round shadow precisely in the middle of the window niche, so that represented space *should* have reciprocity with the human form. Thus arranged the scene, shaped to our minds as to our bodies, would be appropriable for us, and our gaze would feel to us like an answered prayer. Yet is it the reciprocities that keep us looking at, but never fully beyond, the window and the room? Surely what holds us here are objects and angles not arranged: the way the window appears centred in the canvas, while the niche's flanking walls do not; the many small, rotating window locks which always point at different angles; the two glass bottles at the woman's right; the meticulously rendered dents, scars and blunting of the window's wooden sill. Most striking is our tiny view of the landscape outside. Narrowed by our distance from the window, and partialized by the covering presence of the woman, our prospect of nature could hardly be *less* ordered and symmetrical. Near the window the upper parts of ships' masts rise baseless into view, compromising the balance and geometry of the interior space as they sway this way and that. And deeper into space, though with no visible connection to the foreground, a shore lined with an uneven row of poplars runs not quite parallel to the window and therefore to the picture plane. Landscape here is deliberately fragmented, asymmetrical and defamiliarized: a domain set radically apart from the woman, from her ordered and symmetrical domestic space, and from the geometry of the canvas itself. Friedrich wants us to remember the picture plane as we peer over the woman's shoulder into depth; for the proportions of the canvas's rectangle are very nearly repeated in the shape of the window opening through which the woman gazes. The metaphor of painting as window, dominant in Western pictorial thinking since at least Alberti, is given a very new inflection here. As window, the canvas does not invite any easy entrance into the painted world, any fiction of homogeneity between real and rep-

resented space. Rather, the picture-window sequesters us, like the woman, in a position of exile from, and longing for, what we can always only partially see.

As a device for structuring pictorial space, of course, strict axial symmetry itself tends to resist the eye's movement into depth, which is why it is usually banished from classical landscape painting. In Claude Lorrain's *Coastal Scene with Acis and Galatea* of 1657, a work that has hung in the Dresden Gemäldegalerie since 1754, the lovers' bower may indeed be centred in the foreground and framed on either side by coulisses (illus. 56). Yet these flanking forms – the trees to the right and the cliffs to the left – are never paired off along one line parallel to the picture plane (as are, say, the oaks in Friedrich's 1810 *Abbey*), but are instead staggered in space, so that our gaze is at once channelled by their forms and drawn into the distance. Friedrich's

56 Claude Lorrain, *Coastal Scene with Acis and Galatea*, 1657
Staatliche Kunstsammlungen, Gemäldegalerie, Dresden

symmetries forbid such smooth passage. Frequently they frame a radical discontinuity of space, as when the framing coulisses of *Chalk Cliffs on Rügen* of *c.* 1818 give way, via an abyss, to a flat sheet of colour whose legibility as 'sea and sky' is assured only through the two tiny sailing boats that float on its surface, unaffected by the laws of perspective (illus. 107, p. 196). But more importantly, these symmetries, always felt as contingent on our own specific point of view, keep us fixed in place before the picture, so that movement to the side, or into depth, would throw the entire scene into chaos.

But is this not a peculiarity of Friedrich's whole 'system', on the one hand, to arrange landscape more strictly than his seventeenth- and eighteenth-century precursors had done, endowing it with a geometry akin to diagrammatic religious images of a much earlier era; and on the other hand, to 'disorganize' the achieved continuity of traditional pictorial space by rendering the background radically discontinuous with the foreground, and by invoking at the horizon an infinity that no system can arrange?

We have already noted how, in *Cross in the Mountains*, the artist fashions space through a succession of disjunctive systems, each with its own axis of symmetry and implied viewpoint. Friedrich develops a number of other devices for simultaneously organizing and disorganizing the visual field.

Sometimes he foils our visual progress into depth by setting between us and the horizon a band running parallel to the picture plane and across the whole visual field. Thus, for example, in *Augustus Bridge in Dresden*, produced around 1830, Friedrich constructs his image as a series of uninterrupted horizontals: the foreground pavement and handrail, the river that flows below, the Augustus Bridge with its arched piers, the row of intermittent trees, the ridge of hills and the sky's stripes of light and clouds (illus. 57). Now classical landscape painters from Claude to Jacob Philipp Hackert frequently depicted river scenes, delighting in the way the water's path through space could ease the eye into depth, while bridges connecting shore to shore unified the picture's flanking sides. Nothing could be further from Claude, however, than Friedrich's grid-like composition, in which any centralized passage into distance is blocked, and the whole spectacle, lacking any internal frame, stands radically open at both sides. Rather than flowing *into* space, the Elbe runs directly *under* the bridge on which we are positioned and *across* the whole visual field; and the Augustus Bridge, instead of connecting flanking shores, extends indefinitely beyond the picture's sides and effects an abrupt leap into depth.

Such leaps, I believe, are thematized in Friedrich's curious *Garden Terrace*, first exhibited at the Berlin Art Academy in 1812 (illus. 58). Again space is built up as a series of horizontal bands: the intermittent pavements and strips of grass in the foreground, the garden wall, and the panorama of the mountains beyond. Within and among these bands Friedrich establishes relative symmetries: the two chestnut trees placed equidistant to the edges of the canvas, the pattern of grass and bushes flanking a classical statue of a woman, the stone lions guarding the gate, and the pyramid of the highest mountain, whose summit occurs directly above the statue. Friedrich, who after his Copenhagen period almost never depicted park scenes, renders foreground and background spatially discrete as zones which we could code variously as garden versus landscape, culture versus nature, Neo-classical park versus Romantic wilderness, as well as, perhaps, French artifice versus German naturalism, and mediated knowledge (the woman reading, oblivious to her surroundings) versus immediate experience (the world beyond the garden and book). However we choose to interpret the succession of systems in Friedrich's picture, its effect is to establish the alterity of landscape, and to affirm a split between self and world such as was monumentalized in *Woman at the Window*.

Friedrich frequently fragments space by constructing his foregrounds as screens which obscure much of our view of what lies behind. Observe, for example, the extraordinary placement of a stone wall and closed gate right up against the picture plane in *Churchyard* of the late 1820s (illus. 22, p. 44). More commonly he simply

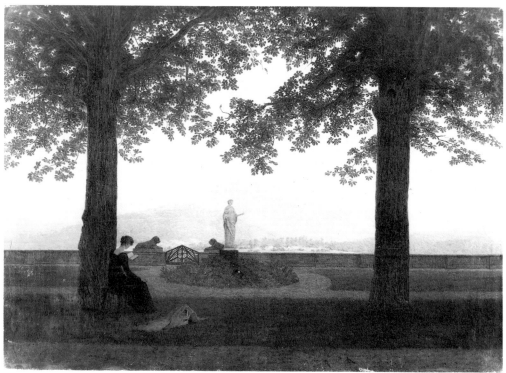

57 *Augustus Bridge in Dresden, c.* 1830
Destroyed, formerly Kunsthalle, Hamburg

58 *Garden Terrace,* 1811–12
Staatliche Schlösser und Gärten, Potsdam

omits a visible midground from his scenes. The foreground summit in *Cross in the Mountains*, covering any hint of landscape beyond, is set immediately against the sky, as figure against ground, which is partly why Ramdohr criticized the canvas as a landscape structured as if it were a portrait or history painting. Other contemporaries took pleasure in such radical elisions. Johanna Schopenhauer, for example, writing in an issue of *Journal of Luxury and Fashion* in 1810, notes approvingly that Friedrich omits from his canvases 'midground and background . . . because he chooses objects in which these are not to be represented. He likes to paint unfathomable expanses'.

One of the most haunting instances of such an elision is Friedrich's tiny canvas of a *Hill and Ploughed Field near Dresden*, dating from around 1824 and now in Hamburg (illus. 24, p. 45). Landscape here is not arranged as a 'view', but rather as the obstruction of view. Instead of shaping themselves around our centralized gaze, as the frame for a prospect of the city, the foreground earth, meadow and trees rise up before us concealing any continuity to the distance, a convexity reaching almost to the horizon line and open at both sides. As in the similarly ordered *Evening Star*, now in Frankfurt (illus. 106, p. 195), Friedrich shows just enough of Dresden's silhouette to fix our eye on the foreground's edge as we make out the shapes of the Kreuzkirche, Frauenkirche, Schlossturm and Hofkirche. The longer we dwell on this baseless cityscape, however, the more powerfully felt the swelling foreground mass becomes. Thwarting our desire for a panoptic view, and undermining therefore our sense of visual mastery, Friedrich trains our eye on things that would, in the traditional veduta, be merely peripheral: the parallel pattern of plowed furrows which lead the eye out of the picture to the left; the maze of branches that, spread out against the sky like the alders of *From the Dresden Heath*, entangle our gaze in its disorder; and the hectic flight of birds, here not guiding our vision into depth, but rather returning us from the horizon at the left back to the soil at our feet, and to that red rose whose strangeness to the landscape eclipses Dresden's beautiful towers. Indeed Friedrich's foreground has the uncanny effect of inverting the whole geometry of landscape painting's vision. Instead of descending to the city below along a centralized channel of vision, our gaze must always climb the swelling foreground whose highest point lies at the picture's core; and instead of plunging into depth, our eye is always caught and doubles back to what lies close at hand, there to find the commonplace (earth, grass and trees) estranged and unfamiliar.

Our expectations are subverted partly by the way our eye 'reads' Friedrich's principal diagonals, here the sloping limits of the foreground hill. Like the steeper slopes of the summit in *Cross in the Mountains*, the diagonals in *Hill and Ploughed Field*, legible as perspective lines converging at a horizon, lead the eye falsely into depth, destabilizing our experience of represented space. Sometimes Friedrich's diagonals do indeed lead into the distance, as when, in *Evening Star*, the great bands of the sky, along with the path rising from the left in the foreground, all appear to converge somewhere beyond the canvas's right edge. Yet here the imagined vanishing point is endlessly displaced,

59 *Cemetery Entrance, c.* 1824–6
Staatliche Kunstsammlungen, Gemäldegalerie, Dresden

for as they pass out of the picture, these quasi-orthogonals run virtually parallel to the horizon, evoking thereby an infinity that simply cannot be pictured. Sometimes Friedrich will juxtapose different *kinds* of diagonals within a single image, as when, in the Hanover *Morning* of *c.* 1816–18, the receding line of sailing boats leads us to the horizon, while the similarly arranged poles at the left leave us in the foreground (illus. 18, p. 40). Here, too, the wings of the airborne gulls, echoing in their shape both the curved upper edges of the receding sails and the Y-shaped tips of the poles, render different objects and different positions in space as equivalent patterns on the picture plane. This conceit serves to articulate the canvas's overt theme of leave-taking. The receding boats articulate the *experience* of departure through an actual disappearance of the objects of our vision, while the poles locate us back on shore, intensifying our sense of having been abandoned and evoking a feeling of bereavement.

A similar logic is at work in the roughly contemporary *Woman at the Sea*, now in Winterthur (illus. 19, p. 41). Friedrich constructs space through an odd conjunction of two principal diagonals: in the foreground, the flat bases of the boulders describe a straight line running from the lower left corner point of the canvas, along the rock on which the woman in red is seated and off to sea at the right; and further into space, a row of sailing boats just off shore establishes an orthogonal that passes from somewhere out of the picture at the right to the precise point where the horizon meets the picture's left framing edge. Such precision optics, like Friedrich's rigid pictorial symmetries, staples the structure of nature to the order of representation. It testifies, above all, to the presence of system *per se*, although this system may be radically incomplete and wholly at odds with the conventions of linear perspective. For unlike orthogonals, which originate at a picture's lower framing edge and converge at the landscape's horizon, the principal diagonals of *Woman at the Sea* run from significant points along the right side of the canvas (horizon line above and lower framing edge below) to converge offstage to the right. This reorientation of spatial construction appears motivated by the pose and outline of the woman in red, who, unlike most of Friedrich's staffage figures, is represented from the side rather than the rear. The displacement of the painting's focus from a centralized point on the horizon to an imagined point off to the right articulates the altered directionality of this internal viewer's body and gaze, as indeed does the whole geography of the scene, which appears as a bay of water open to the right. As if to diagram this intertwining of viewer and viewed, Friedrich establishes a number of peculiar chiasmi. While the diagonal the sailing boats describe leads our eye properly into depth, the boats themselves travel towards the foreground, their path intersecting the line of the woman's gaze at the point where the picture's principal diagonals converge. And against the wedge enclosed by these diagonals, and against the similarly shaped wedge of the woman's reclining body, Friedrich establishes countermovements in the angles enclosed by the boats themselves (between their diagonally slanting masts and their wedge-like bodies), and in the woman's analogously wedge-shaped bonnet which, while concealing from

us her eye, suggests her cone of vision. In innumerable ways, *Woman at the Sea* maps together Romantic landscape's dual infinities – self and world – as if in cross-section.

Monk by the Sea, probably Friedrich's greatest shore scene, uses the diagonal in yet another novel way, one which is more typical of the artist's compositional procedure (illus. 87, p. 168). At the opening of his pioneering study of pictorial structure in Friedrich, Helmut Börsch–Supan discerned in the Berlin canvas the culmination of the artist's early development of a 'contrastive style', in which foreground and background are set against each other as horizontal versus vertical, figure versus ground, finitude versus infinitude and detailed treatment versus generalized. To establish these contrasts, Börsch–Supan argued, Friedrich not only eliminated from his scenes a connective midground, but also evoked an infinite expanse *between* the two pictorial zones. This was achieved by simultaneously deploying and rupturing the diagonals of conventional linear perspective. In *Monk by the Sea*, the pale, broad triangle of the foreground shore, together with the roughly symmetrical descending triangle of the lit sky above the bank of clouds, draw our eye into a certain depth, simply because we read their sloping sides as if they were orthogonals constructing space. The diagonals here, however, do not converge at the horizon to fashion the X of perspectival composition, but rather, pointing only partway into space, they stall us at the disparate apices of earth and sky. Beyond these points begins another kind of space and another kind of system, one whose only markings are the unbroken line of the horizon and the white spots of intermittent gulls and whitecaps.

We know from X-ray photographs and from contemporary accounts that this central strip of 'sea and clouds' was the work of ongoing revision, reduction and concealment. In its initial phase, late 1808 to February 1809, *Monk by the Sea* had a uniformly grey sky and sailing ships were visible on the sea. Sometime later, before June 1809, the sky was repainted a dark blue and the moon and stars were added. And by the time the work was shown at the Berlin Academy exhibition in October 1810, this evening sky was again overpainted with its present mix of clouds, light blue sky and descending fog, and the ships were painted out, creating a landscape of unprecedented emptiness which delighted and disturbed contemporary viewers.

One obvious consequence of this process is that the paint surface of the canvas, particularly in the area above the horizon, appears quite dense or pasty, which is highly unusual for Friedrich, who generally applies colour in thin transparent glazes that betray no evidence of brushwork and little of the physical presence of paint. This density in *Monk by the Sea* intensifies the contrast between foreground and background. For if at the horizon we experience a thickening of paint, the area closest to us – those pale dunes touched here and there by the sparsest grass – has the colour of unprimed canvas. Thus just as he had disrupted the structure of linear perspective, Friedrich overturns the procedures of aerial perspective, which traditionally represents the world as thinnest at its distance. Instead of receding easily into depth, our eye slips past the ethereal foreground, only to be baffled by a plane of palpable, sluggish paint. The

clouds above the blackish-green ocean weigh almost physically on our eye, causing us to look upwards and recover in the triangle of lighter sky an open avenue for our sight. The leap between the two triangles (foreground and sky), which is also a leap across the disruption within conventional perspective, re-enacts the picture's ostensible plot *as* the trajectory of our vision. For what does the monk's attitude dramatize, there at the brink of the world (at the foreground's apex which *should* be the landscape's vanishing point), but a yearning for transcendence, for passage beyond the materiality of earthly existence.

In the pendant *Abbey in the Oak Forest*, the light triangle of sky has become the curved glow of heaven (illus. 88, p. 169). And while the monk will be buried in the

60 J. M. W. Turner, *The Angel Standing in the Sun*, 1846
Tate Gallery, London

foreground, the restored symmetry of the centralized Gothic ruin, rising above the darkened in-between of the graveyard to an area fashioned of the thinnest paint, ritually traverses the distance between pictorial zones, and between system and non-system. That Friedrich achieves these ends in *Monk by the Sea* within the play between the orthogonals and the blankness of a void is more than merely an 'allegory' of the human condition. Dressed in the habit of a monk, and assuming the traditional posture of melancholy (head in hand), Friedrich *is* the Romantic subject at the limits of his world, which are also the limits of his artistic means. For what the artist represents in this canvas, as in all his works which combine fragment and system, is not quite the structure of transcendence, but rather transcendence as the dissolution of structure: here the distant horizon transformed into an all too close surface of paint.

It is true that Friedrich, unlike his English contemporary J. M. W. Turner, rarely invokes the materiality of paint to disorganize pictorial illusion (illus. 60). In the much later *Large Enclosure*, dating from 1832 and now in Dresden (illus. 17, p. 39), the compositional arrangement of the landscape is similar to that of *Monk by the Sea*: the foreground diagonals, legible as orthogonals, and the sky's V are again separated by a broad band of discontinuous background. Yet in *Large Enclosure* this area around

the horizon has been given an altogether different character. As Richard Wollheim remarked, Friedrich stations us directly above the foreground water, allowing the silted Elbe river to run 'on under the point from which it is represented'. Friedrich, that is, draws us immediately into the landscape by making our physical viewpoint somehow part of the picture. Once thus installed, we move easily into depth along the veering diagonals of the foreground. The scale of this recession is, however, profoundly ambiguous and calls into question the posited belonging between viewer and viewed. The sky is mirrored doubly in the foreground river, both as a reflection on the water's surface and as a symmetry between the patches of purple clouds and the pattern of silting in the river. This encourages us to imagine a foreground as capacious as the broad sky. And as many commentators have noticed, the river's diagonals are subtly bent, as if to map the rectilinear progression of orthogonals into depth on to the curvature of the earth itself. The river, and with it our immediate standpoint, becomes an analogy of the whole of the world, and the sailing boat travelling on the further bank occupies a threshold akin to the point inhabited by the monk in *Monk by the Sea*. Yet beyond this world Friedrich does not raise a wall of paint or a groundless abyss, but simply another world. Receding far less dramatically into depth, and mirrored only by a sky of solid purple, this world of flat meadows, trees and low hills is far more familiar, more canny than the colossal, histrionic foreground to which we belong. It is as if, late in his career, Friedrich discovers that what lies at the far side of his system, in the rupture of landscape's space, is not a transcendence beyond the world, but rather simply the return to, or recuperation of a reciprocal being in, *this* world.

In *Monk by the Sea*, Friedrich disrupts the illusion of a world continuous with the self not only through 'contrastive' compositional strategies, but also through shifts within his painterly manner. Of course, the heightened fracture of paint surface above the sea's horizon may be the by-product of a specific historical moment in the artist's development: Friedrich's epochal invention of an emptied landscape through a singular process of indecision and deletion rather than through a premeditated minimalism. Yet this disruptive appearance of paint *qua* paint also lies well within Friedrich's – and Romanticism's – general project. In *Athenaeum* 116, Schlegel writes that Romantic art must 'hover at the midpoint between the represented and the representer . . . on the wings of poetic reflection'. Like Romantic irony, which evokes the infinite through the bathetic collapse of evocation, and like Romantic allegory, which, as we shall see, generates endless meanings in the desire for, but absence of, a totalizing meaning, Friedrich's system, always self-consuming, is the demonstration of the limits of system. And in the case of *Monk by the Sea* this limit, peopled by the representer–viewer in the monastic habit of unbridgeable *Eigentümlichkeit*, appears as nothing less than the materiality of painting itself. From there, as Gottfried Benn wrote in his verse cycle *Alaska*: 'Alles ist Ufer. Ewig ruft das Meer' (Everything is shore. Eternally summons the sea).

7

Symbol and Allegory

In *Cross in the Mountains*, everything is threshold, and eternity is voiced not by the sea, but variously by the abyss beyond the summit, the vault of the heavens and its culmination in the palm leaves and putti of the arched upper frame, and the myth of death and resurrection implied by Christ and his emblem, the setting and rising sun. Friedrich fashions landscape as the edge of an infinity. The dark form of the mountain appears at first glance as pure silhouette on the sky. The sloping and symmetrical sides of the summit and of the individual fir trees, as well as the diagonals of the clouds, read as orthogonals of steep and disparate ground-planes, and therefore guide the eye everywhere to the brink of an abyss. And the carved effigy of Christ, shown from behind and in lost profile, reveals the border of a face traced with reflected light, or rather the edge of a gaze that can see beyond all edges to the source of light at the real limits of the world – the sun upon the horizon.

Nor will it be lost to anyone who beholds Friedrich's 'altarpiece' as a whole that what lies hidden in the landscape, just beyond all these concealing edges, is recuperated at the picture's *actual* limits, in the carved and gilt frame that simultaneously encloses and interprets the mountain scene. In the ensemble's lower panel or predella, the emblem of an eye within a triangle not only dedicates the altar to its deity, the Christian God here conventionalized as the all-seeing gaze enframed by the radiance of the Trinity. It also duplicates and completes the very structure of the painted scene. The summit's pyramid, cleansed of its slight asymmetries and surface objects, reappears as the similarly proportioned and oriented isosceles triangle below. The hidden gaze of Christ's effigy, as well as its obscured object – the sun – becomes the eye/sun at the triangle's centre. The quasi-diagrammatic rays of light on the evening sky become further systematized as the surrounding nimbus. And the arching clouds in the landscape become the arch of palm leaves and the Eucharistic wheat and grapevine signifying Christ's death and eternal life. Painting and frame, it would seem, interpret one another. Yet it is hard to tell which is the text and which the commentary. Beyond whatever Christian or private iconographies might control the whole, the formal resemblances between what is in the picture and what is carved outside as its surrounds, and therefore between landscape and diagram, between the mimesis of a 'whole' of nature and an arabesque of parts and emblems, function to extend past the material limits of the represented scene those contrasts multiplied everywhere *within* Friedrich's landscapes: real/ideal, finite/infinite, this world/the next and so forth.

The art of Philipp Otto Runge provides the closest precedents for this leakage of the work of art into the instruments of its enclosure. In small *Morning*, executed in 1808 but dependent on a number of project drawings dating back to 1803, the frame's surfaces are treated as a continuous pictorial field, and its scene repeats the plot of the central panel (illus. 28, p. 54). In the 'landscape' scene, the newborn child in the foreground, the allegorical figure of Aurora–Venus–Mary striding above the horizon in the manner of Raphael's Dresden *Madonna*, and the natural setting with its sunrise and spring flora, all collectively express the idea of morning. The frame simply extends this proliferation of beginnings, for example, in the emergence of the sun from darkness, in the organic growth embodied by the amaryllis and its paired genii of root and flower, and in the rays of emergent light mingled with the glory of cherubs above. Nothing in their scale, manner of execution, or level of naturalism distinguishes these enframing images from the figures they surround; by which Runge implies that dawn overturns all ends, nights, boundaries or limits, even those inherent in the finitude and closure of the artwork. The colouristic link between the black angels of night vanishing at the upper corners of the central panel and the narrow black mouldings separating painting from frame and frame from world, reiterates this hyperbole of origination's expansiveness.

61 Philipp Otto Runge, *The Contrast Ideal – Real*, 1808–9

Friedrich might have learnt from the small *Morning* how a peculiar interpenetration of nature and symbol, and of object and meaning, can be expressed as a reciprocity between picture and frame. Runge was able to diagram this interpenetration variously and to explicate its terms. In a now lost sketch from 1808, for example, he maps the elements of colour (R = 'red', V = 'violet', B = 'blue', etc) on to areas of a six-pointed star, labelling its upper part 'the Ideal' and its lower 'the Real' (illus. 61). This gesture of *picturing*, in terms of colour, line, and figure, such metaphysical categories, and of proclaiming, as Runge does in a roughly contemporary text, that 'transparent and opaque have a relation to each other like ideal and real', presupposes a certain conception of painting's link to theory, and of an image's link to exegesis. However complex its details, Runge's symbolic programme inhabits equally 'landscape', enframing ornament, geometrical chart, and explanatory text.

Given the expansiveness of Runge's system, it is tempting to transpose the statement, say, about the transparent and the opaque on to Friedrich's *Cross in the Mountains*. The dark and impenetrable summit that is the picture's only proper *land*-scape would thus be interpretable as the Real which, rising up before the diaphane sky, conceals from us the sun as the Ideal *par excellence*. Runge's little sketch *Ideal–Real* could equally serve as exegesis of Friedrich's canvas. The pyramid of the mountain superimposed upon the inverted triangle of the sun's rays configures a similar six-pointed star, which would then encode the scene as a *paysage moralisé* with the cross at the positive pole and the earth at the negative. It is easy, as well, to discern in *Cross in the Mountains* many specific visual echoes of the small *Morning*. The arched upper frame in Friedrich, with its palm leaves and winged putti, resembles the curved design of the angels of night in Runge. And such elements in *Cross in the Mountains* as the silver star at the top of the ensemble, the vegetable forms of the framing's flanking 'Gothic' columns and the radiant sky of the painted landscape itself all have clear precedents in the small *Morning*. So does, as we have seen, Friedrich's use of pictorial symmetry. One might infer from such similarities that these two Romantic paintings also *mean* in analogous ways. Friedrich's crucifix, mountain, hidden sun, and whole assemblage of objects in the landscape, whether symmetrical or asymmetrical, systematized or wilfully chaotic, would therefore be, as in Runge's ensemble, simple translations, albeit in a different pictorial idiom, of ideas and events already developed on the carved frame.

How true is this, though, to our actual experience of Friedrich's landscape? The work's gilt frame stands before us measured and symmetrical, the eye of God returning perfectly our gaze. And if elsewhere in Friedrich's *oeuvre* the instruments of Christian devotion are only dimly legible, as ruins within, or echoes among, natural forms, here the structure of the altarpiece appears as the actual frame through which landscape is viewed and understood. Yet as our gaze passes through this portal into the painted world, we discover everywhere the subtle dissolution of symmetry, the fragmentation of a centralized viewpoint, and the turning away of God's eye toward the hidden sun.

If Runge represents the idealization of the relation between painting and symbol, Friedrich demonstrates the instability of this ideal. When the enframing emblem becomes landscape in *Cross in the Mountains*, when the religious symbol becomes natural object, something is visibly lost, and we enter into a changed relation to what we see. This loss is felt first as a difference in orientation, a shift within the fabric of vision. Instead of encountering us full-face, as it were, like Runge's striding figure of the Virgin Aurora, Friedrich's landscape, with its crucifix, turns its back on us, and with this is diminished the immanent legibility of the world.

In his critique of *Cross in the Mountains*, Ramdohr argued that Friedrich's elaborate carved frame is at least *intended* to determine the painted landscape's overall meaning and function. Alone the frame, 'with its symbols', both arouses in the viewer the suspicion 'that an allegorical meaning lies here submerged', and 'determines the painting as an altarpiece'. Isolated, that is, from the surrounding grapes, wheat, palm leaves, and all-seeing eye, Friedrich's landscape would be merely landscape, empty of significance beyond what meets the eye, and bearing scant relation to that class of images at the heart of the Christian ritual. For in Ramdohr's semiotics, landscape simply cannot be allegorical, since the presence of allegory can only be signalled, its message only conveyed, by objects or events out of keeping with the natural order. At best landscape painting can convey a human message of the most general kind, picturing how people did or should live, or evoking some common sentiment (terror, joy, sadness, etc) through appropriate objects and environs. Jacob Ruisdael's *Jewish Cemetery* formerly in the Dresden Gemäldegalerie stands for Ramdohr as the acme of landscape's expressivity, for it evinces in us not only a solemn mood, but a religious conviction of 'the vanity and evanescence of all human things'. Yet such a picture does not constitute allegory. It simply awakens sentiments already associated with Ruisdael's motif as it would exist in nature – a graveyard in a sublime setting – and the intensity of the evocation alone is the artist's proper achievement.

We have already chronicled the emergence of Friedrich's art from precisely this kind of painting, in which the objects of nature mean in so far as they offer analogies to moral sentiment. Ramdohr would have been comfortable with at least the semantic assumptions underlying an image like *Scene of Mourning* (illus. 47, p. 88), or the slightly earlier *Emilias Kilde* (illus. 44, p. 86), even if he would probably have found fault with their composition. Friedrich, of course, is also capable of fashioning pictures which are allegorical in Ramdohr's sense, that is, which introduce supernatural, exotic or radically anachronistic elements into the landscape, or so formalize nature's structure that it approaches the diagrammatic character of the frame of *Cross in the Mountains*. *Vision of the Christian Church* of 1812, in which two heathen Druids wreathed in oak leaves stand amazed at the mystical appearance of a Christian church in the sky, is a curious example (illus. 62). Instead of enframing mute landscape, as in *Cross in the Mountains*, Gothic architecture is here itself enframed in a legible assemblage of obvious symbols. Works such as this are, however, anomalies within Friedrich's *oeuvre*.

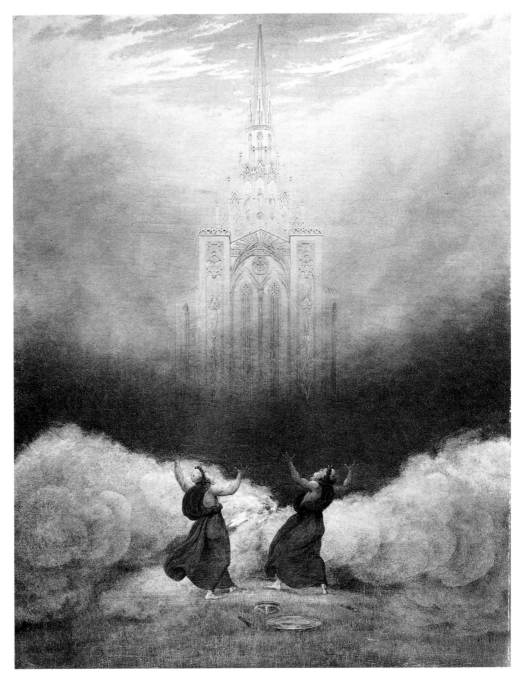

62 *Vision of the Christian Church, c. 1812*
Collection Georg Schäfer, Obbach near Schweinfurt

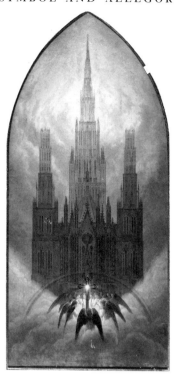

63 *The Cathedral, c.* 1818
Collection Georg Schäfer, Obbach near Schweinfurt

The artist generally tries to achieve exactly what Ramdohr determines cannot be done, namely, to signal the presence of an occulted meaning in the landscape without, however, compromising the structural or temporal integrity of the natural world.

In *Cross in the Mountains*, the frame is this signal. Its symmetrical architecture supplements and intensifies the formalism of the painted scene, while its overall format refigures the landscape thus enclosed into the intentionality of the Christian altarpiece. The signs on its surface announce their character as signs through their non-mimetic design, their arbitrary fragmentation of natural forms and jarring juxtapositions of shapes and objects, as well as through their overtly conventional character, their felt adherence to the lexical canon of Christian symbols. Through these signs' homothetic relation to natural objects represented in the painting, they by extension also subsume landscape under their specific mode of referentiality. The mountain is thus fashioned into a trinitarian symbol, and the arching clouds, mirroring the frame's Eucharistic motif of grapes and wheat and its crowning palm leaves, become signs of a specifically Christian eternity. Yet this transumption of heterogenous and multivalent nature into the fixity of human signifiers is also felt to be only partial. This is why Ramdohr states that, while it makes an altarpiece of the ensemble and an allegory of the landscape, 'The frame is without any relation to the painting'.

It is difficult for us today to recuperate this original sense of separation. The split which Ramdohr experiences between symbolic frame and painted landscape is partly

bound up with his conception of form, and of form's alterity vis-à-vis meaning or content. While he aptly characterizes Friedrich's 'system', describing its irrational structures and contradictory viewpoints and space, he is unable, or unwilling, to regard such qualities as themselves having meaning. This is perhaps the most curious historical feature of the whole debate over *Cross in the Mountains*. Neither Ramdohr, nor his Romantic opponents, nor even Friedrich himself ever articulate what seems obvious to any present-day student of Friedrich's art: namely, that such elements as the abyss between foreground and background, or the play of junction and disjunction between picture and frame, might have semantic value, articulating, say, the difficult relation between the finite and the infinite, the material and the spiritual, earth and heaven, or indeed between the whole host of opposing contraries whose synthesis was the stated task of Romantic art and the Idealist philosophy of identity. A properly historical interpretation of Friedrich's art, one which can account for this curious omission in the critical discourse of the period, will be less concerned with uncovering the various possible meanings – political, religious, biographical or economic – that might inform specific images, than with accounting for *how* such images were thought to mean.

Again it is Ramdohr who offers crucial evidence for our argument. Having described how, through its symbolic frame, *Cross in the Mountains* alerts its viewers that 'behind the natural scene . . . a hidden allegorical meaning lies hidden', Ramdohr asks what, specifically, this meaning might be. His answer takes the form of a remarkable account, claimed to be Friedrich's own, of the artist's original experience of a cross in the mountains. It remains unclear whether Ramdohr simply fabricated this detailed commentary, which is written in the first person and set apart from the rest of the review by quotation marks, or whether he somehow heard or read it when he visited Friedrich's atelier in Dresden. Its authentically Romantic character, together with the fact that Ramdohr's detractors never disputed its authenticity, convinces me that it indeed reflects Friedrich's own reading of his ensemble.

Travelling through a mountain landscape before daybreak, we read, the artist first wanders in darkness, then perceives the first glow of dawn, and finally beholds the rays of a risen sun shining from behind a mountain, so that its summit is a sharp silhouette against the sky. At its peak stands a crucifix with its face turned toward the far side of the mountain; the artist 'deduces' this position from how the sunlight is reflected on the crucifix. The tableau thus complete, the artist interprets what he sees:

How meaningful this sight! The crucified Christ in a wilderness! At the threshold between darkness and light! Yet enthroned above nature's highest, visible to all who seek Him! But He, He beholds the light face to face; and to us, surrounded by twilight in this vale of tears, to us, whose weak eye cannot yet bear the full radiance of clarity, to us He imparts but a reflection of the same! Thus, as herald of the salvation that awaits us, He becomes simultaneously mediator between earth and heaven. And we, we are comforted and rejoice in His message and His works, just as, after a long dark night, we rejoice at the approach of the sun

when we observe its illumination and its effects earlier than its appearance. Here I felt the need to celebrate that commemorative rite which, itself a secret, is the symbol of another [secret]: the Incarnation and Resurrection of the Son of God.

The mass which Friedrich vows here to celebrate, we are meant to infer, *is* the *Cross in the Mountains*. Through its symbolic frame and planned chapel setting, the natural scene evocative of the Eucharist's meaning becomes an actual altar for the sacrament.

At one level, the artist's commentary simply decodes the landscape according to a system of analogies. The painting's stark contrasts of light and dark become signs of a cosmic relation between heaven and earth; the hidden sun's visible rays articulate the extent of God's presence in this world, as word and works rather than full epiphany; the reversed crucifix, read through the metaphoricity of God's face in 1 Corinthians 13, becomes both the visual embodiment of the still-hidden God and the expression of Christ's status as mediating vision; and the picture's whole play of showing and concealing, as well as its placement of the viewer at the threshold of the visible, is invested with a specific religious dimension, as model of the structure of divine revelation in the world. The expansion of the analogon, however, will not stop at the potentially total codification of nature as a legible Book of God. The 'meaningful' appearance of the mountain scene, first felt by the artist in nature, opens secrets within secrets within secrets; or, as Joseph von Görres wrote in 1808 of Runge's hieroglyphic art, 'The secret remains eternally unfathomable, because every solution always becomes again a new puzzle'.

In Friedrich, the carved and gilt summit cross interprets a landscape that interprets the Eucharist that signifies Christ whose meaning now, through the artist's commentary, explicates the painted and gilt *Cross in the Mountains* that, in turn, should interpret the Eucharist performed before it, and so forth. This maddening sense of enfolding without closure, of centres becoming frames and of tenors becoming vehicles, functions to ward off any final statement of the picture's meaning. It places at the heart of our experience of the artwork not a single message, nor even quite the sheer proliferation of messages, but rather the encounter with a process and agency of mediation *per se*: the infinitely meaningful, never fully exhaustible 'symbol', of which nature, religion, art and commentary are but so many local inflections.

While Friedrich's commentary cannot determine the master-allegory of *Cross in the Mountains*, as Ramdohr would wish, it does establish a totality which is the source of the entire configuration of partial allegories: the artist's originary experience. By offering a moment in his own biography as the interpretation of his landscape/altarpiece, Friedrich signals a change in the way art is intended to be made and understood, a change which we described earlier as the invention of *Erlebniskunst*. For what occupies the traditional place of the altar's cult image, indeed what is commemorated in the rite of viewing *Cross in the Mountains*, is no longer the God whose ubiquity is celebrated in the Eucharist, nor even a narrative of the historical moment of His sacrifice on Calvary, but rather a moment in Caspar David Friedrich's life when a

landscape, together with an old emblem of Christ, suddenly appeared to the artist as an apt symbol of the Eucharist. When, for example, the artist remarks that he 'deduced' the reversed position of the summit cross from the way it reflected light, thus recalling his own cognitive leap from uncertainty to surmise, he not only maps our visual aporia as viewers of his painting on to his own original experience of landscape, he also signals that the whole chain of analogies that follow is predicated on an act of *his* mind, and therefore that the universality of such meanings is founded less on the validity of the religious faith that they affirm than on the universality of artistic genius itself.

These are aesthetic principles that Ramdohr cannot accept. He objects to the hermetic nature of Friedrich's picture. If a painting is to function as altarpiece, Ramdohr contends, its meaning must be apparent to all, yet the allegory of *Cross in the Mountains* is open only 'to the perspicuity of a select few'. This indictment locates one of Romanticism's abiding contradictions. On the one hand, Romantic artists burden themselves with the task of forging anew a religion and a mythology which would be universally valid for their society, hence Friedrich's presumption to produce a novel landscape that might also be a working religious image. The retable altarpiece is not only an instrument of faith, but also an idealizing symbol of a perfect reciprocity between art and society that had been lost since the Middle Ages. On the other hand, because it is the uniqueness of genius that makes such extravagant projects possible, the artist's productions will at most represent *particular* fulfilments, his renewed religion and self-originated myths being viable therefore only for an intensely particular audience. Romanticism's 'community-creating', as Hans–Georg Gadamer writes, 'merely testifies to the disintegration that is taking place'. In Friedrich's case, this contradiction grows acute over time. From the 1820s his public dwindled, and contemporaries regarded his pictures as ever more private and arcane.

Ramdohr does not object to the specific sentiments articulated in Friedrich's commentary. He disputes, as he puts it, the 'when and where' of their expression, by which he means their status as the content of a landscape painting. Instead Ramdohr proposes a fascinating alternative: 'If the owner of a chapel near such a mountain with cruxifix were to have an opening set in the altar, so that the gaze of the faithful who approach the altar would be led perspectivally towards the natural scene', then indeed the prospect might summon certain viewers 'to a solemn mood similar to the one Herr F. might have experienced'. *Cross in the Mountains*, however, is not nature but 'a painted picture, a work of art ... and here quite different questions come into consideration'. By 'questions' the critic means the whole discourse of academic criticism, with its canon of rules based on past example, its division and hierarchy of the genres, and its particular conception of the artwork's unity and closure. To set these 'questions' into play, though, Ramdohr must first posit a distinction, indeed the exemplary distinction that sets Ramdohr and the entire rhetorical tradition since Antiquity off against the aesthetics of Romanticism, between experience and the representation of experience. For it is the erasure of that distinction that characterizes

what the Romantics call the 'symbol', and that constitutes Friedrich's break with Sentimentalism.

But already Ramdohr separates art from experience in a manner reminiscent of *Erlebniskunst*. His vision of the altarpiece as opening onto a quasi-sacral landscape is clearly implied by Friedrich's *Cross in the Mountains*, which structures its gilt frame as a window on to the artist's original and fully embodied experience of landscape. More than any other artist of the period, Friedrich perfected and elaborated the motif of a view through an open window, which was for him a metaphor for the subjective status of art and of vision. Already in his powerful 1806 sepia of a *View from the Artist's*

64 August Wilhelm Ahlborn, *Cloister Cemetery near the Watzmann*, 1835
Schloss Charlottenburg, West Berlin

Atelier, Right Window (illus. 25, p. 46), a work which was well received in the exhibition of the Weimar Kunstfreunde in 1808, Friedrich encodes the relation between interior and exterior as a play between self and world, consciousness and nature, by including at the left of his window a partial image of himself (specifically his eyes) in a looking-glass. The mirror's reflection and the window's view are both in their own way 'self' portraits: one picture the artist's gaze, the other the content thereof. When Friedrich painted his atelier 14 years later in *Woman at the Window* (illus. 76, p. 154), this expansion of self became thematized as longing, and the bodies assumed a posture vis-à-vis the natural scene akin to prayer or supplication. An interesting fusion of such window scenes with the structure of an altarpiece is suggested in a canvas of 1835 by the minor Berlin painter and Schinkel-copyist August Wilhelm Ahlborn (illus. 64). The arched opening with Gothic tracery enframes and therefore unifies the scene of crucifix, cemetery, and mountain landscape, while also separating out the foreground monk in his attitude of devotion. Ahlborn's painting is something of

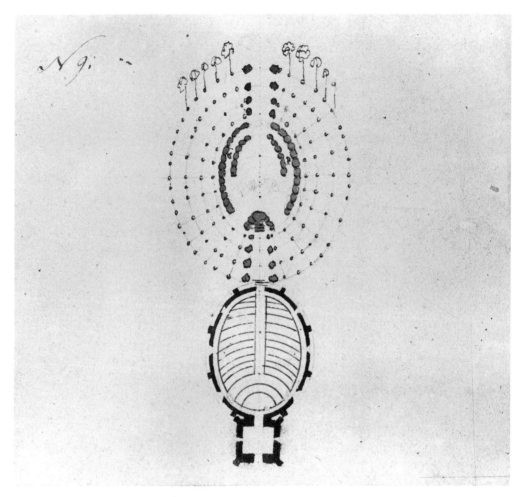

65 *Ground-plan of an Oval Space*, ?1805–6
Germanisches Nationalmuseum, Nuremberg

a pastiche of Friedrich's art. In addition to his use of the *Rückenfigur*, note the window motif, crucifix in the landscape, cloister graveyard and Gothic frame, as well as the depiction of the Watzmann mountain in the distance, a view that Friedrich painted in 1824 and exhibited in Berlin in 1826 (illus. 112, p. 200). Ahlborn's mélange reads curiously as a blueprint of Ramdohr's imagined alternative to *Cross in the Mountains*: devotion to religious symbols in a real landscape aided by an enframing sacral architecture.

Ramdohr's alternative altar-window, Ahlborn's anecdotal *Cloister Cemetery with the Watzmann*, and *Cross in the Mountains* itself all evoke a relation between Christian worship and nature feeling prefigured by Friedrich's spiritual precursor in Pomerania, Ludwig Kosegarten. In his shore-sermons, we recall, Kosegarten celebrated mass outdoors, invoking the whole of landscape as, in his admirer Joseph von Görres's term, 'symbol, prayer, and divine service'. In 1805, Kosegarten planned a simple chapel for the fishing village of Vitte in Rügen, where in bad weather he could deliver

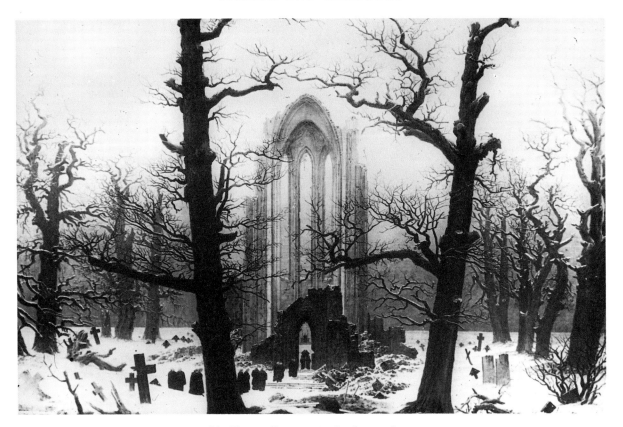

66 *Cloister Cemetery in the Snow*, 1817–19
Destroyed, formerly in the National Gallery, Berlin

his sermons, no doubt to the great relief of his fishermen parishioners. Along with
Philipp Otto Runge, Friedrich competed for the opportunity to execute its altarpiece;
and although the commission was foiled by the Napoleonic wars, Friedrich's *Cross in
the Mountains* represents one fruit of Kosegarten's plan. An architectural drawing
testifies to the artist's further involvement in the Vitte project. Friedrich's sketch,
dated 1805–6 and kept now in Nuremberg, represents the ground-plan for a chapel
whose oval shape and general arrangement repeats a large, elliptical grove of trees
and boulders at the chapel's entrance (illus. 65). Chapel and grove, alternative settings
for Kosegarten's ministry, inscribe landscape into a sacred architecture while also
submitting the chapel, altar and congregation to the order of nature. Friedrich's
various scenes of ruined cloisters in the wilderness reiterate this principle (illus. 66
and 88, p. 169). In the large canvas of a *Cloister Cemetery in the Snow*, formerly in
Berlin but destroyed by aerial bombings in 1945, the barren oaks encircle the central
ruin rather like the oval grove of trees indicated around the outdoor altar in Friedrich's
Nuremberg ground-plan. By echoing the standing remnants of the cloister, the vertical
forms of the oaktrees open up the church, and with it the mass celebrated within, to
surrounding nature. A similar principle is at work in Friedrich's sepia *Pilgrimage at
Sunrise*, first exhibited in Weimar in 1805 (illus. 67). While the rite is celebrated

133

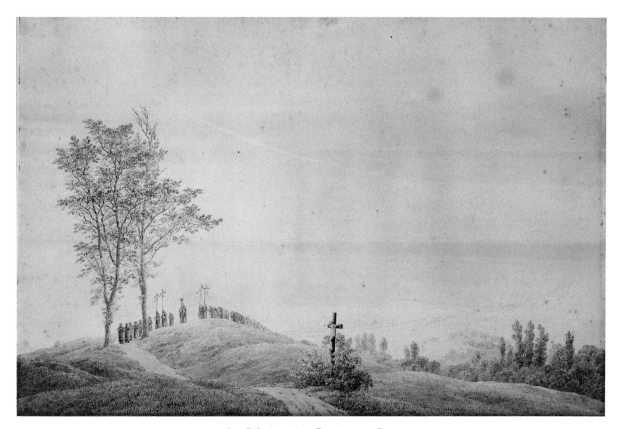

67 *Pilgrimage at Sunrise, c.* 1805
Staatliche Kunstsammlungen, Weimar

outdoors, without any hint of church or ruins, the ordering power of nature and of Friedrich's art construct a sacred architecture: the trees at the left function like a church portal; the sun rises directly behind a priest bearing a monstrance, which places the landscape into an appropriate allegory of resurrection; and the field cross, flanked by bushes, stands near the centre of the sheet, as if to link the order of representation to the order of the icon. Here, as in so many of Friedrich's images, the scene's axial symmetry inscribes the landscape's architecture into the geometry of the canvas, giving the image itself the character of an altarpiece.

Motivating all these expansions, all these dissolutions of boundary and distinction, lies the desire for immediacy. In terms of a Protestant theology shared by Friedrich and Kosegarten, this desire might be expressed as a critique of the church as necessary intercessor between the individual and God. Martin Luther, in his St Stephen's Day Epistle of 1522, wrote that 'it would be better to uproot all the churches and monasteries of the world and burn them to dust', for it does not matter where one prays or sermonizes, 'whether in a house or in the market'. And elsewhere he writes, 'the house of God means where He dwells, and He dwells where his Word is, whether it be in the fields, or in the churches, or on the sea'. In the 300 year-later *Cross in the Mountains*, however, the desire has a different locus and inflection, seeking not

only an immediacy of religious experience, but also an unmediated experience *per se*. To put it simply: does Friedrich's landscape simply reanimate, by way of the modern cult of nature, the sacred instrument of the altarpiece? Or are the vestiges of cathedral and altar, invoked as frames, windows or symmetries, rather a strategy for intensifying the impact of *art*, for rendering immediate, on the model of sacred architecture and icon, the referential relation between image and meaning, representation and experience?

It will be impossible to adjudicate between these two functions. Not because we lack evidence for Friedrich's motives, but because the very terms of the opposition religion/art are destabilized by Romanticism's project, which we here call 'art as religion'. Again, the more programmatic work of Runge can offer historical orientation. Earlier we discussed Runge's vision of a new form of art called 'landscape' that would replace traditional history painting with more abstract figurations suitable to a new epoch. Motivating this succession of genres is not simply a desire for originality in art, but also the present age's radical difference from the past, which Runge rewrites as a history of the decline of religions:

The Greeks achieved the highest beauty in forms and figures at the moment when their gods were dying; the new Romans [i.e. Raphael and Michelangelo] went furthest in the development of historical painting at the time when the Catholic religon was perishing; with us too something again is dying: we stand on the brink of all the religions that originated with Catholicism; the abstractions are fading away; everything becomes more airy and lighter than before; everything draws towards landscape, seeks something definite in this indeterminacy, and does not know where to begin?

The question mark closing Runge's giant sentence signals the open-ended and therefore properly projective character of his history. It situates landscape between belatedness, experienced as the inadequacy of an old era yet to be superseded, and un-timeliness, in which the new is known only through negation or abstraction: as the past that it shall not still be. In the small *Morning*, Runge dramatizes the dawn of landscape itself by transuming the faded religions. Striding from the horizon, the embodiment of the Greek ideal of female beauty, Venus, is fused with Raphael's Christian Virgin and Guido's Baroque Aurora to illuminate the birth of a 'landscape' that is indeed airier in its form and its referentiality, which is to say, less translatable into the old myths and figures (illus. 28, p. 54). In Runge's stated project, however, even such a sublimation is only the initial step towards true landscape, which will ultimately do away with all human forms, all creative and symbolic flowers, and indeed the whole artificial enframing cosmogony, to become an abstract but somehow perfectly legible configuration of colour. Runge's hyperbole of art historical origination, written about the now lost painting of *Mother at the Source*, can be applied here as well. The two works were both meant as 'a source in the broadest sense of the word; also the source of all pictures which I will ever make, the foundation of the new art which I have in mind, also a spring in and by itself'.

135

Runge's art can also trace a different trajectory, one which recuperates the old myths and figures within a new landscape, in a manner akin to Friedrich's resacralization of a common summit crucifix in *Cross in the Mountains*. In the unfinished canvas *Rest on the Flight into Egypt*, dating from 1805–6 and possibly proposed for the altar of the Marienkirche in Greifswald, Runge again represents a morning scene, but takes as his subject a traditional Christian motif (illus. 68). Even the integration of Joseph, the Virgin Mary and the Christ-child into their natural surroundings has precedents in earlier religious art. Since the sixteenth-century artist Lucas Cranach the Elder, the scene of the Rest functioned in German painting as an occasion for depicting exotic and flourishing landscapes. Runge's canvas, however, does not quite introduce the sacred figures into a natural setting, but rather reads them directly out of nature, a process which can be observed, as if in laboratory conditions, in the extraordinary drawing *Nile Valley Landscape* also dated 1805–6 (illus. 69). This sketch, which the artist seems to have sent to Goethe in April 1808, is not a proper 'preparatory' design. Runge had already worked out the figural group and landscape setting of *Rest* in an earlier project drawing, now preserved in Hamburg. And rather than detailing the background for the finished canvas, *Nile Valley* proposes an alternative vision, transforming the figures of sacred legend into objects of nature. Thus the silhouette of Joseph and the ass becomes the twisted form of a tree trunk, with Joseph's shoulder converted to the upper part of a root and his long staff metamorphosed to the lower part; the Virgin draped in her shawl is changed into a bank of earth, while the Christ-child becomes a grassy mound; and the putti in the tulip tree simply vanish, leaving behind a rather ordinary landscape, except perhaps for the strange columned structure and pyramid beyond, indicating 'Egypt'.

Runge stages this transformation within a fiction of artistic origination, that is, the genesis of history painting from nature drawing, only to overturn its temporality and therefore its implicit hierarchy. The mute forms of the sketched landscape become potential players in a sacred drama, symbols of a yet unknown myth or cult; while the personages of the Christian story become naturalized, rather like spirits of the place, or like those more abstract figurations that emerge from, and are consubstantial with, the amaryllises of the small *Morning*. One possible undersong of this reversibility of history and landscape, finished painting and project drawing, figure and ground, is the expression of a *genius loci*: the Nile delta as fecund source at once of nature and of myth and religion. Like such Romantic philosophers of myth as his close associate Joseph von Görres, Schelling and Friedrich Creuzer, Runge was fascinated with beliefs older than the Christian faith. In *Nile Valley* he imagines the reversal of the Christian religon's 'historical' emergence from Near Eastern nature cults. 'Everything draws towards landscape', for nature harbours the concealed forms of erstwhile and future figuration.

In *Rest* and *Nile Valley*, an Ovidian myth of metamorphosis, where legends become places, articulates the metamorphosis of myth itself, with the result that the naturalized

68 Philipp Otto Runge,
Rest on the Flight into Egypt, 1805–6
Kunsthalle, Hamburg

69 Philipp Otto Runge,
Nile Valley Landscape, 1805–6
Kunsthalle, Hamburg

figures of religion become equivalent to the symbolic potential of landscape. Such multiple determination is Romantic art's semantic ideal. We can observe its operation in a passage in German literature of the period that stands very close to Friedrich's *Cross in the Mountains*. In his 1798 novel *Franz Sternbalds Wanderungen*, set in the epoch of Albrecht Dürer, Ludwig Tieck describes a painting of a crucifix in the wilderness in order to theorize the signifying relation between art, nature and religion. The passage occurs at a crucial moment in the novel, when the hero Sternbald, an aspiring German painter travelling as a journeyman through Italy, visits an old artist living in the mountains as a hermit. Motivating the visit is a certain waning of the hero's 'enthusiasm', an artistic crisis, that is, which takes the characteristically Romantic form of alternating feelings of solipsism and engulfment by nature. At one moment Sternbald proclaims: 'Not these plants, not these mountains do I want to copy; rather, I want to portray my feeling, my mood, which moves me in this moment'. A moment later he laments, 'Oh powerless art! How stammering and childlike are your sounds compared with the full, harmonious organ music which springs forth from mountain and valley and forest and sparkling river in swelling, rising chords'. Interpreting and, to a degree, resolving this agon between nature and consciousness, the hermit-painter's life and art stand as pedagogy for Sternbald. The lesson climaxes in the description of a canvas made by the hermit, in which a pilgrim wanders through a moonlit landscape: 'On a hill high above, a crucifix shines from afar, the clouds dividing around it. A rain of rays from the moon pours forth and plays about the holy sign'. As in Friedrich's description of the originary experience for *Cross in the Mountains*, Tieck's description, too, is followed immediately by exegesis. The hermit reads his own painting as an emblem of the relation between earthly existence and heavenly promise, interpreting the pilgrim as Everyman, his path as 'life', the picture's darkness as the fallenness of our vision and the moonlight as God's love incarnated in Christ.

137

Familiar to us is also the painting's mode of signification, although Tieck employs a more finely tuned terminology than Friedrich or Ramdohr. The hermit calls the crucifix a 'Fingerzeig', meaning literally a 'pointing finger'. Pointers are signs with very particular expressive features. They are shifters, for they refer not to a signified which they themselves convey, but to another object or expression temporally or spatially nearby. The deictic 'this', an obvious verbal equivalent to the *Fingerzeig*, will point to a contiguous entity or utterance, as when replying to the question 'which painting do you mean?', one points one's finger towards a canvas and says, '*this* one'. Yet as Umberto Eco has argued, 'this' can also denote 'closeness of the speaker' even if neither the object nor the utterance pointed out is at hand. '/This/', writes Eco, 'does not acquire a meaning because something is close to it; on the contrary it signifies that *there must be something close to it*.' That the pointing finger might, or indeed always, gestures towards an absence is a possibility imagined long before the modern discipline of semiotics. It is the central theme of Hegel's famous discussion of the failure of the deictic 'here' and 'now' which opens the *Phenomenology of the Spirit* (1807). For our purposes, the semantics of Tieck's *Fingerzeig* is useful, both because it elucidates the signifying structure of what Tieck and the Romantics will term 'allegory', and because the insistence that what is represented is always *this* tree, *this* alder thicket, *this* cross in *these* mountains, is so central a gesture in Friedrich's own landscape.

How and to what does the hermit-painter's summit cross point? Unlike the religious icon, it does not refer to the person of Christ represented in effigy, nor to the historical moment of His Crucifixion. Nor does it fulfil itself by infusing the landscape with a

70 Adrian Zingg, *Prebischkegel in Saxon Switzerland, c.* 1800
Kupferstichkabinett, Staatliche Kunstsammlungen, Dresden

vague religious sentiment, as in the 1789 sepia drawing *Prebischkegel in Saxon Switzerland* by Friedrich's precursor in Dresden, Adrian Zingg (illus. 70). Rather, Tieck's cross, pointing upward into the heavens, discovers there neither its own spiritual meaning nor even quite its natural equivalent, but rather only the absence or concealment of meaning. 'I put down here a gentle riddle,' explains the hermit, 'which not everyone can solve, but which is still easier to guess than that sublimity that nature wraps around itself as cover.' As in Friedrich's secret within a secret, Tieck's *Fingerzeig* stands for the endless deferment of sense, the sheer movement 'beyond' that uncovers at its destination only another indication of transcendence. Sternbald names the hermit's signifying mode: ' "One could ... call this painting allegorical." ' The hermit agrees:

All art is allegorical, as you take it. What can man represent, singular and standing for itself, cut off and eternal distinct from the rest of the world, like the objects before us as we see them? Art also ought not to do so: we knit together, we seek to fix to the particular a general meaning, and thus arises allegory.

Allegory occurs because art is not nature, because its objects are not autochthonous and self-contained, and because fallen man cannot decipher the book of nature. The reference of allegory, the target of the *Fingerzeig*, therefore cannot be another object or utterance, clear and differentiated from other entities, for what it indicates *is* the human condition, articulated as the inadequacy of signs and the failure of deixis, or, in the case of Tieck and Friedrich, as the abyss between this world and the next, and between the aesthetic and the religious. The hermit teaches Sternbald that self and world are separated by a gap which allegory cannot span, but can only signify *as* gap. And he instructs us that crucifix, painted landscape and even our own verbal exegesis will no longer settle which meaning is meant, but will only intimate that some meaning might be, as it were, close by.

The influence of Tieck on Friedrich was recognized by the artist's contemporaries; and it was remembered as late as 1876, when Franz Reber, in his important *History of Modern German Painting*, quotes a passage from *Sternbald* to explain what Reber calls the 'spiritual rapport between nature and beholder' dramatized in Friedrich's paintings. Already when Ramdohr, who had been mocked in Wackenroder and Tieck's *Herzensergeissungen* of 1796, terms *Cross in the Mountains* an 'allegory', he may well have registered the link between Friedrich's landscape and the fictive canvas of *Sternbald*'s hermit-painter. Goethe, too, located Friedrich within the orbit of Tieckian aesthetics when in 1817 he criticized the painter as one of the 'cloister brother's companions'. What specifically disturbed the 68-year-old Goethe about this new and young Romantic brotherhood was the artificiality of its art, as well as its tendency to conceive of content as somehow separable from form. Against 'allegorical' expressions which are only externally significant, Goethe set the vision of a 'fitting unity of the spiritual meaning and sensual evocation' wherein 'true art celebrates its triumph'.

In the period of Friedrich's early development as an artist, the ideal of an expression that is inwardly and essentially significant, as the perfect coincidence between the sensible and the non-sensible, being and meaning, the real and the ideal, received the name 'symbol'. Its antithesis was 'allegory', in which meaning remains distinct from expression, residing always elsewhere and never fully constituted by the sign itself, hence the word's prefix *allos*, meaning 'other'. As Gadamer has written in his chronicle of the philosophical origins of this distinction, 'symbol and allegory are opposed as art is opposed to non-art, in that the former appears endlessly suggestive in the indefiniteness of its meaning, whereas the latter, as soon as its meaning is reached, has run its full course'. Tieck, I would note, complicates such a distinction by proposing that allegory, Romantically construed, never fully 'runs its course'. Yet this deferment of meaning itself, this restless pointing beyond sets allegory apart from the symbol's dream of immanence. Where, though, do Friedrich's paintings stand in relation to this distinction on which virtually the whole of Romantic sign theory rests?

The implications of Goethe's vision for the aesthetics of landscape are most fully developed in Carl Gustav Carus's *Nine Letters on Landscape Painting*, published in 1831 but composed between 1815 and 1824. Carus was, among other things, a talented amateur painter who received informal training from Friedrich, beginning in 1817; and in the first three of his *Letters*, Carus simply articulates his teacher's views on art, nature and beauty. After 1821, however, Carus was increasingly influenced by Goethe, to whom the *Letters* were finally dedicated. In Letter 5, Carus sets his ideal against a category of landscape he calls 'sentimental', in which 'nature is regarded only as symbol, as hieroglyph, and one believes that one has done enough when the object is rendered recognizable to the extent merely that its symbolic meaning can be grasped'. Carus takes as his example the painting of the cross in a moonlit landscape described in *Sternbald*, but he may also, via Tieck, be criticizing the art of his friend and mentor Friedrich. His dispute is not with the specific content evoked by the hermit's painting, which he sees as an admirable 'Christian-moral idea', but rather with the painting's manner of evocation. Through its overtly allegorical function, landscape has become primarily the designation of something else, while art's proper end ought to be simply the expression in and of itself. A landscape with a cross, Carus argues, must be fully significant even to someone ignorant of the Christian faith and its hieroglyphs. It must embody its message in the forms of nature alone, which speak directly to all people, 'for it is henceforth demanded that the individual, in such a case, finds himself transported as if into a prospect of nature *[Naturbeschauung]*, a prospect which can appear in every sense as always beautiful, no matter who the viewer is; so that no one else's view infringes upon a person's vision of nature, and he retains the individual freedom of his opinion *[Ansicht]*'. Against allegory, which forces an instantaneous passage from the signifier to the intended signified, and from the particularity of the landscape to the generality of its moral sense, Carus sets an art which values the appearance of the individual sign itself, and which valorizes our

independent contemplation of this opacity, this intransitivity of the signified, as precisely an instance of our *own* moral autonomy as free subjects. Where allegory signals a meaning beyond itself, true art *is* what it *means*. Within a complex intellectual itinerary leading from Kant's analysis of the symbol in the *Critique of Judgment*, through Goethe and Karl–Philipp Moritz, to the Romantics, Schelling, Carus, Cruezer, K. W. F. Solger and Wilhelm von Humboldt, this semantic tautology (or tautegory, as Schelling calls it) comes to be termed the symbol.

In Carus's description, the advent of the symbol proper occurs specifically when a landscape painting no longer stands as arbitrary sign for meanings which it itself does not constitute, but instead confronts the viewer directly, 'as if in a prospect of nature'. This erasure of the boundary between nature and art, and between experience and the representation of experience (a boundary upon which Ramdohr's critique of the meaning and function of *Cross in the Mountains* was founded) is foundational to the new metaphysics of the symbol. In his chapter, 'The Subjectivisation of Aesthetics' in *Truth and Method* (1960), Gadamer demonstrates that the valorization of the symbol at the expense of allegory coincides with the emergence of *Erlebniskunst* as the aesthetic norm. If art is imagined as having its source and its end in experience, rather than in, say, religious dogma or moral persuasion, then the unity to which an individual work refers is not a constative meaning, nor even quite a plurality of meanings, but rather the human subject from whose experience the work issued forth. The lauded inexhausibility of the symbol's reference follows partly from the infinity of this singular source in artistic genius, which transforms individual experience into a universal truth, and partly from the free expansiveness of the viewer's own subjective response. Gadamer traces this modern conception of the artwork back to the semiotics of religion. Where allegory arose from the need to posit valid truths 'behind' seemingly arbitrary or undesirable representations, the symbol assumes some participation of the sensible in the divine, the *signum* in the *res*:

> [T]he symbol is not a random choice or founding of a sign, but presupposes a metaphysical connection between the visible and the invisible. The inseparability of visible appearance and invisible meaning, this coincidence of two spheres, lies at the base of all forms of religious cult.

This theological foundation of the Romantic symbol is exposed in Friedrich's *Cross in the Mountains*. By fashioning the Sternbaldian Cross-landscape as a working altarpiece, and by investing the forms of nature with the message of the Eucharist through the agency of the work's carved frame, Friedrich makes explicit, and therefore reanimates, the historical link between religious and aesthetic signs. The enframing allegory discovers the properly symbolic dimension of *Cross in the Mountains*.

It is thus very difficult to place Friedrich's landscapes within Carus's opposition between his own Goethean naturalism and what he terms Tieck's sentimentalism, or between a symbolic and an allegorical art. Even Carus betrays how slippery such

oppositions still are in 1820 when he terms Tieck's landscape a 'symbol' and a 'hieroglyph'. And in *Sternbald* itself the distinctions are anything but clear. Just a few pages before the hermit episode, the hero of Tieck's novel exclaims, 'the loftiest art can only explain itself; it is the song whose content can only be itself'. This ideal of the coincidence of artwork and commentary, form and content, belongs to the classic definition of the symbol as intransitive and autotelic, as against the transitivity and heterotelism of allegory. And even the referent of the hermit-painter's designated 'allegory' is anything but exhaustible through Christian exegesis, being, as we have seen, the site of an infinite proliferation of meaning. Reading Friedrich's *Cross in the Mountains* through the period terms 'symbol' and 'allegory' will therefore *not* decide whether the landscape is what it means, or whether it stands as a vehicle for some other meaning, religious, political or private, to be decoded. Much recent literature on the artist remains stalled in its various decisions as to the subject of his landscape. Some historians invest every natural object in Friedrich's paintings with esoteric meaning, so that foreground rocks become emblems of faith, misty backgrounds the signs of Paradise, oaks the markers of a pagan past, etc. More recent commentators have rightly rejected such a procedure of translation, asserting that Friedrich allows nature to speak directly to the viewer, without any intervening allegory. Thus in *Cross in the Mountains*, the summit and fir trees (which of course are *Weihnachtsbäume* or 'Christmas trees'), along with the numerous pyramids of clouds and light, are natural triangles, and therefore already potential symbols for Christ even outside of their idealization in the predella's Trinity emblem. From this perspective the crucifix itself, composed of a vertical crossed with a horizontal, has always uncannily embodied the intersection of heaven and earth, God and man. If the movement from frame to landscape involves a naturalization of the symbol, it also discovers the already symbolic character of nature, which is perhaps why Friedrich crowned his ensemble with the canopy of palm leaves and putti as emblems of infinity, as if to suggest not only the traditional proclamation of eternal life, but also a Romantic *et cetera* promising the symbol's continued expansion into our world.

But in certain instances in his *oeuvre*, and even strikingly in passages in his writings, Friedrich himself submits landscape to an allegorization that looks more Baroque than Romantic. As Paul de Man argued for Romantic literature in his 1969 essay 'The Rhetoric of Temporality', we ought to see symbol and allegory not as an opposition of two kinds of art, nor as art to non-art, but as constitutive moments of *Erlebniskunst*. The symbol's unmediated vision, its coincidence between image and substance, may be an aesthetic ideal, yet the story that Friedrich tells is also of the tragic failure of any such perfect reciprocity, and the mode of his telling is the renaissance of allegory constituted by his art.

8

The End of Iconography

Thus it should neither surprise nor disappoint us when Friedrich defends himself against Ramdohr by writing for his ensemble an explanatory allegory. Friedrich's apologia originated as a letter of 8 February 1809, addressed to 'Prof. Schulz' in Weimar. Recent research has identified the recipient as Johannes Karl Hartwig Schultze, who was a notable theologian and disciple of Schleiermacher, as well as a distinguished art historian in Winckelmann's tradition. Presumably Friedrich hoped that with his classicist taste and Romantic piety, Schultze might both be sympathetic to *Cross in the Mountains* and support the artist usefully against Ramdohr's various invectives. And Schultze gave Friedrich's letter to the editor of *Journal of Luxury and Fashion*, who at once published an abridgement of it as part of Christian August Semler's essay on *Cross in the Mountains*. This 'interpretation of the picture', as it is labelled in the review, runs as follows:

Jesus Christ, nailed to the Cross, is turned here towards the setting sun as image of the eternal all-animating Father. With Jesus the old world died, in which God the Father walked upon the earth unmediated. This sun set, and the earth could no longer apprehend the departing light. There shines forth in the gold of the sunset the purest, noblest metal of the Saviour's figure on the Cross, which thus reflects on earth in a tempered glow. The Cross stands erected on a rock, firm and immovable, like our faith in Jesus Christ. Evergreen through all times stand the firs around the Cross, like the hope of people in Him, the Crucified.

The plot of Friedrich's exegesis is familiar to us from Ramdohr and Tieck. The sun stands for God; its concealment enacts our loss of an unmediated vision of the divine; the rays of light on the sky, and the reflections on the gilt crucifix, represent mediated epiphanies; and the landscape's whole signifying structure is analogized to the Christian image of mediation *par excellence*, the God-man dying on the cross for our sins. Additionally, the artist particularizes the tenor of his scene, matching each visible element of landscape with a notional message: the evergreen firs and ivy signal Hope, and the rock Faith, and elsewhere in Friedrich's account, the purple sky emblematizes Christ's Passion. This insistence on hermeneutic closure is, of course, partly a response to what Friedrich perceives are Ramdohr's inaccuracies. Yet threatened by a false or travestying reception, the artist offers his public an interpretive key which, in stabilizing meaning, also compromises Romantic art's impulse towards exegetical uncertainty and creative misprision.

In his lectures on the philosophy of art, delivered in Jena in the winter of 1802–3,

F. W. J. Schelling proposed that in allegory 'the particular merely *means* or *signifies* the universal', while in the symbolic forms of mythology and of art, the particular '*is* simultaneously also the universal'. For this reason 'all symbolism is easy to allegorize', because the particular stands always present in, even though never exhaustive of, the symbol. Friedrich's published *clavis* clearly avails itself of this possibility, discerning a level of particularized sense always potential in the work of art. Sometimes the movement from symbol to allegory occurs within the artist's landscapes themselves, as when the natural worlds of *Landscape with Oaks* (illus. 6, p. 21) and *Winter Landscape* (illus. 5, p. 17) give way, through a connective plot, to the quasi-visionary *Winter Landscape with Church* (illus. 7, p. 22). In *Morning in the Riesengebirge* (illus. 21, p. 43), produced in the year or so following the *Cross in the Mountains* and thus in the midst of controversy, Friedrich might have intended a shift to allegory to answer his detractors' objections. Our perspective of the mountain scene has expanded to include a strip of foreground rocks and a vast background of peaks layered towards the horizon; and the sharp contrast between a darkened summit and an uncanny, glowing sky, criticized by Ramdohr in the 1809 ensemble, has given way to a more variegated diffusion of light and colour. More importantly, the mountain's cross is now attended by figural staffage. A woman in a white gown embraces the crucifix while helping a wanderer ascend the summit rock. These personages, thought to be painted with the assistance of Friedrich's friend Georg Friedrich Kersting, supply what was felt to be missing from *Cross in the Mountains*. The woman, clearly no ordinary mountaineer, belongs to the realm of allegory, and whether she personifies faith, hope or religion, her semantic function is essentially to signal within the landscape, and therefore without the intervention of an allegorical frame, the mere presence of occulted meaning *per se*. And the wanderer, bearing the features of Friedrich himself, makes explicit the implied point of reference of *Cross in the Mountains*: the artist's individual experience of nature.

Yet while thus externalizing the new claims of *Erlebniskunst*, while emplotting the picture *as* the event of the artist's ascent to the cross via landscape and allegory, the staffage of *Morning in the Riesengebirge* acts also to return Friedrich's art to a more traditional mode of reference, one in which we are witness to, but not direct participants in, a relation between self and world. A similar process is at work in a small gouache copy of Friedrich's *Cross in the Mountains*, executed by Joseph von Führich in 1818, probably during his visit to the Tetschen Castle in Bohemia (illus. 71). By adding to the composition a praying hermit-pilgrim upon a mountain path (surely a reference to Tieck's fictive painting in *Sternbald*), Führich cancels the ambivalence, celebrated in Friedrich's ensemble, between landscape and altarpiece, mere nature and divine symbol. Like the shepherdess of Zingg's *Prebischkegel* (illus. 70), the pilgrim belongs to the ambiance of the landscape he inhabits, and through his presence the scene turns away from us, becoming a restricted sentimental anecdote which we view from without. Such closure was enacted also in Friedrich's own written allegorization of

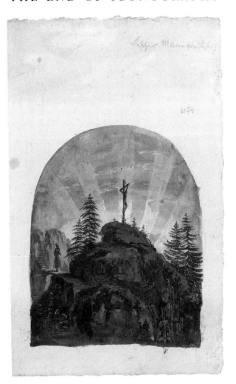

71 Joseph von Führich, *Cross in the Mountains*, 1818
Private collection, Munich

Cross in the Mountains, however, in which the meaning of the picture, if not quite our experience of it, aspires to stand already solved before us.

To what extent does Friedrich's apologia solve the problems of meaning and function raised by Ramdohr? While similar to Tieck's allegory in its overall exegetical procedure, its translation of each landscape element into a mediation between man and God, earth and heaven, Friedrich's commentary additionally accounts for how and when things got this way. The artist reads *Cross in the Mountains* as the allegory of a temporal crisis. The setting sun emblematizes not only the *state* of God's absence from the world, but also the *event* of His disappearance, which occurs simultaneously as the historical moment of Christ's death, when the Law gave way to the Gospel, and as the natural occurrence of night taking place in the here and now of a German mountain landscape. In Friedrich's original letter to Schultze, the dying 'old world' is explicitly the era of the Old Testament, when 'God the Father spoke to Cain . . . and to Abraham'. From this perspective, *Cross in the Mountains* stands in a tradition of religious art reaching back through the Reformation to the very foundations of Christian iconography, in which figures of the new faith emerged paired with, and therefore legitimized by, subsumed figures of the old: Christ with Adam, John the Baptist with Moses, the Crucifix with the Tree of Knowledge, Mary with Eve. In Lucas Cranach's single-sheet woodcut of the *Law and the Gospel* from around 1530, for example, the events of Christ's life (Annunciation, Crucifixion, Resurrection),

145

represented at the right, are paired antithetically with the circumstances of man under the Law (the Fall, death and damnation) at the left (illus. 72). At one level, the picture argues that Christ overturns the Law by fulfilling it, and in the pictorial symmetry that embodies this idea of divine answer or solution, Cranach suggests the directness of reference, or ideal of reciprocity, between signifier and signified, figure and type, instantiated in the Gospel's events, message and very mode of signification. At

72 Lucas Cranach the Elder, *The Law and the Gospels, c.* 1530

another level, Cranach's woodcut, produced in collaboration with Martin Luther, also expresses another temporal crisis: the demise of the era of the Church and papacy, that Luther characterized by their false adherence to the Law, and the advent of the new evangelical faith of Protestantism, emergent at the moment of the production of the print.

Cross in the Mountains was produced in an analogous moment of historical rupture, on the eve of the Napoleonic wars and in the midst of a reformation of the Protestant piety, through both the 'Renaissance of the North' and Schleiermacher. Friedrich visualizes his epoch's crisis very differently from Cranach, however. Instead of placing old and new side by side before the viewer, as if they were choices separated by the bare and leafy tree at the picture's centre (part of the traditional iconography of Hercules at the Crossroads), Friedrich positions the end of the world at the far side of his landscape, in the sunset at the horizon, and he conceals from us its passing through the covering summit and cross. It could be supposed from our symmetry with the sun that we stand at the end of an era whose advent was Christ; and our belatedness, which in a moment shall be literally benightedness, is expressed in the reversed position of His effigy. Christ is no longer even quite present to us as image.

Within the logic of Friedrich's allegory, and outside any analysis of the painter's personal faith, *Cross in the Mountains* stands at the brink of a night that signifies the disappearance of God. The darkness engulfing us could be the dwelling place of a god exiled by the sun of the Enlightenment, which is how Novalis reads the sunset

in his *Hymns of the Night*. There the twilight of a dying world rediscovers in the now
visible stars the gods of an even older world. Yet in Friedrich, the crucifix's reflected
shine is quintessentially a mediated light, and it too will vanish soon, which compels
some commentators to regard the picture as expressing a radical atheism. As Donat de
Chapeaurouge reminded us, there was a place for such a position within the culture
of Romanticism. Jean Paul, for example, in his wilfully eclectic three-volume novel
Flower, Fruit, or Thorn Pieces (1796), tells a tale of the dead Christ in search of God.
Returning from his wanderings about the cosmos, Christ, 'with an everlasting pain',
seats himself upon an 'altar' and informs the shades of the dead that there is no God:

I descended down as far as being still casts its shadow, and I gazed into the abyss and cried,
'Father, where are you?' But I heard only the eternal storm, to which no one responded; and
the shimmering rainbow of beings stood over the abyss, trickling down without the sun that
created it. And as I looked upward to the immeasurable void, seeking a divine *eye*, the world
stared back at me with an empty, bottomless *eye socket*; and eternity lay upon chaos and gnawed
at it, ruminating upon itself. Scream forth, you discords, cry apart the shadows, for He is not!

In Jean Paul's vision of the altarpiece, Christ in his aspect as Man of Sorrows or
Schmerzensmann appears as if in some Anti-Mass of St Gregory, preaching that God
is dead, that man is alone in the universe, and that He, Christ, too shall not transcend
His Passion. Friedrich too stations his effigy of Christ over an abyss, as witness to the
disappearance of God the father. Yet the altarpiece's frame, allegorizing the forms of
nature, still can discover God's all-seeing eye, as well as the sun, guaranteeing the
rainbow of the Covenant (emblematized below by the wheat and vine arch, and above
by the palm branches and putti). Perhaps, then, landscape only expresses the Lutheran
notion of *deus absconditus*, God hidden from the fallen world. And therefore Friedrich's
Cross in the Mountains can indeed still be an altarpiece, though with an appropriately
limited function. His back turned towards us, and as a mere gilt effigy within a painted
scene, an image twice removed, Christ too demonstrates in his presence and absence
our infinite distance from the divine, eliciting from us a faith which is at most a
longing.

Even so, can Friedrich's self-fashioned allegory and the recuperated history of his
Romantic religion, ever decide the message of such an altar? Or, to paraphrase
Ramdohr's question on the function of *Cross in the Mountains*, can landscape, pro-
claimed by the Romantics as the genre that replaces religious history when the old
religions die, 'invite the pious man to devotion'?

In a letter of 1802 to his brother Daniel, Philipp Otto Runge expresses a sense of
combined belatedness and expectation felt by the whole culture of German Romanti-
cism: 'Are we at it again, carrying an epoch to its grave?' *Cross in the Mountains* and
indeed all Friedrich's landscapes that hover in the twilight between day and night,
visibility and invisibility, and summer and winter, allegorize an authentically temporal

predicament, allowing it to be expressed variously at the levels of nature, human history, the history of art, the life of the individual and the moment of our own experience of the work of art. Thus, for example, the mountain sunset becomes at once the *transitus* from the Law to the Gospels, the demise of Enlightenment through Romanticism, the death of the altarpiece and the birth of true landscape painting, and the end of iconography and the beginning of a new, inexhaustible symbolicity. The specific direction of the movement matters little: whether, say, the shift is a decline from a prior fullness to an impoverished present, as when Friedrich in his writings allegorizes a scene of 'rotting cult images, destroyed altars, and broken fonts' as the 'ruined totality of another era' and as the 'collapse of the epoch of the Temple's majesty'; or whether instead the landscape evidences a future restoration. What is vital and characteristic of Friedrich's art is simply that there be transition, and therefore that the fullness of the Romantic symbol, whether as lost past or utopian destiny, is never an achieved aesthetic, but only one moment in an allegory whose theme and whose medium is time.

Hegel wrote in his *Philosophy of History* that 'fine art arose within the church itself . . . although art has already left the principle of the church'. This familiar thesis of art as a secularized religion is a foundation of the historiography of painting as it developed in the discipline of art history since Romanticism. It is in Friedrich's *Cross in the Mountains* that it first appears self-consciously incarnated *as* art. According to Hegel, the image shall function henceforth not primarily for devotion, but rather for the 'aesthetic experience'. Perhaps this is why Friedrich replaces the cult object with an emblem of *Erlebniskunst*, Christ turned to behold a landscape whose fullness we cannot see; the modern Man of Sorrows as surrogate viewer; the mythic intercessor between God and man as the aesthetic mediation between nature and consciousness. When we have understood this curious conceit of a vision of Christ as *Rückenfigur* viewing the landscape that shall replace His altars, we shall have come a long way in discerning Friedrich's place in the history of art.

PART III

The Halted Traveller

———

'And I will take away mine hand, and thou shalt see
my back parts: but my face shall not be seen.'

<div align="right">Exodus 33: 23</div>

'Wer hat uns also umgedreht, daß wir,
was wir auch tun, in jener Haltung sind
von einem welcher fortgeht?'

*Who has turned us round like this so that we,
whatever we do, have the bearing of
someone who's going away?*

<div align="right">Rilke</div>

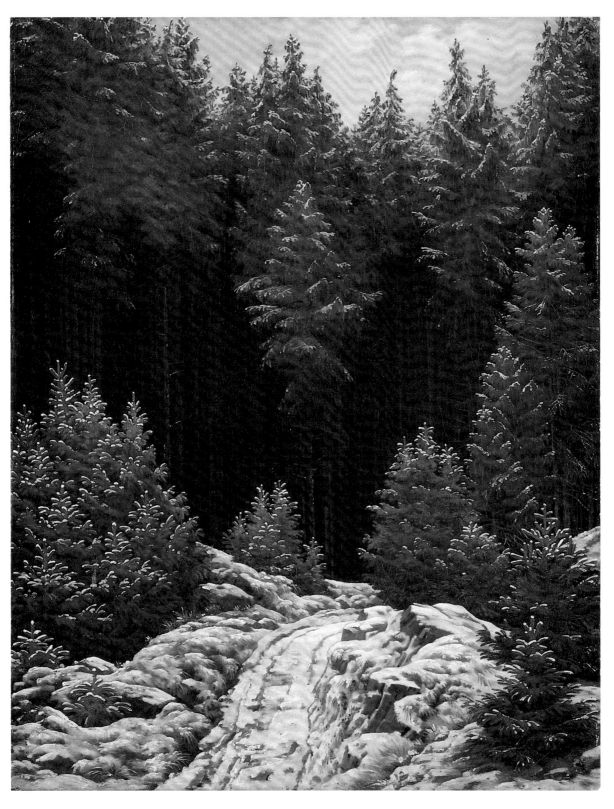

73 *Early Snow, c.* 1828
Kunsthalle, Hamburg

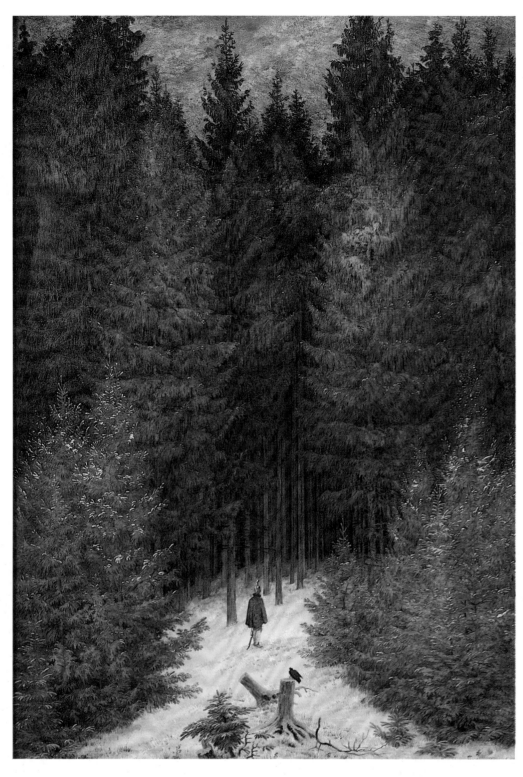

74 *Chasseur in the Forest*, 1813–14
Private collection, Bielefeld

75 *Neubrandenburg, c.* 1817
Stiftung Pommern, Kiel

76 *Woman at the Window*, 1822
National Gallery, West Berlin

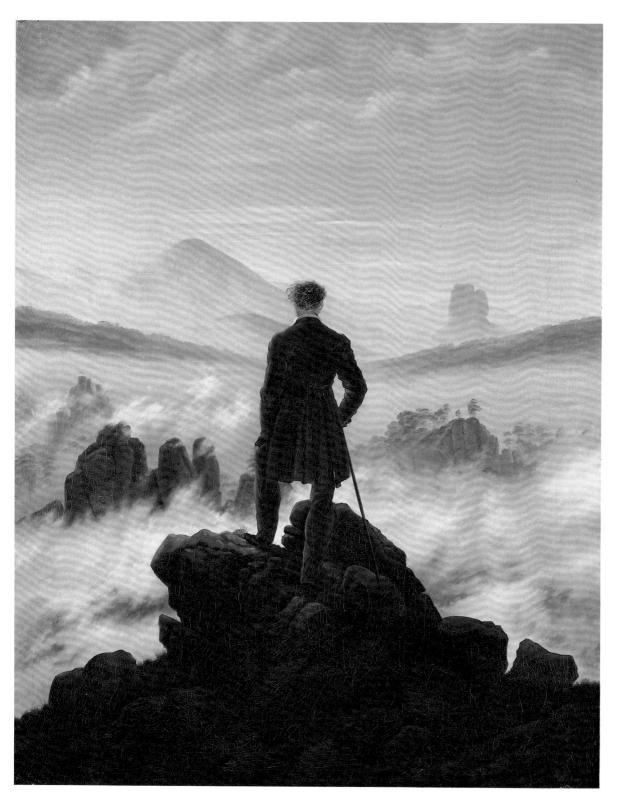

77 *Wanderer above the Sea of Fog, c.* 1818
Kunsthalle, Hamburg

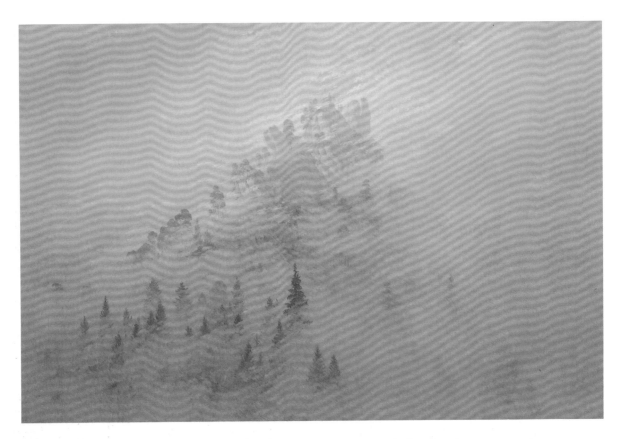

78 *Morning Fog in the Mountains, c.* 1808
Staatliche Museen Schloss Heidecksburg, Rudolstadt

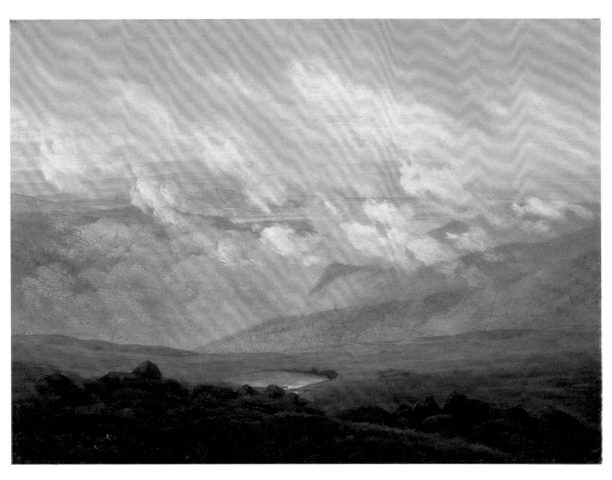

79 *Clouds over the Riesengebirge, c.* 1821–2
Kunsthalle, Hamburg

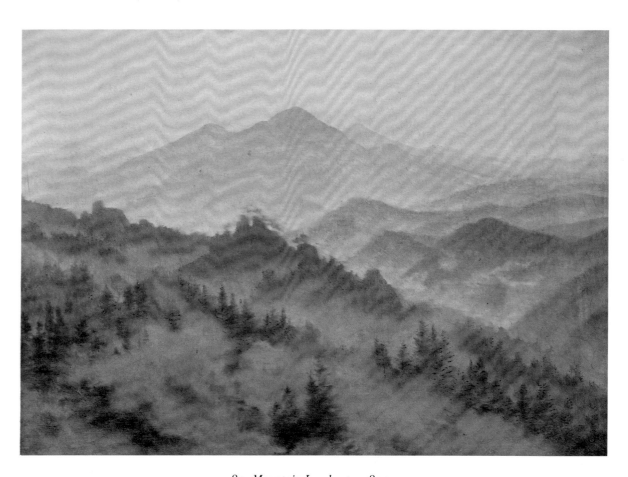

80 *Mountain Landscape*, 1835
Städelsches Kunstinstitut, Frankfurt

9

Entering the Wood

―――――

A path leads into the wood before me (illus. 73). I trace it with my eye: a white painted surface that rises vertically from the bottom of the canvas, but which, as I cling to it with my gaze, stretches forth as a horizontal path. I see into the canvas as if into a wood; my eye goes forth into this picture of an entrance as a stone would fall to earth. Entering the wood, my eye can trace many paths. Straight ahead, bare tree trunks give way to darkness. The wood I enter there appears like woodwork, or better, mock woodwork, like the false surface of a *trompe-l'oeil*. When the forest's distance thus flattens into the canvas's plane, depth and the illusion of entrance vanishes. If I raise my eyes higher, however, above the trees, my gaze can expand. The sky, a little patch of blue, invokes a vast space beyond the picture's narrow horizons. Lowering my gaze, I can enter the wood, now confident of passage under the sky.

The path turns to the right and I follow it, yet it is a phantom path beyond what the painted image offers. To follow it is to trust myself to a 'blind path', yet it is precisely at this turn into blindness that Friedrich situates us in *Early Snow*. We know of such passages in real forests, roads that seem to lead somewhere but end in the unnavigable. These paths are paradoxes, since their existence means that someone was already there, yet their abrupt endings make us wonder where their first travellers have gone. In German such a path is called a *Holzweg*, which means both timber track and, figuratively, wrong track, as in being utterly at fault. Martin Heidegger saw in this double meaning a metaphor for thought and its itinerary. Every *Holzweg* leads off separately, but in the same forest, and 'it seems often as if one is like the other. But it is only apparently so'. Like the foresters, the philosophers 'know what it means to be on a *Holzweg*'. They know, that is, the geography of truth and error from within, and can bring us to the threshold of something never thought before. To pursue the *Holzweg* is to enter the new, although the new with obscure origins in the past.

Painted in 1828, the same year of the pendant canvases *From the Dresden Heath*, Friedrich's *Early Snow*, now in Hamburg, is a picture of the new, of a world uncontaminated by a human gaze. The snow is untouched. I am the first to enter this wood; no footprints mar the uniqueness of my experience. My eyes dart about the canvas's surface, drawn by the blank whiteness. My glance does not disturb the snow, but visits the scene with the snow, which recalls fortuitously the etymological link of 'glance' to ice (French *glace*), suggesting the sliding of the eye about this snowy scene. The snow withstands my gaze and the frozen scene, halted like myself in passage,

remains present to me, its earliest discoverer. While the canvas was first exhibited in Dresden in 1828 under the title *Spruce Forest in the Snow*, it has acquired the appellation *Frühschnee* ('Early Snow'), suggesting that this snow is the year's first. Yet it could well be *Frühlingsschnee*, the last snow in a thawing world of spring. Art historians still argue over the season, just as Friedrich's critics in 1809 were unsure about the time of day in *Cross in the Mountains*. But what is important is, of course, the uncertainty as to whether the scene is early or late. Like so many of Friedrich's landscapes, *Early Snow* fuses temporal extremes. The coming of winter may be the beginning of spring and the killing frost could just as well be a regenerative thaw. Friedrich assembles the old and the new in the picture's vegetation: saplings rise above the snow in the foreground; behind them are older, larger trees until, in the background, the highest trees are red and dry with age. This notion of death combined with birth is developed by what is taken to be *Early Snow*'s pendant: the 1828 canvas entitled *Easter Morning*, now in Lugano (illus. 81). Repeating the Hamburg picture's device of a road leading into the picture from the lower framing edge, *Easter Morning* stations three women in the foreground, recollecting the motif of the Three Marys traditional in scenes of Christ's Resurrection. Read together, the two canvases would express an allegory of death and rebirth. Yet the play of life within death, of the early within the late, is already present in Friedrich's *Early Snow* itself. Its landscape is of the fullness of the *Augenblick* which, as in the *Verweile-doch* of Goethe's *Faust*, is the moment of ourselves. Standing before this painting, I am the first and the last to enter the wood.

About 14 years before painting *Early Snow*, Friedrich finished another picture of virtually the same scene (illus. 74). Yet in *Chasseur in the Forest*, a traveller has entered the wood, halting before the turn in the path. His gaze penetrates the secret space that had been closed to our gaze in the snowy turn in *Early Snow*, and his presence radically alters the way we see the painted world before us. The dark figure draws attention to himself, arresting the movements of our eye about the canvas. The world looks altogether different with this traveller at its centre. Space organizes itself around him: it is no longer my lovely wood, my adventure in the snow, but his. The objects seem to desert me, showing themselves now to him. The trees in the foreground are not my companions, but have turned their shoulders to me as if to gaze at him; whatever is in the background has become his vision. I do not stand at the threshold where the scene opens up, but at the point of exclusion, where the world stands complete without me.

The temporal fabric of the wood has changed, as well. In *Chasseur* we oversee the experience of someone else, someone who was already there in a past long before our arrival. Where in *Early Snow* I had a sense of undisturbed presence, here I am not the first in this snowy landscape, for the traveller remains spatially and temporally before me. Nor am I the last. If I go forth into the painting's space, seeking to stand where the turned traveller pauses, I will feel myself looked at from behind. Maurice Merleau-Ponty, following Karl Jaspers, reported that patients suffering from autoscopy

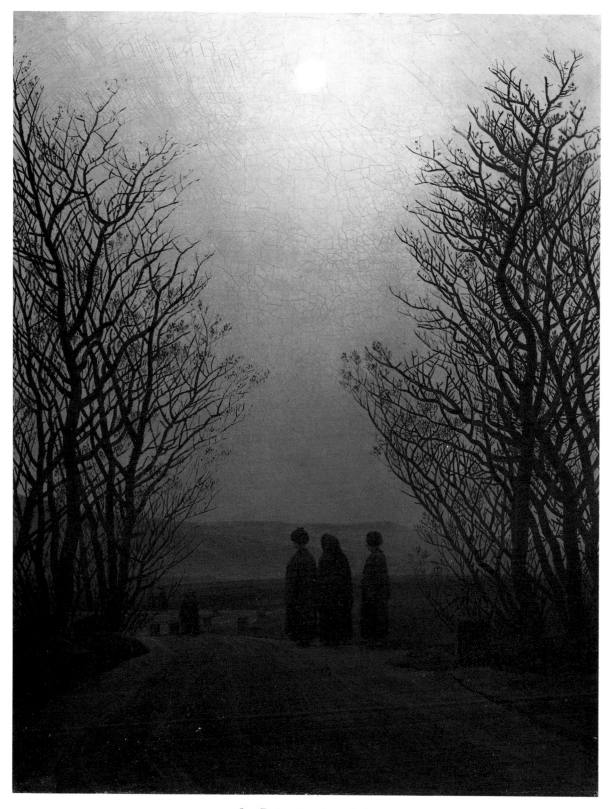

81 *Easter Morning*, 1828
Thyssen Bornemisza Collection, Lugano

(the hallucination of seeing oneself) feel the approach of their *Doppelgänger* through a burning sensation in the nape of the neck, as if someone were viewing them from behind. Autoscopy is somehow always implied by such turned travellers in Friedrich's paintings, for in their faceless anonymity they mirror our act of looking in an uncanny way. During the experience of autoscopy, we read, 'the subject is overcome by a feeling of profound sadness which spreads outwards and into the very image of the double'. The sadness of seeing oneself seeing explains, perhaps, the melancholy colouring which a traveller gives to an empty landscape. Friedrich's paintings are strangely sadder and lonelier when they are inhabited by a turned figure than when they are empty. Who is this sole self who halts before wandering into the painted world, and who, as Friedrich's contemporaries interpreted *Chasseur*, hears his deathsong sung by the raven sitting in the margin that separates him from ourselves?

The *Rückenfigur* is not Caspar David Friedrich's invention, having a long if not quite coherent history in European painting before the nineteenth century. Already in Giotto turned figures sometimes feature in the foreground of a composition, establishing an imaginary fourth wall in the picture's cube of space. These structuring bodies, though, rarely function strictly as *viewers* within the painted scene. And although Leon Battista Alberti in his treatise *On Painting* (1435-6) instructs artists to people their pictures with 'someone who admonishes and points out to us what is happening there', Italian pictorial practice favoured to this end figures gazing out of the picture at the viewer, rather than *Rückenfiguren* looking in. Early in the Northern tradition, Jan van Eyck used the *Rückenfigur* to advertise the extraordinary visual prospect realized through his craft (illus. 82). In the midground of the great *Madonna of Chancellor Rolin*, dating

82 Jan van Eyck, *Madonna of Chancellor Rolin, c.* 1435
Musée du Louvre, Paris

from around 1435 and now in the Louvre, a man peers over a battlement to behold a bustling town and mountainous landscape beyond, while his companion in a red turban (thought to be a self-portrait of the artist) looks on. Confronted with a painting of unprecedented pictorial veracity, detail and scope, Jan van Eyck's viewers discover their own attitude of visual amazement mirrored and thematized by these diminutive *Rückenfiguren*. With the further development of landscape painting in the sixteenth to eighteenth centuries, the *Rückenfigur* took its place within the stock repertoire of staffage which might ornament a panorama's foreground and determine the overall character and message of the scene. In the 'view-painting' or veduta, a turned figure could establish the vista's scale, enhancing its monumentality and marking off the whole pictorial field as something 'worth seeing'. In one popular variant, the *Rückenfigur* is an artist who sits at the margin of the scene, sketching the landscape we see. The draughtsmen at the right of a landscape etching of 1640 by the Dutch artist Allaert van Everdingen represent the operation of drawing from nature on which the print itself claims to be based (illus. 83).

83 Allaert van Everdingen, *The Draughtsman*, 1640

Friedrich's *Rückenfiguren* are perhaps closest to this conceit, although the event they dramatize is never the actual labour of making, but rather the originary act of experience itself. Appearing alone, in symmetrical pairs (illus. 16, 75, 117), or in groups contemplating a sublime view (illus. 95, 118, 119), they dominate the natural scene with their presence, defining landscape as primarily the encounter of subject with world. They are the ubiquitous, almost obsessive, signatures of Friedrich's *Erlebniskunst*. In *Chasseur in the Forest*, it is true, the *Rückenfigur* conveys a very specific message, as well. Dressed in the uniform of the Napoleonic cavalry, the horseless chasseur in the German forest stands for the French foe vanquished in the wars of liberation. In this *Rückenfigur*'s solitude, as well as in the assembled signs of his impending death, Friedrich does not simply mourn the human condition, but also celebrates Germany's military victory. Usually, however, such turned figures are not foes but reflective foils of both artist and viewer, figures, that is, of the subject *in* the landscape. As such, they have a far more totalizing tenor that sets them apart from the marginal staffage that ornamented earlier landscape art.

This change is clear if we compare Friedrich's *Rückenfigur* to similar devices within the Baroque emblem tradition. Art historians have long noted the striking similarities between some of Friedrich's landscapes and Jan Luiken's illustrations for Christophoro Weigelio's popular emblem book, *Ethica Naturalis* (1700). In Luiken, the human figure dominates the landscape (illus. 84). Indeed he seems to exist in a separate space, rather like an actor before a stage setting. He does not claim to 'experience' the scene, the landscape being only a book which he reads and interprets. Often Luiken's figures will gesture towards the scene, as if to say, 'Behold!' They are not concerned with the beauty of the landscape, but with its public and usually moral significance, which they mediate in the texts appearing around the image. In Friedrich's *Mountain Landscape with Rainbow*, the landscape has grown and the *Rückenfigur* has fallen silent (illus. 89). What he mediates is not a meaning, but an

84 Jan Luiken, *Iris*, etching. Illustration from
Christopher Weigelio, *Ethica Naturalis* (Nuremburg, 1700)

experience of the full presence of landscape. This landscape may have, like the face of the halted traveller, more to it than meets the eye, yet this 'more' is closed to us, a private inscription carried by the wanderer whose experience we only oversee. As if to indicate the personal dimension, Friedrich has fashioned the *Rückenfigur* as a portrait of himself, reoccupying but transforming the old motif of the artist sketching in the landscape.

Friedrich represents himself several times as *Rückenfigur*. Occasionally, and more hauntingly, he observes his own family from behind, as in his masterpiece, *Evening Star*, dating from around 1834 and now in Frankfurt (illus. 106, p. 195). Against a sublime evening sky, with the silhouette of Dresden's church recognizable on the horizon, Friedrich depicts what probably are his wife and children walking homewards: to the left, Caroline née Bommer, whom Friedrich married in 1818; by her side one of the couple's daughters, either Emma (b. 1819) or Agnes Adelheid (b. 1823); and at the crest of a small rising, with his arms raised as if to greet the immensity of the

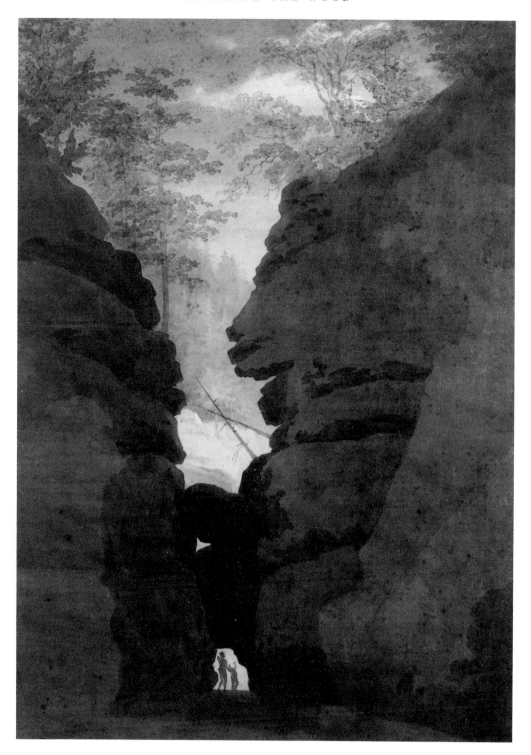

85 *Pierced Rock in Uttewald Valley, c.* 1801
Museum Folkwang, Essen

view, or to grasp the veering bands of clouds above, their youngest child and only son Gustav Adolf (b. 1824). The boy's gesture is unusually animated, for Friedrich typically pictures subjects frozen in contemplation, their stillness a mark of an immense interiority. It is as if, through the gesture of his son, Friedrich were trying to capture the entire afflatus of experience in a single gesture, or as if, from the perspective of a boy, nature's engulfing infinity can be wrested down to earth. And the world responds. For if we block out the child from the picture, observing the scene peopled only by the mother and daughter at the left, the bands of clouds and sky appears to rise higher above the land. Friedrich's son as *Rückenfigur* draws down to earth the evening sky, as if for a moment catching the departing light in the coincidence of his open arms and the edge of the horizon's darkening bank of clouds.

Friedrich observes his family's homecoming from afar, expressing poignantly what we know of the artist's personal stance in later life. After his initial success with *Cross in the Mountains,* and following a period of critical acclaim and financial stability between 1810 and about 1820, Friedrich's star began to fade, his art overshadowed by new directions in landscape; the Nazarene painters in Vienna and Rome, the 'heroic' landscape of Joseph Anton Koch and Ludwig Richter, and the naturalism of the Düsseldorf School. Having failed to secure a regular professorship at the Dresden Academy, and with ever fewer patrons, Friedrich grew embittered, self-pitying and distrustful of his friends, turning even against his wife, whom he suspected (wrongly, Carus informs us) of sexual infidelities. In June 1835 he suffered a stroke which left him debilitated until his death in 1840. Executed just before 1835, *Evening Star* reads as one of his innumerable 'last testaments' from the period (this is, after all, the artist who still in his early thirties fantasized his own funeral in an 1804 sepia). On the last hill that shows him all his valley, Friedrich turns and stops and lingers, before, like his *Rückenfiguren,* he forever takes his leave.

86 *Summer*, 1807
Bayerische Staatsgemäldesammlungen, Neue Pinakothek, Munich

87 *Monk by the Sea*, 1809–10
National Gallery, West Berlin

88 *Abbey in the Oak Forest*, 1809–10
National Gallery, West Berlin

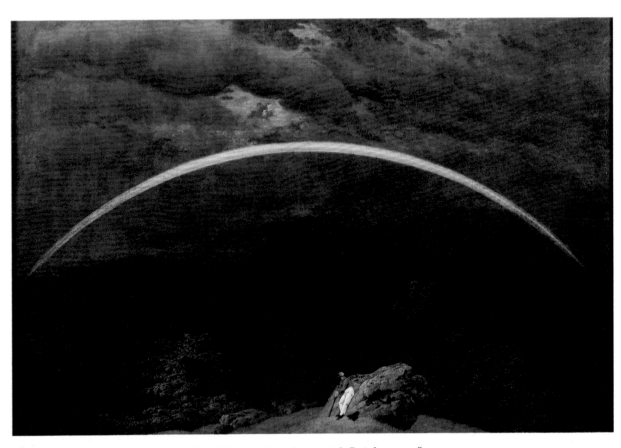

89 *Mountain Landscape with Rainbow, c.* 1810
Museum Folkwang, Essen

90 *Mountain Pasture with the Source of the River Elbe, c. 1828–30*
Private collection, Munich

91 *Landscape in Riesengebirge, c.* 1828–30
Stiftung Oskar Reinhart, Winterthur

92 *Riesengebirge Landscape, c.* 1835
National Gallery, Oslo

93 *Memories of the Riesengebirge, c.* 1835
Hermitage, Leningrad

94 *Oak Tree in the Snow, c.* 1829
National Gallery, West Berlin

95 *Flatlands on the Bay of Greifswald, c.* 1832
Sammlung Georg Schäfer, Obbach near Schweinfurt

96 *Seashore in the Moonlight, c.* 1830
National Gallery, West Berlin

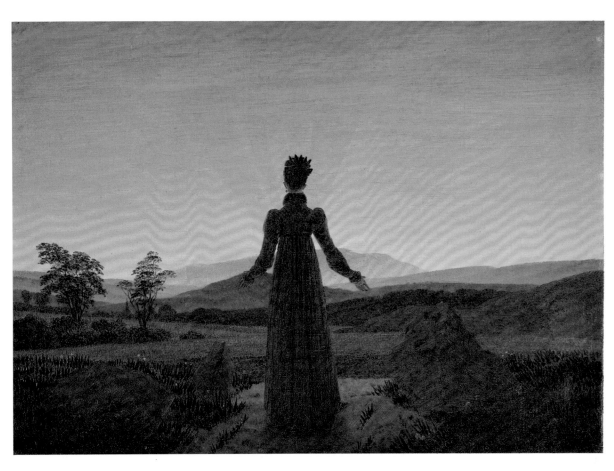

97 *Woman before the Setting Sun, c. 1818*
Museum Folkwang, Essen

10

Theomimesis

The Eighth of Rainer Maria Rilke's *Duino Elegies* (1922), whose lines I have borrowed in reading Friedrich's *Evening Star*, reminds us that the Romantic agon between viewer and world is finally a struggle unto death:

> And we, spectators always, everywhere
> Looking at, never out of, everything!
> It fills us. We arrange it. It decays.
> We re-arrange it, and decay ourselves.

Seldom is this struggle as powerfully visualized as in Caspar David Friedrich's most monumental *Rückenfigur*, the *Wanderer above the Sea of Fog* from about 1818, now in Hamburg (illus. 77, p. 155). Pictured large at the canvas's centre, and determining the landscape's vertical format through his upright form, the halted traveller dominates our visual field. He establishes the central vertical axis of the valley's bilateral symmetry, so that the flanking hills and banks of fog appear like extensions of his person; and at the horizontal of his waist, made visible by the gathering of his green coat and occuring at the canvas's midline, the picture divides into symmetrical upper and lower halves. Even the picture's strongest element of asymmetry – the right slope of the summit in the foreground which is carried into the diagonal arrangement of fog-covered peaks to the left – relates subtly to the traveller. For from the position of his body he seems to have ascended in this direction. Upon him, rather than on some constructed vanishing point in the distance, all lines of sight converge, as if landscape were the mapping of world to body.

The visual prominence of the *Rückenfigur* has encouraged speculation as to his specific identity. According to a tradition dating from the time before the canvas appeared on the art market in the 1930s, the turned figure represents a high-ranking forestry officer named von Brincken, whom historians have identified as a certain Colonel Friedrich Gotthard von Brincken of the Saxon infantry. In Friedrich's canvas, the *Rückenfigur* wears the green uniform of the volunteer rangers (*Jäger*) – detachments called into service by King Friedrich Wilhelm III of Prussia to war against Napoleon. Van Brincken was probably killed in action in 1813 or 1814, which would make the 1818 *Wanderer above the Sea of Fog* a patriotic epitaph. Friedrich turns his subject away from us, rendering him subtly anonymous, or perhaps universalizing his cause; and although we cannot see his face we can share in the substance of his vision.

Day has dawned in the mountains, and the view beyond the traveller lies mostly concealed, veiled by a fog that lifts here and there to reveal fragments of a vast panorama. Friedrich paints away the substantiality of these islands of the visible, allowing the murky pattern of trees in a far-off forest to mingle with the shadowed contours of the clouds upon its slope, rendering rocks like trees, and trees like puffs of smoke. Space is neither an even progression of objects into depth, nor the clean break between foreground and background established in so many of the artist's compositions. Rather, Friedrich hints at the structure of a properly receding landscape through the Claudian device of flanking and overlapped coulisses (here formed by rocks, forested hills and bands of clouds), while simultaneously eradicating the connective ground in between. Instead of an avenue of sight carried by river, bridge or valley, we are given only discontinuous moments of passage to the horizon: coulisses rising from and enframing a void.

Friedrich places these coulisses in space by registering in the level of their detail their distance from the eye. Thus the fir tree on the nearest rocks, peaking from behind the *Rückenfigur*'s left knee, is fully legible down to its individual twigs, while further away the trees become progressively more general: first as the contours of their bows, then as tiny clumps, together indicating a 'forest'. Strangely, though, these differentiations finally read as repetitions of the same. The telescoping forms of needle, twig, bough, tree, forest, mountain, and world are analogized, rendered as equivalent patterns on the canvas's surface. Within this ambiguity of scale, Friedrich lays bare the picture's only constant index. For what takes the place of the central avenue of sight connecting the foreground with the edge of the sky, indeed what is enframed like a view-line by the partialized coulisses, is the landscape's internal viewer himself: the *Rückenfigur* standing parallel to the picture plane and constituting the scene's place of convergence. This replacement of the geography of the view by the body of a viewer, thematizes the nature of our own viewing experience before *Wanderer above the Sea of Fog*. For by rendering his landscape insubstantial and spatially unstable, the artist forces us to participate directly in what we see. The mists and mirages, rocks and trees are what they are only through the creative imagination of the beholder.

Such wilful obscurity in the representation of landscape has its traditional legitimation in the aesthetics of the sublime. Already in 1757 Edmund Burke, in his enormously influential *Philosophical Enquiry into the Origins of Our Ideas of the Sublime and the Beautiful*, valorized obscurity and strength of expression over the Neo-classical ideal of clarity, precision and adherence to rule. Burke argued that terror, the passion associated with the sublime, is best aroused by things 'dark, uncertain, [and] confused', while vastness and infinity, chief attributes of the sublime in nature, can only be elicited through obscurity. For when we can 'see an object distinctly' we can 'perceive its bounds. A clear idea is therefore another name for a little idea'. Friedrich himself wrote that

when a landscape is covered in fog, it appears larger more sublime, and heightens the strength of the imagination and excites expectation, rather like a veiled woman. The eye and fantasy feel themselves more attracted to the hazy distance than to that which lies near and distinct before us.

Leaving aside, for the moment, the artist's controlling erotic metaphor, and his inscription of the viewing subject within the logic of male desire, I would note that Friedrich locates sublimity not in the object itself, but in its subjective effect on the viewer. The distant mountains and forests in *Wanderer* are thus not in themselves sublime. It is their obscurity, their presence and absence as objects of the viewer's gaze that endows them with their power. It was Immanuel Kant, of course, who first located sublimity purely within the beholding subject, rather than in objects themselves. In his *Critique of Judgement* of 1790, we read that unlike beauty, which 'concerns a liking or dislike for the *form of the object*', sublimity

is contained not in any thing of nature, but only in our mind, insofar as we can become conscious of our superiority to nature within us, and thereby also to nature outside us. . . . When we speak of the sublime in nature we speak improperly; properly speaking, sublimity can be attributed merely to our way of thinking . . .

More programmatically than perhaps any other painting of the period, Friedrich's *Wanderer above the Sea of Fog* aspires to invoke the sublime of a thoroughly subjectivized aesthetic, in which the painted world turns inward on the beholder.

But strangely in a painting that so emphasizes the subjective standpoint, *Wanderer* renders our own place as viewers of the landscape deliberately unstable. As in *Cross in the Mountains*, we are left uncertain whether we stand on solid ground behind the summit, or whether we float in space with the clouds. The foreground pyramid rises abruptly from the lower framing edge without any clear connectives between our and the picture's space. Standing with its feet on the ground, however, is the *Rückenfigur*, installed in the midst of things, between the vast, insubstantial landscape and our own ambiguous point of view. It is he who mediates our experience of the scene, and who knits together the landscape's disparate fragments. Indeed it is hard to imagine what the view from the summit would be without his centralizing and concealing presence, how, for example, the symmetrical hills radiating from just below his shoulders would actually meet in the valley. The *Rückenfigur* is so prominent in the composition that the world appears to be an emanation from his gaze, or more precisely, from his heart.

Discussing composition in landscape painting, Carus wrote that 'a painting is a fixed gaze'. Even without an internal viewer in the picture, Friedrich's landscapes present themselves as something seen, rather than simply as something there. Their symmetrical design suggests the presence of an eye arranging nature, and the *Rückenfigur* only advertises this presence. In a sense, he is redundant. Is not our eye enough, coupled with the evidence of the artist's arranging eye, to infuse the landscape with a beholder's gaze, or do we need another hidden look, stationed within the painted world? Must landscape's perceiving subject be literalized as human figure in order

98 *Riesengebirge Landscape with Rising Fog, c.* 1819–20
Bayerische Staatsgemäldesammlung, Neue Pinakothek, Munich

for Friedrich's images to be understood as *Erlebnis*? At the centre of *Wanderer above the Sea of Fog*, a halted traveller gazes. It is from his eye and heart, not ours, that the painting seems to radiate. If repetition is at work (we seeing the *Rückenfigur* seeing, or, alternatively, we seeing the artist's vision of himself seeing), then something has been elided, for what repeats our looking, the turned traveller, hides with his body the very thing repeated: the gaze of the subject. The hidden eye within the picture, recuperated only in the archaizing allegorical frame of *Cross in the Mountains*, testifies to a powerful dimension of loss, of absence, of incompletion within the subject of Friedrich's landscapes.

Friedrich is unique among European painters of the period in his persistent use of the *Rückenfigur*. But the halted traveller as trope of experience, or as surrogate for the artist, and the audience, is a common rhetorical device in Romantic literature. The situation of the traveller, arrested by what he sees in the landscape is nowhere as

182

centrally and complexly explored as in the poetry of William Wordsworth. As Geoffrey Hartman and others have shown, from *An Evening Walk* (1793) to *The Prelude* (1799, 1805, 1850) and the *Excursion* (1814), Wordsworth seems always to be travelling on foot, engaged in a journey that is punctuated by significant pauses – the vision on Snowdon, the encounter with Imagination after crossing the Alps, the story of the Boy of Winander – which take the form of a meditation of a poet-traveller before some intimation of death. In Wordsworth, as in Friedrich, the halted traveller becomes inseparable from the very fabric of the represented landscapes. While there are comparable moments in German literature of the period that would have been known to Friedrich, Wordworth's poetry comes closest to the art of Friedrich in its genuinely dual emphasis on the radical specificity of nature, and on the constitutive role of an intervening subjectivity. This subjectivity may be externalized in a figure like the halted traveller, or it may simply be signaled by a dialectic within the lyrical 'I' itself, an 'I' always implicated in, if also agonistic to, nature's specificity.

In Wordsworth's *A Night-Piece*, composed in 1798 and published in 1815, for example, a traveller halts and beholds a scene of clouds breaking to reveal a vision. The poem opens with a description of a veiled setting where:

> ——The sky is overcast
> With a continuous cloud of texture close,

Nothing is remarkable in the landscape; the dull, flat light creates a uniform surface where nothing stands out and 'not a shadow falls', and where, it would seem, poetic description needs no mediating figure within the landscape. Then something happens:

> At length a pleasant instantaneous gleam
> Startles the pensive traveller while he treads
> His lonesome path, with unobserving eye
> Bent earthwards; he looks up – the clouds are split
> Asunder, – and above his head he sees
> The clear Moon and the glory of the heavens.

At the very moment when familiar nature changes, taking on an aspect more sublime, a traveller appears upon the scene and in the poem. In Wordsworth, this internal viewer is inseparable from the content of his gaze, which is perfectly appropriate to the double meaning of 'vision' as the faculty of sight and the thing that is seen. The wanderer changes with the sky. Where at first he had walked with 'unseeing eye', himself unremarked and unremarking in the closed landscape, now his eyes open with the clouds and he beholds what the heavens reveal. Of course, the glory of heavens was there all along, being only hidden from sight. Like the fragmentary landscape of Friedrich's *Wanderer*, the sublime as something concealed and revealed demands that there be a seeing subject. There are moments when the poem's theatre of the sublime seems to fashion its pageant out of and for itself, as when the vault is

said to 'deepen its unfathomable depth'. This turning of verb on to itself as object suggests a world that likes its own magnificence, whether or not it is seen by man. Yet depth is not a dimension belonging to objects themselves, but only emerges when an object is observed *in perspective*. It announces an insoluble bond between things and a seeing self by which the subject is placed in front of them. When the clouds break in Wordsworth's *A Night-Piece*, the traveller appears before the heavens and, like the *Rückenfigur*, mediates the scene as an experience. His presence is first signalled in the poem by surprise: the 'instantaneous gleam startles the pensive traveller' into being in the poem. This surprise, when familiar nature does something unexpected, when the landscape suddenly appears radically foreign or separate from the self, halts the traveller and elicits his gaze.

In Friedrich's *Wanderer*, the clouds open before the wanderer revealing not the 'glory of heavens', but fragments of the earth as if seen from heaven. The visions of rocky pinnacles, vast forests, open fields and far-off mountains rise up disconnected and bottomless from the foggy deep. Yet once in view they are clarified, each constituting a poignant little world. The artist may celebrate the blankness of the fog and clouds, just as elsewhere he reduces landscape to an empty strip of foreground on a void. However, in depicting what does appear, Friedrich refuses ever to generalize his forms, registering always the radical specificity or *Eigentümlichkeit* of each thing. For example, the summit visible above the fog to the right of *Rückenfigur*, just above the level of his hips, appears within a sea of undifferentiated grey like the revelation of the particular *per se*. The various trees on its gentler slope are not massed together as a 'forest', but emerge from the fog one by one: the lowest, at the left, a blurry, dark grey mass; the next, a legible silhouette of boughs, trunk and branches; the third, an object fully modelled in grisaille; and finally, just below the summit's crest, a tree of distinctive profile and character, and of a uniquely reddish hue, suggesting the coming of autumn. It is here we discern the demonstrative within landscape painting.

The force of this specificity can be felt if compared with the landscapes of the Dutch master Jacob Ruisdael. The tree at left of his *Jewish Cemetery*, for example, may be similarly unpredictable in its fragmentary form (illus. 52, p. 107). Yet in the way its shape is answered by the bare stump at the picture's left, and in the artful manner of its enframement by a shadowed passage in the trees behind, this ruined birch merges easily into its theatrical and gesticulating surrounds. Friedrich's reddish tree, while not ruined, is ultimately more fragmentary, more isolated in its form, being a part of the genuinely hidden whole of landscape. This deeper fragmentation contributes to the felt singularity of what is revealed: Friedrich paints not *the* tree, as fair and universal form within an ordered composition, but rather always *this* tree, this oak upon these cliffs in this season. And through that particularity, which singles out both the object viewed and the subject who views, the picture demonstrates a love and a longing.

In Wordsworth, who was himself a champion of the demonstrative 'this' in English

Romantic poetry, the apprehension of the particular is always mixed with a feeling of bereavement. Thus in the great *Intimations Ode* (1807), in a passage that is said to have moved William Blake deeply, Wordsworth mourns:

> But there's a Tree, of many, one,
> A single Field which I have looked upon,
> Both of them speak of something that is gone:
> The Pansy at my feet
> Doth the same tale repeat . . .

What is lost here is childhood's unmediated and passionate experience of the world, but what saddens us directly as readers of the *Intimations Ode* is not Wordsworth's personal fall into adulthood, nor his attendant intimation of mortality, but rather the way the merely remembered but absent Tree and Field are invoked within a demonstrative diction that desires but cannot finally have their full presence. The poignancy of the singular emerges from a loss experienced by the poet as a disparity in feeling between his present and his past, and it is instantiated within his poem as the failure to capture, through the *Fingerzeig* of language, the here and now of experience as emblematized by the humble 'Pansy at my feet'.

Friedrich, whose paintings are similarly elegiac, conveys the singular within a disproportion between whole and part: in *Wanderer*, within the play between the obscured space which would constitute the total 'view', and the isolated fragments of the visible. The landscape beyond the *Rückenfigur* simply cannot be thought together as a whole. If we deduce spatial recession from the ratio of size, for example, between the fir tree visible behind the *Rückenfigur*'s knee and the tiny tree on the pinnacle furthest to the left, level with the buttons of his green coat, we might assume a horizon hidden somewhere just below this distant summit. The gently sloping hill behind would have to be unimaginably large and far away for it thus to rise up from the clouds beyond. Yet on its slope we can clearly discern the trees and meadows of a proximate and familiar world, and these give way to other hills with other horizons. Each summit, in other words, stands both for itself and for the whole 'landscape' from which it emerges into view. Yet the plurality of summits, taken collectively as the view's expanse, does not add together to form a stable whole, but only replicates the whole – and always somehow a different whole – within each fragmentary summit. These summits are Romantic fragments in the quite specific sense, say, of Friedrich Schlegel's famous *Athenaeum* Fragment 206: 'A fragment, like a small work of art, has to be entirely isolated from the surrounding world and complete in itself like a hedgehog'. Friedrich's canvases, themselves usually small, are instances of the singular and isolated fragment, as in the baseless, horizonless view of *Morning Fog in the Mountains* of 1808, now in Rudolstadt (illus. 78, p. 156), or the Wordsworthian tree 'of many, one' in *Oak Tree in the Snow* of around 1829 (illus. 94, p. 175).

Wanderer above the Sea of Fog, with its centrally placed *Rückenfigur* and its thematiz-

ation of the subjectively constituted nature of the visible, reveals its fragments to be moments of visual attention. We have already encountered similar epiphanies, similar partialized objects of the gaze, elsewhere in Friedrich's art, where a world suddenly becomes only visible through a transition within our own way of seeing. In *Cross in the Mountains*, the fully detailed terrain of the foreground summit, discernible only if we bear down on the dark and glossy surface of the canvas, represents one such moment (illus. 13, p. 35), as does the apparition of the departing ship in the early painting *Fog* (illus. 20, p. 42). Perhaps the most dramatic instances of such visual fragmentation are Friedrich's late paintings of moonlit seascapes. In *Seashore in the Moonlight* from around 1830, now in Berlin, two lights illuminate the scene in different ways. Above, the moon shines through the turbulent mass of clouds that occupies more than half the canvas; below, a fire on an offshore boulder lights up a tiny scene of fishermen, their beached craft and the water immediately before them (illus. 96, p. 177). We find here the familiar contrasts between the heavenly and the earthly spheres. Note the unbroken horizon line which divides the picture radically in two, as well as the analogized positions, within each of these rectangular registers, of the moon and fire, and of the swirling clouds and curved pattern of the foreground boulders. But Friedrich also demonstrates through the effects of light the separateness of worlds, constructing each fragment as a discrete centre of visual attention.

In *Flatlands on the Bay of Greifswald*, of c. 1832 and now in Obbach in southern Germany, he goes one step further (illus. 95, p. 176). The swamp, fishing nets, sailing boat and assembled staffage, together with the thick clouds, appear as mere coverings before a light that shines through all things. The figures in the landscape's midground are silhouetted against the reflective surface of the water, as if at the brink of the world. We know that in the 1830s Friedrich fashioned a series of paintings executed on transparent paper, which were intended to be viewed in a dark room, lit from behind by a lamp. Although these works are now lost, their effect can be gleaned from the uncanny illumination of the Obbach *Flatlands*. The light may here have one source within the picture (indeed the medium of transparent painting insists precisely upon unifying its light source and isolating the image from all other visible objects). But its effect is to fragment the natural world we see, and of which we are a part, from the medium of its appearance. Here the whole is unattainable because it is opposed to us, like the contrast between the bright reflection on the water's surface and the dark, silhouetted *Rückenfiguren* before it.

In *Wanderer above the Sea of Fog*, the fact that the fog-wrapped summits can indeed appear as fragments of a whole rests upon Friedrich's working procedures as a painter. What gives the landscape its particular magic, and what fixes our attention on the crafted surface of the canvas, is our uncertainty as to how this interplay between clouds and mountains, this seamless mix of blank obscurity and brilliant clarity, was achieved *in paint*. That reddish tree on the summit at the right was clearly painted on a ground of white which stands for 'fog', since Friedrich could not have painted the

tree first and then painted around its contours in white. Just below, however, and further along the visual spectrum from clarity to concealment, the process must have been the opposite. The blurred trees and cliffs emerging from the fog would seem to have been set down first, perhaps in contours more definite and clear than they now appear, and then overpainted with white and grey scumbles. Yet what Friedrich's fog demands, and indeed advertises is that any transition from one procedure to the other be absolutely imperceptible, that the cloud before the summit should be of the same substance and moment as the cloud behind, and that, in short, the necessary temporality of an artist's manual labour be erased. Painting, therefore, will be more than the sequential application of colours on the canvas, appearing instead as the simultaneous revelation and concealment of what is always already there.

Wanderer above the Sea of Fog stands suspended between two notional paintings: on the one hand, the total replication of a valley in all its detail that has been overpainted in white; on the other hand, a blank canvas on which have begun to appear, here and there, the fragments of a scene. Describing the artist's working method, Carus noted that Friedrich never fashioned preparatory studies for his oils, but started working directly on the blank canvas with the finished picture fixed within his mind: 'his pictures appeared at every stage in their creation always precise and ordered, and gave an impression of his *Eigentümlichkeit* and of the mood in which it [the landscape] first appeared within him'. Friedrich's paintings, that is, are both already finished before they begin, being fully present to their maker, and never final when they are done. In a canvas like the Frankfurt *Mountain Landscape*, begun around 1835 but left 'incomplete', probably because of Friedrich's stroke, we see only the underpainting of a work in oil (illus. 80, p. 158). *Riesengebirge Landscape* of c. 1835 (illus. 92, p. 173) and *Sunrise near Neubrandenburg* (illus. 99) have similarly been left unfinished. Yet the effect is of a natural scene not yet emerged from fog, as if we were observing a passage of *Wanderer* at an earlier stage, not of its making as painting, but of the life of landscape itself.

Georg Friedrich Kersting's portrait of *Caspar David Friedrich in his Studio* of 1812 shows a picture in the making. The artist is at work, gazing intently at a canvas that stands concealed from us (illus. 33, p. 73). The room is conspicuously bare, empty of the usual riot that traditionally pervades an artist's atelier: the stacks of paintings, drawings and prints in various states of finish; the skulls, plaster casts, joined mannequins, and other usable props; the well-worn books of science, literature and history that make for learned painting; the models, apprentices, patrons, family and friends that play in the social drama of art's production. Contemporaries appreciated the calculated austerity of Friedrich's working space. The French classicist sculptor David d'Angers, visiting the artist's studio in 1834, discerned in it an element of self-denial or mortification shared between the artist and his work: 'A small table, a bed rather like a bier, an empty easel – that is all. The greenish walls of the room are wholly naked and without decoration; the eye searches in vain for a painting or a

99 *Sunrise near Neubrandenburg, c. 1835*
Kunsthalle, Hamburg

drawing'. When, on the Frenchman's insistence, Friedrich brought forth his canvases, they too were empty, bespeaking death. The painter Wilhelm von Kügelgen, son of Friedrich's early friend and supporter in Dresden, Gerhard von Kügelgen, explained in his memoirs the reason for such domestic austerity: 'Even the necessary paint box with its bottles and paint rags was banished to the next room, for Friedrich felt that all extraneous objects disturbed his inner pictorial world'. Where in other artists' studios the clutter of objects, people and pictures turns the atelier into a microcosm of the larger world, Friedrich fashions a votive space for interiority, a sanctuary wherein the subject's inner vision is replicated as art. In Kersting's painting, the artist has even shuttered the lower casement of his window, so that the real landscape outside does not disturb the imagined landscape he paints. The window, traditional symbol of the mimetic power of painting, here functions only as a light source. And the relation between self and world, metaphorized elsewhere in Friedrich's art as the partialized view through a window (e.g. illus. 25, p. 46 and 76, p. 154), is transposed to an encounter between the artist and his vision taking shape on the hidden canvas.

In an early sketch of 1802, Friedrich portrays himself inactive before his sketchbook

(illus. 100). Supporting his head in his hand, so that his pen is wedged against his cheek, he assumes the traditional attitude of melancholy. His mournful glance, cast towards the window at the left, links this sorrow, and indeed this inactivity, to a yearning for nature. The view through the open window at once halts artistic labour, and recalls art's motivating task, as the imitation of nature. The *Self-Portrait*, produced at the moment when Friedrich the landscapist falters, documents this contradiction. Like many of his Romantic contemporaries, of course, Friedrich valorized the direct study of nature over classicism's imitation of past works of art. The hundreds of

100 *Self-portrait with Supporting Arm, c.* 1802
Kunsthalle, Hamburg

drawings that he executed on his walking tours of Rügen, Bohemia, the Harz Mountains in Saxony and the environs of Dresden and Greifswald testify to this ideal. With the exception of his sepias and some of his more finished watercolours (e.g. illus. 90 and 91), such studies from nature are generally of two kinds. Either they record the specific shape of individual objects distilled from their settings, as when in a drawing of 3 June 1813 Friedrich set down a configuration of rocks that he later uses for the summit of *Wanderer above the Sea of Fog* (illus. 77, p. 155). Or else they map out the basic structure of a landscape, fixing the particularity of its profile much like an architect's elevation (illus. 102). Commentators have compared these sketches to the patterns in a medieval artist's model-book, not only because of their simplified outline and unostentatious graphic manner, but also because of their function within Friedrich's working method. These are the artist's raw materials, his repertoire of demonstrative, singular, fragmentary forms – the source, as it were, of that 'Tree, of many, one' – that he integrated into his painted landscapes, but only when he returned to his closed studio to reimagine the landscape from within. Read from the perspective of this process of creation, the *Rückenfigur* stands as a kind of

101 *Rocky Summit*, 3 June 1813
Kupferstichkabinett, Dresden

102 *Landscape Studies (From the Region of Ballenstedt and Thale in
the Harz Mountains)*, 24 June 1811. Fogg Art Museum, Cambridge, Mass.

103 *Plant Study*, 1799
National Gallery, East Berlin

104 *Study of Groups of Trees*, 24 and 26 June 1806
National Gallery, Oslo

trope for origins, designating the original act of gazing by the artist-wanderer in nature. *Tropos* in Greek means 'turn', which is exactly what happens when Friedrich returns. His face turns from us and his gaze, the painting's origin, lies hidden. What we see is the artist in the landscape of a remembered *Erlebnis*.

F. W. J. Schelling, in his 1807 essay 'On the Relation of the Fine Arts to Nature' explains this need for the artist to be both faithful to, and separate from, nature in the production of his art. The slavish imitation of reality will produce not works of art, but mere 'masks' *(Larven)* or empty coverings. Therefore, the artist 'must distance himself from [nature's] product or creation, but only so that he can elevate himself to a creative power, and understand this power spiritually'. The painter imitates not the *products* of nature, but nature's *process*, not created nature *(natura naturata)*, but creating nature *(natura naturans)*. This Romantic revision of the Aristotelian definition of mimesis has, of course, wide-ranging effects for art and its meaning. Because the work of art no longer simply copies what is, its significance will not be exhausted by its objective reference. It will be like the objects of nature themselves, a closed totality, a complete universe, and hence properly a *symbol*. In Kersting's portrait, nature is visible in the artist's studio only as clouds and sky, and the paints readied at the centre of Friedrich's loaded palette are appropriately the colours blue and white. For in the concealing and revealing fogs, mists and clouds of his painted landscapes, Friedrich emblematizes nature itself as creative process, not finished product, a process parallel to his art.

According to Martin Luther's German translation of the Bible, on the day of Creation 'a fog *[Nebel]* went up from the Earth and moistened all land' (Genesis 2:6). Carus, who was a natural scientist and distinguished physician as well as a talented painter and art theorist, was intrigued by this biblical fog which animated the earth, turning barren mountains into verdant forests. In his theory of landscape painting, which he termed *Erdlebenkunst* (literally 'art of the earth's life'), he argued that fog was God's assistant at Creation. The emerging landscape of Friedrich's *Wanderer above the Sea of Fog*, balanced between determinacy and indeterminacy, chaos and particularity, evokes that primal moment and forges thus an analogy between God's origination of the world through a fog and the painter's production of the work of art through paint. Moreover, in the specific painterly manner necessitated by the painting's fog, which works to conceal all evidence of brushwork, the manipulation of paint, and the temporal process of manual labour, Friedrich assimilated his own act of making to the model of divine creation. For traditionally what marked off God's work from man's was that He created the universe instantaneously and 'without hands' – in Greek *acheiropoetos* – whereas we labour manually, in time, and by the sweat of our brow.

Such a reading of Friedrich's fog sheds light on a curious episode in the artist's life. In 1816 Goethe, who early on had admired aspects of Friedrich's work, suggested

105 Johann Christian Clausen Dahl, *Cloud Study with Horizon*, 1832
National Gallery, West Berlin

that the artist should execute a series of cloud studies based on the new meteorological scheme developed by a British natural historian Luke Howard. Goethe saw in man's capacity to classify clouds according to type (cirrus, cumulus, stratus, etc), a mark of the power to decipher and appropriate (Goethe's word is *aneignen*, to 'take as one's own') nature. Where in the past people had fantasized divinities and messages in the clouds, now they were able to read the book of nature directly, discerning there the full significance of the 'thing itself'. In a group of poems celebrating Howard, Goethe sought to accommodate poetry, with its brief of ordering the world and endowing it with human significance, to science, understood by Goethe as both a descriptive and an interpretative discipline. Friedrich declined Goethe's suggestion on the grounds that such a project would undermine the whole foundation of landscape painting, presumably both because it would empty nature of any 'higher' meaning, and because the very attempt to classify would violate the essential obscurity of clouds, and with it the radical alterity of nature itself. To have found the outline, as it were, of clouds

193

and fog, would mean for Friedrich the erasure of one of the foundations of his art: the disparity between the finite and the infinite, consciousness and nature, the particular and the universal, which a landscape like *Wanderer* expressed as the contrast between mountains and fog, and between the *Rückenfigur* and the cloud-theatre before him. When later, under the influence of the younger Norwegian painter Johan Christian Clausen Dahl (illus. 105), Friedrich actually executed some studies of clouds in oil on cardboard (illus. 108 and 109), he was not interested in their structure and outline as such, but in their relationship to the infinite, illuminated heavens they cover. Goethe, for his part, swiftly developed a distaste for Friedrich's art after 1816, objecting, as we have seen, to its allegorizing tendencies, and finally declaring to a great connoisseur of Renaissance painting, Sulpiz Boisserée, 'one ought to break Friedrich's pictures over the edge of a table; such things must be prevented'.

The celebration of boundlessness and indeterminacy in landscape, however, as sign of our inability to appropriate nature, was a stance Friedrich shared with many in his culture. Even Carus, who in the 1820s came increasingly under the spell of Goethe, wrote in the second of his *Nine Letters on Landscape Painting*:

Stand then upon the summit of the mountain, and gaze over the long rows of hills. Observe the passage of streams and all the magnificence that opens up before your eyes; and what feeling grips you? It is a silent devotion within you. You lose yourself in boundless spaces, your whole being experiences a silent cleansing and clarification, your I vanishes, you are nothing, God is everything.

Carus could well have had a landscape like Friedrich's *Wanderer* in mind here. Yet because sublime landscape is felt to emerge in Friedrich's canvas as somehow always dependent upon the cognitive act of a beholding subject, we as viewers do not at all 'vanish' before the immensities we see, but feel ourselves to be part of, or indeed participatory in, the world's appearance. Nor does the *Rückenfigur*, as figure of self, stand as an emblem of loss of identity, being rather the centre and source of the picture's symmetrical emanation. From this perspective, the halted traveller is not subsumed by divine glory, but is himself another deity, an *alter deus* turned with his back to us, as God appeared to Moses on Mount Sinai. The great twelfth-century Jewish theologian Maimonides interpreted this biblical 'seeing of the back' to mean that while God's full presence, metaphorized as face, is denied to man, He has vouchsafed us another gift: the knowledge of the acts attributed to God. Nature, man and human history together constitute this figure of the back, this concealed and revealed God as *Rückenfigur*. Against the Goethean dream of *Aneignung*, but also against the pious cliché of an annihilation of self before Creation, Friedrich fashions a more difficult vision, one in which the experiencing self is at once foregrounded and concealed, and in which God, submitted to a Hebraic iconoclasm born perhaps from the artist's own Protestant spirituality, is shown in His absence, as the image of His consequences.

106 *Evening Star, c.* 1830–35
Freies Deutsches Hochstift, Frankfurt

107 *Chalk Cliffs on Rügen*, 1818–19
Stiftung Oskar Reinhart, Winterthur

108 *Evening*, September 1824
Kunsthistorisches Museum, Vienna

109 *Evening*, October 1824
Kunsthalle, Mannheim

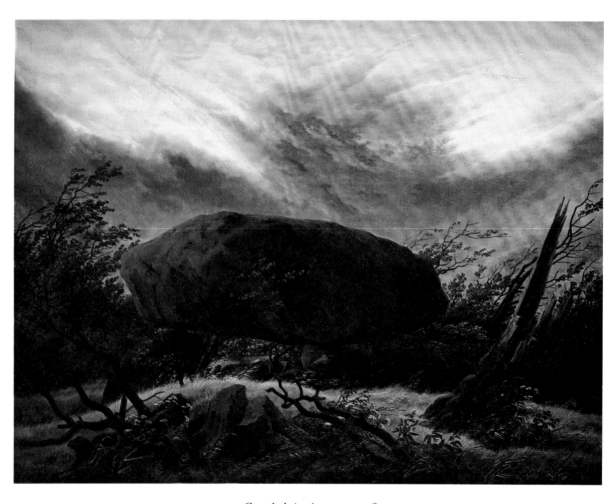

110 *Cromlech in Autumn, c.* 1820
Staatliche Kunstsammlungen, Gemäldegalerie, Dresden

111 *Solitary Tree, c.* 1821
National Gallery, West Berlin

112 *The Watzmann*, 1824–5
National Gallery, West Berlin

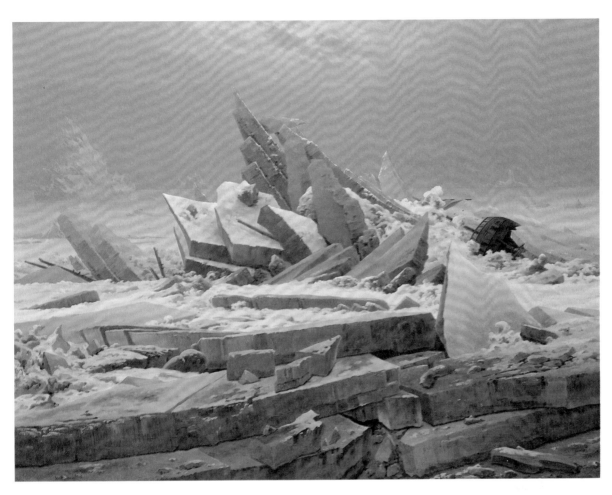

113 *The Sea of Ice, c.* 1823–5
Kunsthalle, Hamburg

114 *Morning, c.* 1821
Niedersächsisches Landesmuseum, Hanover

115 *Noon, c.* 1822
Niedersächsisches Landesmuseum, Hanover

116 *Afternoon, c.* 1822
Niedersächsisches Landesmuseum, Hanover

117 *Evening, c.* 1821
Niedersächsisches Landesmuseum, Hanover

118 *The Stages of Life, c.* 1835
Museum der bildenden Künste, Leipzig

119 *Moonrise at Sea, c.* 1821
National Gallery, West Berlin

120 *Landscape with Windmills, c.* 1822–3
Schloss Charlottenburg, West Berlin

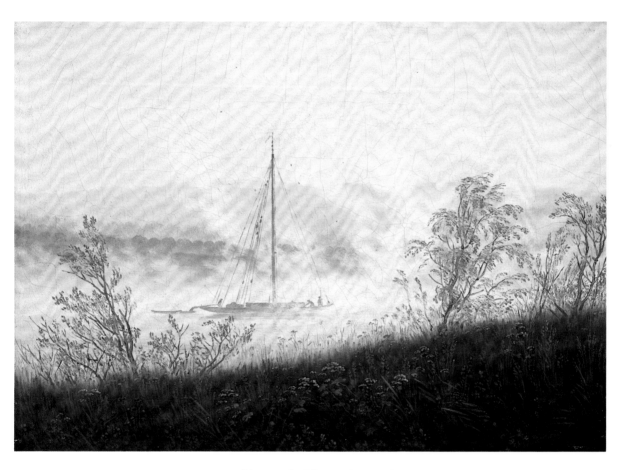

121 *Ship on the Elbe in Mist, c.* 1821
Wallraf-Richartz Museum, Cologne

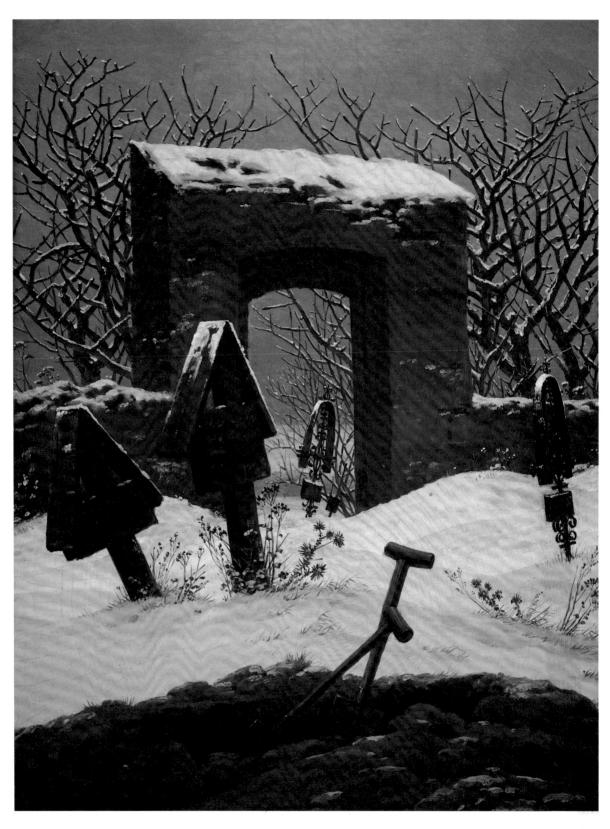

122 *Churchyard in the Snow, c.* 1828
Museum der bildenden Künste, Leipzig

11

Reflection

───

We need some terms to locate Friedrich's *Rückenfigur* more precisely within its historical context. According to classicist aesthetics, staffage, or the human figure in a natural scene, will both determine the overall meaning of a landscape painting, and elevate it above its lesser status within the hierarchy of the genres to the level of a history painting. As Carl Ludwig Fernow, one of Germany's most eloquent spokesmen for classicism in painting, wrote in his *Roman Studies* in 1806: 'Not through the represented environs, but through the figures that inhabit them, can a painter make known that his picture is not the real world, but rather a scene from Elysium'. The shepherds, gods, heroes and martyrs populating the idealized landscapes of classicist art from Claude and Nicolas Poussin to Friedrich's German contemporaries Philipp Hackert, Joseph Anton Koch and Johann Christian Reinhart, are what decide a picture's category (pastoral, heroic, etc) and glorify the general project of landscape.

Against this privileging of the human subject, Carus argued that while the presence of 'animate creatures' might help to deepen the effect of a natural scene, they will remain secondary to the landscape itself: 'Landscape will always determine the animate creature, who will emerge necessarily out of, and belong to, the landscape, insofar as landscape wishes to and should remain landscape.' As an example of this properly subordinate function of the human figure, Carus cites the motif of a beholder *in* the picture: 'a solitary figure, lost in his contemplation of a silent landscape, will excite the viewer of the painting to think himself into the figure's place'. In this vision of staffage as a surrogate for the viewer, or as bridge between our world and the painted image, we can discern one obvious interpretation of Friedrich's *Rückenfigur*. Where classical staffage aspires to humanize landscape, inscribing it into a plot and determining its value according to an artificial hierarchy of types, the halted traveller works to naturalize us as viewers, enabling us to enter more fully into the landscape.

Carus's account of the *Rückenfigur* as site of identification or mediation between painting and viewer, nature and consciousness, finite and infinite, remains to this day the dominant interpretation of Friedrich's master-trope. 'The motif of the *Rückenfigur*', one recent historian concludes, 'is therefore no symbol of separation'. For the Romantics themselves, however, the line between identity and difference was anything but clear; and it was their awareness of the deep ambiguity of mediation itself that led them to develop those central devices of semantic estrangement, allegory and irony. Nowhere is the *Rückenfigur*'s inescapable multivalence as cheerfully and insistently

proclaimed as in Heinrich von Kleist's extraordinary essay 'Sentiments before Friedrich's Seascape', published on 13 October 1810 in a short-lived daily newspaper, the *Berliner Abendblätter*, edited by Kleist himself. The essay, reviewing Friedrich's *Monk by the Sea* (illus. 87, p. 168) which was then being exhibited at the Academy of Art in Berlin, is divided into two parts. An extended introduction, written by Kleist, registers the reviewer's 'own' sentiments before the canvas. And a series of fictive dialogues, composed by Clemens Brentano in collaboration with Ludwig Achim von Arnim, represents conversations supposedly overheard between unnamed members of the Berlin art public. The essay title's plural 'Sentiments' *(Empfindungen)* has thus a threefold determination, indicating at once the multiplicity of feelings within any single viewer, the actual dialogue format of much of the published text and the fact of the review's multiple authorship. What sets this instance of Romantic dialogism into play, according to the speaker within the text who has the last word, is the small painted figure of the monk himself. It is he 'who motivates everyone to articulate what many have already said in exuberant, universal familiarity'. The *Rückenfigur* is thus made into an initiator of discourses, somehow inspiring his viewers with unbounded exegetical confidence. The views he elicits, while radically heterogenous in content, all reflect the same false faith within their speakers that they know whereof they speak.

Kleist begins by describing the experience of a real seascape. He notes the feelings of solitude and infinity evoked by the ocean; locates these feelings within their temporal embeddedness in a remembered journey to, and an anticipated return from the sea; and states the message of the whole:

that one has wandered out there, that one must return, that one wants to cross over, that one cannot, that one lacks here all life and yet perceives the voices of life in the rushing tide, in the blowing wind, in the passage of clouds, in the solitary birds.

The desire for transcendence, for passage over the sea, remains unfulfilled, and Kleist at once expresses and recuperates his loss through the discovery of life within signs of the absence of life. Only now does he turn to the painting of a seascape, Friedrich's *Monk by the Sea*:

Such things are not possible before the painting; and that which I should find within the painting itself, I have already found between me and the picture, namely, the demand *[Anspruch]* that the picture made upon my heart, and the loss *[Abbruch]* that the picture inflicted upon me. And thus I was myself the Capuchin [monk], the painting was the dunes, but that across which I should have gazed with longing – the sea – was altogether missing.

The feelings of longing and bereavement, of lure and lack, experienced before the landscape cannot simply be replicated by an artistic representation of landscape. Or, in the language of our discussion of *Erlebniskunst* and the aesthetics of the symbol, experience and the representation of experience are *not* identical. Yet by transposing the terms of the relation art/nature Kleist discovers a deeper analogy. For what the viewer experiences *in* landscape was not the full presence of reality and life. And

therefore Friedrich's painting will not evoke longing and loss by allowing us entrance into its spectacle, any more than the real sea allowed us passage from the shore. It will instead simply repeat the experience of exclusion, keeping us out of the landscape by being merely a painted image. The 'painting [is] the dune' because rather than drawing us in, it distances us tragically from the sea, from reality, from the fullness of life and experience. And this is what enables the viewer to identify with the *Rückenfigur*, here Kleist with Friedrich's monk: not an erasure of the boundary between self and world, but the establishment of boundary. The viewer's ability 'to think himself into' the *Rückenfigur's* place becomes the very instance of separation.

Responding to his failure to enter the picture except as a figure of exclusion, Kleist shifts his rhetorical strategy and opens his review to the voices of the public: 'I listened to the reactions of the variety of beholders around me, and repeat them as belonging to the picture'. These dialogues, the work of Brentano and Arnim, begin as a comic chain of conversations interlinked by misunderstandings. One viewer's exclamation of praise, 'How infinitely deep!', is taken to refer to the represented sea, rather than to Friedrich's canvas; another viewer, associating the picture with the spirit of 'Ossian ... playing the harp', is misheard as saying 'ocean', and a search for a harp within the landscape ensues; and a criticism of the canvas as 'atrocious' *(greulich)* elicits lively agreement: 'Yes indeed! Greyish *[gräulich]*. Everything is grey'. Such local errors serve to ironize the deeper hermeneutic problem of the review as a whole, for they juxtapose to the silent work of art a ceaseless babel of misreadings, of which Kleist's is but one.

Following these communication failures are a series of more extended dialogues which are delightfully at odds with the high seriousness of Friedrich's art, yet which together outline a repertoire of possible responses to *Monk by the Sea*. First in line is a governess with her charges, who treat the picture as material for a history lesson:

Governess: This is the sea off Rügen.
First Demoiselle: Where Kosegarten lives.
Second Demoiselle: Where the products from the colonies arrive. . . .

Their disconnected statements, ambiguously covering the spheres of geography, culture and economy, but always descending into non sequiturs ('Ah yes, I'd love to fish together for myself a string of amber'), mocks a 'context' oriented art history widely practised today. As this little group marches on in search of further edification, a group of culture vultures arrive, speaking in the jargon of speculative Idealism. Their attention drawn to the figure of the monk, they offer their interpretations as to his meaning.

Second Man: . . . [He] is the singularity in the totality, the solitary middle-point within a solitary circle.
First Man: Yes, he is the mind, the heart, the reflection of the whole painting in itself and about itself.
Second Man: How divinely this staffage has been chosen. It is not here, as in the works of vulgar painters, as mere measure to establish the scale of things. He is the thing itself, he is the

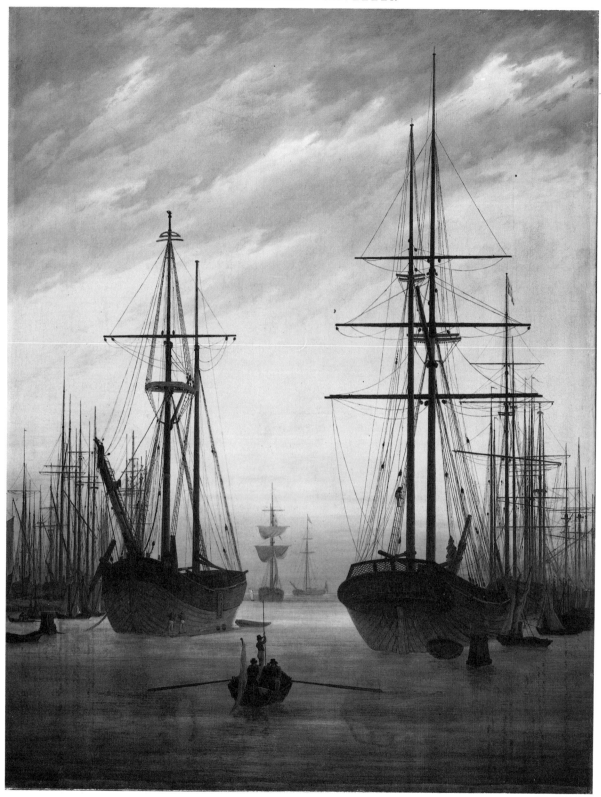

123 *View of a Harbour, c.* 1816
Staatliche Schlösser und Gärten, Potsdam

picture: and in the very moment when he seems to be dreaming himself into this landscape as into a sad mirror of his isolation, the shipless, enveloping sea, which limits him like a vow, along with the empty shore, that is joyless like his life, seems to impell itself further upon him symbolically, like a lonely shore-plant that points beyond itself.
First Man: Marvellous! You are certainly right.

I myself am tempted to agree. For the monk as 'reflection of the whole painting in itself and about itself' summarizes only too well what I myself might end up saying about the *Rückenfigur*: that, say, he does not explain or mediate the picture's meaning, but only repeats the picture's essential deferment of meaning; or that he emblematizes the subject *of* landscape as the subject *in* landscape; or that he is a mirror of myself, who is at once forced and unable to constitute the picture's true subject; and so on – until I discover myself to be the butt of Romanticism's caricature of Romanticism. I could rally to my own defence, of course, and recall that for Romantics like Brentano and Arnim, irony was the constitutive mode of all literature, and that to find myself ironized is therefore not the same thing as having been proved wrong. Or I might argue for the legitimation of my own discursive style on the grounds that it is already fully present, if bathetically, within the historical material itself. Or finally I could take comfort in the text's parody of my work, regarding it as just one more reflection of the beholder in the work of art, one more version of *Rückenfigur*, in which irony is simply the mark of heightened self-reflexivity.

Brentano and Arnim's dialogue marches relentlessly on. A 'lady' appears on the scene, accompanied by her male 'guide', who turns everything she says into a sexual innuendo. Thus when she piously associates Friedrich's *Monk* with Edward Young's *Night Thoughts* (a long English poem in blank verse of 1742 which had a significant effect on the early Romantic movement in Germany), her companion encourages a chain of associations about the night, leading first to the mention of Gotthilf Heinrich von Schubert's *Views of Nature from the Night-Side* (the text, properly titled *Views of the Night Side of the Natural Sciences*, contains a lengthy discussion of Friedrich), and then on to the guide's off-colour remark: '[I'd] rather see a view of your nature from the night-side'. 'Nature', in the dialect of south Germany, carries the meaning of 'genitals'. And the woman retorts angrily, 'You are rude'.

Man: Oh, if only we could stand with each other, like the Capuchin stands!
Lady: I'd leave you and head for the Capuchin.
Man: And ask him to couple [*copulieren*, meaning both 'to marry' and 'to copulate'] you and me.
Lady: No, to throw you in the water.
Man: And stay with the monk alone, and seduce him, and ruin the whole painting and all its night thoughts.

In this final irony of ironies, Kleist's opening conceit of becoming the internal viewer by the sea, of joining with the *Rückenfigur* so as to enter and unite with 'nature', becomes debased as sexual coupling with the monk. The woman, represented as an

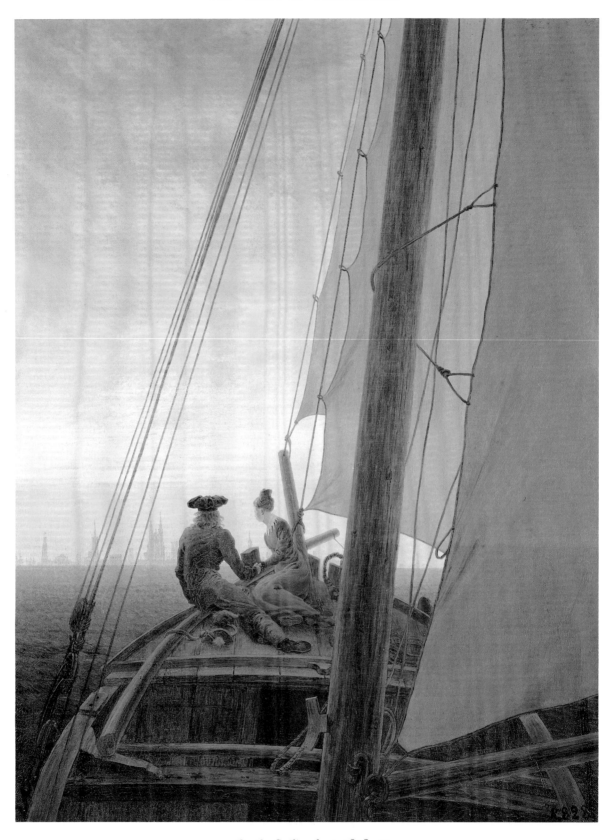

124 *On the Sailing-boat*, 1818–19
Hermitage, Leningrad

avid consumer of Romantic and sentimental poetry, and therefore as a sort of female foil for the jargonizing male commentators who extemporized before the picture earlier on, cannot express aesthetic sentiments without having them inverted by her guide *(Führer)* who is also her seducer *(Verführer)*. He, in turn, operates by literalizing and thereby degrading the controlling terms of her aesthetic, that is, the metaphor of union in Romantic *Identitätsphilosophie*. The interpretative discourses generated before Friedrich's *Monk by the Sea*, submitted thus to the destabilizing fact of sexual difference, reveal their motivation in power. The guide/seducer, by refusing to grant the woman her sovereignty of 'sentiment' (earlier in the dialogue she complains, 'If only you didn't just go and ruin one's sentiments'), demonstrates the limits of the Romantic ideology of freedom and autonomy in aesthetic response. The lesson could be applied to Friedrich's art as well. In several of his canvases, male and female viewers inhabit separate spheres, as in *Moonrise over the Sea* of 1821, where the women in the foreground are relegated to the position of voyeurs to their male companion's more primary experience of landscape (illus. 125). In Brentano and Arnim, the conflict is momentarily resolved only when, scorned by the woman, the guide engages in his own Romantic ecphrasis: 'Oh, I wish I was the Capuchin, who so eternally alone looks out into the dark, beckoning sea, which stands before like an apocalypse; so I would long eternally for you, dear Julie, etc'. Wherupon the woman falls into his arms, helpless before so sweet an exegesis of the *Rückenfigur*.

The viewing of Friedrich's painting has become a vehicle for sexual temptation; or more precisely, interpretation has proved to be a product of personal desire, dependent upon real power relations. Having demonstrated this, Brentano and Arnim produce one final speaker who stands back from the throng and delivers his indictment. The monk in Friedrich's painting, he argues, 'looks from a certain distance like a brown spot', and the work would be better without him. For it is the *Rückenfigur* who generates the review's clamour of 'Sentiments before Friedrich's Seascape', who indeed occasions that infinity of interpretation valorized by the Romantics, yet he also bears no relation to the silent landscape beyond. The painting both is and is not the *Rückenfigur*; art both is and is not the totality of its interpretations; landscape both is and is not a subjective *Erlebnis*.

The *Rückenfigur*'s paradoxical nature as site of both our identification with, and our isolation from, the painted landscape, is usefully explicated by F. W. J. Schelling in his *Philosophy of Art* of 1802. According to him, landscape is 'a completely empirical art form', in that it restricts itself to depicting the mere appearance of objects in light and space. However, in so far as a painter infuses such appearances, such topographies of empty objects, with a higher significance and awakens in his viewers the 'spirit of ideas', landscape will always 'revert back to the subject'. Thus while its material may be '*objectively* meaninglessness', the status of landscape painting as an art, which is to say its elevation above the formlessness of nature, depends upon 'subjective portrayal' and response. This dilemma, according to Schelling, has prompted landscape painters

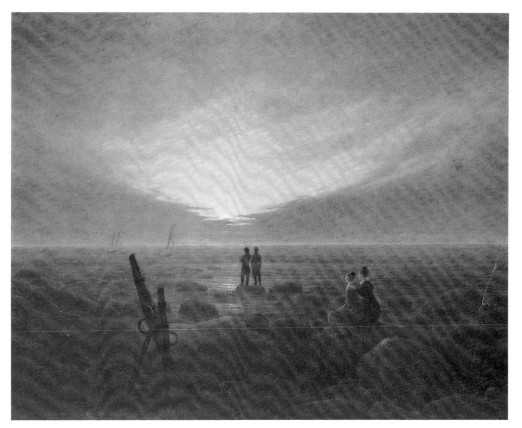

125 *Moonrise over the Sea*, 1821
Hermitage, Leningrad

'to give this form objective meaning by enlivening it with people'. Like Neo-classical critics before him, Schelling regards staffage as a device for endowing landscape with legible human significance. Yet his repertoire of desirable figures reflects a different aesthetics. A landscape painter must be careful not to disturb the unity of place through its human inhabitants:

Hence, the people in a landscape either must be portrayed as indigenous, as autochthonous, or they must be portrayed as strangers or wanderers recognizable as such by their general disposition, appearance, or even clothing, all of which is alien in relationship to the landscape itself. In this way proximity and distance yet allow themselves to be combined in the landscape in a different sense, and the unique feelings attendant on our conceptions of such juxtaposition can be elicited.

Where classical staffage functioned to classify landscape according to an objective system of genres (heroic-epic, elegiac, pastoral, etc), Schelling's two figure-types, the autochthonous staffage and the wanderer, articulate antithetical orders of experience: sameness/otherness, proximity/distance, being/becoming, etc. Their message, if indeed it is a message, is neither a human narrative nor a moral lesson legible in nature, but an expression of the ways humanity has or has not access to nature and its messages.

218

Friedrich was probably familiar with the *Philosophy of Art* through his friend and earliest exegete Gotthilf Heinrich von Schubert. In his *Views of the Night Side of the Natural Sciences*, published in Dresden in 1808, Schubert calls Friedrich's now lost 1803 sepia series of the *Stages of Life* a 'parable of the developmental history of the human mind represented through the developmental history of nature', a formulation dependent upon Schelling's aesthetics and philosophy of nature. In two of Friedrich's earliest oils dating from this period, Schelling's antithetical figure-types appear as if programmatically paired within pendant landscapes. *Summer*, produced in 1807 and now in Munich, depicts a man and a woman embracing in a love-bower in the foreground (illus. 86, p. 167). This figural group, which Friedrich has borrowed from Claude Lorrain's *Coastal Landscape with Acis and Galatea*, exhibited since 1754 in the Gemäldegalerie in Dresden (illus. 56, p. 113), is placed off to the left of the canvas, clearing a centralized view to the horizon. Literally enveloped by nature, the lovers appear as if born into each other's arms as an autochthonous staffage *par excellence*. Friedrich emphasizes the couple's state of belonging by allowing nature to respond to their forms. The vines that form the bower concatenate about the lover's intertwined bodies, connecting all objects in the foreground into a single fabric. And nature itself couples its elements in imitation of the human pair: the two round trees on the hill form a unity, as does the birch (white like the woman's dress) and darker poplar in the foreground; two doves perch together on the ivy; and a pair of heliotropic sunflowers grace the entrance to the bower. The couple, together with the edenic landscape that answers their forms, embody 'summer' not simply as a season of the year, but also as a phase of biological life (the stage of love, fertility and reproduction), an epoch of human history (a golden age embodied in the couple's Antique garb), and an episode in 'the developmental history of the mind', here expressed in a typically Romantic fashion as a reciprocity of woman and man, nature and consciousness, painting and viewer. For the lovers not only merge with each other and with their natural surrounds, but also mirror our own sense of belonging as we gaze into the canvas. Uncharacteristically of Friedrich, our eye is allowed to travel easily here from foreground to horizon, following the serpentine river and checked by the flanking hills. This equilibrium between ourselves and what we see is expressed within the canvas not by figures like ourselves, turned to gaze into the distance, but by the autochthonous staffage blind to the world around. Our looking has been embodied not by the restless repetition of our gaze, but by lovers turned inward towards each other, indeed by an idealized version of that embrace which Brentano and Arnim's seducer-guide imagined for the foreground of *Monk by the Sea*.

In the pendant canvas *Winter*, completed early in 1808, the verdant landscape has been replaced by a scene of death, and Friedrich carries this change into effect throughout all aspects of his image (illus. 126). The smooth, rounded and integrated forms of *Summer* become jagged, helter-skelter fragments of horizontals and verticals juxtaposed; the easy movement from foreground into distance becomes interrupted

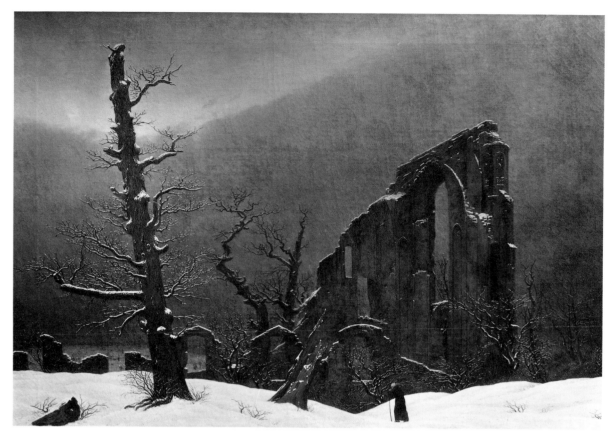

126 *Winter*, 1807–8
Destroyed

by the broken wall of a church; the edenic earliness of an almost wholly natural scene becomes a belated vision of ruins of past human epochs; earthly love becomes the love of God; and the foreground pair, autochthonous, young and swathed in classical drapery, become the single aged pilgrim in the medievalizing habit of a monk. Here, as in *Monk by the Sea* and the 1810 *Self-Portrait* (illus. 32, p. 70), the otherworldliness of monastic life serves to heighten the idea of otherness *per se* attributed by Schelling to the wanderer. In general, of course, Friedrich peoples his landscapes with wanderers rather than 'autochthonous beings'. Even when they are not monks, his *Rückenfiguren* do not appear as inhabitants of the landscape, but as strangers to the country, dressed in the garb of a bourgeois city dweller. Schelling, we recall, writes that staffage can knit together near and far through its presence in a painting. The *Rückenfigur* indeed draws the beholder into the canvas, making the landscape seem closer, more immediate, yet his otherness to landscape makes nature something experienced only from afar, from the standpoint of the *Bürger* who has lost a natural bond to the land and seeks it now with his gaze. His gaze, which defines his surroundings not as his home, but as something 'beautiful', distances him from the landscape.

In Schelling, the wanderer's exile is simply the attribute of his particular being.

And the evocation of distance represents but one choice open to the artist in rendering his work meaningful. In Friedrich, however, the choice between autochthony and estrangement has already been made, not as the painter's free decision, but as our own essential being in the world. The halted traveller, who doubles as ourselves, reveals how strangeness is proper to our present age, which is to say, our stage of life and epoch of history. Already in the pendant *Summer* and *Winter*, Friedrich accounts for this state of affairs by linking staffage to its moment in *time*. The lovers and the wanderer do not so much express the season in human terms. Rather, Friedrich's curiously archaic motif of 'seasons' itself functions primarily to temporalize and emplot his whole artistic project, to define as 'era' the vision that is his. The artist-monk before a ruined church, the altarpiece abandoned in the landscape, the barren alder in the snow, the present as a sad rememberance of the past: all these have become moments in a process and a history, or better, signs of the alienating dimension of history as such.

In the sepia *Stages of Life*, completed by 1834 but developing and partly repeating compositions from the lost series of 1803 discussed by Schubert, Friedrich envisions the whole of this process. The seven sheets, now kept in Hamburg, describe simultaneously a cycle of the cosmos, the epochs of history, the stages of life, the seasons, and the times of the day. The lovers of the Munich *Summer* are followed here from cradle to grave, their relationship to landscape and to each other reflecting their various temporalities. Following a vision of the cosmos at Creation (illus. 127), the couple appears in *Spring* (illus. 129) as infants born from the land itself, their heliotropic gaze fixed on the morning light. In *Summer*, they are again lovers, here surmounted by a prospect of their home (illus. 130). *Autumn* finds them as *Rückenfiguren* travelling upon the path of life (illus. 131). Dressed for war, the man marches towards the bright city at the right, past a hero's monument that might soon be his; the woman gestures towards the mountains, which, marked by a cross, suggests the difficult path of virtue. And while *Autumn* may thus be a scene of parting, *Winter* gathers the couple at their grave (illus. 132), while the final sheets follow the fate of their bodies (illus. 128) and the progress of their souls (illus. 133). What interests us here is how Schelling's distinction between autochthonous being and traveller is plotted not simply as alternative types of staffage, but as moments in a totalizing history of nature and man. The movement from *Summer* to *Autumn*, which is the turning point from life to death, as well as from nature to culture, occasions a change in staffage, and defines the *Rückenfigur* specifically as something late, something passing into death. The same holds true for Friedrich's 1820–22 *Times of the Day*, now in Hamburg, in which 'evening' is expressed through the presence of halted travellers in the wood (illus. 117, p. 205).

But Friedrich's most mature statement of autochthony and wandering as fundamentally temporal categories are his pendant canvases *Solitary Tree* and *Moonrise at Sea* of 1821, both now in Berlin (illus. 111, p. 199 and 119, p. 207). These landscapes

127 *Sea with Sunrise*, from the *Stages of Life* series, *c.* 1826
Kunsthalle, Hamburg

128 *Skeletons in Cave*, from the *Stages of Life* series, *c.* 1834
Kunsthalle, Hamburg

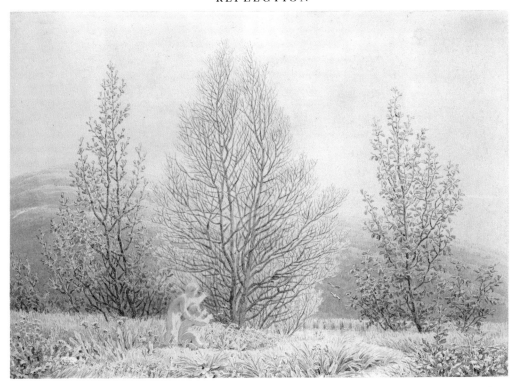

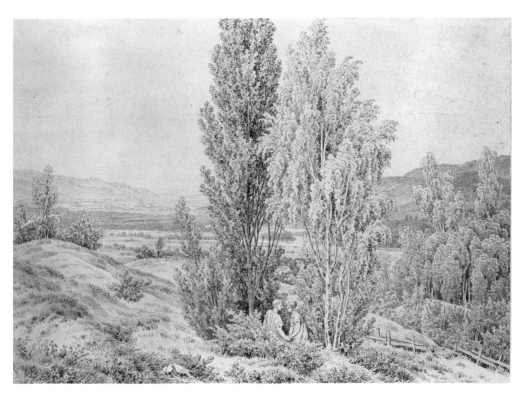

129 *Spring,* from the *Stages of Life* series, *c.* 1826
Kunsthalle, Hamburg

130 *Summer,* from the *Stages of Life* series, *c.* 1826
Kunsthalle, Hamburg

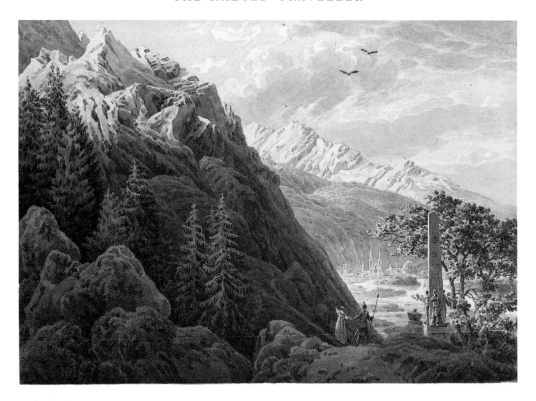

131 *Autumn*, from the *Stages of Life* series, *c.* 1834
Kunsthalle, Hamburg

132 *Winter*, from the *Stages of Life* series, *c.* 1834
Kunsthalle, Hamburg

133 *Angels in Adoration*, from the *Stages of Life* series, *c.* 1834
Kunsthalle, Hamburg

contrast not so much different seasons or times of day, nor even antithetical types of
staffage, but rather two modes of human experience relative to the world. In *Solitary
Tree*, we behold a wide, flat valley that embraces us as it does the central oak. Each
tree, pond and hamlet is mapped into a perfectly legible space, and we take pleasure
in the way our eye can colonize the scene: how, for instance, the many little wreaths
of smoke sent up among the trees – signs of human habitation throughout the
landscape – keep us at home wherever we look; how, too, our high perspective on the
whole forbids any concealment, any loss of sovereignty over what we see. The shepherd
with his flock is therefore appropriate here, not simply because he belongs to such a
vision of at-homeness in the landscape, but because our own viewing, too, is a pastoral
exchange, an easy dialogue of mind with nature and mind with mind. In *Moonrise at
Sea*, enough has been retained of this earlier architecture for us to know how
much is lost. The valley's flanking hills have become curved banks of clouds; the
distant mountain a glowing moon; the central tree a boulder on which sit, in the garb
of city-dwellers, three travellers turned to the sea. Yet where formerly we were
surrounded by the landscape, now we face a void of sea and sky. And where near and

far were equal to our gaze, now all is directed outwards, and the shepherd *in* the landscape has accordingly become three viewers *of* the landscape.

These three strangers on the rock need not be watching the passage of ships at sea for us to know that their message is death. Within their hidden gaze itself, they heighten our sense of the directionality of sight, reminding us of our blindness to what lies behind, and to where we now stand. And they metaphorize thereby the loss always sustained by us as directional beings caught in the irresistible flow of time. Friedrich brings us from our elevated place in *Solitary Tree* down to earth, to a place behind and below the *Rückenfiguren*. The very idea of a 'subjective viewpoint' undergoes inquiry: it is a stage within the life of humanity where landscape no longer is lived but viewed. The contrasts in *Solitary Tree* and *Moonrise* between objective and subjective, morning and evening, nature and culture, pastoral and elegiac, country and city interpret the very project of landscape painting and its subject.

'Poets', writes Friedrich Schiller in *On the Naïve and Sentimental in Literature* (1795), 'will either *be* nature or they will *look for* lost nature.' While the shepherd of *Solitary Tree* may be nature, the vision that encompasses him as well as *Moonrise* is clearly that of one looking for lost nature. Friedrich knew that his sentimental search was born from his place in time, and that the classical categories of landscape such as pastoral and heroic, were no longer present, but were now moments in a history. Schiller, asking how this history began, wrote again the story of the Fall:

It comes *from this*, that nature for us has vanished from humanity and we only meet it in its true form outside of humanity in the inanimate world. Not our greater *accord with nature*, quite the contrary our *opposition to nature* in our relationships, circumstances, and customs, drives us, to seek a satisfaction in the physical world which is not to be hoped for in the moral world. . . .

Landscape can replace history painting because the impulse to paint landscape is itself the mark of our place in time.

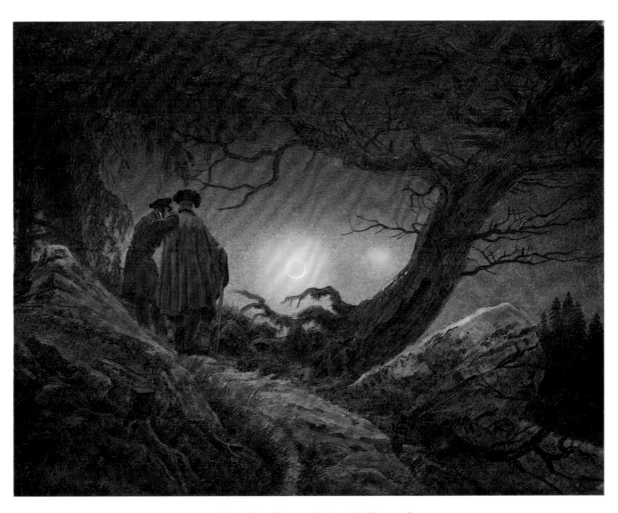

134 *Two Men Contemplating the Moon*, 1819
Staatliche Kunstsammlungen, Gemäldegalerie, Dresden

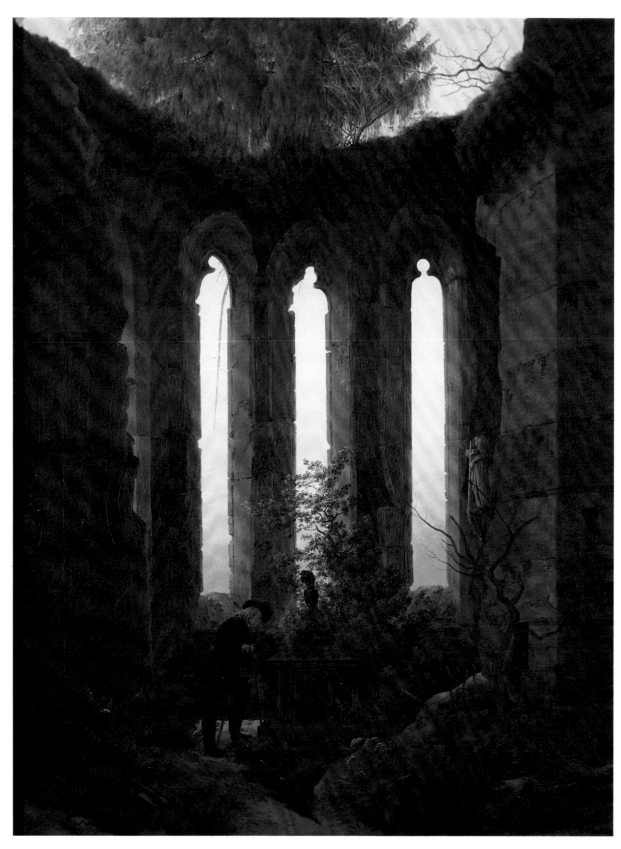

135 *Ulrich von Hutten's Grave, c.* 1823–4
Staatliche Kunstsammlung, Weimar

136 *Graves of Ancient Heroes*, 1812
Kunsthalle, Hamburg

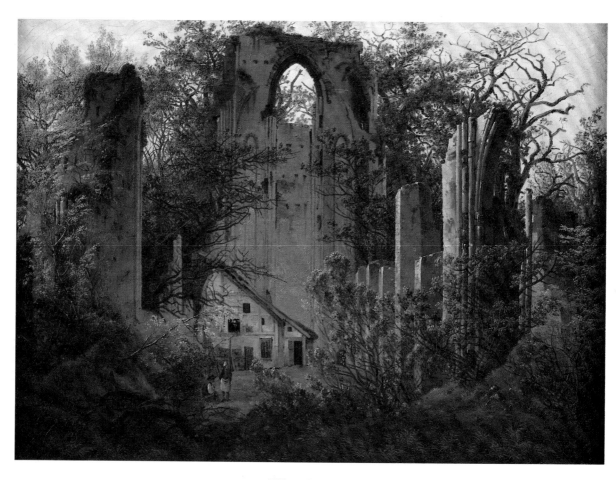

137 *Eldena Ruin, c.* 1825
National Gallery, West Berlin

138 *Meadow near Greifswald, c.* 1820–22
Kunsthalle, Hamburg

139 *Rocky Gorge, c.* 1823
Kunsthistorisches Museum, Vienna

12

Déjà vu

The *Rückenfigur* confers upon a landscape an aspect of pastness or belatedness. Let us experience this by returning to Friedrich's wood, this time through his canvas *Evening* from the series of 1820–21 (illus. 117, p. 205). Consider first the scene without the two dark figures, hiding them, say, with a finger. We see a scene late in the day. *We*, however, do not feel late; indeed we have arrived in time to see the sun's afterglow. The landscape is present to us and the day, though it has passed, has given birth to a beautiful moment. Our eye passes easily to the distant brightness, through the diaphanous band of tree trunks that lies between the darkening areas of rising terrain below and impenetrable foliage above. Now we lift our finger from the two halted travellers, and the structure of the landscape suddenly shifted, turning away from us to surround them. Even the sunset had changed, becoming accessible only by way of the travellers, who hauled us from the distance back into the wood, installing us always behind. What we saw becomes what they had already been seeing in a past long before our arrival. Their anteriority, expressed as our view of their backs, deepened our sense of 'evening'. It enabled the canvas not only to depict a late time of day, but also to elicit within us an experience of our own lateness as subjects of landscape.

Romantic poetry can help us navigate this pastness in Friedrich's landscapes, for it mounts an argument of its own about the temporality of experience. In *Resolution and Independence*, composed in 1802, William Wordsworth articulates a similar tense shift to the one we posited for *Evening*, presenting a landscape before and after it is inhabited by a traveller. The poem opens with a description of nature written in the pure present:

> . . . now the sun is rising calm and bright;
> The birds are singing in the distant woods;
> Over his own sweet voice the Stock-dove broods;
> The Jay makes answer as the Magpie chatters
> And all the air is filled with the pleasant noise of waters.

Morning discovers a landscape in harmony with itself. The birds, simultaneously attending to their own voice and answering each other's song, embody the pastoral ideal of a poetry in perfect reciprocity with nature and society, while the 'noise of waters', Wordsworth's preferred image of inspiration, augurs success for the poet, as well. Yet when the poet himself enters the scene in the third stanza, everything slips away:

> I was a Traveller then upon the moor;
> I saw the hare that raced about with joy;
> I heard the woods and distant waters roar . . .

'Now' becomes 'then' when the subject appears on the moor, and Wordsworth, no longer able simply to *hear* the waters roar, registers his distance from poetic voice and natural reciprocity through the past tense *heard*.

Of course, as Gotthold Ephraim Lessing observed in the *Laocoön* (1766), poetry as an expressive medium employs 'articulate sounds in time', while painting 'uses forms and colours in space', which enables the former to articulate tense shifts that are impossible in the latter. Friedrich's painting *Evening* without its *Rückenfiguren* is as present to us *as* painting as it is with them. We only 'read' the two dark patches of paint as travellers and invest them with a gaze. The shift in time that these figures seem to occasion is an illusion born from our encounter with the representation of an other. That Friedrich's paintings seem like landscapes already seen, even if we behold them for the first time, suggests the mysterious phenomenon of the *déjà vu*. In the *déjà vu*, I feel as if what I am experiencing has already happened, and I have been thrown back into a past moment of my life. While the illusion lingers, I experience a sense of expectancy, as if I know for sure what will happen next. What I anticipate in this immediate future is that I will recall the original experience that I now feel myself repeating. I await a recognition that will turn the *déjà vu* into a memory, one which will recapture some lost past. The recognition fails to come and the *déjà vu* fades. What is perplexing in this failure is that the anticipated moment a little further on contains the illusion of a past origin of experience. The *déjà vu* excites us with an anticipated return, yet leaves us in a state of exile; anticipation becomes finally nostalgia for a place I have never visited. The *Rückenfigur* in Friedrich occupies this curious place a little further on where the past is made present. It stands before us already there in the place we hope to be. From this vantage point, we occupy its past, the place from which it has wandered. Its footprints lead back to us. And yet, from another perspective, the *Rückenfigur* as an emblem of subjective experience, or even as painted object, is a trace of the past. It gazes not into its future, but into a now concealed past anterior to its being: the unseen wood, the unpainted surface of the canvas. We, the community of viewers who pass behind, are its future. Thus walking forth into a world that is both past and future, the *Rückenfigur* can show us a vision of having already been in a place never visited before. It marks a *locus* of fulfilled desire, desire with its endlessly deferred anticipations and its embeddedness in pasts we never experienced, desire as it was formulated in Sigmund Freud's Heraclitean aphorism: 'Wo es war, soll ich werden' ('Where it was, there I shall come into being').

'What is called "romantic" in a landscape', wrote Goethe in his *Maxims and Reflections*, 'is a silent sense of the sublime in the form of the past, which is to say, of solitude, of absence, of seclusion.' Friedrich sometimes registers the temporality of his scenes in their titles, as in his pendant pictures called *From the Dresden Heath*

(illus. 1 and 2) or, more explicitly, in the canvas exhibited in Dresden in 1835 under the title *Memories of the Riesengebirge* (illus. 93, p. 174). Yet even without such textual evidence, his paintings can read as landscapes of memory. In the *Meadow near Greifswald* of around 1821, the artist's birthplace becomes a distant object of longing or nostalgia, not simply because a golden light envelopes the silhouetted city like a vision of paradise, or even because the city's distant gate, occurring at the precise midpoint of the visible horizon, discloses a special relation between the distant city and the original viewing subject (illus. 138, p. 231). Friedrich locates us in a dark and more imperfect foreground zone with no clear link to the prospect beyond. The bank of earth pushes us back from Greifswald and its beckoning gate, setting our own perspective off against a more privileged position within the visible, here occupied by the blissful horses leaping on the sunlit field.

More commonly, of course, it is the *Rückenfigur* that occupies this place a little onward into the scene. In *Woman before the Setting Sun* of around 1818, the subject in the landscape blocks with her body our view of the departing sun (illus. 97, p. 178). The woman, who probably represents Friedrich's wife Caroline in the first year of marriage, stands at the centre of the canvas, at the dead end of a path flanked by boulders. The rays of the sun seem to converge at her womb and are picked up again in the radiating lines of her gathered gown, in her outstretched arms and her crenellated headdress. She becomes the sunset we cannot see, rather like the halted traveller was figured as source for the vision of landscape in *Wanderer above the Sea of Fog* (illus. 77, p. 155). And she recuperates the departed sun of *Cross in the Mountains* (illus. 13, p. 35), not only by inhabiting the radically mediated position of the effigy of the dying Christ, but also, perhaps, by her projected role as mother to a future child. The sun in *Cross in the Mountains*, we recall, was partly an emblem of King Gustav IV Adolf of Sweden, whose promise for Friedrich would be reborn as Caroline's first son, also named Gustav Adolf. While she stands before the setting sun, the turned woman, crowned like a goddess, thus becomes Aurora, like Runge's striding woman in small *Morning*, only seen from behind.

Woman before the Setting Sun is Friedrich's vision of origins, yet the experiencing human subject as source of art, the sun as giver of light and life, and the woman as mother to the artist's future self, have all been concealed or turned away from the artist and from ourselves. Perhaps in answer to Runge's small *Morning*, in which beginnings proliferate from an open centre outward past the picture's frame and towards us, Friedrich fashions a movement into absence: the sunrise that takes place as sunset, the anticipated son that appears as the departing sun and overthrown sun-king, the birth that is prefigured at the dead end of a path leading nowhere. Our position behind this convergence of past and future is not altogether melancholy. If the sun were real, its light would blind. If it were painted, its colours would disappoint. The light of the sun, like the origin of painting, is a moment that shall have already passed away and can only be imagined retrospectively. Or as Wordsworth writes of

235

the experience of the nature's rebirth in *Lines Written in Early Spring*, 'And I must think, do all I can/That there was pleasure there'.

Experience is full of memories of pasts we never really experienced. Such gaps in our temporal being are a central concern of Romantic crisis poems. In *Tintern Abbey* (1798), for example, Wordsworth feels himself 'changed' when he returns to the banks of the Wye River and tries, through a remembrance of things past, to heal the discontinuity of days not bound each to each. And although he can describe vaguely a time when nature was 'all in all', he complains finally, 'I cannot paint what then I was', leaving us with the sense that the landscape of memory is as elusive as the *déjà vu*. Similarly, in the sleep-filled opening of *Frost at Midnight* (1798), Samuel Taylor Coleridge muses on the fabric of his past and seeks a mood of sympathy in which he can bless the future: his infant son cradled by his side. The 'film' flapping back and forth on the fire grate becomes vehicle for memory, for according to a superstition alive in Coleridge's childhood, such soot was called a 'stranger' and was supposed to portend the arrival of some absent friend. Gazing at the film, the poet recalls a time in his youth when he had gazed at such a sight:

> But O! how oft,
> How oft, at school, with most believing mind,
> Presageful, have I gazed upon the bars
> To watch that fluttering *stranger*! and as oft
> With unclosed lids, already had I dreamt
> Of my sweet birth-place . . .

The memory of having seen the 'stranger' in youth evokes within itself another memory of the poet's earliest childhood. In this remembrance of having already remembered, Coleridge anticipates the future. The bells of his birthplace ring 'falling on [his] ear/ Most like articulate sounds of things to come!' This projection of the future from the past, of Coleridge's adulthood now at the side of his sleeping child from out of the memory of the child he was, is an '[e]cho or mirror seeking of itself', in which before and after play about an elusive present. The anticipated figure is held in another awaited moment. The 'stranger' augurs the appearance of some past acquaintance: 'my heart leapt up / For still I hoped to see the *stranger's* face'. The 'stranger' will not reveal something strange. Fluttering on the threshold between the canny and the uncanny, it will herald the deeply familiar, the countenance of some friend or relative. As in the *déjà vu*, the sight of the 'stranger' anticipates a figure in which something will return; but in the poem, as again in the *déjà vu*, the stranger does not yield a familiar face. The sooty flap, fluttering this way and that, elicits something hidden, something secret: 'For still I hoped to *see* the stranger's *face* . . .' (italics mine). Coleridge here articulates our desires when we confront Friedrich's halted travellers. We anticipate the turn of the *Rückenfigur* whose face will remain always hidden.

The German poet Friedrich de la Motte–Fouqué expressed this anticipation as a desire in his ecphrastic poem of 1823 on Friedrich's *Woman at the Window* (illus. 76):

Who draws me on, through a magical force?
I might almost flee, but I cannot yet from hence!
I might approach her – stand back, O bold undertaking!
Do not enrage the magnificent figure!
O turn you – no, no, O do not turn
Your face toward me, gracious riddle!

The *Rückenfigur* evokes in the poet both desire and anxiety, desire that he should see her face and anxiety that he should incur her wrath or uncover her mystery. Such a turning would indeed change the fabric of Friedrich's painted world. The *Rückenfigur* intensifies our sense of the forward direction of our experience of the painting. It seems to direct our look in the direction of its gaze, a gaze imagined in the field of the other. Of course, what we experience is only the direction at the heart of our bodily experience: we see only from our face. To experience blindness, we must not close our eyes (for then we see darkness and a play of after-images), but try to see from the back of our head, a position of sightlessness which the *Rückenfigur* enacts in relation to us. What would happen if it would turn and face us? The dark figures of *Evening* are indistinct enough to imagine this movement (illus. 117, p. 205). If the eyes of the travellers were staring at you, eyeing you with the same indifference as you eye them, the painted world would shift 'as with the might of waters'. The trees, flowers, the luminous light on the horizon would also stare at you. The structure of the landscape would turn inside out, like a glove too hastily removed from a hand. The recognition that one has been seen comes as a shock, changing all perspectives in our world, ordering it from the privileged position of the travellers who watch us. Such terrible turns are mythologized variously as the face of the Medusa, the evil eye, the gaze of the *Doppelgänger* that kills, the backward glances of Lot's wife and of the poet Orpheus. The turn of the *Rückenfigur* would render us part of the painting, would turn us to paint.

Such turns of an Other, such shifts from seeing to being seen, have a central place in Wordsworth's poetry and belong to the motif of the halted traveller. Consider the disturbing effect of the gaze in the 'Stolen Boat' episode of the autobiographical poem *The Prelude* (1805 version). The story takes place in the poet's youth, when, as Wordsworth writes, 'I was a fell destroyer'. In the wake of his childish disregard (in German *Rücksichtslosigkeit*, literally 'backward viewlessness') for nature he hears something creeping up from behind:

. . . when the deed was done
I heard among the solitary hills
Low breathings coming after me, and sounds
Of undistinguishable motion, steps
Almost as silent as the turf they trod.

Signs of the approach of the Other here seem more imagined than real: its steps echo as silence within silence. Its presence is felt, though invisible and 'undistinguishable', perhaps because it is the totality of the visible that will fix him in its gaze. The event takes place, Wordsworth notes, in 'a vale/ Wherein I was a stranger', and it begins with seeing: 'No sooner had I sight of this small skiff . . . Than I unloosed her tether and embarked'. Rowing out on to the lake in the stolen boat, the boy reveals his narcissistic feeling of power in his gaze:

> . . . as suited one who proudly rowed
> With his best skill, I fixed a steady view
> Upon the top of that same craggy ridge
> The bound of the horizon . . .

He gazes toward what he thinks are the limits of his world, rowing forward, yet facing back. This reversed gaze *(Rücksicht)* yields a deeper reversal. Something rises up from the bounds of the boy's horizon faster than he can row:

> . . . a huge cliff
> As if with voluntary instinct,
> Upreared its head. I struck, and struck again,
> And, growing still in stature, the huge cliff
> Rose up between me and the stars, and . . .
> . . . like a living thing
> Strode after me.

The mountain seems to follow the boat because the smaller ridges in the foreground appear to recede more swiftly into depth. The cliff, relative to the foreground, disobeys perspective, growing in its apparent size as it becomes more distant. Accordingly, the boy feels the world moving in the reverse direction of his rowing; he is hauled backwards in the direction of his turned gaze. The phenomenon itself is a product of the gaze for, in reality, the landscape is motionless; only when the scene is beheld from the boy's particular perspective (one of a 'stranger' moving about in a landscape not his own) does the world have this animism. When the landscape turns inside out, the boy invests the huge cliff with a face (the mountain 'uprears its head') and a gaze that pursues him. Thus followed, the boy-traveller must halt and return to shore.

In the famous 'Boy of Winander' episode of *The Prelude*, there is a similar experience of being seen by the gaze of nature, this time ending in death or annihilation. The boy, we recall, believes he is fooling nature with his 'mimic hootings' that stir the owls into song. His sounds seem to initiate the natural hoots that follow antiphonally. But when 'pauses of deep silence mock his skill', he discovers the *phoné* of nature which is prior to his voice, and which enters into his heart, along with the whole visible scene. Where the experience of being watched in the 'Stolen Boat' episode involves a reversal in spatial direction, here the reversal is revealed as a temporal one.

Interestingly, the hyperbole of entrance takes the form of a flowing in or *influence* of the world into the heart of the boy. Such an influence, like the gaze of the Other, annihilates, and the boy dies 'in childhood ere he was full ten years old'.

When the child returns home in the 'Stolen Boat' episode, he is aware of a sense of 'solitude or blank desertion'. It is the loneliness of a heightened self-consciousness born from guilt. The boy is not merely seen by the gaze of the cliff; he is also caught in the act of trespass or theft. Here, as later in Jean-Paul Sartre's scenario in the park in *Being and Nothingness* (1943), being seen involves becoming an object which the Other judges. Guilt and a sense of separation of self are the costs of knowledge. When Eve and Adam ate of the Tree of Knowledge, 'the eyes of them were opened, and they knew that they were naked' (Genesis 3: 7). Consciousness involves a new way of seeing: the self exposed to a gaze that makes it feel naked, and because naked, self-conscious. To know one is exposed involves distinguishing oneself from nature, and experiencing one's own body as something that can be looked at and must therefore be hidden. One cannot hide, however, for what sees me is (like Wordsworth's cliff) the totality of the visible, and thus one bears the burden of guilt. Such an intertwining of guilt, self-consciousness and solitude is expressed in the *Rückenfigur*. As a wanderer, his existence recalls the purgatorial lives of Cain, Ahasuerus, and Coleridge's Mariner. He stands alone in nature, distinct from the landscape that occupies his gaze. His back is turned from us, as if to hide his face in shame, and to conceal the front of his body which would be his nakedness.

A being who sees and is seen, the *Rückenfigur* mediates the position of the subject in the landscape. Sensible and sentient, his body exists both as part of the visible landscape, and as a place within the scene that is inhabited with a touch and a vision like our own. 'As soon as I see,' writes Merleau–Ponty, 'it is necessary that vision (as is so well indicated by the double meaning of the word) be doubled with a complementary vision . . . myself seen from without, such as another would see me, installed in the midst of the visible, occupied in considering it from a certain spot'. In Friedrich, we behold precisely this doubled vision. Yet, how are *we* situated within this doubling? Surely the eye that sees the *Rückenfigur* will also itself be seen by another gaze. The limits of our own sight are clear enough to us when we encounter Friedrich's *Rückenfigur*. When we beheld the *Chasseur in the Forest*, the turned soldier deepened our sense of the narrowness of our experience: we could not see his eye nor what he saw, the snowy path beyond the turn. Beholding the *Rückenfigur* we become aware that we see only from one point, while in our existence we are observed from all sides. The gaze that sees the *Rückenfigur* turns to watch us as well. It is a gaze that is prior to the eye, a seeing to which, as Jacques Lacan says, 'I am subjected in an original way'.

From this perspective, which constructs us as subjects, our sense of belatedness vis-à-vis Friedrich's landscapes emerges within the experience that we are neither the centre nor the origin of our vision, and that what we see has already been formed by

a gaze prior to our act of seeing. The *Rückenfigur*, here as the artist returned to the original moment of his perception of nature, elicits from us an awareness that experience is constituted retrospectively, as always only a landscape of memory. Indeed the *Rückenfigur* itself compromises the fullness of our own experience as viewers, a fullness idealized in the concept of *Erlebniskunst*. In analysing the motivations for the Romantic motif of the halted traveller, Geoffrey Hartman has argued that the self's arrest in nature, and with it the reader/viewer's arrest before the work of art, is always linked to an encounter with an earlier vision, a prior self or prior voice:

> In every case ... there is some confrontation of person with shadow or self with self. The intense lyricism of the Romantics may well be related to this confrontation. For the Romantic 'I' emerges nostalgically when certainty and simplicity of self are lost. In a lyric poem it is clearly not the first-person form that moves us (the poem need not be in the first person) but rather the I towards which that I reaches.

This retrospective moment may be variously constituted. In Walter Scott and Ludwig Tieck, for example, it is antiquarian; in Friedrich Hölderlin and to some extent in Novalis, it is visionary; in Wordsworth and Coleridge, it is, as Hartman puts it, 'deeply oblique', embedded in the reading structure of the lyrical monologue itself. In Friedrich, it occurs not only in the *Rückenfigur*'s doubling of vision, but also in the artist's taste for the Gothic. A nostalgia for the Middle Ages informs both individual motifs in Friedrich's art, such as monks, ruined churches, retable altarpieces and visionary cathedrals, and also the artist's whole formal 'system', for example, his partly archaizing preference for compositional symmetry, which reoccupies the diagrammatic religious art of the Middle Ages, and his particularizing painterly manner, which contemporaries like Ramdohr understood as the conscious imitation of an 'old German' style discernible in Albrecht Dürer and his contemporaries.

In a curious canvas from 1838 and now in Frankfurt, Carl Gustav Carus makes explicit one relation between Romantic historicism and the motif of the *Rückenfigur* (illus. 140). The sixteenth-century masters Raphael and Michelangelo, depicted as subjects in the landscape, emblematize the contemporary viewer's belatedness doubly, both as a temporality mediated by the halted traveller as such, and as a latecoming vis-à-vis artistic tradition. The two greatest masters of Italian painting may be heroized as quintessential precursors (in German *Vorgänger*, literally 'walking before') of the art of Carus and his culture, yet as Runge remarked, they belonged precisely to an earlier epoch, one before the advent of landscape; and thus their portrayal as Romantic *Rückenfiguren* represents less a continuity with Rome than a rift between present and past. Friedrich never places his art so clearly within a grand tradition, yet his *Rückenfiguren* are meant to convey a quite specific relation to the past.

Friedrich's only known explanation of the *Rückenfigur* motif is recorded in the memoirs of the Dresden poet and translator Karl Förster. Förster describes his visit to the artist's studio in 1820 in the reluctant company of the Nazarene painter Peter

240

140 Carl Gustav Carus, *Raphael and Michelangelo*, 1839
Freies Deutsches Hochstift, Frankfurt

Cornelius, who at the time was widely regarded as Germany's greatest master. Friedrich humbly displayed some canvases to the arrogant Cornelius, while the latter pretended at first not to remember who exactly Friedrich was. Förster, for his part, admired the way the artist 'always knew to place his figures in a meaningful relation to the landscape', a relation that Förster interpreted succinctly as the 'contemplation of the infinite'. When Friedrich brought forth a painting of 'two cloaked men embracing each other as they gaze enraptured at a landscape with a moon', however, he offered his own rather different exegesis: ' "They are plotting demagogic intrigues *[demagogische Umtriebe]*," said Friedrich ironically, as if in explanation'. The landscape thus described dates from 1819 and hangs now in Dresden (illus. 134, p. 227); the two *Rückenfiguren* probably represent, at the left, Friedrich himself and, at the right, his student August Heinrich. And Friedrich's phrase 'demagogic intrigues' has a very precise meaning within German politics in the year of Cornelius's and Förster's visit.

'Demagogue' was a derogatory term used by conservatives for someone who espoused the ideal of a unified German state established by constitution and governed with the consent of its citizens. Liberal nationalism had emerged in Germany mainly as a consequence of the wars against Napoleon. The German bourgeoisie, having been mobilized to defeat the French armies, returned to their variously governed territories with a strengthened belief in the possibility of national unity. They trusted, too, that their rulers, the territorial princes and Prussian king under whom they had fought, would now support them in this goal. One centre of such nationalist sentiments was the universities. Before 1813 students had organized themselves regionally, in hard drinking and often brutal fraternities or *Landsmannschaften* comprised of natives

of an individual territorial principality (such as Saxony, Franconia, Westphalia). After 1815, the students returning from the battle-field had lost their strong local allegiances. Inspired by the nationalist rhetoric of the writer Ernst Moritz Arndt (a close acquaintance of Friedrich), they banded together in well-behaved and strongly liberal corporations or 'German societies' with names like Teutonia, Vandalia, Germania and Arminia. Their colours were black, red and gold; their songs celebrated German unity; and their appearance and apparel consisted of a short black jacket and shirt with stand-up collar, a barret, soft-leather shoes (rather than the traditional student footgear of jack-boots and spurs), bushy beard or side-burns, and long unpowdered and uncurled hair. This costume, called *altdeutsch* ('old German'), was invented by Arndt himself in 1814, and it was believed to imitate the garb of the townsman in the supposed heroic era of German unity, the late Middle Ages and Reformation.

The significance of the *altdeutsch* attire was summarized by the painter, poet and future revolutionary Harro Harring, who journeyed from Copenhagen to Dresden in 1819 to study at the Academy and eventually to join Friedrich's circle. Harring wrote of his voyage to Germany:

The ship sped there at a remarkable time. What had been strange for centuries now returned to light; the German had made himself a jacket like his fathers wore, and he strode in this jacket towards the future – a future which stretched out magnificently before him, decorated with all the blessings of peace, rich in promises, and rich in proud hopes! The German wandered on blood-soaked ground whose freedom was purchased through the death of thousands of excellent men, who sacrificed themselves as offering for a long-yearned-for atonement! The German oaks murmur mysteriously of a wondrous thing, of a powerful age . . .

It was nationalists like these who in 1817 gathered by the hundreds at the Wartburg Festival in Thuringia to mark the 300th anniversary of the Reformation. Dressed in the *altdeutsch* garb of an imagined lost unity in order to anticipate a single Germany still ahead, they recuperated the songs and rituals of the late Middle Ages, celebrating German unity by recollecting a heroic past. And in imitation of Luther's burning of the papal bulls, they set fire to 'un-German' books and to various tokens of oppressive princely rule.

Their hopes were soon to be disappointed, however. Fearful of such agitation, the territorial princes and their conservative allies rejected as unhistorical the link between the Napoleonic wars and German unification, regarding the former as merely the people's revolt to restore a previously legitimate sovereignty, rather than as a mandate for political change. Regarding liberals 'rich in proud hopes' as a threat to aristocratic and royal privilege, Friedrich Wilhelm III of Prussia decreed that the struggle against Napoleon should be termed the 'War of Liberation' *(Befreiungskrieg)*, rather than 'Freedom War' *(Freiheitskrieg)*, so as to discourage any analogy to the American and French revolutions. In his first speech to parliament in 1847, Otto von Bismarck was still disputing the liberal 'legend' that the liberation of Prussia from the French was not the sufficient and final goal of the war of 1813. While the repression of nationalism

began already in 1815, it intensified in 1819, after a theology student, Karl Ludwig Sand, assassinated the poet and playwright August Kotzebue, despised by liberals for his frivolous comedies, his enjoyment of lucrative foreign patronage, his reactionary politics, and his alleged spying for Russia. Immediately after the murder, Prince Klemens von Metternich, the conservative Austrian foreign minister and chief architect of the 1815 Congress of Vienna, appointed a commission to end what it would call 'demagogische Umtriebe'. This resulted in the Karlsbad Decrees of September 1819, which limited freedom of the press, banned from the schools and universities teachers professing liberal or nationalist ideas, forbade student fraternities of all kinds and outlawed the *altdeutsch* costume.

Thus in 1820, when Cornelius and Förster were shown Friedrich's *Two Men Contemplating the Moon*, they would have recognized at once the political message of the picture. The artist and his student stand dressed in 'jackets like [their] fathers wore', flanked to the right by a ruined tree, perhaps symbolic of the passing old order, and to the left by an evergreen, symbolizing hope. They gaze into a moonlit landscape, there to discern a future Germany. Friedrich's 'ironical' use of the phrase *demagogische Umtriebe* reflects not only his bitter disillusion following the condemnation of his cause, but also his recognition of the disparity between the alleged intrigues and their repression by the state. The *Rückenfiguren* reveal their demagogy to have been nothing but a passive hope, a faith that the individual would be spectator to the necessity of historical change, just as he or she is witness to the constantly changing life of landscape. Interesting recent work on Friedrich has reminded us that his paintings almost always depict specifically *German* landscapes, and that the artist's rejection of the Claudian 'ideal' landscape, as well as of the new classicizing 'heroic' landscape of the German Romans Koch and Richter, reflect his political stance. Landscape is for him a mode of auguring a new Germany. And natural history – that is, the irreversible process legible in the times of day, the seasons of the year and the geological epochs of the earth (illus. 112 and 139) as recorded in *Erdlebenkunst* – demonstrates the inevitability of that historical future. The *Rückenfigur* belongs partly to this message. After 1817, Friedrich generally peoples his landscapes with men and women dressed in *altdeutsch* clothes. The retrospective moment articulated by the halted traveller, which we have analysed in terms of a confrontation of self with earlier self, has thus a profound historical dimension as well. On the one hand, the *Rückenfigur* expresses nostalgia by the historicism of its costume, which invokes an earlier epoch of political, social and cultural cohesion, indeed the epoch of the Christian altarpiece and cathedral, whose fragments order and disorder the present landscape. On the other hand, referring to the new national ideal, the *Rückenfigur* transposes the metaphysical yearning for union with nature into the contemporary political imperative of a unified state.

However, like all allegories discoverable within Friedrich's pictures, such a concrete ideological message belies the complexity of Romantic art. The historical subject of

landscape, by which I mean both the *Rückenfigur* as reference to the events of Friedrich's time, and the historicizing vocabulary (*altdeutsch* costume, etc) whereby such events are represented and understood, is not an interpretative solution to Friedrich's art, but only another vehicle for that endless doubling back of meaning celebrated in Tieck's *Sternbald* and mocked in Kleist's 1810 review. The impoverishment of history stands emblematized in what is perhaps Friedrich's most overtly political canvas, the *Grave of Hutten* of 1823–4, now in Weimar (illus. 135, p. 228). A man in an *altdeutsch* barret, uniformed as a German soldier, stands contemplating the sarcophagus of the early sixteenth-century humanist and patriot Ulrich von Hutten. On the grave are inscribed the names of G. J. D. Scharnhorst, who died a hero in battle in 1813, along with Joseph von Görres, Ernst Moritz Arndt, and Friedrich Ludwig Jahn, the main liberals opposing the restoration. The painting is an occasional work commemorating at once the 300th anniversary of the failed German Knights' Revolt of 1523 against the Roman Church, which was inspired and supported by Hutten, and the 10th anniversary of the French defeat. In 1823 there existed no proper monument to Hutten, and this failure to honour a patriot of the distant past, embodied in Friedrich's canvas by the ruins surrounding the tomb, is compared to the persecution of the nationalists of the artist's own time. The patriotic traveller in the dress of the past contemplates here his historical model and himself becomes a figure of neglected history.

Interestingly, Ulrich von Hutten's own patriotism took a similarly nostalgic form. In his writings, he sought to resurrect the vision of Germany presented by the first-century Roman historian Tacitus in *Germania*, in which a courageous Teutonic people, dwelling in northern forests, constantly wars with the Latins. By Hutten's account, the Roman popes of his time were the successors of the ancient caesars. When Friedrich and his culture thus link themselves back to Hutten and his visionary, but ultimately unsuccessful nationalism, they evoke what was already, in the Renaissance, a proto-historicist evocation. Friedrich's *Rückenfigur* thus embodies not history, but a missed encounter with history. Its project of reunification takes place always as *déjà vu*, repeated in the Renaissance; in the Romantic era; in the nationalistic Friedrich-renascences of the twentieth century, culminating in the Nazi reception of Romantic landscape; and perhaps even in our time, as the borders of the Germanies unravel.

Friedrich's *Rückenfigur* is a traveller in this purgatory, and through its gaze, which at once constitutes our vision and transforms political action into internalized *Erlebnis*, we can discern the troubled and still unstable relation between art and history. It is discernible in *Wanderer above the Sea of Fog*, where the deceased patriot beholds a Germany whose form as yet can be only imagined, as the product of the heart and of desire, and whose boundaries are already established as disturbingly infinite. And it arrests you on the Dresden heath, before the thicket in winter, when what you thought were just alders in the snow are fragments of your darkest history.

Sources and Bibliography

The main general work on Caspar David Friedrich is Helmut Börsch–Supan and Karl Wilhelm Jähnig, *Caspar David Friedrich: Gemälde, Druckgraphik und bildmäßige Zeichnungen* (Munich, 1973), which contains a short biography of the artist, an extensive bibliography of critical responses to his work (many reprinted in full), and a complete *catalogue raisonné* of the paintings, prints and major graphic works. Friedrich's drawings are catalogued in Sigrid Hinz, 'Caspar David Friedrich als Zeichner: Ein Beitrag zur stilistischen Entwicklung der Zeichnungen und ihrer Bedeutung für die Datierung der Gemälde' (Ph. D. dissertation, Greifswald, 1966), and are published in Marianne Bernhard, ed., *Caspar David Friedrich: Das gesamte graphische Werke* (Herrsching, n. d.). Friedrich's writings, along with a selection of relevant documents by the artist's contemporaries, are gathered most recently in Sigrid Hinz, *Caspar David Friedrich in Briefen und Bekenntnissen* (Munich, 1968); see also Gertrude Fiege, *Caspar David Friedrich in Selbstzeugnisse und Bilddokumente* (Reinbek bei Hamburg, 1977), and, for additional material, Karl–Ludwig Hoch, *Caspar David Friedrich: Unbekannte Dokumente seines Lebens* (Dresden, 1985). Indispensable for Friedrich's early training and career is Werner Sumowski, *Caspar David Friedrich–Studien* (Wiesbaden, 1970), which also includes an extensive bibliography; useful, too, is the catalogue for the great 1974 Hamburg Kunsthalle exhibition *Caspar David Friedrich 1774–1840*, ed. Werner Hofmann (Munich, 1974).

Part I Romanticizing the World
1 From the Dresden Heath

For a discussion of the two canvases *From the Dresden Heath*, see Börsch–Supan and Jähnig, *Friedrich*, pp. 410–11; *Caspar David Friedrich 1774–1840*, ed. Hofmann, p. 282; Munich, Kunsthalle der Hypo–Kulturstiftung, *Deutsche Romantiker: Bildthemen der Zeit von 1800–1850*, ed. Christoph Heilmann, exh. cat. (Munich, 1985), 194–6; Christoph Heilmann, *Caspar David Friedrich: 10 Gemälde. Ausstellung anläßlich einer Neuerwerbung des Ernst von Siemens–Kunstfonds für die Neue Pinakothek München* (Munich, 1984); and Hamburg, Kunsthalle, *Luther und die Folgen für die Kunst*, ed. Werner Hofmann (Munich, 1983), cat. no. 456–457.

For a discussion of the phrase *naer het leven*, see Svetlana Alpers, *The Art of Describing: Dutch Art in the Seventeenth Century* (Chicago, 1983), pp. 40–41. The aesthetic foundation and historical origins of *Erlebniskunst* is outlined in Hans–Georg Gadamer, *Wahrheit und Methode: Grundzüge einer philosophischen Hermeneutik*, 3rd rev. ed. (Tübingen, 1972), pp. 56–77.

2 The Subject of Landscape

Carl Gustave Carus's anecdote about Friedrich's inverted canvas appears first in his *Lebenserinnerungen und Denkwürdigkeiten* (Leipzig, 1865–6), 3, p. 288, excerpted in Hinz (1968), p. 204.

Friedrich's interpretation of *Swans in the Rushes* appears in *Biographische und literarische Skizzen aus dem Leben und der Zeit Karl Försters*, ed. L. Förster, reprinted Hinz, p. 220.

Landscape with Oaks and Hunter, Winter Landscape and *Winter Landscape with Church* are identified as belonging to a series in Börsch–Supan and Jähnig, *Friedrich*, pp. 316–19, on the basis of a letter from Gustav Heinrich Naeke to Dr Ludwig Puttrich dated 9 June 1811, which Börsch–Supan and Jähnig reproduce (pp. 212–13). The attribution of the London *Winter Landscape with Church* as an original Friedrich, and the Dortmund version as a copy, is argued convincingly in John Leighton, Anthony Reeve and Aviva Burnstock, 'A "Winter Landscape" by Caspar David Friedrich', *National Gallery Technical Bulletin* 13 (1989), pp. 44–60.

My quotation from John Clare is taken from 'A Vision' of 1844.

3 Romanticism

My reading of the equivocal nature of the term 'Romanticism' is indebted to Philippe Lacoue–Labarthe and Jean–Luc Nancy, *The Literary Absolute: The Theory of Literature in German Romanticism*, trans. Philip Barnard and Cherly Lester (Albany, NY, 1988), especially pp. 1–8 and 39–58. For a general introduction to the problem, see R. Immerwahr, 'The word *romantisch* and its History', *The Romantic Period in Germany: Essays by the Members of the London University Institute of German Studies*, ed. Siegbert Prawer (New York, 1970). An early attempt to come to terms with the historiographical nebulousness of the term is Arthur O. Lovejoy, 'On the Discrimination of Romanticisms', *Proceedings of the Modern Language Association*, 39 (1924), pp. 229–53; this essay, along with a number of other definitions of Romanticism, is usefully collected in Robert F. Gleckner and Gerald E. Enscoe, eds, *Romanticism: Points of View*, 2nd ed. (Detroit, 1975). See also the anthologies by David Thornburn and Geoffrey Hartman, eds, *Romanticism: Vistas, Instances, Continuities* (Ithaca, 1973) and by Harold Bloom, ed., *Romanticism*

and Consciousness: Essays in Criticism (New York, 1970).

The most perceptive analysis of the metaphor of the book in Romanticism is Hans Blumenberg's chapter, 'Die Welt muß romantisirt werden' in his *Die Lesbarkeit der Welt* (Frankfurt, 1981), pp. 233–66, which stands behind my reading of Novalis and Schlegel. Other useful studies on the metaphor of the world as book are, first and foremost, Ernst Robert Curtius, 'The Book as Symbol', in *European Literature and the Latin Middle Ages*, trans. Willard R. Trask (Princeton, 1953), pp. 302–47; Frank Kermode, *The Sense of an Ending: Studies in the Theory of Fiction* (Oxford, 1966); Jacques Derrida, 'Edmund Jabès and the Question of the Book', in *Writing and Difference*, trans. Alan Bass (Chicago, 1978), pp. 64–78; and Gabriel Josipovici, *The World and the Book: A Study of Modern Fiction*, 2nd ed. (London, 1979). For an attempt to trace one after-life of the Romantic idea of the book in twentieth-century painting, see my own 'Paul Klee and the Image of the Book', in Rainer Crone and Joseph Leo Koerner, *Paul Klee: Legends of the Sign* (New York, 1990).

Ludwig Tieck's remark about Friedrich and Romantic philosophy is quoted in Paul Kluckhohn, *Charakteristiken: Die Romantiker in Selbstzeugnissen und Äusserungen ihrer Zeitgenossen* (Stuttgart, 1950), p. 142. For Friedrich Schlegel's *Athenaeum* fragments, I have used throughout the following recent edition: *Kritische Schriften*, ed. Wolfdietrich Rasch (Munich, 1970). The standard critical edition of Novalis is *Novalis: Schriften*, ed. Paul Kluckhorn and R. Samuel, 4 vols (Stuttgart, 1960–75).

The fragment on 'romantization' appears in *Novalis: Schriften*, 2, p. 545; Friedrich Schlegel's letter to Novalis on the new Bible, of 20 October 1798, also appears in *Schriften*, 4, p. 501 ff; and Novalis's response, 7 November 1798, in *Schriften*, 4, p. 262 ff. Novalis's comment on the object as temple appears in his *Vermischte Bemerkungen* (1797), no. 73 (*Schriften*, 2-VI, no. 343); and his definition of Romanticism as distance in his *Allgemeinen Brouillon* (1798–9), *Schriften*, 3-IX, no. 342.

Part II Art as Religion
4 The Non-Contemporaneity of the Contemporary

There is a large literature on Friedrich's *Cross in the Mountains* and the controversy it sparked. For a general account, in English, see William Vaughan, *German Romantic Painting* (New Haven, 1980), pp. 6–22; useful summaries of the problem, along with bibliography, are given in Börsch–Supan and Jähnig, *Friedrich*, cat. no. 167 and *Caspar David Friedrich 1774–1840*, ed. Hofmann, pp. 158–61. More specialized readings are offered by Carla Schulz–Hofmann, 'Studien zur Rezeption der deutschen romantischen Malerei in Kunstliteratur und Kunstgeschichte' (Ph. D. dissertation, Munich, 1974), pp. 67–111; Norbert Schneider, 'Natur und Religiosität in der deutschen Frühromantik –zu Caspar David Friedrichs *TetschenAltar*', in Berthold Hinz et al. *Bürgerliche Revolution und Romantik: Natur und Gesellschaft bei Caspar David Friedrich* (Gießen, 1976), pp. 111–43; Eva Reitharovà and Werner Sumowski, 'Beiträge zu Caspar David Friedrich', *Pantheon*, 35 (1977), pp. 41–50; Donat de Chapeaurouge,

'Bemerkungen zu Caspar David Friedrichs Tetschener Altar', *Pantheon*, 39 (1981), pp. 50–5; Karl–Ludwig Hoch, 'Der sogennante Tetschener Altar Caspar David Friedrichs', *Pantheon*, 39 (1981), pp. 322–6; Werner Hofmann, 'Caspar David Friedrichs "Tetschen Altar" und die Tradition der protestantischen Frömmigkeit', *Idea. Jahrbuch der Hamburger Kunsthalle*, 1 (1982), 135–62; and Timothy Mitchell, 'What Mad Pride: Tradition and Innovation in the *Ramdohrstreit*', *Art History*, 10 (1987), pp. 315–27.

Ramdohr's original review was published in *Zeitung für die elegante Welt*, 12–15 (17–21 January 1809), pp. 89 ff, 97 ff, 108 ff and 112 ff, and is reprinted in Hinz (1968), pp. 138–57; his response to his critics appeared as 'Über kritischen Despotismus und künstlerische Originalität', in *Zeitung für die elegante Welt*, 56–7 (20 and 21 March 1809), pp. 446 ff and 453, reprinted in Hinz, pp. 178–83. Gerhard von Kügelgen's defence, entitled 'Bemerkungen eines Künstlers über die Kritik des Kammerherrn von Ramdohr, ein von Herrn Friedrich ausgestelltes Bildbetreffend', appeared first in *Zeitung für die elegante Welt*, 49 (19 March 1809), pp. 389 ff, reprinted in Hinz, pp. 175–8. An abridged (and sometimes faulty) translation of Ramdohr and Kügelgen's texts is given in Elizabeth Gilmore Holt, ed., *The Triumph of Art for the Public 1785–1848: The Emerging Role of Exhibitions and Critics* (Princeton, 1983), pp. 152–68. Ferdinand Hartman's defence appeared as 'Über Kunstaustellungen und Kunstkritik', *Phoebus, ein Journal für die Kunst*, ed. Heinrich von Kleist (1809), reprinted in Hinz, pp. 159–75. Christian August Semler's essay 'Über einige Landschaften des Malers Friedrich in Dresden' appeared in *Journal des Luxus und der Moden* (1809), pp. 233–40, and his 'Beilage zu einem Briefe über Friedrichs Landschaften' in *Zeitung für die elegante Welt* (1809), pp. 579–81; both reprinted in Börsch–Supan and Jähnig, *Friedrich*, pp. 72–5.

Johann Jacob O. A. Rühle von Lilienstern's account appears as Letter 4 (1 March 1809) of his *Reise mit der Armee im Jahre 1809* (Rudolstadt, 1810), reprinted in Hinz, pp. 183–7. Maria Helene von Kügelgen's account appears in *Ein Lebensbild in Briefe* (Leipzig, 1900), p. 146. The letters of Countess Theresia Thun–Hohenstein and her mother were discovered by Eva Reitharovà and published in the article 'Beiträge zu Caspar David Friedrich', co-authored by Sumowski, and cited above.

For an analysis of the possible relation between *Cross in the Mountains* and Gustav IV Adolf, see Gerhard Eimer, *Zur Dialektik des Glaubens bei Caspar David Friedrich* (Frankfurt, 1982), pp. 106–68 and *passim*. My quotation from Zinzendorf is taken from his *Eine Sammlung offentlicher Reden* (Nicolaus Ludwig von Zinzendorf, *Hauptschriften*, ed. Erich Beyreuther and Gerhard Meyer (Hildesheim, 1962–3), 2–IV, p. 12), as quoted in Jaroslav Pelikan, *The Christian Tradition: A History of the Development of Doctrine*, 5, *Christian Doctrine and Modern Culture (since 1700)* (Chicago, 1989), p. 125. The best general introduction to the religious climate in Germany at 1800 is still Franz Schnabel's volume on *Die Religiösen Kräfte* in his monumental *Deutsche Geschichte im neunzehnten Jahrhundert*, 4 vols

(Freiburg, 1937, reprinted Munich, 1987), 4, especially pp. 279–492.

The photograph of *Cross in the Mountains* in a bedroom in the Tetschen Castle was published in *Die Zeit*, 3 December 1939, and is reproduced in Hoch, 'Der sogennante Tetschener Altar', p. 324. Philipp Otto Runge's remarks on Raphael's *Sistine Madonna* appear in a letter to his brother Daniel of 9 March 1802, and in an unpublished essay of the same year, both reprinted in Runge, *Briefe und Schriften*, ed. Peter Betthausen (Munich, 1982), pp. 76 and 238, respectively. Runge's reading of Raphael's canvas as an instance of secularization is taken up again by Walter Benjamin in 'Das Kunstwerk in Zeitalter seiner technischen Reproduzierbarkeit,' (second version, 1936), *Gesammelte Schriften*, ed. Rolf Tiedemann and Hermann Schweppenhäuser, 4 vols (Frankfurt, 1974), 2, p. 483 n.11, who follows Hubert Grimm, 'Das Rätsel der Sixtinischen Madonna', *Zeitschrift für bildende Kunst*, 57 (1922), pp. 41–9. The literature on Runge's *Morning* is vast and complex; the best overview is Jörg Traeger, *Philipp Otto Runge und sein Werk: Monographie und kritischer Katalogue* (Munich, 1975), pp. 156–68 and cat. no. 414.

The function and audience of German literary journals and reading clubs in 1800 are discussed in Henri Brunswig, *Enlightenment and Romanticism in Eighteenth-Century Prussia*, trans. Frank Jellinek (Chicago, 1974), pp. 33–40. Wilhelm Heinrich Wackenroder and Ludwig Tieck's *Herzensergießungen eines kunstliebenden Klosterbruders* (1797; Stuttgart, 1979) is available in English as *Confessions from the Heart of an Art Loving Friar*, trans. Mary Hurst Schubert, in *Confessions and Fantasies* (University Park, Pennsylvania, 1971); the reference to Ramdohr appears in the introductory remarks 'To the Reader'.

On the concept of *Eigentümlichkeit* in Friedrich and his culture, see Klaus Lankheit, 'Caspar David Friedrich und der Neuprotestantismus', *Deutsche Vierteljahresschrift für Literaturwissenschaft und Geistesgeschichte*, 24 (1950), pp. 129–43; Schleiermacher's comment in the *Monologen* is quoted in Lankheit, p. 134 n.2; see also Schleiermacher, *On Religion: Speeches to its Cultured Despisers*, trans. John Oman (New York, 1958), pp. 218–19. Friedrich's undated fragment 'Über Kunst und Kunstgeist' was among the artist's literary remains preserved by Johann Christian Claussen Dahl; it is published in Hinz (1968), pp. 83–4.

The historicism of Friedrich's defenders is stressed by Timothy Mitchell, 'What Mad Pride', cited above. For an excellent account of the discipline of art history in its relation to historicism, see Hans Belting, *Das Ende der Kunstgeschichte?* (Munich, 1983); see also Dieter Jähnig, *Welt–Geschichte: Kunst–Geschichte. Zum Verhältnis von Vergangenheitserkenntnis und Veränderung* (Cologne, 1975). Justus Möser's *Osnabruck History* is collected in *Justus Mösers sämtliche Werke: Historisch–kritische Ausgabe*, ed. Eberhard Crusius *et al.*, 14 vols (Oldenburg, 1943–present), vols 12 and 13. On the relation between Möser's historicistic concept of the state and the concept of *Eigentum*, see Mac Walker, *German Home Towns: Community, State and General Estate 1648–1871* (Ithaca, 1971), pp. 182–4 and *passim*;

see also Brunswig, *Enlightenment* pp. 91–3; and Jonathan B, Knudsen, *Justus Möser and the German Enlightenment* (Cambridge, 1986), pp. 94–111.

Friedrich Schlegel's famous statement about poetry as 'republican speech' appears as *Kritische Fragment*, 65 in *Kritische Schriften* ed. Rasch, p. 14, and is discussed in Tzvetan Todorov, *Theories of the Symbol*, trans. Catherine Porter (Ithaca, 1982), pp. 176–7; Kant's statement on genius occurs in § 60 ('On Methodology Concerning Taste') of the *Critique of Judgment* (1790), trans. Werner S. Pluhar (Indianapolis, 1987), p. 231; Schlegel's statement on criticism as art appears as *Kritische Fragment*, 117 in *Schriften*, p. 22. For an excellent account of the 'subjectivisation of aesthetics' in Kant and the Romantics, see Gadamer, *Wahrheit und Methode*, pp. 52–3. Novalis's statement about the reader as 'erweitete Autor' is discussed in Walter Benjamin, *Der Begriff der Kunstkritik in der deutschen Romantik*, in *Gesammelte Schriften*, ed. Tiedemann and Schweppenhäuser, 1, p. 68.

Carus's account of Friedrich's transformation of landscape appears in the preface to *Caspar David Friedrich, der Landschafismaler–Zu seinem Gedächtnis, nebst Fragmenten aus seinen nachgelassenen Papieren* (Dresden, 1841), reprinted in Hinz, pp. 204–6. The negative notice on Dresden landscape painting appeared in *Zeitung für die elegante Welt* (1839), p. 532, excerpted in Börsch-Supan and Jähnig, *Friedrich*, p. 127. Reviews of the 1906 Berlin exhibition are also listed and summarized there (p. 170). For full discussion of the history of Friedrich's reception, and of its various political circumstances, see Roswitha Mattausch, 'Rezeption und Transformation im 19. Jahrhundert', Klaus Wolbert, ' "Deutsche Innerlichkeit": Die Wiederentdeckung im deutschen Imperialismus', and Berthold Hinz, 'Die Mobilisierung im deutschen Faschismus', all in *Caspar David Friedrich und die deutsche Nachwelt: Aspekte zum Verhältnis von Mensch und Natur* ed. Werner Hofmann (Frankfurt, 1974), pp. 34–63. The review from 1940 appeared in *Die Kunst*, 81 (1940), p. 151, as quoted in Hinz, 'Mobilisierung', p. 62 n.2. Johann Christian Claussen Dahl's statement was first quoted in Andreas Aubert, *Kunst und Künstler*, 3 (1905), p. 198 and reprinted in Hinz (1968), p. 217.

Friedrich's statements of *c.* 1830 on his art and its relation to contemporary tastes appear in a text entitled 'Äußerung bei Betrachtung einer Sammlung von Gemälden von größtenteils noch lebenden und unlängst verstorbenen Künstlern'. It was published posthumously by Carus as part of his *Caspar David Friedrich, der Landschafismaler*, cited above, and is reprinted in Hinz (1968); the passages I have quoted appear, in order, in Hinz, pp. 82, 119 and 123.

The anecdote of skating is first recorded in the anonymous 'Gespräch über die Kunstausstellung in Dresden', *Der Freimüthige und Ernst und Scherz*, 2 (1804), pp. 330–1 and reprinted in Börsch–Supan and Jähnig, *Friedrich*, p. 62.

5 Sentimentalism

Friedrich's early graphic manner is discussed in Sumowski, *Friedrich-Studien*, pp. 50–1 and in Jens Chris-

tian Jensen, *Caspar David Friedrich: Leben und Werk*, 2nd rev. ed. (Cologne, 1985), p. 45. Jensen offers compelling readings of most of Friedrich's self-portraits (pp. 7–20). On the Berlin *Self-Portrait*, see Sumowski, p. 92, who suggests the allusion to portrait bust, and Börsch–Supan and Jähnig (*Friedrich*, cat. no. 170), who argue for a reference to a monk's habit. Goethe's definition of Classic versus Romantic art is quoted in Mario Praz, *The Romantic Agony*, trans. Angus Davidson, 2nd rev. ed. (Oxford, 1970), p. 8. David d'Anger's statement is quoted in Carus, *Lebenserinnerungen*, 2, p. 389; Ferdinand Hartman's remark about Friedrich's beard is recorded by Wilhelmine Bardua in a memoir published posthumously as *Jugendleben der Malerin Caroline Bardua* ed. W. Schwarz (Breslau, 1874), pp. 58–61, and reprinted in Hinz, p. 199; Wilhelm von Kügelgen's anecdote about Friedrich's cloak appears in his *Jugenderinnerungen eines alten Mannes* (Ebenhausen, 1909), and is quoted in Jensen, *Friedrich*, p. 20. Schelling's definition of the subjective character of landscape painting appears in *Philosophie der Kunst* (1802–3), in *Sämmtliche Werke*, ed. K. F. A. Schelling, 14 vols (Stuttgart, 1856–61), 1–5, p. 544; Friedrich's famous statement on the subjectivity of art is reprinted in Hinz (1968), p. 128.

On the city of Greifswald, see J. Zeigler, *Geschichte der Stadt Greifswald* (Greifswald, 1897). Friedrich's early biography and career are recounted in Herbert von Einem, *Caspar David Friedrich*, 3rd rev. ed. (Berlin, 1950), pp. 7–46; and Sumowski, *Friedrich–Studien*, pp. 45–68. Quistorp's letter to Runge (dated 28 August 1803) is quoted in Sumowski, p. 45. Ludwig Gotthard Kosegarten's *Jucunde* is published in *Dichtungen*, 8 vols (Greifswald, 1812), 1, p. 148. Helmut Börsch–Supan's discussion of the pivotal role of Friedrich's Rugen sketches on the artist's overall development appears as 'Die Bildgestaltung bei Caspar David Friedrich' (Ph. D. dissertation, Munich, 1960), pp. 65–76.

On the organization of Copenhagen Academy, see F. Meldahl and P. Johansen, *Det kongelige Akademi for de skjøne Kunster 1700–1904* (Copenhagen, 1904), as well as Friedrich Wilhelm Basilius von Ramdohr, *Studien zur Kenntnis der schönen Natur, der schönen Künste, der Sitten und der Staatsverfassung auf einer Reise nach Dänemark* (Hanover, 1792), 1, p. 152 ff. Runge's comments on the Academy appear in a letter of 17 February to his brother Daniel, published in *Briefe und Schriften*, pp. 48–9. The Sister Doctrines of the hierarchy of genres and supremacy of history painting are discussed by Rensselaer W. Lee in *Ut pictura poesis: The Humanistic Theory of Painting* (New York, 1967), pp. 16–23. On Juel, see E. Poulsen, *Jens Juel* (Copenhagen, 1961). An allegorical reading of Friedrich's *Landscape with Pavilion* is offered by Börsch–Supan and Jähnig, *Friedrich*, cat, no. 12.

Friedrich's relation to Sentimentalism is discussed in Herbert von Einem, 'Die Symbollandschaft der deutschen Romantik', in *Klassizismus und Romantik: Gemälde und Zeichnungen aus der Sammlung Georg Schäfer* (Nuremberg, 1966), p. 36; my account of the transition from Sentimentalism to Romanticism, as well as my reading of inscriptions in Friedrich's early works, owes

much to Geoffrey Hartman, 'Wordsworth, Inscriptions, and Romantic Nature Poetry', in his *Beyond Formalism: Literary Essays 1958–1970* (New Haven, 1970), pp. 206–30. See also the essays in the anthology *From Sensibility to Romanticism: Essays Presented to Frederick A. Pottle*, ed. F. W. Hilles and Harold Bloom (New York, 1965); William K. Wimsatt, 'The Structure of Romantic Nature Imagery', (1954) anthologized in *Romanticism and Consciousness*, ed. Bloom, pp. 77–88; and M. H. Abrams, 'Structure and Style in the Greater Romantic Lyric', (1965), anthologized in *Romanticism and Consciousness*, pp. 201–29.

On the history of the Dresden Gemäldegalerie, see Ruth and Max Seydewitz, *Das Dresdener Galerie Buch: Vierhundert Jahre Dresdener Gemäldegalerie* (Dresden, 1957). On the conditions of student life in Dresden, see Brunswig, *Enlightenment*, pp. 135–146. The phrase 'Metaphysikus mit dem Pinsel' was coined by the Swedish Romantic poet Per Daniel Amadeus Atterbom, in his *Menschen und Städte: Begegnungen und Beobachtungen eines schwedischen Dichters in Deutschland, Italien und Österreich 1817–1819*, ed. C. M. Schröder (Hamburg, 1947), p. 79, quoted in Sumowski, *Friedrich–Studien*, p. 35. Friedrich's fragment alluding to Hegel is reprinted in Hinz (1968), p. 127.

Robert Rosenblum's interpretation of Friedrich appears as *Modern Painting and the Northern Romantic Tradition: Friedrich to Rothko* (London, 1975), pp. 10–40.

6 Friedrich's system

Schlegel's statement of *c.* 1800 about the infinity of genres appears as Fragment 1090 of his posthumously published *Literary Notebooks, 1797–1801* (London, 1957), quoted in Todorov, *Theory of the Symbol*, p. 187. For an analysis of the Kantian and Romantic sublime, see Thomas Weiskel's classic study, *The Romantic Sublime: Studies in the Structure and Psychology of Transcendence* (Baltimore, 1976), pp. 3–62. For a discussion of the notion of chaos in Schlegel's writings, see Lacoue–Labarthe and Nancy, *Literary Absolute*, pp. 50–5. Schelling's statement about art as the identity between subject and object occurs in his *System des transcendentalen Idealismus* (1800), in *Sämmtliche Werke*, 1–3, p. 628. My analysis of Friedrich's compositional strategy has profited from Börsch–Supan, 'Bildgestaltung'.

Goethe's essay on the Strasbourg cathedral, entitled 'Von deutscher Baukunst: D. M. Ervini a Steinbach', was first published in Darmstadt in 1772 and subsequently included, along with essays by Johann Herder and Justus Möser, in the enormously influential collection *Von deutscher Art und Kunst* (1773), collected in Goethe, *Berliner Ausgabe*, 19, *Kunsttheoretische Schriften und Übersetzungen*, ed. Siegfried Seidel, (Berlin, 1973), pp. 29–38. Theodor Körner's ecphrasis, 'Friedrichs Totenlandschaft', was first published in *Theodor Körners poetischer Nachlaß*, 2, *Vermischte Gedichte und Erzählungen* (Leipzig, 1815), nr. 2; it is included, in full, in Börsch–Supan and Jähnig, *Friedrich*, p. 83. Johanna Schopenhauer's description of Friedrich's elision of a midground in his composition appears in 'Uber Gerhard von Kügelgen und Friedrich in Dresden: Zwei

Briefe mitgetheilt von einer Kunstfreundin', *Journal des Luxus und der Moden* (1910), pp. 690–3, excerpted in Börsch–Supan and Jähnig, *Friedrich*, p. 78.

A history of the genesis of *Monk by the Sea* is given in Börsch–Supan and Jähnig, cat. no. 168. Richard Wollheim's reading of the *Large Enclosure* appears in *Painting as an Art* (Princeton, 1987), pp. 136–8. The threshold experience described by Gottfried Benn is analysed brilliantly in Hans Blumenberg, *Höhlenausgänge* (Frankfurt, 1989), p. 24.

7 Symbol and Allegory

The literature on the Romantic distinction between symbol and allegory is vast. The most powerful and succinct account is still Gadamer's *Wahrheit und Methode*, pp. 66–77. Useful, too, is Todorov, *Theories of the Symbol*, pp. 147–221; Hazard Adams, *Philosophy of the Literary Symbolic* (Tallahasse, 1983), pp. 46–98; and Götz Pochat, *Der Symbolbegriff in der Ästhetik und Kunstwissenschaft*, trans. Martha Pochat (Cologne, 1983), pp. 11–68. More specialized studies include Lorenz Eitner, 'The Open Window and the Storm-Tossed Boat', *Art Bulletin*, 37 (1955), pp. 281–90; Gunnar Berefelt, 'On "Symbol" and "Allegory",', *Konsthistoriska Studier tillägnade Sten Karling* (Stockholm, 1966), pp. 321–40; and Jan Białostocki, 'Romantische Ikonographie' (1960), in *Stil und Ikonographie*, rev. ed. (Cologne, 1981), pp. 214–62. My approach to the way Friedrich's images mean owes much to Paul de Man's revisionist reading of Romantic aesthetics in 'The Rhetoric of Temporality', in *Blindness and Insight*, 2nd rev. ed. (Minneapolis, 1983), pp. 187–228.

Runge's drawing *Ideales – Reales* appeared in his *Hinterlassene Schriften, herausgegeben von dessen ältesten Bruder*, ed. Daniel Runge, 2 vols (Hamburg, 1840–1), I, p. 164; see also Hamburg, Kunsthalle, *Runge in seiner Zeit*, ed. Werner Hofmann, exh. cat. (Munich, 1977), p. 147. Josef Görres's original interpretation of Runge's *Times of the Day* appeared as 'Die Zeiten, vier Blätter nach Zeichnungen von Ph. O. Runge', in *Heidelberger Jahrbücher für Philologie, Historie, Literatur und Kunst*, 1 1808, pp. 261–77; see his *Ausgewählte Werke* (Freiburg, 1978), I, p. 209.

August Wilhelm Ahlborn's *Cloister Cemetery with the Watzmann* is mentioned in Hofmann, 'Caspar David Friedrichs *Tetschen Altar*', pp. 146–7. On the 'shore-chapel' in Vitte, see Sumowski, p. 11; Gerhard Eimer, *Caspar David Friedrich und die Gotik* (Hamburg, 1963), p. 29; and Eimer, *Zur Dialektik des Glaubens*, pp. 52–81. For Görres on landscape, see Georg Bürke, *Vom Mythos zur Mystik: Joseph von Görres' Mystische Lehre und die romantische Naturphilosophie* (Einsiedeln, 1958), p. 354. Luther's 'Epistell an Sankt Stephans tag', from the *Kirschenpostille* of 1522, appears in *Werke: Kritische gesammtausgabe*, 94 vols (Weimar, 1883–1980), 10–1, pp. 252 and 253; my other quotation from Luther is taken from 'Scholien zum 118. Psalm. Das schöne Confitimini 1529 (1530)', (*Werke*, 31–1, p. 179). Similar passages occur in *Werke*, 5, pp. 142–143, and 14, pp. 386–7.

Runge's history of the decline of religion appears in *Briefe und Schriften*, p. 238; his interpretation of his own

Mother at the Source, in a letter of 27 November 1802 to his brother Daniel (*Briefe und Schriften*, p. 102). Runge's project of abstract art is usefully summarized in Rudolf M. Bisanz, *German Romanticism and Philipp Otto Runge: A Study in Nineteenth-Century Art Theory and Iconography* (DeKalb, Illinois, 1970), pp. 100–102 and *passim*. On Runge's *Rest on the Flight*, its meaning, and genesis, see Hubert Schrade, 'Die romantische Idee von der Landschaft als höchstem Gegenstande christlicher Kunst', *Neue Heidelberger Jahrbücher*, n. s. (1931), p. 62 ff; Otto Georg von Simson, 'Philipp Otto Runge and the Mythology of Landscape', *Art Bulletin*, 24 (1942), pp. 335–50; *Runge in seiner Zeit*, pp. 174–81; and Traeger, *Runge*, pp. 61–7, 382–86.

Ludwig Tieck's *Franz Sternbalds Wanderungen* (Berlin, 1798) is available in a modern critical edition by Alfred Anger (Stuttgart, 1979); the episode of the visit to the hermit–painter appears there on pp. 247–58. I have profited here from Alice Kuzniar's recent account, 'The Vanishing Canvas: Notes on German Romantic Aesthetics', *German Studies Review*, 3 (1988), pp. 359–76. Another important literary description of a cross in a landscape appears in the opening scene of Joseph von Eichendorf's novel *Ahnung und Erwartung* (Nuremberg, 1806; ed. Gerhart Hoffmeister [Stuttgart, 1984], pp. 3–4); see Richard Alewyn, 'Eine Landschaft Eichendorffs', *Euphorion*, 51 (1957), pp. 42–60. On landscapes with crosses generally, see Karl Woermann, 'Kirchenlandschaften', *Repertorium für Kunstwissenschaft*, 13 (1890), p. 337 ff, and *Caspar David Friedrich 1774–1840*, ed. Hofmann, pp. 56–9. Umberto Eco's account of indexical signs appears in *A Theory of Semiotics* (Indianapolis, 1976), p. 116. On Friedrich's affinity to Tieck, see Franz Reber, *Geschichte der neueren deutschen Kunst* (Stuttgart, 1876) and Goethe, *Kunst und Altertum* (1817), quoted in Sumowski, *Friedrich–Studien*, p. 15. Carus's *Neun Briefe über Landschaftsmalerei* exists in a modern edition by Kurt Gerstenberg (Dresden, n.d.); see pp. 99–101. The most sensible account of the way 'the forms of Nature speak directly' in Friedrich is Henri Zerner and Charles Rosen, 'Caspar David Friedrich and the Language of Landscape', *Romanticism and Realism: The Mythology of Nineteenth-Century Art* (New York, 1984), p. 58.

8 The end of Iconography

Friedrich's letter to Schulz was published in abridgement, edited by Christian Semler, in *Journal des Luxus und der Moden*, 3 (April 1809), p. 239; the complete text of the letter appears in H. Zeeck, 'Romantische Kunstanschauung: Ein unveröffentlicher Brief von Caspar David Friedrich', *Das Kunstblatt*, 17 (1933), pp. 2–4, 13–14, and again in Börsch–Supan and Jähnig, *Friedrich*, p. 183. Hoch ('Der sogenannte Tetschen Altar', pp. 322 and 326 n.12) locates flaws in Börsch–Supan and Jähnig's published version; the original manuscript is kept now in the Goethemuseum in Frankfurt (Inv. Hs. 13912).

Schelling's discussion of symbol and allegory occurs in § 39 of *Philosophie der Kunst* (*Sämmtliche Werke*, 1–5, pp. 406–13). Führich's gouache sheet after Friedrich's *Cross in the Mountains* is discussed in the exhibition

catalogue of the Munich Kunsthalle der Hypo–Stiftung, *Deutsche Romantiker: Bildthemen der Zeit von 1800–1850*, ed. Christoph Heilmann (Munich, 1985), cat. no. 103.

Donat de Chapeaurouge's interpretation of *Cross in the Mountains* ('Bemerkungen zu Caspar David Friedrichs Tetschener Altar') has been criticized by Hoch ('Der sogennante Tetschener Altar'), both cited above; see Jean Paul, 'Reden des Toten Christus vom Weltgebäude herab, dass kein Gott sei', *Blumen- Frucht- und Dornenstücke oder Ehestand, Tod und Hochzeit des armenadvokaten F. St. Siebenkäs* (1796), in *Werke*, ed. Gustav Lohmann (Munich, 1959), II–2, p. 269.

Runge's vision of epochal change occurs in a letter of 9 March 1802 to Daniel Runge (*Briefe und Schriften*, p. 72) . Hegel's famous statement on the movement of art from the church appears in *Werke*, 9, *Vorlesungen über die Philosophie der Geschichte*, ed. Eduard Gans (Berlin, 1937), 414; as quoted in Benjamin, 'Kunstwerk',p. 482–3 n.10.

Part III The Halted Traveller
9 Entering the Wood

See Martin Heidegger, *Holzwege* (Frankfurt, 1950), p. 3. The link between *Early Snow* and the lost *Easter Morning* is made by Sumowski (*Friedrich–Studien*, pp. 242, cat. no. 463), who follows an account by an early owner of both canvases (W. Wegener, 'Der Landschaftsmaler Friedrich: Eine biographische Skizze', *Unterhaltungen am häuslichen Herd* n.s. 4 [1859], pp. 71–7, reprinted in Börsch–Supan and Jähnig, *Friedrich*, pp. 146–50). On Faust's *Verweile–doch*, see Ernst Bloch's 'Goethes Zeichnung *Ideallandschaft*', in *Verfremdungen II: Geographica* (Frankfurt, 1978), p. 189. Maurice Merleau–Ponty's discussion of autoscopy appears in *Phenomenology of Perception*, trans. Colin Smith (London, 1962), p. 262; Merleau–Ponty relies on Karl Jaspers, 'Zur Analyse der Trugwahrnehmung', *Zeitschrift für die gesamte Neurologie und Psychiatrie* (1911), E. Menninger–Lerchenthal, *Das Truggebilde der eigenen Gestalt* (Berlin, 1934), p. 67, and J. Lhermitte, *L'Image de notre Corps* (Paris, 1939), p. 191. The interpretation of the raven in Friedrich's *Chasseur* as singing a deathsong appeared in an anonymous review in *Vossische Zeitung* (1814), excerpted in Börsch-Supan and Jähnig, p. 82.

On the *Rückenfigur* and the question of staffage, see M. Koch, *Die Rückenfigur im Bild von der Antike bis Giotto* (Recklinghausen, 1965); W. Wagmuth, 'Das Staffageproblem in der deutschen Landschaftsmalerei um 1800' (Ph. D. dissertation, Munich 1950); Sumowski, *Friedrich–Studien*, pp. 22–5; *Caspar David Friedrich 1774–1840*, ed. Hofmann, pp. 40–3. Alberti's recommendation occurs in *On Painting*, trans. John R. Spencer, rev. ed. (New Haven, 1966), p. 78. On the relation between Friedrich and Luiken, see Herbert von Einem, 'Ein Vorläufer Caspar David Friedrichs?', *Zeitschrift des deutschen Vereins für Kunstwissenschaft*, 7 (1940), p. 156.

For an introduction, in English, to the main currents in German art after Friedrich, see Vaughan, *German Romantic Art*, pp. 121–238.

10 Theomimesis

For Rilke's *Duino Elegies*, I have used the translation by J. B. Leischman and Stephen Spender (New York, 1939). On *Wanderer above the Sea of Fog*, see Ludwig Grote, 'Der Wanderer über dem Nebelmeer', *Die Kunst und das schöne Heim*, 48 (1949–50), p. 401 ff; and Börsch–Supan and Jähnig, *Friedrich*, cat. no. 250. Edmund Burke's definition of the sublime appears in *Philosophical Enquiry into the Origins of Our Ideas of the Sublime and the Beautiful*, ed. James T. Boulton (Notre Dame, 1968), p. 59 and 63. Friedrich's comment on fog appears in Hinz (1968), p. 123. Kant's definition of the sublime appears in § 28 and § 30 of the *Critique of Judgment* (pp. 123 and 142). For Carus on the painting as gaze, see his *Lebenserinnerungen*, 1, pp. 207–8, excerpted in Hinz, p. 202.

For the motif of the halted traveller in Wordsworth, see, especially, Geoffrey Hartman, *Wordsworth's Poetry: 1787–1814* (New Haven, 1971), pp. 3–30 and *passim*; and Roger Shattuck, 'This Must Be the Place: From Wordsworth to Proust', in *Romanticism*, ed. Thornburn and Hartman, pp. 177–86. In my reading of 'A Night-Piece', I have profited from Kenneth R. Johnston's excellent 'The Idiom of Vision', *New Perspectives on Coleridge and Wordsworth: Selected Papers of the English Institute*, ed. Geoffrey Hartman (New York, 1972), pp. 1–39.

Carus's description of Friedrich's working methods occurs in *Lebenserinnerungen*, 1, pp. 207–8 (Hinz, p. 202). On Friedrich's studio: David d'Anger's account of his visit to Friedrich's studio is cited by Franz Bauer in *Caspar David Friedrich: Ein Maler der Romantik* (Stuttgart, 1961), pp. 64–5; Wilhelm Kügelgen's description appears in *Jugenderinnerungen*, pp. 109–11, as quoted in Metropolitan Museum of Art, *German Masters of the Nineteenth Century*, exh. cat. (New York, 1981). The comparison of Friedrich's nature studies with drawings in medieval model books is made in Klaus Lankheit's 'Die Frühromantik und die Grundlagen der Gegenstandslosen Malerei', *Neue Heidelberger Jahrbücher*, 20 (1951), p. 74; for a general account of Friedrich's mature graphic manner, see Hans H. Hofstätter, 'Caspar David Friedrich: Das graphische Werk', in *Caspar David Friedrich*, ed. Bernhard, pp. 793–829. Schelling's statement on the proper relation of an artist to nature appears in 'Ueber das Verhältniss der bildenden Künste zu der Natur', *Sämmtliche Werke*, I–7, p. 301. On the Romantic revision of the concept of *mimesis*, see Todorov, *Theories*, pp. 147–64; and on the whole problem of *mimesis*, see Hans Blumenberg, 'Nachahmung der Nature: Zur Vorgeschichte der Idee des schöpferischen Menschen', in *Wirklichkeiten in denen wir leben* (Stuttgart, 1981), pp. 55–103.

On the biblical fog, see Wilhelm Fraenger, *Hieronymous Bosch: Das tausendjährige Reich* (Amsterdam, 1969), p. 46. For Goethe's interest in clouds, see Kurt Badt's marvellous chapter 'Goethe und Luke Howard', in *Wolkenbilder und Wolkengedichte der Romantik* (Berlin, 1960), pp. 18–32. Goethe's comment to Boisserée is recorded in Mathilde Boisserée, *Sulpiz Boisserées Briefwechsel nebst Aufzeichnungen*, 2 vols (Stuttgart, 1862), 2,

pp. 276–7. Carus's Friedrichian vision from a summit appears in *Neun Briefe*, p. 36. My citation from Maimonides is taken from *The Guide for the Perplexed*, trans. M. Friedländer, 2nd rev. ed. (New York, 1956), pp. 30–1.

11 Reflection

Fernow's theory of staffage is usefully discussed in relation to German art at 1800 in Gerhard Gerkens's introduction to the Bremen Kunsthalle exhibition catalogue *Staffage. Oder: Die heimlischen Helden der Bilder* (Bremen, 1984). Carus's statement on the beholder in the picture occurs in *Neun Briefe*, p. 60–1.

'Verschiedene Empfindungen vor einer Seelandschaft von Friedrich, worauf ein Kapuziner', by Kleist, Brentano and Arnim, was published in *Berliner Abendblätter*, 12 (13 October 1910), pp. 47–8; the German text is reprinted in Hinz (1968), pp. 222–6; Holt's *Triumph of the Art for the Public* contains a good English translation of the whole piece. For the question of the text's authorship and genesis, see Helmut Sembdner, *Die Berliner Abendblätter Heinrich von Kleists, ihre Quellen und Redaktion* (Berlin, 1939); see, further, Helmut Börsch-Supan, 'Bemerkungen zu Caspar David Friedrich's *Mönch am Meer*', in *Zeitschrift der Deutschen Verein für Kunstwissenschaft*, 19 (1965), pp. 63–76; and Bodo Brinkmann, 'Zu Heinrich von Kleists "Empfindungen vor Friedrichs Seelandschaft" ', *Zeitschrift für Kunstgeschichte*, 44 (1981), pp. 181–7.

The relation between Friedrich's *Rückenfigur* and Schelling's theory of staffage was first noted by Sumowski, *Friedrich-Studien*, p. 23. The relevant passage is Schelling, *Philosophie der Kunst*, in *Sämmtliche Werke*, 1 –5, p 546. G. H. Schubert's interpretation of the sepia *Stages of Life* appears in *Ansichten von der Nachtseite der Naturwissenschaft* (Dresden, 1808), p. 291. An interesting interpretation of the relation between Friedrich's Munich *Summer* and the lost *Winter* canvases is offered by Peter Rautmann, *Caspar David Friedrich: Landschaft als Sinnbild entfalteter bürgerlicher Wirklichkeitsaneignung* (Frankfurt, 1979), pp. 36–8. Erika Platte's *Caspar David Friedrich: Die Jahreszeiten* (Stuttgart, 1961) is a reliable account of the sepia *Stages of Life*; a political reading of the series is offered by Peter Rautmann in 'Der Hamburger Sepiazyklus: Natur und bürgerliche Emanzipation bei Caspar David Friedrich', in *Bürgerliche Revolution und Romantik*, ed. Hinz (Gießen, 1976), pp. 73–109. In my citation of Schiller, I have used Helen Watanabe-O'Kelly's translation of *On the Naive and Sentimental in Literature* (Manchester, 1981), p. 33.

12 Déjà vu

On the *déjà vu*, see Ernst Bloch, 'Bilder des Déjà vu', *Verfremdungen I* (Frankfurt, 1977), pp. 24–36. Goethe's statement on the pastness of landscape appears in *Maximen und Reflexionen*, as quoted in Kuzniar, 'Vanishing Canvas', p. 359. In my essay of 1982, 'Borrowed Sight: The Halted Traveller in Caspar David Friedrich and William Wordsworth', I offer an extended reading of the relation between the structure of belatedness in Wordsworth's 'Tintern Abbey' and our experience of Friedrich's *Rückenfigur* (published in *Word and Image*, 1

[1985], pp. 149–63). Friedrich de la Motte Fouqué's ecphrasis, 'Zwey Bilder aus Maler Friedrichs Werkstatt', appeared in *Reise-Erinnerungen* (Dresden, 1823), 2, pp. 206–9, co-authored with Caroline de la Motte Fouqué; it is included in Börsch-Supan and Jähnig, *Friedrich*, pp. 99. The *Prelude* of 1805 is usefully collected in William Wordsworth, *The Prelude 1799, 1805, 1850*, ed. Jonathan Wordsworth, M. H. Abrams and Stephen Gill (New York, 1979). Jean-Paul Sartre's park scenario appears in *Being and Nothingness: An Essay on Phenomenological Ontology*, trans. Hazel E. Barnes (London, 1957), p. 261; a brief summary of this passage and its significance for contemporary art historical theorization of the gaze is offered by Norman Bryson in 'The Gaze in the Expanded Field', *Vision and Visuality*, ed. Hal Foster (Seattle, 1988), pp. 87–94. Merleau-Ponty's account of vision appears in the posthumously published collection *The Visible and the Invisible*, ed. Claude Lefort and trans. Alphonso Lingis (Evanston, 1968), pp. 130–55; Lacan's account appears in *Four Fundamental Concepts of Psycho-Analysis*, ed Jacques-Alain Miller and trans. Alan Sheridan (Harmondsworth, 1977), p. 67–119. My quotation from Hartman is taken from his 'Romanticism and Anti-Self-Consciousness', in *Beyond Formalism*, p. 304.

Carus's *Raphael and Michelangelo* recalls a passage from Heidegger's essay 'Wozu Dichter?' in which the philosopher imagines the poet-precursor in a vespertine landscape: 'Hölderlin is the pre-cursor [*Vor-gänger*] of poets in a destitute time. This is why no poet of this world can overtake him. The precursor, however, does not go off into the future; rather, he arrives out of that future, in such a way that the future is present only in the arrival of his words . . . If the precursor cannot be overtaken, no more can he perish; for his poetry remains as a once-present being [*als ein Ge-wesenes*]' ('Wozu Dichter', in *Holzwege*, p. 315). Are not Friedrich's *Rückenfigur* visual emblems of *das Ge-wesene*?

Peter Cornelius's visit to Friedrich is described in Förster, *Biographische und literarische Skizzen*, pp. 156–7, excerpted in Hinz (1968), p. 219–20. Harro Harring's travel account appeared in *Rhongar Jarr: Fahrten eines Friesen in Dänemark, Deutschland, Ungarn, Holland, Frankreich, Griechenland, Italien und der Schweiz* (Munich, 1828), 1: 193. The episode is described in Peter Märker, 'Caspar David Friedrich zur Zeit der Restauration: Zum Verhältnis von Naturbegriff und geschichtlicher Stellung', in *Bürgerliche Revolution*, ed. Hinz, pp. 43–4. For further political readings of Friedrich's landscapes, see also Märker's 'Geschichte als Natur: Untersuchung zur Entwicklungsvorstellung bei Caspar David Friedrich' (Ph.D. dissertation, Kiel, 1974); and, more extensively, Peter Rautmann, *Caspar David Friedrich*. For general account of politics of the period, see Friedrich Meinecke's classic *The Age of German Liberation 1795–1815*, trans. Peter Paret and Helmut Fischer (Berkeley, 1977), and Schnabel, *Deutsche Geschichte*, 2, pp. 215–63. On Ulrich von Hutten, see Volker Press's *Kaiser Karl V, König Ferdinand und die Entstehung der Reichsritterschaft* (Wiesbaden, 1976); and 'Ulrich von Hutten, Reichsritter und Humanist 1844–1523', *Nassauische Annalen*, 85 (1974), pp. 71–86.

List of Illustrations

All measurements given in centimetres.

PHOTOGRAPHIC ACKNOWLEDGEMENTS
Jörg P. Anders 14–16, 21, 29, 33, 64, 76, 87, 88, 94, 96, 105, 111, 112, 119, 137; Artothek 2, 29, 64, 78, 80, 93, 118, 122, 124, 139; Bayerische. Staatsgemäldesammlungen 126; Bildarchiv Marburg 50, 66; Bildarchiv Preussischer Kulturbesitz 14, 16, 21, 33, 76; Ursula Edelmann 38, 106; Fotostudio Otto 20, 25, 108; Réunion des Musées Nationaux 82; Rheinische Bildarchiv 121; Sachsische Landesbibliothek, Deutsche Fotothek 1, 11–13, 17, 110, 134; Elke Walford 9, 24, 28, 31, 44, 46, 51, 54, 68, 69, 73, 77, 79, 99, 100, 113, 127–133, 136, 138

Index